AFRICA
In the footsteps of the
Great Explorers

AFRICA
In the footsteps of the
Great Explorers

Kingsley Holgate

ACKNOWLEDGEMENTS

More and more whilst travelling, I realise our journeys are but a grain of sand on the timeless continent, and what makes the journey go round is a shared sense of humanity. The fishermen who, with a polite 'Karibu', move aside to allow you a place around the cooking pot for finger-pieces of ugali and fish. The old mama that comes over to your tent and offers you fruit and coconut wine. Thank you, Mama Africa!

On our travels there's also a shared sense of adventure from kindred spirits, friends who go out of their way to help make it work. While in the Eastern Cape, Adrian Gardner and his team from Shamwari assisted on our Livingstone journey, as did the Protea Hotel group and the Moffat Museum at Kuruman.

For the Makgadikgadi adventure, I thank Sam Kelly and her crew, Billy Campbell and the land yacht skippers. Old mate Barry Leitch, Rampap and dear friends Mike Yelseth and Tim Chevallier, two of South Africa's greatest adventure cameramen with whom I'm privileged to have shared many a great adventure.

Over the years many an expedition has started from Shakaland. *Siyabonga* Aart van der Heijden, Errand Sullivan, Alan Louw, Francois Meyer, Charl van Wyk, and Baba Biyela and his wonderful Zulu team.

In East Africa I'd like to thank the Unitrans team at Kilombero, Max Nightingale, Nick Veldman, the intrepid Keven Stander of the Sea Cliff Hotel in Dar Es Salaam, and Ryan Wienand and his team from Zuka Safaris, Benson Kibonde from the Department of Wildlife and the fearless game scouts of the Selous Game Reserve.

In Mozambique all our adventures seem to begin or end with Paul and Liz Hallowes who are always free with a bottle and a bed and a wonderful friendship.

Chris 'Hungry' Hurlin and his wife Leigh have provided a home from home at Inhassoro and only he'll understand the story of the half-burnt dhow and the winning lotto.

At Pemba in Cabo Delgado, our adventures have been kept alive by dear friends Charles Gornal Jones, Russell Bott from Blackfoot Camp and friend Fai Chababe, Martin and Annetjie Visagie, Gustav Gulzar and all the other crazy characters that prop up Russell's bar. I'd like to thank Neville and Veronica who shared the Rio Rovuma – Lake of Stars expedition and all the other pilgrims of adventure who travelled with us. Chris Boshoff of the Halo Trust and his team who gave us incredible assistance through the landmine fields in northern Mozambique.

Photojournalist Tony Weaver, who kept our oddball stories alive, Marcus Wilson-Smith for his sense of adventure and wonderful photographs, Linda

Sparrow from Australia, Adrian Verduyn and David Gwenca on the Zambezi.

Learner explorer Bruce Leslie, Lumbaye Lenguru, Mohammed Nasoro (Mohammed the Brave) and all the other great characters that acted as guides and rivermen.

In Uganda there's John Dahl, Bingo and the team at the Nile River Explorers. Congratulations, Jonno. It's people like you who keep adventuring alive.

In Kenya there's Rob Dodson, Ron Beaton, and Rob and Dale Melville, great friends who shared wonderful exploits. I'd also like to pay tribute to that great fellow of adventurer, Patrick Wagner, who was killed in a plane crash. Pat, your memory lives on!

Family adventures would not have been possible without great sponsors who benefited from the exposure on TV and in print. Lesley Sutton and the team of Land Rover South Africa. Carl Reinders, Candace, Greg and Helen of the Captain Morgan team in Cape Town – you are truly great and bring true meaning to your Spirit of Adventure slogan. To Dave Fraser of Howling Moon tents, Jenny Soons of tough Cooper Tires, Greg Bennett and Hanlie du Preez of Yamaha in Durban, Colin and Adolf from 4x4 MegaWorld, Marc Lurie from Motorola and Gemini Boats in Cape Town.

In our fight against malaria, I'd like to thank Ivan Clark and the team from Grindrod, especially Alison Briggs. From Vodacom, Alberts Breedt and Don Schoorn.

Joan la Rosa, Vanessa Coelho and all the team from USAID, Jenny C Peters from PSI Maputo, Romanus Mtunge (PSI Tanzania) and Desmond Chavasse (PSI Kenya), Ezra Chesno of Peaceful Sleep, Dave Erasmus and the team from *Natal Witness*, as well as the team from East Coast Radio, Matthew Frank from RDF International and Pierre Roode in his 34-year-old Forward Control Land Rover. In time to come, I promise you that we'll continue the fight in our One Net One Life malaria prevention campaign.

Joceline Roe, the lovely little character who took up the challenge to type up my crazy scribblings; you'd never tackled anything like this before and succeeded with a smile. *Siyabonga*, Joss! You and Steve were also great expedition members on the Rovuma, a journey we'll never forget.

To my family – Mashozi, Ross and now Geraldine and little Tristan – thanks for the shared adventures and wonderful memories.

At Struik I'd like to thank Dominque le Roux, Lesley Hay-Whitton, Mariëlle Renssen and Samantha Fick for being able to successfully condense tens of thousands of kilometres and years of travel to something readable between a cover. I know I've left people out. Friends and acquaintances with whom we've shared many a campfire. Please forgive me …. Thanks to you all for sharing our travels with us.

Published by Struik Travel & Heritage
(an imprint of Random House Struik (Pty) Ltd)
Company Reg. No. 1966/003153/07
80 McKenzie Street, Cape Town 8001
PO Box 1144, Cape Town, 8000, South Africa

www.randomstruik.co.za

First published in 2006, Reprinted in 2007, 2009

10 9 8 7 6 5 4 3

Publishing manager: Dominique le Roux
Managing editor: Lesley Hay-Whitton
Editor: Mariëlle Renssen
Project co-ordinator: Samantha Fick
Designer: Martin Jones
Proofreader: Cecilia Barfield

Reproduction by Hirt & Carter Cape (Pty) Ltd
Printed and bound by Tien Wah Press (Pte.) Ltd, Singapore

ISBN 9 781770 071476

CONTENTS

In the footsteps of the Great Explorers

Enlivened with stories of Heroism and Unparalleled
Daring – Marvellous hunts and Incredible adventures among
Savage saurians – Giant fish, Monstrous behemoths and Strange and Curious tribes

Replete with astounding Incidents, mysterious Providences, grand Achievements and glorious
Deeds in the Pursuit of Knowledge and Adventure

The Whole enriched with Coloured plates, Engravings
and Hand-drawn maps – for the Use of Adventurers & Dedicated to all Those who Love
Messing around in Land Rovers and Boats!

Africa's True Heroes

A Dedication

Africa, Cradle of all Humankind, and one of the last great frontiers of adventure. The river Nile, longest and most historic in the world, the mighty Congo, Rovuma and Rufiji. The Sahara, the world's largest desert, the Namib, the most ancient. The lakes and wildlife of Africa's Great Rift Valley. The Ruwenzori's Mountains of the Moon, *Izinthaba zo Khahlamba* – 'barrier of spears' – the mighty Drakensberg, and Kilimanjaro, largest freestanding mountain in the world. Drinking blood with red-ochred Nilotic Maasai, following the migration of over a million wildebeest as they move across the vast plains of the Serengeti, the silver-backed gorillas of the equatorial rainforests.

This is Africa. But it wasn't easy for those tough, courageous individuals, the early explorers, who attempted to open up this so-called Dark Continent. Without maps and with only the most basic of navigational equipment and medicines, they faced starvation, fever and often death. Many of them became famous, were awarded gold medals from the Royal Geographical Society and honoured by royalty. Their reports brought about the Scramble for Africa, in which large portions of the continent – without thought for the indigenous people – were cut up like a cake and devoured by the five rival nations: France, Germany, Italy and Britain (with some crumbs for Spain).

But who were the real heroes of this early Victorian exploration of Africa? Without taking anything away from the 'glorious deeds' of the explorers themselves,

I believe it was the African guides, askaris, translators and porters who deserve the real praise. Men like Chuma and Susi, David Livingstone's companions who carried his body across Africa, and the Makololo porters who supported Livingstone on his transcontinental expedition. Mohammed Sief, one of Count Teleki's bodyguards who, refusing to give up, climbed with the count to 15 355 feet, so becoming the first men to penetrate the moorlands of Mount Kenya. Juma Kimameta, the Swahili trader who befriended Joseph Thomson and Teleki. Brave Mabruki who travelled with Stanley and died on the shores of Lake Victoria. There's a long list of brave men, not to mention the porters who invariably followed their leaders with great loyalty and bravery, often risking their lives in the endeavour.

It is the same today. We would not succeed without the generous help of our African expedition members who help, guide and translate. Men like Lumbaye Lenguru, Mohammed the Brave, Fai Chababe, and Selous game scouts Edward Ngogolo and Jabili Ngau.

It's such people that are the backbone of every successful expedition and so I dedicate these humble scribbles from my expedition journal to them – the true unsung heroes of African exploration.

AFRICA

In the the footsteps of the Great Explorers

Modern-day family journeys in the footsteps of the great explorers

Africa will always be the Africa of the Victorian atlas, the blank
unexplored continent, the shape of the human heart.
— Graham Greene

Full Moon, Cape Agulhas
5th February 2004

Friends,

The Southeasterly blows cold as I scribble you this note whilst seated
on a windswept rock on the southernmost tip of Africa. The waves
crash below me and, to the west, the setting sun lights up the clouds
over the cold South Atlantic. At the same time, to the east, the full
moon, a giant yellow orb, rises slowly over the warm Indian Ocean. It's
a magical moment.

At the end of the 15th century, the early Portuguese seafarers
christened this southern tip of Africa Cabo das Agulhas – 'Cape of
Needles'. The 1848 lighthouse, which first used oil from sheep's-tail fat
for its lamp, still stands above the jagged rocks, flashing a warning to
passing ships, way out into the darkness where the two oceans meet.
I close my notebook and turn to face this ancient and mysterious
continent, cradle of all humankind. In the back of the Land Rover
is a crate of old expedition journals, maps and reference books, some
kit, supplies, a few bottles of Captain Morgan Rum, a bicycle, and
Thatcher the dog. I'm not computer literate, so there's no laptop; just
ballpoint pens and jotters. I've come to the southernmost Cape to
piece together this personal account of our crazy family journeys in
Africa, adventures in the footsteps of early explorers such as Teleki,
Stanley and Livingstone; Chuma and Susi, the two unsung heroes of
African exploration who carried Dr Livingstone's salt-dried corpse
for over a thousand miles across Africa, from Lake Bangweulu to
Bagamoyo opposite Zanzibar; and Frederick Courtney Selous, the
great hunter and naturalist after whom Africa's largest game reserve
is named.

I feel privileged to have been born in Africa, and to be able to share
with you this humble collection of stories taken from our old sweat-
stained, leather-bound expedition journals. I have decided to call this
anthology: *Africa – In the footsteps of the Great Explorers*. I do hope
you enjoy it.

Siyabonga and thanks

Kingsley Holgate

It's a family affair

Born in 1946 in Durban, South Africa, I was christened Kingsley by my God-fearing parents after, I'm told, the early Rhodesian missionary adventurer, Kingsley Fairbridge.

The Zulus call me *Nondwayiza*, the African jacana or lily-trotter, a bird with long legs and big ungainly feet – but nowadays I'm often referred to as the 'greybeard of African adventure'. My real good fortune, however, is to have been born in Africa – and to have lived the fascinating but sometimes dangerous life of a modern-day explorer. This rough, tough existence is normally a lonely one but fortunately for me it's been a family affair. Gill, my adventurous wife, nicknamed *Mashozi* ('she who wears shorts') by the Africans, is my constant travelling companion.

In a piece narrated on-camera for a *National Geographic* documentary, with a herd of elephants around her, *Mashozi* once put it this way:

'I first met Kingsley in England thirty-four years ago. As a young man he had left Africa to travel the world; all he owned was a rucksack full of dirty clothes and a short black beard. I fell in love twice: first with Kingsley, and then with Africa, my new-found home.

'It's not an easy life, but I don't regret leaving suburbia for the life of a gypsy, especially when surrounded by the timelessness and beauty of my adopted Africa.'

Ross, our son, is the second string to my bow. He has become a great adventurer, speaks several African languages, and through his incredible survival skills, he has often saved our lives. But, at the end of the day, we are not a bunch of gung-ho commandos. Rather, just an ordinary family who has fallen in love with Africa and has had the passion to live out its dreams.

The Zulu calabash

Our expedition talisman remains a beaded Zulu calabash which we fill with water at the commencement, then empty at the completion, of each journey. A piece of African symbolism that began in 1993 when we carried the calabash, filled with Cape Point seawater, across Africa to Cairo, Alexandria, and the mouth of the Nile. Later expeditions included a global circumnavigation along the Tropic of Capricorn; crossing the Makgadikgadi pans by land yacht; a circumnavigation of the world's largest desert lake; the Zambezi, Congo, Rovuma and Rufiji rivers; the Great African Rift Valley; and other calabash odysseys that were to change our lives forever.

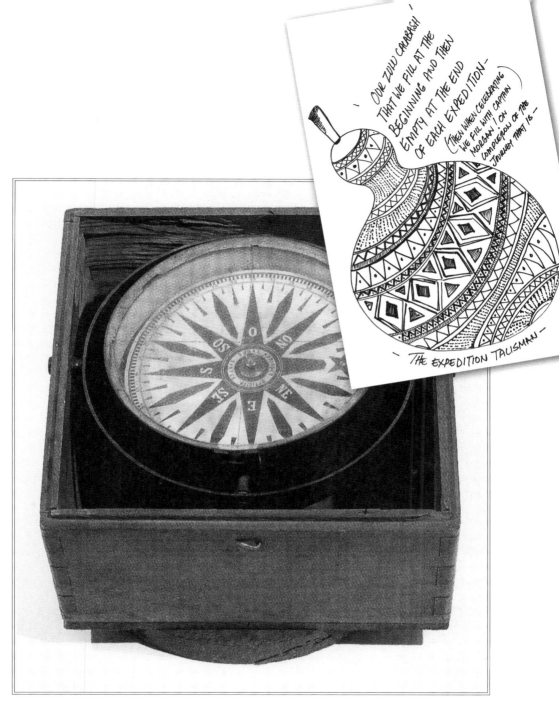

OUR ZULU CALABASH THAT WE FILL AT THE BEGINNING AND THEN EMPTY AT THE END OF EACH EXPEDITION —

(THEN WHEN CELEBRATING WE FILL WITH CAPTAIN MORGAN! ON COMPLETION OF THE JOURNEY THAT IS —

— THE EXPEDITION TALISMAN —

Dr Livingstone's compass

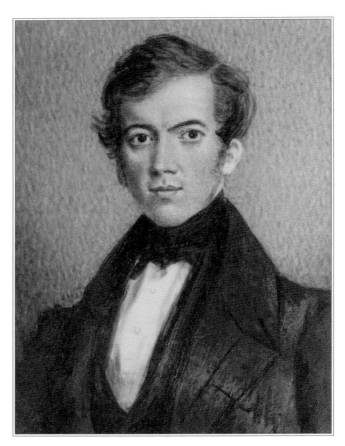

The young Dr David Livingstone

Chapter I

Makgadikgadi

Where the Wind Speaks

Being the Narrative of a crazy Family journey taken by
Land Rover, on Foot & by Land yacht
in the Footsteps of the famous Victorian explorer, Dr David Livingstone,
and Gentleman hunter & adventurer, William Cotton Oswell

Including an Authentic account of
Livingstone's journey to Kuruman – the Fearful attack by a Lion
The Kalahari thirstland – Search for Lake Ngami – Lost Aviators – Near Death from
Rampap's Pudding – Circumnavigating Makgadikgadi by Land yacht – the Chobe
& Great Zambezi rivers

And Comprehending whatever is Remarkable & Curious
in the world of Travel & Adventure

The Whole enriched with Photographs – coloured Plates – Drawings, Engravings & hand-
drawn Maps – for Use by Adventurers & all Those who Love the Great Outdoors

Some sort of explorer you are, Mate! ·

'Where to, guv?' asks the cockney cabbie.

'R.G.S.' I reply, ducking out of the driving rain into the heated cab. My old African bushjacket isn't made for this sort of weather. The black cab soon pulls up outside the Royal Geographical Society's red-bricked headquarters at No. 1 Kensington Gore, just around the corner from London's Royal Albert Hall. I take some time to work out the taxi's childproof door handle. It's hidden behind a perspex shield.

'Some sort of bloody explorer you are, mate!' laughs the cabbie, blue eyes twinkling from beneath a 'cor blimey' cap. 'Why, you can't even get out of the bloomin' cab'

'Keep the change,' I mumble, handing over a £20 note as if it's a gold bar. Jeez! Converted into South African rands, that's a night out in the Babanango pub. I chuckle as the cab speeds away. To survive in this wet, grey world so far from Africa, you need a sense of humour.

Looking down at me from the recess in the wall of the Royal Geographical Society, dressed in boots and a tropical hat, is the stern-faced statue of Dr David Livingstone. Famous explorers' names are printed in gold on the roll of honour in the entrance hall. Here in this musty old building, full of explorers' memorabilia, you can have tea and cucumber sandwiches, mingle with pipe-smoking, tweed-jacketed explorer types, get married on the lawns outside, or listen to lectures and slide shows on travel and adventure.

But for me the attraction is the library and map room, original expedition journals, hand-scribbled notes and maps, the smell of old leather. My objective is clear. It's to research the incredible journeys of Dr David Livingstone and then return to Africa to follow in his footsteps.

Born of a missionary teacher family, I was fascinated as a child by my father's stories of Dr David Livingstone's great African journeys of discovery. The Victorians of Britain hailed the Scottish-born missionary as a near saint. His travels in Africa made him one of the greatest geographers of his age.

Today we have the use of modern Magellan GPS receivers, survey maps, HF radios, expedition Land Rovers and boats. Just imagine how it must have been for Livingstone who, with only a sextant and a compass, mapped a staggering 1.5 million square miles of Africa and spent 30 years travelling vast areas of the continent, mostly on foot.

Born in Blantyre, Scotland, David Livingstone arrived in South Africa's Cape Colony in 1841, aged 27. He was a tough young fellow who had fought his way out of poverty and put himself through medical school. As a young missionary doctor, he had taken up a position with the London Missionary Society. His first posting

Nineteenth-century Cape Town

IT'S EASIER THAN BY OX WAGON

was to a lonely mission station called Kuruman, deep in the South African interior. Now, some 150 years later, Ross, Mashozi and I set off to follow in the footsteps of the man who became the greatest missionary explorer of all time.

Zulu calabash

At Simonstown, seagulls swoop and dive as I fill the Zulu calabash with seawater to be carried all the way to the Zambezi. There is always a feeling of great excitement when we start a new odyssey. A delightful but nervous feeling of anticipation as we load up with expedition supplies, tents, bedrolls, sand mats for the Kalahari, extra fuel and water containers to make our way east up the magnificent Cape coast. We will follow the sea route Dr Livingstone would have taken in 1841 to Algoa Bay, a journey that the young doctor made in the sailing ship *The George*, the same vessel that had brought him from England to Simon's Bay. The fierce wind tugs at my beard and rocks the Land Rovers. When Livingstone arrived here, it was still the age of sailing ships, and Algoa Bay in Port Elizabeth – with the strong prevailing winds – was a difficult and sometimes dangerous anchorage. British settlers had been arriving here since 1820, some 20 years before Livingstone's arrival. How strange and exciting this all must have been for the young missionary doctor who, in the opening chapters of his journal, wrote:

> On my arrival in Port Elizabeth, the first thing I had to do was purchase an ox wagon suitable for travel into the African interior. An ox wagon costs 40 pounds and trained oxen are 3 pounds each.

I'd heard about two old pioneer settler-type characters who still understand ox-drawn transport. We find them sitting on the front *stoep* of an old corrugated-roofed farmhouse. Bozie Sansom, built like an ox, is the best 'whip cracker' in the district. John Snead squints into the sun, pulls on his pipe, looks me up and down, then with an Eastern Cape drawl says, 'Ja, Kingsley! If you want to experience Livingstone's old wagon route in a bullock cart … well, Bozie and I, we're the right blokes!'

Journey by ox wagon

Mashozi and Ross go ahead in the Land Rovers, leaving me in the hands of these two delightful old characters. Soon we're bouncing along a bush track, pulled by

16 yoked bullocks, through thick, thorny Eastern Cape scrubland. John shouts to each of his bullocks by name. '*Mooi loop, Witpens!* Come on, *Swartland.*'

Mhlekazi, the Xhosa tribesman, runs out in front with the *riem*. Bozie's long whip cracks as it snakes out above the bullocks' backs, urging them forward. Then bouncing downhill, John in his old settler's hat cranks down the ancient iron lever, tightening the large block of wood which, with a screech, serves as a brake against the iron-shod, wooden-spoked wheels. Bozie's whip stings me across the shoulders. 'Sorry!' he yells. 'I'm a bit out of practice!' Thereafter, every time I hear it whistling through the air, I duck for cover onto the wooden floorboards of the wagon. This has ol' John Snead howling with laughter.

Livingstone enjoyed ox-wagon travel and in his letters home he wrote:

> *I enjoy African travel; the complete freedom of stopping where I want, lighting a fire to cook when I am hungry. The novelty of sleeping under the stars in thinly populated country makes a complete break from my cramped and regulated past existence in Scotland.*

Whilst Livingstone might have enthused about the freedom of ox-wagon travel, let me tell you, they're damned uncomfortable things. I am pleased to leave the wagon and travel on foot after saying goodbye to Bozie and Snead and their team. I come across a tortoise heading for high ground. It's a sign of rain on the way. Soon, the sky blackens and lightning cracks overhead.

At Van Zyl's Drift, in the Shamwari Game Reserve, the old grey skeleton of a handmade ox wagon stands on the side of the old wagon track heading north. Now I'm really getting into the spirit and head space of Livingstone's first ever African journey. Still following in his footsteps, my rucksack held above my head, I wade across the old drift on the Sundays River. I can only imagine how it must have been for Dr Livingstone, this tough old Scot who spent 30 years in Africa and, by the time he died, had covered some 30 000 miles, mostly on foot.

In one of his journals he wrote:

> *The mere animal pleasure of travelling in wild unexplored country is very great. The mind works well, the eye is clear and the step is firm. A day's exertion always makes the evening repose thoroughly enjoyable.*

By hitching a ride on a local donkey cart, I am able to ease my Livingstone journey and also meet the delightful Mr and Mrs Landingwe, fellow travellers of the north road. They drop me off at a mission station at the foot of the Zuurberg. I wave

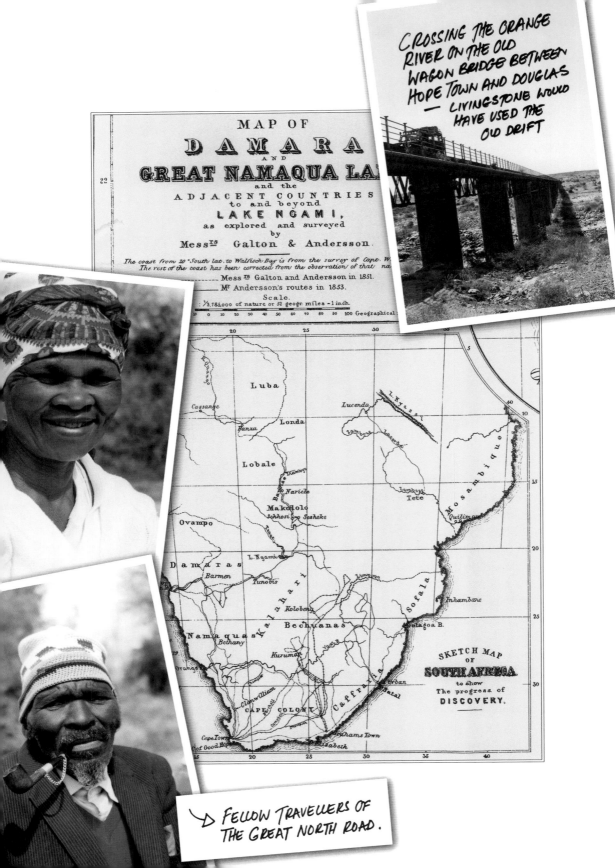

CROSSING THE ORANGE RIVER ON THE OLD WAGON BRIDGE BETWEEN HOPE TOWN AND DOUGLAS — LIVINGSTONE WOULD HAVE USED THE OLD DRIFT

MAP OF
DAMARA
AND
GREAT NAMAQUA LAND
and the
ADJACENT COUNTRIES
to and beyond
LAKE NGAMI,
as explored and surveyed
by
Messᵗˢ Galton & Andersson.

The coast from 20° South lat. to Walfisch Bay is from the survey of Cape W.
The rest of the coast has been corrected from the observation of that na

Messᵗˢ Galton and Andersson in 1851.
Mʳ Andersson's routes in 1853.

Scale.
⅟3,785,000 of nature or 52 geogr. miles = 1 inch.

SKETCH MAP
OF
SOUTH AFRICA.
to show
The progress of
DISCOVERY.

↘ FELLOW TRAVELLERS OF THE GREAT NORTH ROAD.

goodbye, he raises his pipe, she grins and waves – two old Xhosa pensioners whose greatest asset is their donkey cart. When Livingstone travelled through this area in 1841, there was a continuous state of war between the Xhosa clans and the British 1820 settlers.

Making tracks to Kuruman

I'm back with the expedition Land Rovers. It's good to be together again, sharing our adventures of the last few days. The Great Karoo is vast and beautiful. We decide to splurge on a night out in historic Graaff-Reinet, fourth oldest town in South Africa. It makes a change from camping. At sunset we watch eagles soar over the jumble of dramatic, twisted, rocky outcrops that make up the nearby Valley of Desolation.

The owners of the guesthouse are real Afrikaans Karoo folk, with hospitality as endless as their arid surroundings. Supper is *boontjiesop* with hot home-baked bread, *boerewors* and Karoo lamb, Tannie van Jaarsveldt's original *melktert*, rounded off with sweet, twisted, golden *koeksisters* and *koffie*. All washed down with the speciality of the house, Oom Gert's *stuksvy mampoer*, strong enough to blow the top of your bloody head off.

When Livingstone travelled through here in the 1840s, he was following the wagon track across the Karoo to Kuruman, the northernmost mission station in southern Africa, built by Dr Robert Moffat some 20 years before. At times the track was so bad that Livingstone feared the wagon would overturn and crush them all. Boulder-filled, dried-out riverbeds played hell with the oxen. He was amazed by the endless open space, the flat-topped hills which the Dutch called *kopjes*, and the vast herds of springbok that inhabited the plains. It was slow going – sometimes walking, sometimes riding in the creaking, lumbering wagon, travelling at 10–15 miles a day. It took nearly two months to reach the Orange River. Now he was within easy reach of Kuruman. One can just imagine his youthful excitement! Soon he would be in Darkest Africa, healing the sick and converting the 'heathens'. This is what he'd come to Africa for. Little did he know at the time that his missionary years were to become a bitter struggle. Finally, it was not missionary work that would bring him fame and recognition; rather, his later journeys of discovery!

We drive our two dusty Landies across the Orange on the old narrow wagon bridge that spans the river between Hopetown and Douglas, and by that afternoon we're in Kuruman. It's hot, dry and dusty. An old ox wagon stands in the mission grounds. The mission station is still shaded by trees, planted by Robert and Mary Moffat.

Mashozi, Ross and I go and sit quietly on the wooden pews of the old church, built in 1833. It still has its hand-hewn beams and mud and cow-dung floors. A group of colourfully dressed men and women are busy with choir practice. The harmonising of the African voices is delightful. As I listen, I'm reminded that it was here at Kuruman that the great Dr Robert Moffat, founder of this mission, had translated the Bible from English into the Sechuana language.

The directors of the London Missionary Society saw Kuruman as the jewel in the South African missionary crown. Livingstone arrived here on the 31st July 1841 but he was terribly disappointed to find that the mental picture of the place he had treasured for so long was a distorted image.

> *I had expected wildest Africa and a mission surrounded by hundreds*
> *of villagers and Christian converts. Instead I found a replica of a little*
> *English village with English ways. Where was the smoke rising from a*
> *thousand villages to the north, as suggested by Dr Robert Moffat?*

This was the impression given by Dr Robert Moffat during fund-raising talks in Britain and now Livingstone felt cheated. But within the year his longing to venture into wildest Africa was rewarded with a 700-mile exploratory journey among the Bechuana. Finally, the break he needed.

Loading his ox wagon, Livingstone and a fellow missionary by the name of Edwards set off to start a mission station at Mabotsa and work among Chief Motsealele's Bakhatla people. At last, this was the world of untamed Africa he had so longed for. Zebra, giraffe, buffalo, impala and wildebeest roamed the veldt. There were also lion and rhinoceros – and most of this tribe had never seen a white man before.

Mauled by a lion

But it was here, near Mabotsa, that disaster struck. Initiated with the roar of a lion, the incident lived with David Livingstone forever. After he'd recovered, he recorded:

> *The Lion caught my shoulder as he sprang, and we both came to the*
> *ground below together. Growling horribly close to my ear, he shook me*
> *as a terrier dog does a rat. It caused a sort of dreaminess, in which there*
> *was no sense of pain nor feeling of terror, though I was quite conscious*

Dr Livingstone being attacked by a lion

JUST IMAGINE — LION BREATH IN YOUR FACE
11 TEETH WOUNDS — THEN THE PAIN AS WITH NO
ANAESTHETIC, YOU RESET THE BONES AND
STITCH YOURSELF UP —

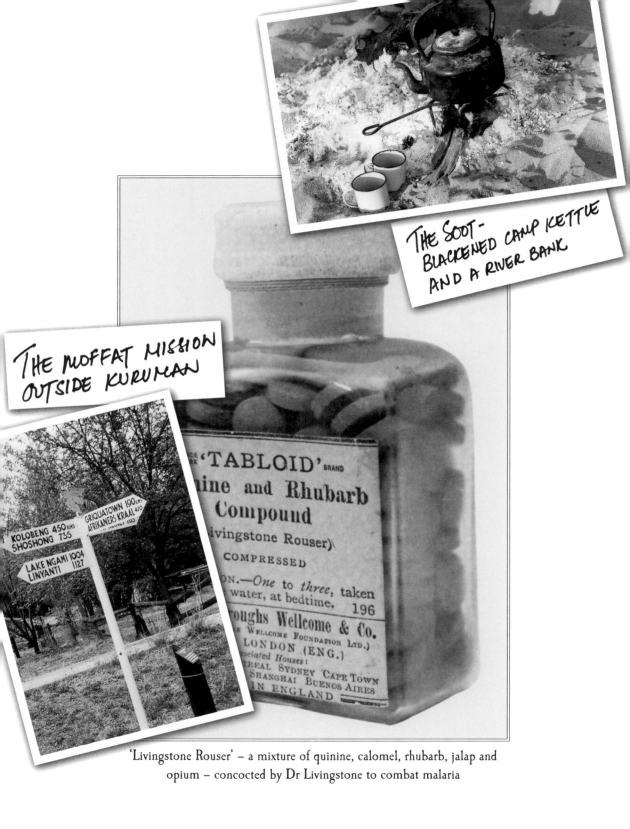

THE SOOT-BLACKENED CAMP KETTLE AND A RIVER BANK

THE MOFFAT MISSION OUTSIDE KURUMAN

'Livingstone Rouser' – a mixture of quinine, calomel, rhubarb, jalap and
opium – concocted by Dr Livingstone to combat malaria

of all that was happening. It was like what patients partially under the influence of chloroform describe, who see all the operation, but feel not the knife. The Lion was killed and in order to take out the charm from the heart, the Bakhatla on the following day made a huge bonfire over the carcass, which was declared to be that of the largest Lion they had ever seen. Besides crunching my shoulder bone into splinters, he left 11 teeth wounds on the upper part of my arm.

Livingstone's medical skills were to save his life on many occasions, but this was the first. With no anaesthetic and in absolute agony, he reset the bones, treated the septic wounds and stitched himself up. It left him with a permanently shortened left arm. Many years later, in a postmortem at the Royal Geographical Society, Dr Livingstone's body was identified by these distorted bones of his upper left arm.

His near-fatal brush with death had an impact on his decision to return to the Kuruman mission station. Here, he once again met Dr Robert Moffat's eldest daughter, 23-year-old Mary, who nursed him back to health – in more ways than one! Livingstone explained it like this.

I screwed up courage to put a question beneath one of the fruit-trees, which, I believe, is generally accompanied by a peculiar thrilling sensation in the bosom, and which those who have never felt it can no more explain than the blind man who thought that scarlet colour was like the sound of a trumpet, and I became united in marriage to Mary on the 9th January 1845.

In the grounds of the Kuruman mission station, Mashozi and I hug each other at the remains of the old almond tree under which David proposed to Mary. A signpost in the little street outside the old Moffat mission house gives distances to Linyanti, Kolobeng and the Victoria Falls. A cold autumn wind blows dead leaves across the dry mission grounds. I think this was a busier place in Livingstone's time.

To a friend, Livingstone wrote that Mary was '*a matter of fact lady, a little thick* [he meant wide], *black-haired girl, sturdy and all I want*'. But there was plenty in Mary for him to love. She was caring and kind and skilled in many of the ways that Livingstone valued. Trained as a teacher, she could also speak Setswana and the Bushman tongue. But had Mary known what she was in for, she might not have married the determined Scotsman. Her life and that of her family was to be an exceptionally tough one as she followed her Livingstone into the heart of the African bush to finally settle at Kolobeng, in the wilds of present-day Botswana.

Death at Kolobeng

We cross the Molopo River into Botswana and at bustling Gaborone meet up with well-known adventure cameraman, Tim Chevallier – an old friend who's come along to film our journey for *National Geographic*.

From 'Gabs', as some of the locals affectionately call the capital of Botswana, we set off in search of Kolobeng, where David and Mary Livingstone had worked their fingers to the bone, building up a home and mission station with virtually no supplies. Left off the road to Thamaga, we turn the Landies down a small dirt track that leads to the Kolobeng River.

Here it is heartbreaking to find that all that remains of David and Mary Livingstone's six years of missionary activity are a few ruins and a sad little pile of stones that mark their little daughter Elizabeth's grave.

Taking off our hats, we call for a minute's silence and Mashozi places a small bunch of wild Kalahari flowers on the grave. I can imagine the squeaking of Livingstone's quill pen as he wrote out these words of despair:

> *After years of hard work my only convert remains Chief Sechele. In order for him to become a good Christian I suggested he stop practising polygamy and have only one wife. This and other changes led the Bakwena people to reject Christianity and our presence here at Kolobeng. But worse was to follow in the form of the most severe drought in living memory. Soon the crops withered and failed, the Kolobeng River dried up and the cattle and livestock perished. The Bakwena people were desperate and when Chief Sechele, the greatest rainmaker in the tribe, refused to intervene because of his Christian beliefs, our situation became more difficult.*
>
> *Matters worsened when our baby, Elizabeth, succumbed to a bronchial infection and very soon died screaming! The cry I would remember in eternity!*

Some distance northwest of Kolobeng, we camp on top of a rocky outcrop: two Land Rovers, tents, old battered green safari chairs, a few pots, a light from the battery, the old dented camp table, water containers, a braai grid and a fire. Life can be so simple. In the west the sun sets in a massive, orange ball over the Kalahari desert – the largest mantle of vegetated sand in the world – donkeys bray at a nearby village, there's the cry of a hyena and jackal.

Tim is great company, always ready with a smile and a joke. He was born in Malawi and loves and understands the bush. The sparks from our fire leap up into the night sky, we throw meat on the coals and raise our dented enamel mugs. A nightjar calls, there's the smell of wood smoke.

This is Africa's magic hour and soon the heat and the dust are all forgotten. This is the close-to-nature freedom that Livingstone so enjoyed. What is it about Africa that so steals the heart?!

Early next morning, the steam rising from my coffee mug, the body still a little stiff from sleeping on the ground, I gaze out from our campsite. The sun breaks the horizon – 360 degrees of Kalahari desert. From the thatch-roofed villages in the distance, I can hear voices, a child crying, the sound of cattle and goats. The forebears of these people, who would have dressed in skins and hunted wild animals, might well have known the Setswana-speaking Livingstones from the Kolobeng mission: the moustached doctor with a stiff left shoulder who treated the sick and Mary, his wife, daughter of Moffat, the 'white chief' from Kuruman; the missionaries' children playing in the dust; the terrible drought that even Chief Sechele, the great rainmaker, would not stop.

Kgalagadi – the Great Thirst

Livingstone had heard rumours of a great lake called Ngami, far to the west across the Kalahari desert, and was eager to discover it. He was understandably fed up with sedentary life at Kolobeng and believed his new role was to open up missionary routes in Africa. But how, on his meagre London Missionary Society salary of £100 per year, was he possibly going to afford to go in search of the mysterious lake? Livingstone prayed and good fortune intervened. Out of the bush arrived the sportsman-hunter William Cotton Oswell, sent to Livingstone by his father-in-law in Kuruman. Oswell was a wealthy and charismatic English gentleman who had been schooled at Rugby, and he and Livingstone clicked and became friends. Their search for Lake Ngami was to be funded by Oswell, helped by the sale of ivory.

For Oswell – the tall, good-looking aristocrat who'd come out to Africa to relax and recuperate after an illness – it was a hunting safari; for Livingstone – a thickset, determined, working-class Scotsman – it was a search to open up Africa. Cotton Oswell had already hunted in the Kalahari, where the Bushmen had given him the name *Tlaga*, meaning 'on the lookout', a name which clung to him throughout his travels in Africa. Their expedition in search of Lake Ngami slowly moved out of Kolobeng on the 1st June 1849.

Now 150 years later, we load up the Land Rovers from our rocky outcrop camp, and set off to follow their historic journey across the great Kalahari, a name taken from the Tswana word *kgalagadi* meaning 'the great thirst'. Ross, travelling with Tim, navigates from the front Land Rover, Mashozi and I tail behind.

From a letter written by Cotton Oswell to his uncle, Benjamin Oswell, on 16th January 1850, we get an idea of just how incredibly difficult their ox-wagon journey across this Kalahari heartland must have been:

> *We had eighty oxen, twenty horses and thirty or forty men, all thirsty*
> *… the old guide assured us that if we dug we should obtain a supply*
> [of water]. *Spades and land turtle shells were accordingly set to work,*
> *and at the close of the day we had sufficient to give the horses a sip each.*
> *For two days longer the poor oxen had still to remain without, but four*
> *pits being at length opened to the depth of eight or nine feet, a sufficiency*
> *for all our beasts was obtained …. The sand was distressingly heavy and*
> *the sun fiery hot. The oxen moved so slowly and with such difficulty that I*
> *was at times afraid we should fail even in the very outset.*

No other Europeans had yet succeeded in getting this far into the Kalahari. A Griqua hunting party, in search of ivory with over 30 wagons, had heard of Lake Ngami but they too had been turned back by the Kalahari thirstland. It is no wonder that Oswell continued:

> *You will perhaps wonder at our being so long in covering so short a*
> *distance, but a wagon is not a steam-carriage. Water was excessively*
> *scarce, its whereabouts unknown, and the sand, occasionally for miles*
> *together, over the felloes of the wheels.*

It is second nature to keep an eye on the temperature gauge and listen to the growl of the engine as our two Landies grind slowly through endless Kalahari sand. We make our way from cattle post to cattle post, filling our jerry cans from old Lister-powered boreholes. Asking directions from Bushman-like cattle herders. Somehow getting lost. Forever camping out under the stars. The good-humoured banter around the fire, the night sounds, whispers in the dark – 'Did you hear the lion?' I love the early mornings in the Kalahari, the bird calls, not a person in sight.

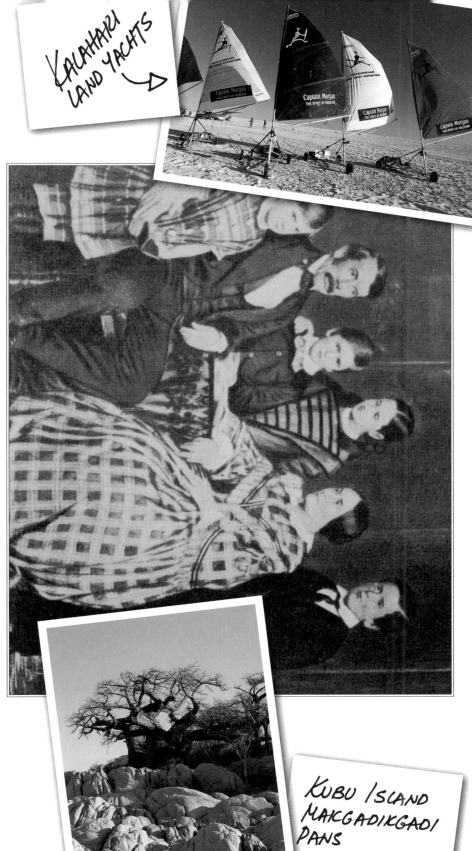

Dr David and Mary Livingstone and their children

Reaching the Botletle

We rake last night's hardwood coals and blow them into life; put on the old soot-blackened kettle; go through Livingstone's journals, making notes. Ross is standing with GPS and maps spread out on the bonnet of his Land Rover. Tim is filming the sunrise; Mashozi, always neat and clean in her old khaki shorts, is repacking the grub box.

Breakfast is *renoster koffie* (strong coffee with the 'kick' of a rhino – a tot of Captain Morgan rum) and the leftover stew from last night. We might be the very first people ever to have slept on this piece of Kalahari sand. The Landies are loaded and the campfire covered with sand. We're heading for the Botletle River, which Livingstone and Oswell referred to as the Zouga. Oswell wrote:

> *I shall never forget the pleasure with which, whilst riding out ahead of the wagons on the 4th of July, we came suddenly upon a considerable river* [the Zouga – nowadays known as the Botletle] *running, as we struck it, N.E. by E. The wagons reached it the same evening, and our troubles were looked upon as past.*

There are just the four of us: Mashozi, Ross, Tim Chevallier and myself. We camp under massive shade trees, on the banks of the Botletle River. Wildebeest and zebra come down to drink. One night, whilst on the Makgadikgadi Game Reserve side of the river, Mashozi wakes me up, concerned that a rat has got into her sleeping bag. I shine the torch underneath the vehicle. Three pairs of eyes glare back at me – three hungry lionesses just a few metres from where we lie under the stars on a piece of canvas, next to the vehicle. We manage to jump into the vehicle and chase them off with the spotlight. Then they're back again, circling the camp. Needless to say, we spend the rest of the night in the vehicles. When in lion country, it's much better to put up tents.

From their arrival on the Botletle River, Livingstone and Oswell followed the river for 280 miles, '*and meeting with no difficulties to speak of, save from the denseness of the bush and trees in particular tracts, through which we had to cut our way, we at length reached the object of our expedition*'.

They were overjoyed. On the 1st August 1849, David Livingstone, William Cotton Oswell and a fellow hunter by the name of Mungo Murray were the first Europeans to reach Lake Ngami. Oswell wrote:

> *None save those who have suffered from the want, know the beauty of water. A magnificent sheet without bound that we could see, gladdened*

our eyes … the elephant and buffalo were most numerous, the latter roaming in immense herds, and every accessible drinking place in the river being trampled with spoor of the former. I had not much spare time to shoot, but a few capital specimens fell to my gun.

Cotton Oswell enjoyed the hunting while Livingstone was caught up in the bigger picture. He now appreciated the extreme difficulty of crossing the Kalahari on foot, horseback or by ox wagon. His ambition was to find a river artery which he could use to open up Africa. He was fascinated by the rivers that flowed into Lake Ngami, and even more so by information he received from the African people of a great navigable river called the Zambezi that lay to the north. His mind was made up. He would find that river, come what may.

We no longer find, 150 years later, a fine sheet of water at Ngami. Now it's almost dry, and instead of wildlife, there are villages and cattle. The mozzies are bad and the people complain about malaria. Ross goes down and we treat him immediately. He has a bad night of high temperatures and the 'sweats'. Mashozi sponges his brow and keeps him rehydrated. We've lost two friends to the deadly *Anopheles* bite and know to be careful.

In order to stay alive, Dr Livingstone eventually concocted a compound: 3 g of quinine, 3 g of calomel, 10 g rhubarb, 4 g essence of jalap and a little opium! These he called 'Livingstone's rousers'.

It was 40 years after Dr Livingstone's travels here to the Kalahari that a British physician finally proved it to be the *Anopheles* mosquito that caused malaria. Sub-Saharan Africa still has the highest malaria infection rate in the world, with over a million deaths annually.

Return to Kolobeng

Of their return journey to Kolobeng, Oswell wrote that they were *'almost at the end of their strength for lack of water'* when he spotted a Bushman woman and induced her to show him water. *'There was a large pool at eight miles' distance, and this saved the expedition.'*

Ross is over his malaria now and we travel into Maun to resupply. It's no longer the old Wild West town out of a Robert Ruark novel, with hunters swapping yarns at Ryleys Hotel and the occasional shoot-out in the pub. Now there are supermarkets, even ice cream, and droves of khaki-clad tourists buzzing in and out in light aircraft and safari vehicles to explore the beauty of the Okavango Delta and the

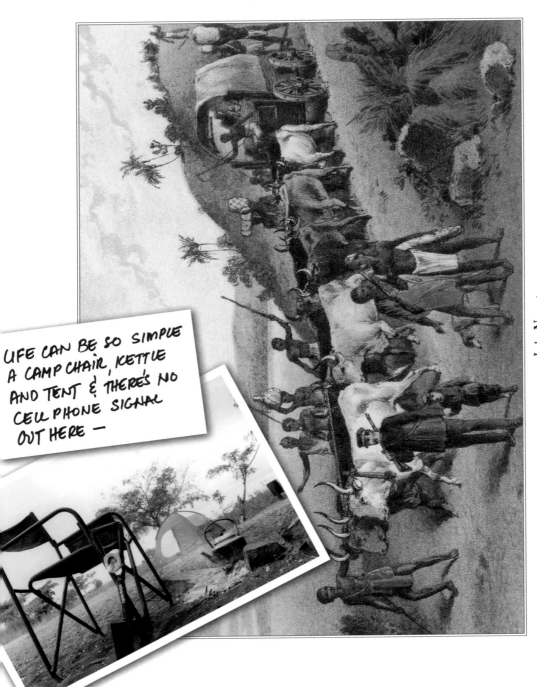

Lake Ngami

LIFE CAN BE SO SIMPLE A CAMP CHAIR, KETTLE AND TENT & THERE'S NO CELL PHONE SIGNAL OUT HERE —

game reserves to the north. We set up camp at Island Safari Lodge, sort out the vehicles and kit, and prop up the bar. Ross and I go through the maps, excited at the thought of our next Livingstone adventure. This time to follow his footsteps on foot, by Land Rover, microlight and land yacht. We have a lot of setting up to do.

Back from Ngami, Livingstone lost no time in sending off letters from Kolobeng, explaining the success of the expedition. These were read out at the Royal Geographical Society. They caused a sensation, and overnight the doctor became famous. William Cotton Oswell, the true organiser of the expedition, was hardly mentioned. Queen Victoria sent Livingstone a gift of £20. In spite of the fact that Livingstone and his family were in a poor financial situation, eking out a living at his mission station at Kolobeng, he characteristically used the money to buy a watch for the observing of the occulation of the stars by the moon to find latitudes. At the top of his mind was to find the Zambezi. He heard that three other European explorers were in search of this geographic prize and he desperately wanted to be the first.

Mary and the children

But what about Mary and the children? Mary was pregnant again. Robert, aged five, was a frail little lad; Agnes, aged four, was her Dad's favourite; Thomas was only two; after a wagon journey into the Kalahari, Elizabeth had died the year before. And in the Kalahari, their wagon had overturned into a game pit, crushing Mary and resulting in temporary paralysis to the left side of her face. It was no wonder the Moffats, Livingstone's in-laws at Kuruman, were so outraged at Livingstone's rashness in exposing his family to such appalling hardships. Particularly now that they'd heard he was leaving on a dangerous journey to search for the Zambezi. It was not surprising that Livingstone received this harsh letter from his mother-in-law:

> *My dear Livingstone, Before you left Kuruman, I did all I dared to do to broach the subject of your intended journey, and thus bring on a candid discussion, more especially with regard to Mary's accompanying you with those dear children … Was it not enough that you lost one lovely babe, and scarcely saved the other while the mother came home threatened with paralysis? And will you again expose her and them in those sickly regions, on an exploring expedition? All the world will condemn the cruelty of the thing, to say nothing of the indecorousness of it. A pregnant woman with three little children trailing about with a company of the other*

sex through the wilds of Africa, among savage men and beasts! Had
you found a place to which you wished to go and commence missionary
operations, the case would be altered. Not one word would I say, were
it to the mountains of the moon. But to go with an exploring party, the
thing is preposterous. I remain yours in great perturbation.

M. Moffat

It was characteristic that this letter increased rather than weakened Livingstone's
determination to take Mary. He had tried to explain to the Moffats that this was
no ordinary exploring expedition, but rather *one for opening the way to thousands*
of natives waiting to become Christians'. To the Moffats, however, the idea of
missionaries punting their way up malarial rivers and bringing the gospel to a
land lying on the wrong side of a massive desert seemed quite ludicrous. But
Livingstone's mind had been made up, even if it meant risking his and his own
family's lives. He was leaving in search of the Zambezi.

In order to reach Sebituane, the Makololo chief who Livingstone had hoped
would lead him to the Zambezi, and mindless of anything except getting to the
great river before anyone else, he decided to head north through the Kalahari. This,
despite the fact that he was told there would be few wells on this direct route and
many of these might be dried up from the unusually hot summer.

Livingstone was amazed by the size of the salt pans they had to traverse, writing,

> *'We passed over a country which is perfectly flat, covering several hundreds*
> *of miles. We came across a giant salt pan so large that the latitude might*
> *have been taken on its horizon just as one would have taken it upon the sea.'*

He was referring to the Ntwetwe area of the Makgadikgadi, one of the largest
salt pans on earth, stretching for approximately 12 000 km² across northeastern
Botswana. Scientists believe that thousands of years ago, the great Zambezi,
Okavango and Chobe rivers flowed into Makgadikgadi, making it the largest lake
in Africa. Now it's just an endless, glittering salt pan.

Near death on the pans

For Ross and me, this is not our first time on these giant pans. We came here about
10 years ago with two land yachts and made excellent distance over the first two
days, then we got becalmed for four days. It had turned into a nightmare and I'd
made these rough scribbles in the expedition notebook.

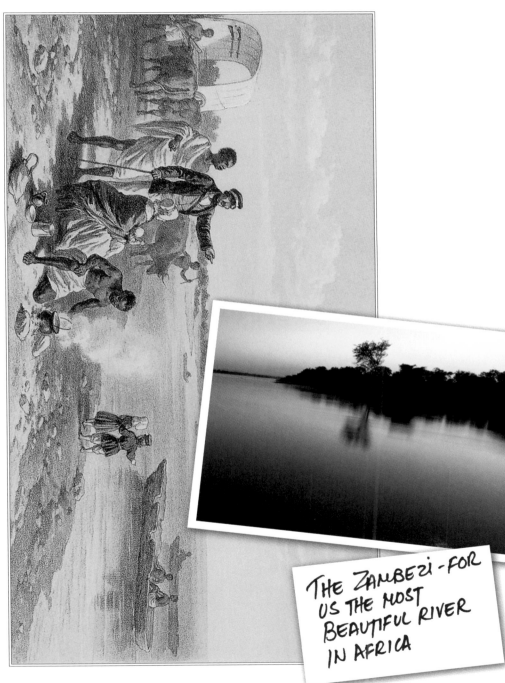

Dr Livingstone's first sighting of Lake Ngami

THE ZAMBEZI - FOR US THE MOST BEAUTIFUL RIVER IN AFRICA

We are down to about 10–15 litres of water. It is called 'suicide season', the month of October here in Botswana, as the heat builds up before the rains. High whirlwinds throw the yachts to the ground – then all goes quiet again. The winds have gone. We have come at the wrong time of the year.

Finally, after four days, we realise there's only one way out of here, and that's to walk it. I'll never forget the crunch, crunch, crunch of tired boots breaking the crust of the pans, walking in the dark to avoid the blinding heat of the Kalahari. Somehow, in the dark, we walk right past where we had left the vehicle. Ridiculous when you think we'd even made a flag out of a spare mast and an old rugby jersey and tied it to the bakkie. Ross is only sixteen; we're on a father and son thing. Faces burnt black from the sun, lips cracked, thick tongues swollen and dry. We drain the last few drops from our felt-covered water bottles.

I really don't think we're going it make it. I am in a shocking condition, starting to hallucinate. Mirages, like vast lakes of water, dance on the horizon. Ross sees a reflection – he's not sure, metal shining. 'Do you think it's a vehicle? Do you think it's a village?'

He says, 'No, no, it's just a mirage', because always, every time you look out for something, for a vehicle, for some buildings, for a village or something, you see so many different strange shapes in the mirages. You see a vehicle coming towards you and it actually turns out to be nothing. Ostriches and springbok look like humans from a distance.

It's a lorry, in fact, with some local tribespeople. I remember, they loaded me physically into the cab. We're taken into a nearby village. With true African hospitality, an old galvanised bath is prepared for us, filled with water, and we sit and just soak away our aching muscles. We're given plenty to drink and then we're taken to the local headmaster, the only person in the village who speaks English. 'You know, you white people are crazy,' he says. 'It's obvious to me that you are Lost Aviators!'

I can only imagine how it must have been for the Livingstone family when, on 29th May 1851, their expedition entered the salt pan of Ntwetwe and had to go five days without water. With his peculiarly insensitive sense of humour, Livingstone wrote, *'The less there was of water, the more thirsty the little rogues became.'* He did, however, concede that the possibility of the children *'perishing before our eyes was terrible'*. When they did find water *'it was stagnant and full of rhinoceros dung, but people with swollen lips and blackened tongues should not be fussy'*. To Livingstone,

these were simply the hardships of the journey. It was typical of his character that he viewed everything with Scottish grit and determination. Livingstone with his family, and joined again by William Cotton Oswell, struggled across this vast uncharted wilderness on foot, horseback and by ox wagon.

Kubu Island, Botswana

Our expedition is going to have to rely on the wind as we prepare to circumnavigate the Makgadikgadi in land yachts. I just hope we have better luck this time. Here we are, back at it again, but this time with five land yachts, a microlight, sand tyres and tough Ramsay winches. Also, an incredible six-wheel-drive all-terrain Polaris motorbike, expedition supplies, three GPSs, a sponsored satellite phone and six drums of water. We've certainly learnt a lesson from the past.

Although modern land yachts are relatively new in Africa, historians have discovered that, like most things, they were developed by the Egyptians, and later, the Chinese. The Dutch were also reputed to use 'galleons on wheels' to move troops around in the 16th century. Land yachts can sail up to three times the speed of the prevailing wind, since the sail acts as an aerofoil, creating a pressure drop on one side that sucks the yacht forward.

Our Livingstone land yacht expedition is made up of myself as expedition leader, Ross for navigation and logistics, Dave Rees, Marcus Wilson-Smith and Trevor Naylor, each with his own land yacht, and Billy Campbell on a 6x6 Polaris motorbike. Caroline, in her green microlight called *Zu Bie*, has also joined the expedition. She will help navigate from the sky.

Tagging along too is a delightful documentary film crew who call their production company Out of a Suitcase. Out of a Rucksack would be more apt for this windblown expedition. The backup team is headed by well-known anthropologist Barry Leitch and his sidekick, Nico de Lange, now known to us as *Rampap* because of last night's pudding of maizemeal, honey and rum. It turned so solid, he couldn't get the spoon out of it. Rampap is also the cook ….

Kubu base camp

I roll up my bedroll on a high shelf of rock, a vantage point I am sure the early Bushmen used. Spread out below me is the expedition base camp and the five land yachts' sails flapping in the wind, ready to go. Beyond stretches the endless Makgadikgadi. It's an inspirational place to scribble these opening notes in the expedition journal.

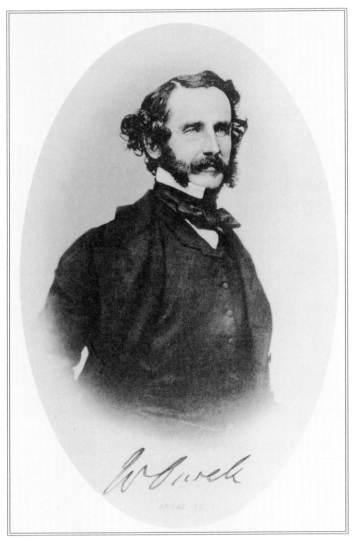

William Cotton Oswell – the unsung hero of the Kalahari

Kubu Island – a rocky outcrop set in a sea of sand. The enormous granite boulders, whitewashed with fossilised guano from a time when the island was a breeding ground for waterbirds. Grey-red baobabs stand tall against the sky. We hear jackal and hyena. At night, the five land yachts seem strangely at home here in what was once Africa's largest lake. Each two-seater land yacht has a seven-metre mast and rides on three wheels; cleats at port and starboard are meant to ease fingers, arms and shoulders. A luggage rack carries sleeping gear, drinking water, first-aid kit, a change of clothes. Goggles are worn over sunglasses, while a GPS and sense of humour make up the rest. My worst fear is the doldrums – to be left to the blistering sun and the windless eternity that surrounds us. Kubu Island is an ancient spiritual place of the Bushmen. Baobab trees cover the island. The Bushmen believe these giants were hurled by God from the sky in a fit of anger. They landed with their roots in the air and have grown that way ever since. I call them the 'elephants' of the plant kingdom. These venerable sages have seen such famous explorers as Livingstone come and go, and gave the explorers their only points of reference for hundreds of miles. Kubu Island is thought to have been an initiation site for young men of the Great Zimbabwe empire. Locals leave libations of coins and feathers to appease the spirits they say suffuse the island.

Crossing Makgadikgadi

But there's no such malignant spirit on our expedition; just uncontainable excitement as we prepare for the greatest sailing adventure of our lives. Dave Rees and Trevor Naylor fly red sails, Marcus Wilson-Smith is a black-sailed pirate, Ross and I have the old blue-and-white sails from our previous adventure. Billy Campbell travels both ahead and behind us on his six-wheeled Polaris motorbike called *Vat Hom*, carrying emergency supplies, food, equipment – and The Water. With having 12 000 km^2 to circumnavigate, we're in for a long haul!

The Kalahari nights are cold. Wearing beanies and blankets wrapped around our shoulders, we huddle close to a small fire. Lying the yachts down, we use the sails as groundsheets. Captain Morgan in enamel mugs keeps the spirits high. Dave, Billy and Trevor snore loudly from their blue tents, the rest of us sleep under the stars.

Billy is a great practical joker. He waits until Trevor and Dave are snoring away before making lion tracks outside their tent with a plastic mould of a big lion's paw. Then from behind one of the land yachts, he blasts them with a frightening recording of a roaring lion. Dave and Trevor eventually pluck up enough courage

to peer cautiously out of their tent. They're shattered to see just how close the lion tracks are. I'm pleased we never let on, because later in the expedition, Kalahari lions do indeed visit, roaring close to camp.

Sailing with the wind at breakneck speeds, an ostrich races alongside my land yacht. I sheet in, but am unable to overtake him.

For Livingstone it was a desperate race against time. He was still fearful that the other three European adventurers would reach the Zambezi River before him. Livingstone, too, was amazed by the speed of the ostriches he came across on the Makgadikgadi pans and took time to write:

> Only in one case was I at all satisfied of being able to count the rate of speed by a stop watch, and, if I am not mistaken, there were thirty paces in ten seconds; generally one's eye can no more follow the legs of the ostrich than it can the spokes of a carriage-wheel in rapid motion.

The praying mantis is much revered by the Bushmen as a great hunter. On each land yacht sail there is a Bushman painting with the head of a mantis. We're hoping that these images will call up the Wind Spirit. The early morning kettle bubbles on the fire and there's only a trace of a new dawn.

Ross and Marcus laugh and shout as they take the lead. They are the lightest but as the northwester picks up, us heavier sailors join the race and soon we're off at a rate of knots, adrenaline pumping, dust in the throat, nose and eyes. Most of the pan has dried out since the summer rains but certain patches are still wet and sticky, with big flecks of grey mud flying into our faces off the front wheel. It's quite exasperating at times as the yachts slide sideways, the front wheel bogging down and the whole lot turning turtle.

Covered in mud, sunburnt and tired, we flatten most of our drinking water as, in the middle of the pans, miles from nowhere, we make camp while the sun disappears over the horizon in a red ball of fire. Soon 360 degrees of open pan is lit up under a canopy of stars. They snore again!

The Wind Spirit arrives

Caroline in the microlight *Zu Bie* finds us next morning. She brings us water and the GPS reading for the land party camp near the village of Mosu in the south of the pans. On the harmonica I blow the expedition's theme song, 'The Answer, My Friend, is Blowin' in the Wind' as we sit around and wait for the wind to blow. And blow it does!

Filled with excitement, we race for our yachts. Dave Rees has sailed the Mauritius-Durban twice and is an experienced sailor. Ross goes over with a crack, Marcus is soon flying a wheel, and Trevor and I bring up the rear, while Billy races past in the loaded Polaris, pointing towards the southern escarpment with a wide grin on his stubbled face.

After three days we're blown into Mosu on a mile-high dust storm that whips across the pan. Visibility is at about five metres, and Billy the Kid's Polaris guides us straight in, like phantoms of the wind, at over 80 km/h. That is frighteningly fast when your backside is just 6in off the ground! And so, one day runs into the next in this timeless place. The land yachts make their way to Kukonje Island and then up the east coast of Sua Pan to the Nata River. This area is the largest breeding ground for flamingos in southern Africa but the birds will only arrive with the rains in a few months' time. At the Nata River, the land yachts are loaded onto the 4x4 vehicles, as land and 'boat' parties meet for the halfway bash before reaching Ntwetwe Pan, the second of Makgadikgadi's two big pans.

Finding Ntwetwe

It's absolutely beautiful! Tall green swaying palms, yellow Kalahari grass, the white of the pan and the blue sky.

I think of Livingstone, the children worn out and thirsty as they travelled this way in 1851, heading north in search of the Zambezi. Mary, heavy with child, bouncing along in an ox wagon; Livingstone dreaming of the great river to the north; Cotton Oswell going ahead on horseback to look for game. Livingstone later wrote in *Journeys and Researches* that '*wagon-travelling in Africa is a prolonged system of picnicking, excellent for the health and agreeable to those who are not overfastidious about trifles*'. Livingstone certainly had a way with words.

We rely heavily on Caroline in *Zu Bie* to fly ahead and take GPS readings so as to guide us through the gaps between the large grassy islands. Caroline is such a star! She started off the expedition not wanting to fly in strong winds or during the midday thermals – and certainly not alone. Now she takes off in her green 'dragonfly', braving the winds to fetch water from isolated cattle posts on the edge of the pans. She ties the water containers onto the back seat and then, like a guardian angel from the sky, finds us wherever we are.

Day 12 and there is not a breath of wind. Desperate for shade we lie the land yachts on their side and crawl under the sails. Then, a strange thing happens. In broad daylight an owl flies in and settles close to us on the cracked crust of the

glaring white pan. It's as if this is a good luck omen. Within seconds, the dry mopane leaves race across the pan, driven by a strong wind. Soon we're overtaking springbok and ostrich as we race between the grass islands, flying with the wind. It's a wonderful feeling of freedom.

That night, it's a merry gang that sits around the fire, against a backdrop of land yacht sails silhouetted against the moonlit sky. Despite Rampap's pudding incident, his brisket stew cooked with Captain Morgan and Coke is the best in the world. And his jokes are endless.

Victory – the final stretch

It's been a bitterly cold night under the stars, but as the Bushmen say, 'When the stars are bright at night, man is one with the wind.' Cold and tired, we stretch aching limbs before commencing a ritual breakfast of Captain Morgan *renoster koffie*, toast and peanut butter. Soon all five land yachts are upright and pointing into the northeaster. Main sheets and pulleys rattle against the tall aluminium masts. The Bushman paintings on each sail move eagerly in the wind.

The morning checklist begins: sunscreen, binoculars, sunglasses and goggles, GPS, waterbottles and gloves (to save the blisters). Check the wheel bearings, bolts and shackles, tighten the batons on the sails. Billy Campbell's a great comic. Every morning he goes through the ritual of the Wind Dance, furiously blowing a plastic 'trumpet' and beating his rump with the backs of his hands as he bends, facing the wind.

It works, and soon five land yachts are racing across the world's largest salt pan. I overcorrect the steering mechanism controlled by my feet, bringing my land yacht crashing to the ground. Sunglasses, hat and waterbottle go flying. I dust myself off. Droplets of blood indicate that Betadine and plaster will be required later, but no time for that now as we race towards a distant horizon, following Caroline in her green dragonfly to keep on course for the southeast corner of Ntwetwe Pan – and Kubu Island. The Wind Spirit of the ancient Bushmen has arrived to take us across the finishing line.

The vehicles have gone ahead with Rampap and Barry. Billy scouts ahead for a way through the grassy stretch between the Ntwetwe and Sua pans. The wind continues to push us at breakneck speed as we skippers perform our balancing act between main sheet, steering, and flying a wheel. Lower backs ache and fingers are numb. With chapped lips and sunburnt noses, we can taste the sweet success that is blowing on the Makgadikgadi wind. And so, as the sun sets over the red baobabs of Kubu Island, that mystical rocky outcrop set in a sea of salt and sand, we find ourselves back at our starting point. Our land yacht journey has taken us 16 days.

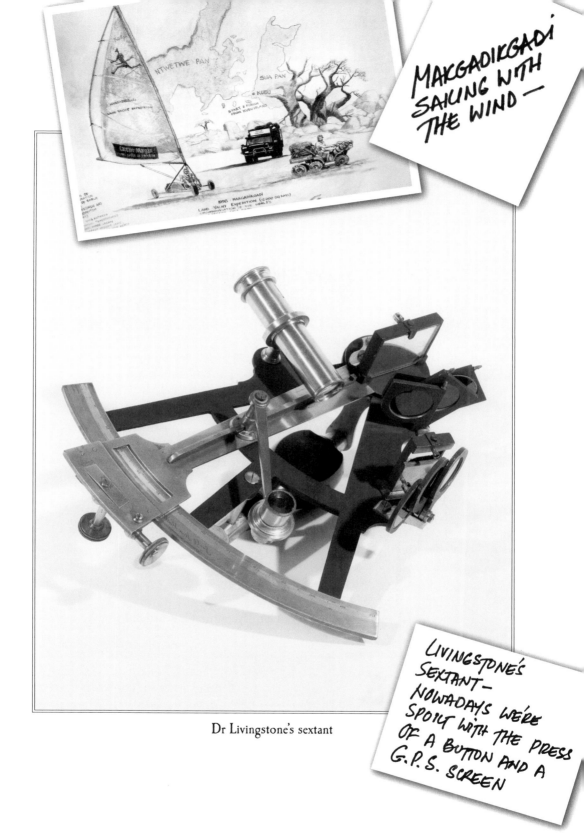

Dr Livingstone's sextant

Our spirits soar, and as the smoke and flames of our hardwood fire rise into the Kalahari night sky, we fill our dented enamel mugs with the Captain's brew, and dance and sing, our bare feet shuffling in the desert sand – not too different, I'm sure, from the way the Bushmen must have celebrated a successful hunt.

Once again, we have been inspired by Livingstone's spirit of adventure, and have succeeded in our circumnavigation of one of the largest salt pans on earth. Like Livingstone, our odyssey, too, seemed guided by the spirit of the Bushmen who once roamed the Makgadikgadi – 'at one with the world, at one with the wind'.

The River of God

From the Makgadikgadi, determined to reach the Zambezi, Livingstone made his way north to set up camp on the Chobe River. It is one of our best places in Africa. It's the elephants – they're our favourites.

Livingstone, too, was fascinated by the elephants and recorded:

> You can watch the sun setting over the river as hundreds come down to drink, swim, splash and play, it's a daily ritual that starts in the late afternoon. You can almost set your watch by it as, accompanied by much trumpeting and stomach rumbling, the elephants emerge, dust flying from the thick Mopane bush. Fish eagle survey the scene from their lofty perches, warthog roll in the mud, hippos snort at the intrusion. A shy Chobe bushbuck looks the other way. On the bank a large bull elephant squirts water over its back. Early that day I'd seen Sable antelope, and away from the river a pride of lions on a kill, vultures circling overhead.

Having survived the wrath of Makgadikgadi, Livingstone left Mary and the children at their Chobe River base camp. From Linyanti, with dugouts provided by Sebituane's Makololo people, Livingstone and Cotton Oswell finally arrived on the banks of the great Zambezi on the 4th August 1851, at a point opposite the present-day town of Sesheke.

He had beaten his competitors and soon all England would know that he had been first.

> I was stunned by the size and navigability of this Great River. My dream of the Zambezi as a God-given highway into Africa was now possible.

On the 12th August 1851, Livingstone turned back from their camp on the Chobe. They were happy to get away; the place was full of malaria and they were losing oxen to the tsetse fly. On reaching the shade trees of the Zouga River on 15th September, Mary gave birth to a baby boy christened William Oswell Livingstone. For the rest of his life, he was known as Zouga.

Livingstone's Zambezi discovery was a turning point in his life. So determined was he to explore Africa further that he heartlessly exiled Mary and the children to England. It was a cruel thing not to have sent Mary and her children back to Kuruman, where her parents would have gladly cared for them. Mary was terrified at the thought of having to live in Scotland – the only home she had ever known was Africa. It was William Cotton Oswell, the unsung hero of Livingstone's Lake Ngami and Zambezi journeys, who, when the Livingstones reached Cape Town penniless, provided Mary and the children with clothes and paid for their fare to England.

In December 1852, armed with a sextant and a tattered Bible, Livingstone set out on the greatest geographic endeavour of the time: to journey across Africa from Luanda on the Atlantic Ocean to Quelimane on the Indian Ocean. A transcontinental journey that was to make him famous and test his Scottish grit and determination to the very limit.

Glugging slowly from the narrow mouth of our decorated Zulu calabash, seawater from the bay at Simonstown mixes with that of the fast-flowing Zambezi – called the 'River of God' by Livingstone. This river, Africa's most beautiful, was also to change our lives forever.

David Livingstone was the first European to discover the Victoria Falls and cross Africa from the Atlantic to the Indian oceans. His lasting impact on Africa was both good and bad. His carefully documented diaries and letters not only helped abolish the despicable slave trade but also heightened European awareness for the continent, bringing about the Scramble for Africa, in which European powers seized virtually all of the continent, cutting it up like a cake without much thought for existing tribal boundaries.

Apart from being honoured by Queen Victoria, Livingstone was awarded the Royal Geographical Society gold medal – freedom of the cities of London, Edinburgh and Glasgow – and an honorary degree from the University of Oxford.

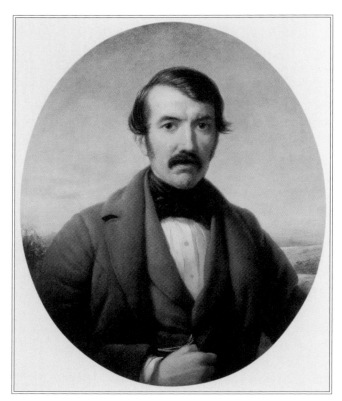

Dr David Livingstone

Chapter II

From Mouth to Source

Zambezi,

River of God

Being the Narrative of a Family Journey taken from the
Mouth to the Source of the Great Zambezi –
Livingstone's River of God

An Authentic account of Smoke that Thunders – A myriad
Channels & Backwaters – Croc-infested waters – Boiling rapids – Tropical
ulcers – Rivergods – Interrogations by military Commandos & Rebels

The Whole enriched with
Pics, maps & Historic accounts
Dedicated to all Those who Love Messing around in Boats

Zambezi River mouth

'Quite confidentially,' said Mr Big, 'we're launching a new deodorant – long-lasting, you know? We could have a competition! Say … guess the number of kilometres of river journey through deepest Africa, with tough conditions, needing a long-lasting deodorant – and winners could get to come along! Part of the launch of our new brand. Wonderful opportunity!'

Shit! I thought. Here we are pimping for a deodorant so as to cross Africa – where no-one on the river would give a damn how we smelled! Livingstone had been funded by the London Missionary Society. Henry Morton Stanley had been sent to Africa by the *New York Herald* and the *London Telegraph* – and here we were, at the mercy of the new, long-lasting Speed Stick, a name that 24-year-old Ross was not so keen to have sign-branded on the side of his boat, let alone trousers and T-shirt!

Fortunately, the inevitable happened. After promising the funding, the agency suddenly went quiet. Then we're told, 'Bad luck, old boys! New brand manager from France hates the bush; prefers football. And thinks you guys should be black! Different target market … so, sorry! Oh, but we do have this toothpaste – trying to get it into Africa!'

Fuck off! I thought, as Ross and I loaded our old leather-bound journal, maps and pics to take the long road back to Zululand. It's close to D-day, and still no funding, when old friend Tony Weaver suggests we try Captain Morgan rum, whose slogan is 'Spirit of Adventure'. They've heard of our adventures – and agree immediately over the phone. Halala! At last we've got an expedition. I scribble these few words in the cover of our expedition journal.

> The following pages are my simple thoughts and notations for what is the first known crossing by boat from the mouth of the Zambezi River on the Indian Ocean to the source of the great river in north-western Zambia. Then down the Congo River …. There is still a civil war in Angola and in Zaïre, where Mobutu comes under attack from Kabila's rebel forces. Who knows if our journey across Africa in the footsteps of Livingstone and Stanley will be possible – however, we accept the challenge!

I then add the names of the expedition members – fellow pilgrims of adventure who are all bundled into the vehicles heading north through Zululand, Swaziland and up to Chinde in the malarial swamps of the vast Zambezi Delta in the north of Mozambique. Our Zambezi/Congo expedition begins on Saturday 26th April 1997 at Chinde.

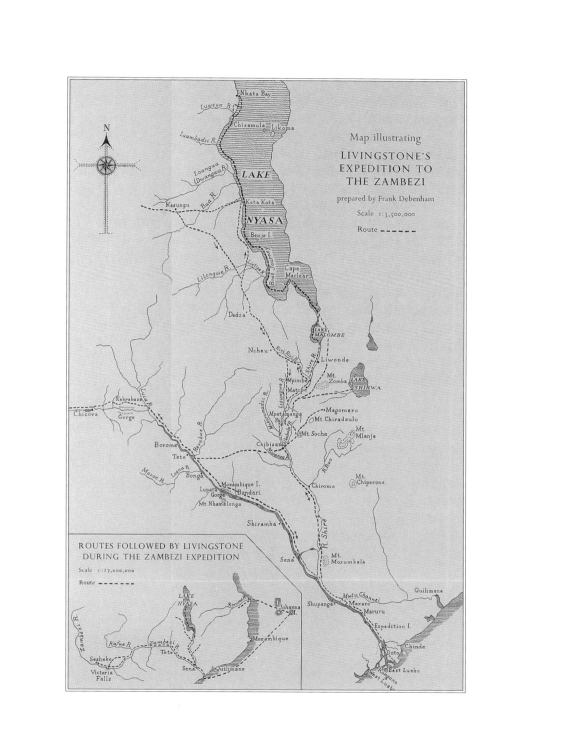

Map illustrating

LIVINGSTONE'S EXPEDITION TO THE ZAMBEZI

prepared by Frank Debenham

Scale 1:3,500,000

Route ━ ━ ━ ━ ━

Nkata Bay

Luweya R.

Chisamula · Likoma

Luambadzi R.

Loangua R.
(Dwangwa)

LAKE

Bua R.

Kasungu · Kota Kota

NYASA

Benje I.

Lizile R.

Boat Journey

Lilongwe R.

Cape Maclear

Dedza

LAKE MALOMBE

Ncheu · Rivi Rivi R. · Shire R. · Liwonde

Mpimbe · Mt. Zomba · LAKE SHIRWA

Mamvadzi R. · Lisungwe R. · Matope

Magomero

Mpatamanga Falls · Mt. Chiradzulu

Kebrabasa · Mt. Soche · Mt. Mlanje

Chicova · Gorge

Luia R.

Ruvubue R.

Boroma · Chibisa's

Tete · Mwanza R.

Mazoe R. · Luena R. · Bonga

R. Ruo

Mt. Chiperone

Mozambique I.

Lupata Gorge · Bandari

Mt. Nhamalonga

Chiromo

Shiramba · R. Shire

Sena · Mt. Morumbala

ROUTES FOLLOWED BY LIVINGSTONE DURING THE ZAMBEZI EXPEDITION

Scale 1:27,000,000

Route ━ ━ ━ ━ ━

Mutu Channel · Quilimane

Shupanga · Mazaro · Maruru

LAKE NYASA

Rovuma · Johanna I.

Expedition I.

Zambezi R.

Kafue R. · Zambezi R.

Mozambique

Chinde

Seshele · Tete

Doto

Sena · Quilimane

East Luabo

Victoria Falls

Congone

West Luabo

John Kirk, Livingstone's friend on the Zambezi. He later played a leading
role in the fight against slavery.

Chinde, the Zambezi mouth

When Livingstone arrived at the Zambezi Delta in the steamer *Pearl* on the 14th May 1858, he was 45 years of age, now the most famous explorer of his time. His book *Missionary Travels and Adventures in South Africa*, published in 1857, had sold 70 000 copies. He'd been awarded a gold medal by the Royal Geographical Society, had had a private audience with Queen Victoria and had been granted the freedom of a number of major cities.

Now he was back again on his beloved Zambezi, this time as the leader of the British government-sponsored Zambezi expedition to prove that his River of God was navigable all the way from the delta to below the Victoria Falls, so opening up Africa to Livingstone's three Cs of Commerce, Christianity and Civilisation. As a result of his Africa crossing, he was suffering from dysentery, a problem that was to plague him for the rest of his life and finally kill him. He wrote in his Zambezi journal:

> *Nothing can exceed the discomfort and pain when one is obliged to hold on with all his might to prevent being pitched off the closet.*

It was a rough beginning as the *Pearl* lay anchored in a storm off the mangrove mudflats that form the mouth of the Zambezi. Livingstone was impatient to get going. He fully understood the dangers of malaria; he knew that he would have to get his expedition upstream as soon as possible, away from the fever-ridden malarial mangrove swamps of the Zambezi Delta.

It's memory lane for us. Four years earlier in 1993 we'd travelled nearly 3 000 kilometres downstream, all the way from the Angolan border to Chinde. Now we're back again, this time to conquer the Zambezi in an upstream journey from mouth to source. Thereafter, it's the Congo River downstream.

We pitch camp on a sandbank island in the river mouth. A small band of local fishermen come out to meet us – colourful ragtag characters with their nets and dugout canoes. Small fish dry on racks in the gentle sea breeze; we're surrounded by mangrove swamps, river and ocean.

At sunset we make our way out to sea in the boats *Livingstone* and *Stanley*. The river mouth is dirty brown, feeding ground for giant Zambezi sharks. We nose into the waves. With shouts of encouragement, Ross and I leap overboard. I tread water as two litres of Indian Ocean glug slowly into the tiny mouth of the Zulu calabash. Ross and I hug and shake hands, and pass the calabash up to Mashozi, who corks it with a wooden stopper. We're hauled on board, with handshakes and hugs all round. I look at the animated faces of my fellow passengers. I hope to hell

we make it! We turn the boats back to the land where, stretched out in front of us in the 18 000 km² Zambezi Delta, smoke rises from faraway bush fires. A warm wind blows from the sea. In the distance are the lights of the coastal settlement of Chinde, the river port which originally traded slaves, ivory and mangrove poles; then, later on, thanks to Dr Livingstone's discoveries, served as a gateway to the interior, the Shire River and Lake Nyasa (also known as Lake Malawi). Now, 139 years after David Livingstone first arrived at the Zambezi Delta, we race through the surf at last light. Back to camp for curried prawns and rice – here, a bucketful of prawns costs three cigarettes. What a great place, this sandbank island!

A great team

The vast Zambezi Delta stretches along the coast for 120 km. It's a hot and humid place dotted with small fishing villages and it hasn't changed much since Livingstone's time. With local fisherman Antonio Fumbane, we go fishing for eels. This means standing in waist-deep water, feeling in the soft black mud with your toes for long thick eels and then spearing them – of course being careful not to plunge the point of your weapon through your own foot! Only afterwards, with a massive eel squirming in the bottom of the boat, does Antonio, with a big smile, tell us that crocodiles are plentiful, some as long as the boat, he indicates with a pointing spear!

Mashozi treats an old woman for malaria, fishermen queue up as she dresses deep septic tropical ulcers with antibiotic cream and surgical plaster. It's an unhealthy place. Tomorrow we leave our sandbank camp and head upstream. Ahead of us lie approximately 3 000 km through six countries. If we survive it, next is the Congo.

We're certainly a bunch of oddballs. There's Tony Weaver, a Cape Town journalist with a deep interest in Africa. He hasn't shaved since leaving home and already looks like a war correspondent on a dangerous mission. Tony, we find, has a great thirst and keeps us well entertained around the fire at night. Ross, Mashozi and I are the nucleus of the expedition. Tim Chevallier, the old professional, will point his camera for *National Geographic*. Very British, Marcus Wilson-Smith, with his shirtsleeves down against the sun, is the expedition stills photographer. Tough little Linda Sparrow chirps away in her Aussie accent. She's signed up to assist Mashozi. Helpful young schoolboy Johann Senekal, from Maputo, is terrified of crocs and is already a bit homesick. He's our Portuguese interpreter. The backup vehicle team is made up of learner explorer Adrian Verduyn and a delightful Zulu game ranger and old friend, David Gwenca, whom we've all just sung 'Happy Birthday' to on the HF radio. We'll celebrate when we meet

up with them at Marromeu. Twelve days into the expedition and we're getting along just fine. The most important thing on any expedition is having a good team. Humour and support for each other is the key ingredient! We're fortunate ….

With Livingstone's Zambezi expedition, however, it was a disaster. He was used to travelling as the only white man in the company of Africans, and now that he had a contingent of six European expedition members, he turned out to be a simply disastrous leader. To make things worse, it took them two weeks of arguing and frayed tempers before they found an entrance through the sand bar into the Zambezi at the Kongone mouth. The river was falling rapidly and by 16th June, the *Pearl*, the 160-foot-long steamer that had been loaned to the expedition by the colonial service, could go no further. Livingstone's great River of God was now too shallow. It was a disaster. The *Pearl* had to return to the open sea and the expedition became reliant on a small steam vessel called the *Ma-Robert*, which had been taken off the *Pearl* and bolted together by engineer George-Rae. Conditions on board the paddle steamer were cramped, tense and uncomfortable, and they spent days and weeks pulling her off countless sandbanks.

As things got worse, Livingstone described the *Ma-Robert* as a '*wretched sham vessel*', adding that its small steam engine had, evidently, been made to '*grind coffee in a shop window*'.

Chugging upstream it guzzled hardwood to the extent that one and a half days' chopping was only enough to keep the boilers going for one day's steaming. The feed pipes blocked up, the cylinders and boilers gave trouble and the thin metal sheeting of the hull soon rusted through in hundreds of small holes that had to be plugged with clay. It was no wonder that he nicknamed the disastrous vessel 'The Asthmatic'. Even village dugout canoes overtook them, it was so painfully slow-going.

Casa Blanca

After 12 years of bitter civil war, peace has only recently returned to the river. The villagers wave and shout, skimmers fly gracefully in front of the boats, borassus palms and open grasslands soon replace the endless mangroves of the delta. The river is pumping and we chow fuel. The boat *Livingstone* runs out just short of Marromeu. Ross in *Stanley* goes ahead and brings back a jerry can from the vehicles.

That night we celebrate David Gwenca's birthday with an invitation to attend a dance at a local village. Conical thatched roofs with wide eaves to keep off the rains, grain stampers for maize and cassava, huge mango trees, bananas, scrawny

Mary Moffat's grave on the south bank of the Zambezi

long-necked chickens, and wide-eyed children. Aussie Linda is great with the kids. Drumming and dancing around a fire, the dancers use an old US-aid oilcan as a shaker; the lead singer uses a large metal funnel as a megaphone. The kill-me-quick coconut wine flows like the Zambezi. We all sing along as David high-kicks a frenetic Zulu war dance. The crowds go mad, especially when Mashozi does the Bum Jive.

We sleep in a large sugar-mill house called Casa Blanca. It's one of the buildings that survived the war. Next morning we climb up the rusted stairway to the top of the wrecked sugar factory, built in 1910 by the British-owned Sena Sugar Company.

Standing overlooking the Zambezi and the derelict town, the remains of beautifully laid fields and railway lines to cart off the sugar cane, we're again reminded of what a terrible disaster the hurried independence from Portugal, and the civil war that followed, had been. Señor Almeida tells us that in 1985, the company had employed over 20 000 people, and for sugar production, it had been the third biggest in Africa. But Renamo had ended all that. They'd terrorised the people by cutting off hands and ears, and had invaded the town in January 1985. 'I escaped into the bush,' he said. 'It was terrible, bodies everywhere. They used bulldozers to clear the corpses. The bank was blown up and the money taken, the sugar in the warehouse was looted, the generators blown up. Later, soldiers loyal to Frelimo came in helicopters from Zimbabwe and chased Renamo back into the bush. But as you can see,' he pointed dismally to the ruins, 'we lost our jobs and our lives have been ruined. Frelimo government officials tell us that the mill will one day be rebuilt, but still we wait. In the meantime, I fish and grow maize, the soil is good here. Be careful, my friends, there are many crocodiles in the river.'

We shout cheers to Adrian and Dave, who we'll see at Shupanga village on the south bank of the river, upstream from the ruins of Marromeu. We'd just seen the blown-up railway lines and entire trains lying on their sides in the bush. Unexploded land mines are still a killer, and everywhere we come across legless victims using crutches carved from the bush, others with no legs at all, pulling themselves along the ground.

Mary's grave at Shupanga

It's Wednesday 30th April 1997. Everybody is damp on this cold, windy morning – such a change from the heat. I read Livingstone's journal and have the customary cup of instant tomato soup and toasted stale Portuguese rolls with peanut butter and jam. The boats are overloaded with fuel and it's slow-going as we make our way west to Shupanga.

We stand next to the grave we visited for the first time in 1993. It appears nobody has visited it since. For us, Shupanga is one of the spiritual places on the river. It is here that one gets a feel for the hardship and dangers that exist for people who travel along the great Zambezi. The inscription on Mary Moffat's gravestone reads:

> *Here repose the mortal remains of Mary Moffat. The beloved wife of Doctor Livingstone. In humble hope of joyful resurrection. Your Saviour Jesus Christ.*

She died in Shupanga House on 27 April 1862, aged 41 years. Although this was our second expedition to Mary's grave at Shupanga, we are still overcome by the sadness of the place, the neglected graves, the war-torn mission station and the once beautiful church all ruined by the civil war. Ross climbs into the bell tower and soon the sound of the bells rings out across the banks of the Río Zambezi. One can feel the atmosphere of this shot-up and desecrated place.

How sad it must have been for Livingstone who had finally been joined on the Zambezi by Mary. He tried everything to keep her alive, administering regular doses of quinine, but the malaria killed her. She was buried at noon the following day under the spreading branches of a massive baobab tree. Four sailors acted as pallbearers and stood guard over the grave to protect the body from wild animals, until a stone cairn could be built.

Livingstone must have felt terribly guilty – Mary stuck in Scotland whilst he'd been exploring. She had led a desperately unhappy life. Now she was dead, and to make matters worse, his Zambezi expedition was going really badly.

Sitting on the banks of the Zambezi, I read these words from his journal, written to his friend Oswell:

> *With many tears running down my cheeks I have to tell you that poor dearly beloved Mama died last night about seven o'clock. For the first time in my life, I feel willing to die. D.L.*

Mashozi is a tough and truly remarkable woman, but this is an emotional time for her and I find her sitting quietly in the old church, her chin cupped in her little hands. She is touched by Mary's life, by the incredible hardships she endured as, like Mary, Mashozi, too, follows her adventurous husband into the wilds of Africa.

Crocodile camp

Crocodiles and a small pod of hippo. The river is becoming clearer but this stretch is a myriad channels and backwaters. Dark clouds mask the sunset as Ross and Marcus go off to collect firewood. It's a cold evening on the Río Zambezi. At least no mozzies tonight. Tropical ulcers are becoming a problem, especially on the feet and ankles, as with the pushing and shoving of the boats we're constantly in and out of the Zambezi. They start as a scratch but soon end up as puss-filled open sores. Betadine, antibiotics and a thick band of surgical plaster are the only answer. Tony is suffering with a 'real bastard' right on the bone. There are huge croc tracks everywhere. Ross takes a stick and writes 'Crocodile Camp' in the mud. The locals are terrified and use long sticks with calabashes tied to the end to collect water from the Zambezi. A group of local fishermen tells us that already this year, four people have been eaten. Drums beat throughout the night.

It took Livingstone six months and five journeys in the leaking, chugging, painfully slow *Ma-Robert* to finally get all his men and supplies upstream and together at Tete. By this time the morale of the crew was in tatters. They'd simply had enough of pushing and winching 'The Asthmatic' *Ma-Robert* over endless sandbanks. The vessel had a draft of three feet but in many places the river was only two feet deep. It was a nightmare for the crew, especially as Livingstone had appointed his inept brother Charles to lead the men as his second-in-command. Livingstone had had a serious fallout with Bedingfeld, the master of *Ma-Robert*, and now the artist Thomas Baines, who Livingstone believed had taken Bedingfeld's side, was becoming a target for his hatred. This was fuelled by Charles's report to Livingstone that Baines was a hard drinker, had been taking part in Portuguese 'orgies' and had also stolen sugar from the expedition stores. These serious accusations were never proven, but once again they brought down the morale of Livingstone's Zambezi expedition.

The men felt that Livingstone had 'bullshitted' the British government about the navigability of the Zambezi. To add to their misery, many of them were suffering from malaria but Livingstone, their leader, the man who they were risking their lives for, remained unsympathetic and distant. With the *Ma-Robert* tied up at the old Portuguese slave-trading river port of Tete, there was, in the first week of November 1858, only one major thought that occupied Livingstone's mind. This was the rumour of the 'small rapids' upstream which the Portuguese had told him about, but which, on his earlier transcontinental expedition, he'd missed in his hurry to get to the coast by taking a detour. Now the previously ignored rumours of the wild waters of Kebrabassa had returned to haunt him. If the *Ma-Robert* failed to navigate through the rapids, Livingstone's Zambezi expedition would be a dramatic failure.

Kebrabassa gorge

In the meanwhile, for our motley crew, following Livingstone's 1858 journey up the Zambezi is becoming an exciting odyssey. Getting into serious trouble with the Frelimo military at Caia for standing in the turret of an old Russian tank. Spending the better part of a day digging and winching our vehicles out of a stinking mud hole as they attempt to reach the river with much-needed boat fuel. And like Livingstone did, taking a bearing on towering Mount Morrumbala. Then making camp at the confluence with the great Shire River where it flows from distant Lake Malawi.

Interacting with the friendly Mozambican people, now that there's peace returning to their villages in the bush. Marimbas and drums playing through the night. Fishermen in dugout canoes. Crocodile, hippo and incredible birdlife. The settlements of Villa de Sena and Mutarara, struggling to come back to life after the war. Passing under the repaired Dona Ana bridge – longest railway bridge in Africa, the lifeline to the north that had been blown up in the war.

The beautiful Lupata gorge and Mozambique Island standing out like a big plum pudding in the middle of the gorge. Sandbank islands to camp on, the good company around the fire at night and the endless freedom of the river that finally brings *Livingstone* and *Stanley* and their ragged-looking occupants to Tete on Tuesday 6th May 1997.

On the 8th November 1858, Livingstone, Rae the engineer and John Kirk (Livingstone's only friend on the expedition) set off in the *Ma-Robert* for the Kebrabassa gorge – nowadays known as Cahora Bassa. Thomas Baines, Thornton and Livingstone's brother Charles, all of whom were suffering from malaria, remained behind at Tete. After a day and a half of steaming, the Zambezi began to narrow until it was soon only about 30 yards wide. Steep black basalt rocks rose up to form cliffs several hundred feet high. It was impossible for the *Ma-Robert*. They passed a small rapid; the second one swung the steamer's bows onto the rocks, holing her above the water line.

The next day, they proceeded on foot but the fast whitewater, cascades and waterfalls that roared over jagged black rocks turned them back. Livingstone did not give up. Too much was at stake, and soon he was back again with all the men and some of his Makololo guides.

After four days of clambering up the Kebrabassa gorge, the men were beaten. It was impossible to get around the rapids. The banks were a jumble of massive rocks and boulders, some 30 feet high and smooth, slippery and black. Livingstone's thermometer showed readings of up to 130°F. The rocks were too hot to touch and soon the porters' feet became a mass of blisters and burns. For two more days they

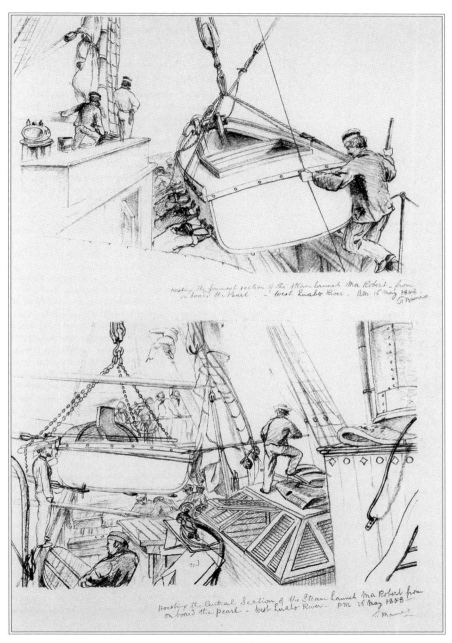

Hoisting the foremost section of the Steam Launch Ma-Robert from on board the Pearl. — West Luabo River. AM 16 May 1858
T. Baines

Hoisting the Central Section of the Steam Launch Ma-Robert from on board the pearl. — West Luabo River. PM 16 May 1858
T. Baines

Unloading the *Ma-Robert*

struggled on. Then Livingstone's blood ran cold. His worst fears had come true. The navigability of Livingstone's River of God was blocked by a thundering 30-foot-high waterfall. His Zambezi expedition had failed, and it was a forlorn, dispirited team that struggled back to Tete.

The challenge of the gorge

It's Monday 7th May 1997 and we must tackle the gorge that turned Livingstone back. Nowadays, the top of the gorge is blocked by the 160 m-high Cahora Bassa dam. Our objective is to get as close as possible to the wall. Some 20 km upstream from Tete, we set up a base camp below the derelict but beautiful Baroma mission, established in 1890 but destroyed and then abandoned after the civil war. Johann, the interpreter, has had to fly back to college in Maputo, and Dave Gwenca has an extreme aversion to rapids and crocodiles and is delighted to stay behind to look after the camp. Always eager for an adventure, Adrian, his co-driver, is going to tackle the historic gorge with us.

We load up with boat fuel, kit is kept to a minimum – we need to keep the boats light. It's midday by the time we get going. Everybody is nervous, but the river is beautiful – baobab trees and fishing villages with chessa, Cornish jacks, bream, tigerfish and giant vundu smoking and drying on racks. We trade for some fresh fish and, eating with our fingers, share some smoked bream and maizemeal with friendly local fishermen. Here the Zambezi is deep and narrow. No wonder Livingstone couldn't get through in the *Ma-Robert*. Sheer black basalt cliffs slide into the water, rocky outcrops sculpted by millions of years of Zambezi flooding.

Gunning the motors, we make it through the first rapids, set in a twisting S-bend of the Zambezi with giant pinnacles of rock sticking out of the swirling white water. The adrenaline rush has begun. At sunset we make camp on a sandbank, perched high above the swift-flowing river. Aussie Linda peels the potatoes, Adrian and Ross scale and gut the fish. We scramble for firewood – chips need plenty of heat. Pity there's no lemon! And chocolate biscuits, for that matter. And … who's the idiot who mentioned ice cream and hot chocolate sauce?!

Tony turns his short-wave radio onto BBC World Service. We crowd around. Through the crackle and squelch, a clipped British accent informs us that Kabila has agreed to meet with Mobutu Sese Seko on the South African warship, *Outeniqua*, anchored off Congo. Mandela and Mbeki would be present. Meanwhile rebels are 200 km from Kinshasa and are about to take Gabadolite. How will things be for us when we reach Zaïre? That's the burning question hanging over the expedition, now camped above the Zambezi's Cahora Bassa gorge.

Disaster on God's highway

Thursday 8th May – a beautiful morning in paradise, but Ross and Adrian complain about not having slept because of pulling up the boats as the river rose rapidly throughout the night. Mashozi decides to remain in camp whilst we tackle the gorge. If all goes well, we'll be back by nightfall.

At full revs, I follow Ross into the wild, ferocious river. We hit a wall of water. Tim's filming and gets thrown onto his back but keeps the camera rolling. The motor hits a submerged rock, kicks up and we lose power. Out of control, we're pushed back onto the same rock – the force of the water is too powerful and in seconds the screaming outboard is torn from the transom, taking the safety strap and bracket with it. At full revs it disappears into the very depths of the Zambezi, leaving us motorless. Our boat *Livingstone*, like the *Ma-Robert*, has been defeated by the Cahora Bassa gorge!

My mouth hangs open in disbelief. It all happened in a matter of seconds. Our boat is swept downstream and into an eddy. Ross comes racing back to look for us. He also can't believe it! We look down into the swirling water; it's too fast and deep to even attempt to dive and search for the lost motor. A big crocodile slides off a nearby bank.

Ross tows us back to camp. Mashozi is speechless – we'd only left 10 minutes earlier to tackle the gorge and here we are, back again with a motor gone! I feel bloody stupid, but we can't give up now.

Leaving the rest of the team in camp, Marcus, Adrian, Tim and myself jump into the boat *Stanley*. With Ross at the helm, I feel we've got a better chance; he's an excellent skipper. And so we're off.

Evil rapids, some flat water, and then into the gorge proper after the confluence with the Luie River. It's a wild, chaotic jumble of boulders and cliffs. Now I know what Livingstone went through – most of the rapids are only navigable at full throttle. Finally, within about five kilometres of the dam wall, we're into an impossible rapid. It would be a giant waterfall in low water. It's absolutely impossible in our boat, and with one outboard motor already gone, we realise it would be crazy to risk it. Ross steers the boat into a quiet section of water and we proceed on foot. It's hard work scrambling over the massive boulders. We struggle on, but after two hours, it's time to turn back before we run out of light.

I'm more than happy. We've made it to within just a short distance of the dam wall. Ross pulls on the starter rope and we move back out into the mainstream. A massive crocodile makes a beeline for the boat. Unusual – I suppose it's never heard an outboard before! On one of the rapids, we ship a wave that turns Marcus's Nikon into an underwater camera. And then it happens. All we hear is a slight 'clack' as we go through a rapid, then no power!

'Oh, shit!' exclaims Ross with a horrified look on his face.

Somewhat of an understatement, I think, as he pulls up the motor and we all gaze in astonishment at the place where the prop should be. The propeller shaft has snapped in two and complete with propeller, gone to visit the other outboard in the depths of the Río Zambezi. We've got spare props but not a complete shaft. We grab for the paddles as we get swept downstream now at the mercy of the fast-flowing rapids. Not ideal! We row back to camp to arrive at sunset. Two boats, no power and 86 kilometres to Boroma mission where Dave is waiting with the vehicles. Just as the Cahora Bassa rapids had destroyed Livingstone's dream, so now the same rapids had come close to destroying ours.

We decide to row through the night. It'll be cooler and we'll get back to our base camp before Dave panics and launches a search party. We'd tried him on the radio, but no luck. Four tough young fishermen with their dugout paddles agree to help us reach Boroma. In true 'warrior' spirit, they shout goodbye to their families, and with *Livingstone* and *Stanley* lashed together, we head downstream.

It's difficult to feel demoralised in this dramatic and beautiful place. Behind us the sun sets, turning the Zambezi orange and gold. Downstream there's the perfect arc of a double rainbow.

The oarsmen sing and we crack jokes about our predicament. On the clear starlit river, we drift past the twisted shapes of baobabs, the outline of the high hills on either side of the Zambezi guiding us downstream, past countless small fires lit to keep the hippos out of the maize and millet fields. It's well past midnight, and our loud excited voices have now dropped to tired whispers. I lie back in the squashed boat, looking up at the stars and pondering over the situation our Zambezi-Zaïre expedition now finds itself in.

Had it been worthwhile – the loss of an outboard and the second breakdown, the time, and now the cost of getting in new equipment? Most definitely! I decided. No-one had been hurt and we had completed the first chapter of our journey from Chinde to Cahora Bassa in 14 days.

Back at Tete we call for help. Our sponsors get into gear. Yes! A new outboard motor and spares would be sent to Harare.

Ugezi fishing camp

Ross with Tony, who had now completed his assignment, together with Marcus for company, will make a dash for Harare. Mashozi, Tim and I are taken in by Hennie Muller who, with Phil and Ronnie Bezuidenhout, have a kapenta fishing operation and Ugezi fishing camp near Songo, just above the dam wall. That night we hear why the water has risen so high in the gorge.

'The Portuguese president had been visiting, you see,' says Phil Bezuidenhout, 'and they wanted to take a picture of him at the dam wall. So, for effect, the sluice gates had been opened.'

How were they to know that two little boats were heading upstream, crazy enough to be following Livingstone's 1858 journey?

Realising his Zambezi expedition had hardly been a success, Livingstone now decided to turn his attention to going up the Shire River [in Mozambique and Malawi], to where, he had heard from the Portuguese, lay a massive inland sea. This, he felt, would take the attention off his failure to prove the Zambezi navigable. On the 17th September 1859, Livingstone discovered Lake Nyasa and this finally led to missionaries settling in southern Nyasaland.

But Livingstone's affair with the mighty Zambezi didn't stop there. In 1860, with his brother Charles and Dr Kirk, he returned to the upper Zambezi and the Victoria Falls, which he'd first discovered in 1855.

Our immediate expedition objective remains clear: to tackle the length of the Zambezi, including the dogleg through war-torn Angola and on to the source. It's a week before we're all back together again. The vehicle papers get nicked in Harare and it is a battle for Ross to get the new outboard through customs.

But, finally, with the new motor bolted on, we say cheers to our mates at Ugezi fishing camp and head up Cahora Bassa lake, two boats side by side with that damned gorge now behind us. David and Adrian refuel us at Mague – pronounced 'magwe' – and then we meet up again for the night at MacGuire's camp.

Next day, running with the wind, we're through the narrows to camp at sunset on a spit of land covered with mopane trees. For company we've got a pair of fish eagles, grunting hippo and the most unbelievable sunset over the distant hills of Zambia, Zimbabwe and Mozambique. As we eat stew, rice and a little Captain Morgan, we hear the great news on our HF radio that Kabila and his rebel forces have finally taken over Kinshasa and are preparing for democratic elections in Zaïre. Congo River here we come! Weeks of indecision now seem over.

Ladies of Lusaka

We speak to the vehicle party on the radio. They've crossed through into Zimbabwe okay and have camped at the Mount Darwin police station. As arranged, they'll meet us on the Zambezi at Kanyembe. At full throttle we plough into massive, thick, green islands of water hyacinth, floating weed that blocks our way and burns up our fuel supply. It takes hours and hours of chopping through the weed with

our props before we are through. Cahora Bassa is the fullest it's been in years and it's a strange sensation to float, motors on shallow drive, between the huts, raised granaries and cattle kraals of villages that, as one old fellow tells us in perfect English, 'have been swallowed by the Zambezi'.

Now, we can tell we're getting closer to Zambia. At a fishing village we meet the 'Ladies of Lusaka' – fish buyers from Zambia who introduce themselves as Regina, Stella, Anna and Margaret. They travel by bus and then by dugout to get to these remote villages on the Mozambican shore. With them they bring trade goods, radios, secondhand clothes, salt, soap, fish hooks and line. These enterprising ladies live in the villages for four to six weeks, buying fish fresh from the fishermen's nets and then drying them on racks over smoking hardwood coals. Once dried, the fish are stacked into massive woven cylindrical baskets, each weighing up to 100 kg and containing about 350 fish.

The Ladies of Lusaka then load up the dugouts with their fish baskets and the paddlers row throughout the night against the current, up the mighty Zambezi to Zumbo borderpost, across to Zambia, and then it's by bus to sell their fish in the markets of Lusaka. A hard life and another example of the amazing strength and ability of African women to survive and feed their families.

Regina invites us in to her minute thatched hut for a lunch of fried fish and maizemeal. An old dented pot filled with water is first passed around for the washing of hands. The thick maize porridge is scooped up in small portions with the right hand, then rolled into a ball and used as a 'spoon' to dip into the fish and sauce. Simple and extremely appetising; traditional hospitality in the sharing of a basic meal. Mashozi hands out some much-needed medicines. Here, there is no clinic or doctor.

Past more sunken villages, we make Zumbo in the late afternoon and amidst much smiling, stamps and documents we end our delightful Mozambique chapter. We cross the river into Zimbabwe and camp on a sand spit. Hippo grunt throughout the night. Dave and Adrian, who have got the supply vehicles through to Kanyemba, join us for the night.

Livingstone was as fascinated by the abundance of wildlife in this area as we are 142 years later. He wrote:

> *We usually followed the footpaths of the game, and of these there were no lack. Buffaloes, zebras, pallahs and waterbuck abound and there is also a great abundance of wild pigs, koodoos and the black antelope.*

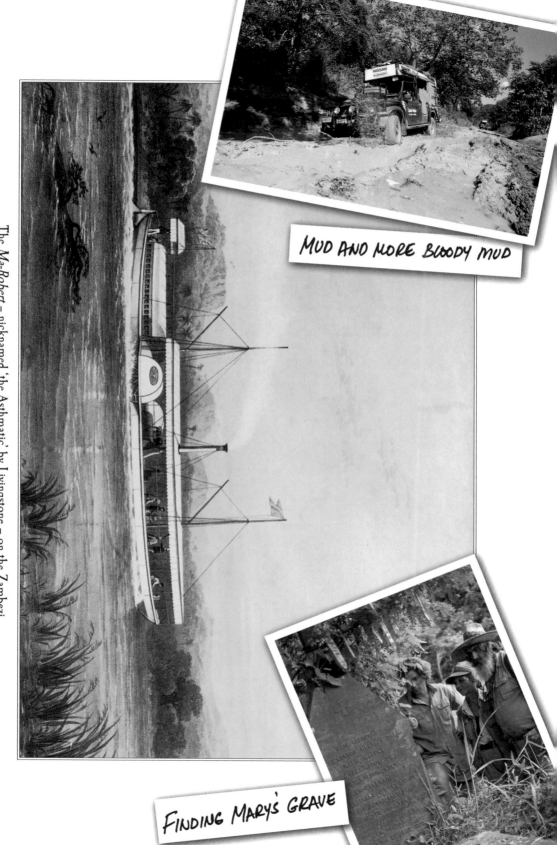

The *Ma-Robert* – nicknamed 'the Asthmatic' by Livingstone – on the Zambezi

MUD AND MORE BLOODY MUD

FINDING MARY'S GRAVE

I just love Livingstone's spelling of kudu, not to mention the 'pallahs'! He went on to write:

> *… elephants are numerous and many are killed by the people of both banks. They erect stages on high trees overhanging the paths by which the elephants come, and then use a large spear with a handle nearly as thick as a man's wrist, and four or five feet long. When the animal comes beneath they throw the spear … the motions of the handle, as it is aided by knocking against the trees, makes frightful gashes within and soon causes death.*

Mupata gorge

It's Wednesday 21st May and there is early morning mist on the Zambezi, upstream from Zumbo, Luangwa Feira and Kanyemba – the point where Mozambique, Zambia and Zimbabwe all meet.

Here the river becomes very picturesque as it runs between two fine hills, Nyamvuru on the right and Kapsuku on the left – tall, flat-topped and dropping almost uninterruptedly into the river. It's storybook Africa.

Mupata gorge, with its steep rocky hillsides dropping almost vertically into the river, is quite spectacular. Huge baobabs line the riverbank and the odd croc slides into the river at the sound of our droning outboard engines (will our ears survive 7 000 km?). Pods of hippo grunt with disapproval before disappearing under the surface of the fast-flowing river.

Above Mupata gorge the land flattens out on the Zimbabwean side and the river becomes extremely wide and shallow. We spend hours dodging sandbanks and pushing boats – gives you the heebie-jeebies with all the crocs about. A lone buffalo swims across the Zambezi, hippo are everywhere. We camp at sunset on an island in the middle of the river. Lion and hyena call at night.

We wake to film the sunrise, eat leftover bean stew and are back on the river. Within 15 minutes we come across a hippo cow that has just given birth to a calf. This beautiful Mana Pools section of the river is wide and full of sandbanks. Tall forests of spreading *Acacia albida* line the banks. Two elephants lock tusks in mock combat whilst white cattle egrets hover around. We spot openbill storks, Egyptian geese, little bee-eaters, fish eagles. A large herd of buffalo come down to drink – what a great way to start the day! A lone bull elephant wades, then swims across the Zambezi.

During his transcontinental trek, Livingstone reached the Kafue River on the 18th December 1855. He wrote:

> We saw many elephants among the hills, and my men ran off and killed three … when we came to the outer range of hills, we had a glorious view. At a short distance below us we saw the Kafue, winding away over a forest clad plain to the confluence, and on the other side of the Zambezi beyond that, lay a long range of dark hills. The plain below us, at the left of the Kafue, had more large game on it than anywhere else I had seen in Africa. Hundreds of buffaloes and zebras on the open spaces, and there stood lordly elephants feeding majestically … I wished that I had been able to take a photograph of a scene, so seldom beheld, and which is destined, as guns increase, to pass away from earth.

How right Livingstone was. With his discoveries came the Scramble for Africa and the end of the game. Fortunately, and thanks to conservation measures, the Zambezi valley remains one of the finest wildlife areas in Africa. Let's hope that the governments of Zambia and Zimbabwe keep it that way.

Some 13 km above the confluence with the Kafue, we come to the massive suspension bridge at Chirundu, the busy border town between Zimbabwe and Zambia. Now there are other motorboats on the river, and a long line of trucks queueing up to cross the frontier. Noise and people everywhere. Somehow the incredible magic of the lower river has disappeared.

> There can be no happier or more satisfying mode of existence than to live for a time in country far away from all contact or reminders of the strife, conventionalities and empty vanities so inseparable from town life.
>
> — Robert Sutherland, *Zambezi Camp Fires*

Early in the 1900s, long before the bridge was built, Jimmy Vlakis (known as Jimmy the Greek) operated the ferry service from the north bank of the river, where he also farmed with his brother Nick. In 1912 Nick was killed by a lion, but the small, amiable Jimmy remained in the area for many years. He was reported to be a fine hunter and killed over 80 lion in the time he was at Chirundu. We tie up both boats under the bridge and climb the steep rocky bank up to Zambian customs and immigration.

Then it's off to the Chirundu Valley Motel for a slap-up mixed grill and ice-cold Zambezi beer. Lorry drivers and hookers fill the bar. We camp upstream.

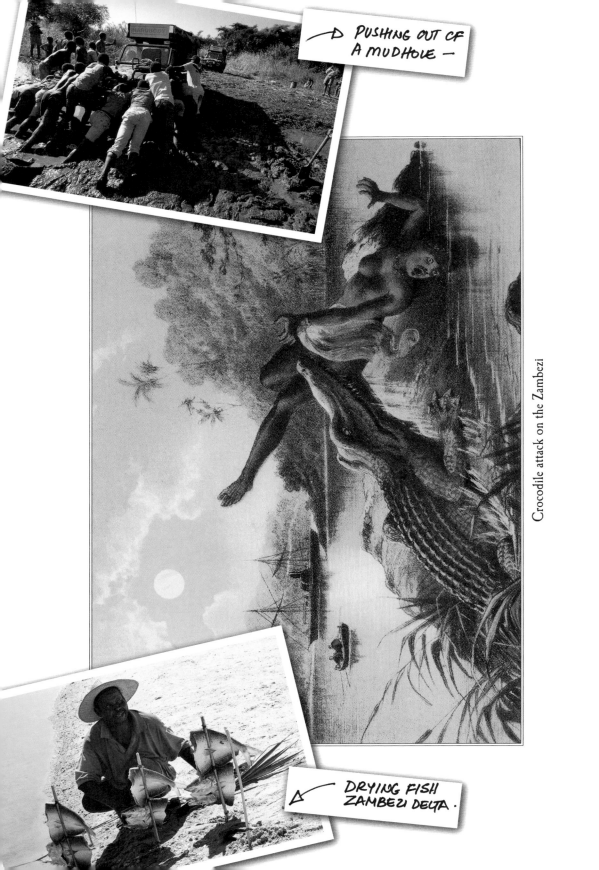

PUSHING OUT OF
A MUDHOLE —

DRYING FISH
ZAMBEZI DELTA.

Crocodile attack on the Zambezi

The spirit of Nyaminyami

It's Friday 23rd May in the Kariba gorge. The boat *Stanley*, with Ross skippering, frightens a massive crocodile close to five metres long, which dives off the high bank and lands on the nose of our boat, giving us the bloody fright of our lives! This section of the river between Chirundu and Kariba certainly seems to have the highest crocodile population on the Zambezi, and we need to be extra careful as we bathe, wash dishes and camp on the riverbank. The expedition has been resupplied and Ross makes an oven by digging a shallow hole in the sand and filling it with red-hot coals, on which he places a flat-topped aluminium pot, the lid covered with burning coals. The result is two beautifully roasted, succulent chickens served with gravy, roast potatoes and salad, all washed down with some cold Bollinger beer. Hippo walk through camp during the night, and we hear the splash of the dugout oarsmen as they paddle the shoreline off the Zambian side, fishing for tigerfish, chessa and bream.

A full moon lights up the river and distant hills of the Kariba gorge. A lion roars continuously … Marcus and Ross decide to put up a tent – it's amazing the sense of security a thin piece of canvas and a plastic zip give you!

The following morning, Ross chats to the vehicle team on the HF radio. The aerial stretches out from the only tree, with me holding the other end some 30 m away. Using a 12-volt battery that charges off the outboard motor, we soon have a connection and are able to establish that they've hired some porters and will meet us at a point below the Kariba wall. The Kariba gorge is hauntingly beautiful; giant baobabs and steep cliffs. The water – fast-flowing – is the cleanest we have yet seen on the Zambezi. David Livingstone spelt the gorge name as 'Kariba' but gave no explanation of its meaning. It is now generally considered a corruption of the Shona word *kariwa*, *riwa* being the part of a trap that falls upon and kills its victim. According to local legend, three great rocks that jut out of the swirling water near the top end of the gorge will, at the behest of the rivergod Nyaminyami, suck passing boats down into a vast whirlpool. We are fortunate, however, and whilst the river does tug and pull at our boats, we do make it past the rocky outcrops to the very base of the concrete dam wall at Kariba.

The Batonga people refer to the Zambezi River as *Kasambabezi*, which means 'those who know wash here' (in other words, if you know the river, you can wash without being attacked by crocodiles). But in more recent times, the greatest threat to these people has not been the crocs but the arrival of white men with their 20th-century technology and their plans for a mighty dam.

In 1955 it was decided to build a dam here in the Kariba gorge. A gargantuan scheme was envisaged, with a massive concrete arch to be thrown across the Zambezi, so forming a lake of 5 000 km². It would be the largest man-made lake

on earth, putting upon the earth's crust a weight of 177 billion tons. The Batonga believed that the lair of their rivergod, Nyaminyami, was below the dark waters of the Kariba gorge – was the white man insane? Nyaminyami would destroy their foolish dream and tear it to shreds. The engineers laughingly dismissed the rivergod myth and work began, but by early March 1957, it became apparent that Nyaminyami had planned an attack. An enormous volume of water was descending towards the dam site and, as the floodwaters hit the Kariba gorge, the Zambezi rose 5.5 m in just one day. Incredibly, the workings were not entirely washed away.

The coffer dam was pumped dry and work on the main wall began in earnest. But Nyaminyami was licking his wounds and plotting a fearful revenge. On 16th February 1958, the coffer dam succumbed to the raging Zambezi. The river continued to rise with the torrent, the engineers recording a height of 33.5 m above low-water level. There were waves of nearly 5 m. The damage was severe and work was put on hold for months. But in December 1958, the last opening in the wall was finally sealed. Behind the Kariba wall, the lake grew to nearly 322 km in length and 32 km at its widest point.

A massive sheet of water bisected the traditional lands of the Batonga; their lives had changed forever. Operation Noah was launched to rescue and relocate the many animals that were trapped on the fast-diminishing islands of high land but, even so, many animals drowned in the dam's rising waters.

Possibly our presence is reviving the spirit of Nyaminyami. The level of the lake had dropped considerably over the last few years and at present, the level of the lake is rising by the hour.

R&R on a houseboat

Believe me, my young friend, there is nothing – absolutely nothing – half so much worth doing as simply messing about in boats.

— Kenneth Graham, *The Wind in the Willows*

At Kariba we meet up with our old friend Geoffrey Blythe for two days of much-needed R&R aboard his houseboat, *Barbelle*. In the bar is an old dugout paddle taken from our 1993 Cape to Cairo expedition in which Geoffrey had been a member for the Kariba to Chinde section, and then up the Shire River to Lake Malawi. Mad John Murphy, a colourful Irish float-plane pilot, joins us. He's great fun on guitar and mouth organ, and much later that evening tells us the shocking story of how he had been the sole survivor of a DC-3 crash while carrying relief

maize into Mozambique. They'd crash-landed into a mopane forest near Mutarara and the captain had died on impact. John had been at the back of the plane at the time, throwing out bags of maize in an effort to lighten the load and keep the plane flying. On impact he'd become buried under a load of maize bags. The smell of aviation gas had him fighting to get out from under the bags. The co-pilot had been thrown from the cockpit and got chopped up by the propeller, dying two days later. So in the heat of the Zambezi valley, with the aircraft's compass around his neck, John walked in the direction of the river. He nearly died of thirst, but, finally with the help of locals who knew where the landmines were, he made it through to Chembe on the Zambezi, where he was finally picked up by a UN helicopter.

John has a love affair with the Zambezi and spends his life in his float-plane, shuttling people and goods up and down The River. He sees a lot from the air, and his biggest concern is the ongoing ivory poaching – the obvious signs being carcasses in the bush and vehicle tracks.

Lake Kariba has always had a very special place in our hearts – the dry grey-white ghost trees that glow at sunset, bright green Kariba weed that snarls up the boat props, elephants, buffalo, waterbuck and impala coming down to drink. The Sanyati and Ume rivers. The Batonga villages with their conical thatched huts and raised granaries. Old women puffing away at their dagga-filled hubble-bubble calabash pipes. The roar of the Matusadona lions. Fishing for tiger and bream, the endless lake, mopane trees, the distant mountains and the spirit of Nyaminyami.

Halfway point

But, today, the rivergod's against us. There's a cold wind and rough wave action on the 250 km-long lake. Everything's tied down and secured on our two open boats, we're all huddled in raingear, spray slapping our faces. After hours of being pounded by the elements, we stop out in the lake and I pass round a bottle – a tot or two each of rum for the sailors. Always there's the humour. Sometimes I think it's the only thing that keeps us going.

Our journey up the lake turns out to be a struggle. Livingstone, I know, would have shrugged at the hardship. Africa is not for sissies and it's three days before we tie up our boats outside the old Deka Drum Hotel, at the confluence of the Deka and Zambezi rivers some 120 km downstream from the Victoria Falls. There are some enormous crocs here. We prop up the bar and buy some braai packs, which quickly get turned into a massive stew. Tomorrow we tackle the Batoka gorge.

It's Sunday 1st June, a new month on the Zambezi. We know it's not possible to follow the Batoka gorge all the way up to the base of the Victoria Falls, so our plan is to make it as far as we can, and then to run the missing section downstream

by specialised whitewater craft. Tim and I are in *Livingstone*, Ross and Marcus in *Stanley*. The rest of the team will move upstream by vehicle to set up a camp at the confluence with the Matetsi. High floodwater has ironed out a lot of the rapids, but when we get into the bigger whitewater, it's simply too fast to tackle upstream – we'd need powerful jet boats.

With engines screaming at full power, it's great adrenaline-pumping fun and not without drama. We're belting along when Tim picks up his camera to film a massive evil-looking crocodile as it slides off some rocks into the Zambezi. As if on cue, we get jerked sideways by a wave and over Tim goes. I drop the tiller bar and manage to grab one of his ankles. Somehow the Betacam recorder ends up in the bottom of the boat and survives the ordeal. We roar with laughter. Imagine another piece of valuable machinery ending up at the bottom of the Zambezi, not to mention Tim having to do a quick swim with the croc he was filming!

That night Mashozi and Linda put on a candlelight dinner, wild flowers decorating the beautifully set long camp table dragged from the roof rack. Just the eight of us celebrate the reaching of our Zambezi halfway point. There's still that dogleg through UNITA-controlled Angola, though, and, of course, the Congo. It's best to concentrate on the now and let the final destination look after itself. After a night's merrymaking, that's the decision we come to, anyway!

Mosi-oa-Tunya … Livingstone had first heard of the great waterfall in 1851, but it was only in 1855 that he set out to visit it. He spent the night at Kalai Island, a few kilometres upstream, having come down the riverbank on foot. The next morning he set out by dugout canoe to approach the 'smoke that thunders', and landed on what is now called Livingstone Island, from where he had his first view of the falls. In his journal he wrote:

> *Creeping with awe to the verge, I peered down into a large rent which had been made from bank to bank on the broad Zambezi, and saw that a stream of a thousand yards broad leapt down a hundred feet and became suddenly compressed into a space of fifteen to twenty yards. It is the most wonderful sight I have ever witnessed in Africa.*

Of the surrounding area he wrote:

> *No-one can imagine the view from anything witnessed in England … it had never been seen before by European eyes, but scenes so lovely must have been gazed upon by angels in their flight.*

THE PEACE AND
TRANQUILITY OF
THE ZAMBEZI —
MY FAVOURITE
RIVER —

A WIND SPIRIT
ATTACKS OUR
CAMP —

Lions attacking a buffalo

In honour of his regent queen, he named this place of great beauty the Victoria Falls. Said to be the widest curtain of falling water in the world, they are as spectacular now as when David Livingstone first discovered them on the 16th November 1855.

A string of visitors followed Livingstone, the first of whom was the hunter William Baldwin, who walked up from Natal using a pocket compass to guide him. Thomas Baines visited the falls two years later and was probably the first artist to record their spectacular beauty. Others followed. In 1876, a Mr E Mohr wrote:

> *No human can describe the infinite, and what I saw was a part of infinity made visible and framed in beauty.*

River rats

The Zambezi is in full spate. The flooding is late this year and over 500 million litres per minute are tumbling over the lip of the falls into the spray-filled chasm below. Just as the fishermen of the Cahora Bassa gorge had helped us row out of trouble, so the whitewater rivermen of Victoria Falls now come to our rescue.

Top whitewater expert Chris Hurlin, known affectionately to all as 'Chris the Hungry', offers to sponsor our downstream section, even though some of the rapids are currently unrunnable commercially because of the dangerously high whitewater. With him are three of the Zambezi's finest 'river rats' – Peter Meredith, Barry Meikle and Skinner.

Life jackets and safety helmets giving us a gung-ho air, we set off from the Boiling Pot below the falls to run the high water in two specialised rafts.

Ross gets swept overboard and is dragged back up by 'Hungry'. We paddle for our lives, adrenaline pumping. Rapid No. Nine is particularly memorable for Barry Meikle, who was once casevaced out of there with a broken back. It's a roller-coaster ride that we'll never forget – not to mention the steep climb out of the gorge, which soon sweats out the previous night's festivities.

Hungry didn't kill us on the river, but that night at a dinner party at his house, also attended by Penny Smythe, the charming presenter (at the time) of the TV show *Front Row* (no longer on air). She'd flown in to interview us, and there was Hungry trying to kill us all off in a hot chilli-eating competition, washed down with copious quantities of alcohol.

'It blows out the cobwebs,' says Hungry between spoonfuls of instant death. Believe me, there's no competing with these wild Zambezi characters.

Unfortunately, Tim Chevallier's time with us has run out and replacement cameraman Mike Yelseth now joins the expedition. We'll miss Tim. A fine

gentleman of the African bush, he writes these words in our journal, whilst sitting at the lip of the falls on Livingstone Island:

> Looking out onto one of the wonders of the world, Victoria Falls! What incredible beauty, all this water on a journey to Devil's Gorge, Cahora Bassa and beyond to the Indian Ocean. For me it's the end of an incredible journey, loads of humour and the privilege of having shared Zambezi sandbanks and a bottle or two with dear friends Kingsley, Mashozi, Ross, Adrian, Dave, Marcus and little Linda. I shall think fondly of you all as you head upstream – Bon Voyage!

Farewell to the smoke that thunders

In contrast to the furious whitewater below the lip, the Zambezi above the falls is dotted with islands and is beautifully peaceful. It's not surprising that the early flying boat service across Africa used to land their Solent flying boats here on the river. It was the grand age of air travel and the passengers would be taken off to overnight at the gracious Victoria Falls Hotel.

As a farewell to *Mosi-oa-Tunya*, Ross takes his boat to the very lip of the falls before turning and accelerating upstream past Livingstone Island. It's exciting to be on the move again, loaded up and heading for the unknown. We push and pull through the narrow reeded channels of the fast-flowing Katambura rapids. Up to our necks in water, holding the boats against the current, there is always the fear of crocs. Equally, ploughing between the rocky rapids, there's the dread of the terrible sound of tearing metal against rock. Thank God we've got a box of spare propellors. Then it's flat water again up to the Kazungula ferry point between Botswana and Zambia, and the confluence with the Chobe River.

On Sunday 15th June we enter Namibia and tie up at an old South African military base that was used by the air force officers on R&R. Now it's called Hippo Camp, with a cheerful pub and great grub. Mashozi is there to meet us. In desperation she'd flown off to South Africa to sort out our paperwork and now she's back, on the riverbank waving in excitement. With her are our passports, each with a visa for Angola and Mr Kabila's New Democratic Republic of Congo.

We resupply at the Namibian riverside town of Katima Mulilo – the name meaning 'to douse, or put out, the fire' in Silozi. One explanation has it that people travelling the river often used to carry live coals in their dugouts for use in making fires when they came ashore at night. Very often the rapids at Katima would douse

THANKFULLY THE ZAMBEZI VALLEY IS STILL RICH IN WILDLIFE— LET'S HOPE OUR GRANDCHILDREN AND THEIR CHILDREN STILL GET TO SEE IT THIS WAY

An elephant hunt

the coals as water washed into their boats. Another story goes that young men, wading across the river to visit their girlfriends on the opposite bank, would have the flames of their desire cooled by the icy, waist-deep Zambezi waters!

Rapids and more rapids. Upriver expeditions are a mug's game. We're always in the water, pushing and pulling, losing a foothold and being swept downriver, worrying about crocodiles and gearboxes. Ross does the incredible job of navigating; I follow.

Explorers as crazy as us

In Michael Main's fascinating book *Zambezi, Journey of a River*, I learn from a chapter titled 'Men, Madmen and Maniacs' that, apart from us, there've been others crazy enough to attempt an upstream boat journey of the Zambezi. One such fellow was Major A St H Gibbons who, with six companies, set out from Chinde at the mouth of the Zambezi in May 1898, just 40 years after Livingstone had been turned back by the rapids of Cahora Bassa. There were several paddle steamers operating on the lower Zambezi at that time, and one of them hauled Gibbons' expedition up to Tete.

To achieve the expedition objectives of exploring Barotseland, the upper Zambezi, and locating its source, the expedition had three shallow-draft aluminium boats that could be carried in portable sections. It took them five weeks to portage around the Cahora Bassa gorge, then, back on the river, they managed only 10 km in five days. I sympathise with Major Gibbons. We've both tackled the river at 50 years of age. They, too, pushed and shoved – but the river was too shallow and the current too strong for the small steam engines. After reaching Zumbo and the confluence with the Luangwa, they found themselves in the Zambezi valley at the hottest time of the year with the water at its lowest. They fought their way up through the Mupata and Kariba gorges, but finally, somewhere in the now-flooded Devil's gorge, Gibbons called it a day. With Stevenson-Hamilton (who later became the first warden of the Kruger National Park) and Captain Quicke, they continued their expedition on foot to finally arrive at Lealui in Barotseland.

Today, with our modern outboard engines and high-flotation inflatable boats, we shouldn't complain. We've chosen the winter months and high water. But still we struggle through 24 more sets of rapids before finally negotiating some seriously fast whitewater that brings us to the very base of Sioma-Ngonye. If there were no Victoria Falls, then this would certainly be the most beautiful waterfall on the entire Zambezi. We're exhausted.

Livingstone saw these falls on the 30th November 1853, whilst on his way down the Zambezi by dugout canoe, travelling with his Makololo porters who had been loaned to him by his friend, the Kololo chief, Sekubethu. The Makololo, a migrating Sotho tribe, had, at the time of Livingstone's discovery of the Zambezi, established themselves as the overlords of the Lozi people. This was most convenient for Livingstone as he could understand Sotho, and it was thanks to this hardy group of men that he survived his journey across the continent. Livingstone was as impressed by the Sioma-Ngonye falls as we were and wrote:

> *The water goes boiling along, and gives the idea of great masses of it rolling over and over, so that even the most expert swimmer would find it difficult to keep to the surface. Viewed from the mass of rock which overhangs the fall, the scenery was the loveliest I had seen.*

Livingstone at this stage had not yet seen *Mosi-oa-Tunya*.

Congo, the dog

From above the basalt dyke that forms Sioma-Ngonye falls, and stretching upstream towards Angola, is the vast Barotse flood plain. This is the river kingdom of the friendly Lozi people – and for me one of the most beautiful places on the Zambezi. A land of water where long-horned cattle swim between the islands, herded by men in dugout canoes.

The Silozi word *ku'omboka* means to 'get out of the water onto dry ground'. Every year, as the floodwaters of the upper Zambezi rise, so the Lozi people celebrate the *ku'omboka* in a colourful ceremonial move to higher ground. Only when the king of Barotseland, known as the *litunga*, decides to move does he give the command, and the silence of the night erupts to the booming rhythm of the massive royal rawhide drums. It's the signal to commence an ancient ceremony that dates back more than 300 years to when the Lozi people broke away from the great Lunda empire of the Congo to settle here in the upper reaches of the Zambezi. The next morning, the *nalikwanda*, the zebra-striped royal barge, with its 120 paddlers dressed in wild-animal skins, ostrich plumes and colourful cloth, complete with onboard royal orchestra of xylophones and drums and surrounded by a flotilla of hundreds of dugout canoes, moves out across the Barotse flood plain. The *ku'omboka* ends when the royal barge reaches the village of Limulunga, a short distance north of the bustling river port of Mongu where, on Sunday 21st June 1997, we arrive to shouts and whistles, and open-mouthed amazement from the local rivermen.

At the rough-and-ready harbour of Mongu, where you can buy anything from Angolan diamonds to antique outboard spares, Mashozi buys a dog. A typical African variety with a pointed snout, ridged back, sickle tail and warm brown eyes. We christen him Congo; Mashozi is delighted to have a mutt on board. She tells us that he will be our guard dog through Angola and the Congo. Ross looks down his nose at his mother. I can see what he's thinking – as if he doesn't have enough logistical hassles and now there's a dog who only understands Silozi!

But what a character mascot Congo turns out to be. He loves the boats, and even at full throttle, jumps from one boat to the other. He's a typical expedition member. No sooner do we stop, than he's into a village, has a fight, steals a bone, chases a bitch and is back on the boat.

Seven days later we arrive at Chavuma. Once described by a colonial official as 'the most remote place in the British empire', Chavuma is the border town between Zambia and Angola. The moment of truth has arrived. Will Jonas Savimbi's UNITA forces allow us to continue upriver? Currently there's a UN-monitored cease-fire in place and I'm desperately hoping that this will allow us a window of opportunity.

We set up camp at the Zambian government resthouse overlooking the thundering Chavuma falls. Bob, a friendly American missionary, and his family invite us up to the mission station on the hill for dinner. Ross and Adrian are delighted as we're about to sit down to another meal of pasta, which they abhor. Surely, they mused, all American missionaries have huge deep freezers? So, with expectations of a massive roast beef with gravy, rice and roast potatoes plus vegetables – and pudding – we pile into the 4x4s for an anticipated gastronomic adventure. After glasses of fresh juice we are finally called through to dinner and shown to our places. Bob, at the head of the table, gives thanks for the food we are about to receive. Sunburnt, unshaven and somewhat scruffy, we sit, heads bowed in prayer and anticipation for the feast ahead. The daughters carry in two steaming tureens of food. There is an expectant hush. The lids are raised. It's … pasta!

Mashozi chokes on her orange juice; Linda gets the giggles; Adrian, with a sick look, says 'None for me, thanks. I had too much lunch!'

'I haven't been across into Angola for twenty years,' says Bob between spoonfuls of pasta. 'Terrible! The war, it's all about politics, greed and diamonds. But the ordinary people suffer so badly. You'll have to get the UNITA rebels on your side. They've got full control over the area you need to go through. You really must be careful, especially because of the landmines. Personally, I think you are crazy to attempt it.'

The pudding is delicious. Ross and Adrian go for seconds.

GEOFFREY BLYTHE'S HOUSEBOAT `BARBELLE ON KARIBA

Livingstone being taken down the Zambezi by Makololo porters

A PAZ SÓ SE FAZ COM AQUE- LES QUE NÃO FODEM FAZER A GUER- RA.

SCENES FROM WAR TORN ANGOLA

Angola – finding a solution

It's Saturday 28th June and we're armed with what we call our 'bullshit file'. We've learned over the years that there is no substitute for good documentation with plenty of colourful stamps and signatures … Mashozi and I take off on an overgrown track to the border 11 km away. We meet with Zambian customs and immigration officials, Mr Masemba and Mr Zuru. They are somewhat suspicious at first but finally buy into the fact that we are crazy enough to be doing the Zambezi River upstream by boat. They offer to escort us over to the UNITA forces who, in their words, 'have to be found in the bush'.

'Angolans do come to the border to buy supplies,' says Mr Zuru. 'They bring diamonds and bush meat with them. Everything in this part of Angola is destroyed – there is nothing. Bridges have been blown up and the area landmined.'

A rusty stop sign tells us we are now in 'No man's land'. Mashozi and I are taken down a footpath and into a mud-plastered African thatched hut. Mr Kabinda, the UNITA commander, is a thin tall man with a strong military presence and a quiet, no-nonsense manner. He has several 'cronies' with him. Through our man from Zambian immigration, who speaks Luvali, we ask to state our case. Everyone listens in hushed silence. I realise that in this thatched hut, here in a remote and hostile corner of Africa, the continuation of our Zambezi/Congo expedition hangs in the balance. After all the effort, imagine failing now …. The question is: will UNITA allow us to travel through Angola?

The UNITA guys go through our documents. I notice that they are more comfortable using the Luvali language; no Portuguese is spoken. A man with a sallow complexion, sunglasses and red beret eyes us with suspicion. They talk amongst themselves. We sit and wait. It's the way of Africa. The stern-faced UNITA commander then explains to us that the entire area we intend to travel through is controlled, not through the Luanda-based government, but firmly by UNITA, and as such he has to get the go-ahead from his headquarters at the riverside town of Cazombo some 150 km upstream.

I feel that we are being fobbed off. We desperately need to find a solution. Mashozi comes to the rescue. 'How would it be', she asks, 'if two UNITA soldiers were to travel with us? We would be prepared to surrender our passports to them under safe armed escort to the UNITA-held headquarters at Cazombo.' They talk again in Luvali – I wish I could understand! Mr Zuru, the Zambian immigration man finally interprets. 'Aah, sir, you are lucky! Two UNITA men will meet you on the river in the morning. Early! On Monday you can go!'

Into the lion's den

We spend the day working out emergency procedures should things go wrong in Angola. Checking and rechecking, we load the boats and prepare for the journey ahead. We also carry some giveaways – cigarettes, lighters, some football magazines, small packets of sugar and salt and, just in case, a wad of US dollars and kwachas hidden in different places. We have to be ready for every possible emergency, which includes taking along Marcus's satellite phone.

With much waving we are finally off. A bit embarrassing, as it takes us about 300 m to get the boat skimming on the plane – just too much load for one boat. As we burn off fuel and eat through our supplies, we will get lighter and things will improve. We don't know what to expect and feel as if we are venturing into the lion's den.

The countryside along the riverbank is absolutely pristine. Virgin Africa like it must have been in precolonial times. We hardly see a person other than a group of five armed men with AK-47s. Heavy woodland is interspersed with wide open grasslands. We do not see any cattle or even a goat but are told that wildlife is plentiful ….

We are on our own. No backup team here! Nothing to fear, though. We've got our UNITA guides with us. Then about 40 km upstream from Caripande we get pulled over by some UNITA heavies who demand that I leave the boat with our two men and follow them to the nearby village of Lumbala Ka Kenge. And so I find myself limping along a bush path (I'd twisted my knee badly in the rapids), being escorted to an unknown village by a gang of mean-looking UNITA rebels. I try to chat but Joseph, our interpreter, tells me to be quiet. In silence we push on through high elephant grass; the path seems to go on forever. Finally we reach the bombed-out village of Lumbala Ka Kenge.

Zambezi house arrest

I'm pushed into a dingy room and ordered to sit down on a lone chair set back against a wall on which is displayed a UNITA flag, with its emblem of a black cockerel heralding a large rising sun. On the opposite bullet-holed wall hangs a stiff, sun-dried leopard skin.

More rebels file into the room. They all sit on the floor in a half-circle, facing me. There's dead silence, and blank faces look up at me suspiciously. I find myself wondering what other sinister interrogations and talk of bush war may have taken place in this eerie room. I hand over my passport and papers. These get passed around. And still … silence!

CONGO THE DOG - CURLED UP NEXT TO THE FIRE IN ANGOLA

Victoria Falls (Mosi-oa-Tunya) as depicted by Thomas Baines

THE PEOPLE LOOK ON IN AMAZEMENT - AND MUTUAL GAWKING TOOK PLACE

Then the questions start: What are we doing on the river? Are we looking for diamonds and do we have guns? Why do I have an opposition MPLA visa from Luanda in my passport? Do I not understand that, here, UNITA is in control? Why had we not come through a better-known borderpost? Why? Why? Why? The questions just keep coming.

I gabble on, hoping that phrases like the Royal Geographical Society of London, South African Department of Foreign Affairs, United Nations and footsteps of David Livingstone will all suitably impress my roommates.

Joseph, I can tell, is as nervous as I am. I'm not sure how well he's interpreting. Our other UNITA man, the normally ebullient Zoze Luis – well, he just sits on the floor with all the others, not saying a bloody word! I get a horrible sickening feeling. What about Ross, Marcus and Mashozi, left behind with the boat? Are they OK? Is this the end of the line for us? Life is cheap out here!

And then something clicks. I can't explain it, but without thinking I take two steps forward, and grab the hand of the UNITA man who appears to be in charge. With a smile I shake his hand repeatedly, in the meantime informing Joseph to tell him that I apologise for such bad manners – I should have greeted him and introduced myself earlier … I can see he's really an important man. I go on to thank him for his kind hospitality and for allowing us to use his beautiful river. Moving from person to person, I greet them all, smiles and handshakes all round. Immediately the tension goes out of the room, and so, Daniel and his rebels escort me back to the boat. I'd been gone for nearly six hours.

Mashozi, I can tell, is really anxious. Ross looks at me with relief. Struggling to control my emotions, I look at him in the eye, wink and nod. He knows the signal and comes forward to shake hands and smile a lot. Marcus digs in the kit for football mags and cigarettes. Congo growls as the UNITA men search the boat for weapons. We're told not to move from here under any circumstances; not until a bush telegraph (a man on a bicycle) has been sent to UNITA at Cazombo.

And so we find ourselves under a sort of Zambezi house arrest as everybody comes down to the riverbank to gawk at us setting up camp. Our every move is watched. Later that night Marcus gets a message out to an emergency UN number on his satellite phone – just a few words from his tent, then it goes dead. It's a long, anxious wait but by the following afternoon things improve when Daniel (the UNITA headman) comes down to camp and presents me with a small UNITA flag. The man with the bicycle has returned, we are free to go, but only as far as Cazombo.

We've never packed up and loaded so quickly. Ross opens the throttle, Congo barks with excitement, Joseph leans over and shakes my hand. 'Mr King,' he says, 'you are lucky that they didn't kill us. Those people are crazy at Lumbala Ka Kenge!' It's a name that we will all remember forever.

Panic stations

Little did we know, however, that we'd sparked off an international incident. In the satellite call that Marcus had made last night to the UN peace-keeping mission in Luanda, he had only got out the words: 'We have a problem with UNITA at Lumbala Ka Kenge; they will not allow the expedition to proceed' before the phone went dead. Together with a totally unrelated Reuters report from Lusaka that 'people had been shot at on the Zambian/Angolan border', panic stations had been the result at the UN offices in Luanda, Luena and Cazombo.

We're only made aware of all this when a massive Sikorski helicopter flies up the river and over our little red boat. We give it a thumbs-up sign and it lands on an open grassy patch beside the river. As the giant rotor blades sigh to a halt, UN soldiers pile out of the whirlybird – four Russians, two Brazilians, one Zimbabwean, a Portuguese pilot, a Malaysian and a Major Sham from Bangladesh, all wearing sunglasses, blue UN berets and an assortment of camouflage gear. What an odd bunch we must look like as we walk through the long grass to meet them with Congo barking at his very first helicopter.

Are we safe? Have we been shot at? How have we been treated by UNITA? Did we realise that this was an extremely sensitive area?

It appears that the interpretation of our message has brought about this high-level UN search party. Relieved to see that we are safe and sound, the peace-keepers pull out their little black point-and-shoot cameras and pose for photographs with our motley band of adventurers, still with the hope of reaching the source of the Zambezi, then on to the Congo and the Atlantic. It seems all so far away.

The UN chopper, after many farewells from its occupants and a fly-past, moves upriver, this time to make absolutely sure that UNITA at Cazombo know that we're on our way. We spend the night on a narrow spit of a clean white sandbank. Just a small open boat, three tents, a fire and a dog. I feel privileged to be here.

Heroes' welcome

It takes us most of the next day to reach Cazombo. The twists and turns in the river seem endless and at times I'm sure that we are doubling the as-the-crow-flies distance. The river is dropping fast and rocks and rapids are now a constant problem. The bush telegraph is obviously working properly with some help from the UN helicopter – but nothing could have prepared us for our heroes' welcome into Cazombo. The entire population seems to have turned out to meet us. Fists are raised in Viva! salutes, some kids have climbed trees so as to get a better view of these crazy oddballs in a boat. One little fellow, an obvious UNITA entry for the

Kebrabassa Gorge – the end of God's Highway

CABORA BASSA GORGE
WHAT A CHALLENGE

Olympic Games, races along the riverbank, keeping up with the boat for several kilometres before a raging bush fire on the northern bank brings the race between boat and man to an end.

We pass under a beautiful stone bridge over the Zambezi built by the Portuguese in the 1950s, but now just a bombed-out monument to colonial bridge-building. At a viewsite overlooking the river, we are met by UN and UNITA officials – and a great surprise. Adrian and Mike had made it through by vehicle. This means we have fuel and supplies with which to complete the Angolan leg. A huge relief!

A new chapter of the adventure is about to begin as we're escorted into Cazombo. We're taken to the bombed-out kitchen of the airport, which has been roofed over with some corrugated iron and serves as the UN base. The UNITA officials, led by Colonel Mulyata, troop in and soon the air is thick with cigarette smoke. Once again, things don't look too good for us. Captain Cruz, the UN chief, reminds me that this is an extremely sensitive time between UNITA and the UN. Our incident has obviously not helped as UNITA has suffered embarrassment through the report of us being 'held captive' at Lumbala Ka Kenge as well as the helicopter rescue bid.

I heavily downplay the Lumbala Ka Kenge incident, explaining the nature of the Zambezi/Congo expedition, and apologise for any confusion. I assure Colonel Mulyata that UNITA will be mentioned in a positive light, explaining that this is the reason Mike is filming the meeting. It works. Colonel Mulyata makes a speech, congratulating us on our achievement, and assures us of UNITA's goodwill. A UNITA pass will give us 'safe passage' through to Jimbe on the Zambian/Angolan border. Everybody cheers and claps, and we are given the freedom of bombed-out Cazombo.

A man is sent out to procure some African chickens – 'road runners' – and within no time nine of these scrawny birds are lined up on the braai grid. Out from the vehicle comes our supply of boxed SA red wine and a bottle or two of the Captain. Soon we're having a great party with our new-found friends. Once the concern for our expedition's safety – and the fact that the UN has spent US$9 000 on our helicopter search mission – have been forgotten, all is well. We will be back on the river tomorrow.

Source of the Zambezi

It wasn't possible to keep a detailed journal for the balance of the journey through Angola for, as the river became narrower and more shallow, so the obstacles to our journey increased. It was all hands on deck for 12 hours a day as we fought our way

over countless rapids, portaged around waterfalls, and pushed and pulled the boat over rocks, fallen trees and stumps. This section of the Zambezi was by far the most difficult. The bends in the river sometimes meant travelling double the planned distance. Then we smashed a gearbox, which Ross repaired from parts he'd retained from the other motor. The relief, when, after eight hours of battling it roared back into life with a pull on the starter rope, was indescribable. The motor cut in some tricky rapids and we got swept downstream at an alarming rate to within metres of the top of a thundering waterfall. We dived overboard. Ross grabbed the boat rope and slowly, metre by metre, we were able to pull the boat to safety.

With all the landmines, how would we have walked out of there? Such have been the horrors of war that the local people, from whom we were often desperate for help, ran terrified into the bush, even throwing themselves out of their canoes into the crocodile-infested river.

Using a black pen, Mashozi ticked off the number of obstacles on the right-hand pontoon – 151 in total. We lost Congo, but there he was at the next bend in the river, swimming out towards the boat. Mashozi screamed a warning as a crocodile slid off the bank. We raced for Congo and pulled him into the boat by the scruff of his neck. Bruised and battered, at 6pm on Wednesday 9th July, we finally arrived at the confluence of the Jimbe and Zambezi rivers. It had taken us eight punishing, back-breaking days to cross Angola.

Ross went off to report to UNITA and the Zambian customs officials. A message was to leave by bicycle at sunrise the following day to inform our land party that we had made it. We ascertained that they were camped at Pete Fisher's farm near the source of the Zambezi. We ate some maizemeal porridge with slices of biltong – the only food we had left. We were completely and utterly exhausted.

The reunion

What a party we have on Thursday 10th July! The land party arrives down a bush path with Zambian bicycles loaded with beer and meat. Dave Gwenca is singing in Zulu, Linda is carrying a bunch of wildflowers, Adrian and Mike are there – they all look so clean! We sleep on the Zambian side of the Jimbe River, tired and battered, with torn hands and feet. We've survived the AK-47s, landmines, crocodiles and rapids, and are back in English-speaking Africa, safe and sound in Zambia. We have made it! It's as if it's all a dream.

But it's not over yet. We tackle the final piece of so-called navigable river. Marcus gets swept down a rapid and nearly drowns. There is more pushing and pulling and cutting through trees that have fallen across the Zambezi. Bridges built out of sticks, vines and creepers allow the smiling, waving, friendly Zambian

villagers to cross overhead – so different from Angola! Finally, the boat *Livingstone*, leaking air from countless holes, is hauled out of the Zambezi for the last time.

On Sunday 13th July we walk through thick miombo woodland until we reach a small spring of crystal-clear water gurgling and bubbling out of the ground, between the roots of the high trees that form a canopy overhead. The faces of the expedition team are reflected in the pool as, one at a time, we stoop to drink from the source of the Zambezi. I uncork the Zulu calabash and empty the Indian Ocean water taken from Chinde into the source of Livingstone's River of God.

We are overjoyed. Conquering the Zambezi has been an incredible challenge. We're not, after all, a bunch of gung-ho commanders. Just an ordinary family, friends and a dog.

And still lying ahead, is the Congo.

Henry Morton Stanley –
Bula Matari (the Breaker of Rocks)

Chapter III

A Journey down the Congo

Into the Heart of Darkness

Being the Narrative of the Slow Sweat of the
Congo River – Following Stanley's Treacherous journey – The
Lady Alice – Cataracts and boiling Rapids – Fights with Cannibals – Interrogations
by the Military & house Arrest – Tippu Tip the Slaver – Dugouts and
Tugboats – live Crocodiles and smoked Chimpanzees

The whole Replete with
Historic plates, Maps and extracts from the
Journals of Henry Morton Stanley

A letter from a white man

Boma on the Congo estuary was one of those middle-of-nowhere frontier-type places where, from a handful of box-like corrugated-iron-roofed houses, about 20 white traders sweated out the heat and malaria on the north bank of Africa's longest river. There were no women and some of the traders had taken African mistresses along with them. The men traded pots and pans, trinkets, cotton, gin and guns from Europe for ivory, palm oil and ground nuts brought to them by African middlemen.

It was a little after sunset on the 5th August 1877 that four emaciated, starving Swahili dressed in rags handed over a strange-looking letter to two European merchants at the trading station at Boma. The elder merchant, a Portuguese called da Motta Veiga, was puzzled and put on his spectacles to read it.

Upstream, the broad yellow-brown Congo River was blocked by impassable cataracts, beyond which were the vast unknown jungles of the Congo basin. Da Motta Veiga questioned the Swahili-speaking Zanzibaris, who confirmed the incredible story. The letter brought from the village of Nsande, two days' journey upriver, had been sent by a white man. It was written in English.

To any gentleman who speaks English at Embomma [Boma].

Dear Sir,

I have arrived at this place from Zanzibar with 115 souls, men, women and children. We are now in a state of imminent starvation.

I do not know you; but I am told there is an Englishman at Embomma, and as you are a Christian and a gentleman, I beg you not to disregard my request …. The supplies must arrive within two days, or I may have a fearful time of it among the dying.

Yours sincerely,

H.M. Stanley,
Commanding Anglo-American Expedition
For Exploration of Africa.

PS: You may not know me by name; I therefore add, I am the person that discovered Livingstone in 1871.

In answer to Henry Morton Stanley's cry for help, da Motta Veiga sent out a string of porters at first light. For the Swahili, they carried two sacks of potatoes, four sacks of rice, tobacco, three large bundles of fish, five gallons of rum, rolls of cotton; for Stanley, sundries included sugar, tea, bread, sardines, salmon, plum pudding, English shag [tobacco] and cigarette paper, three bottles of India Pale-Ale, and even some champagne.

A couple of days later, hearing that Stanley was now approaching Boma, da Motta Veiga and four other Europeans, including a visiting British sea captain, set off in their Sunday best. Their path led up through the high elephant grass, past twisted baobab trees, towards the rocky ridge that overlooks the Congo estuary.

Their meeting in the wilds of Africa must have had something of the same sense of drama and absurdity as the meeting between Stanley and Livingstone at Ujiji six years prior, when Stanley had immortalised those words, 'Dr Livingstone, I presume?' However, this time, it was Stanley who stared unbelievingly at the strange pale faces of his rescuers. They were the first white men he'd seen in well over a year.

Stanley was on the verge of collapsing. When his men began to sing a victory chant, he broke down and wept. Despite his feeble protests that he was strong enough to walk, he was loaded onto a hammock, and like a triumphant hero, carried back to Boma.

It was the 7 088th mile and the 999th day since Stanley had left Zanzibar. He'd circled the Great Lakes and proved that the Lualaba was the Congo. But the cost in suffering and loss of life was enormous. Frank Pocock, the last survivor of his three white companions, had drowned on 3 June in one of the gigantic lower falls. Stanley had sailed from Zanzibar with over 250 men, women and children. Only 108 (including 13 women and six children) had survived. The balance had either died or deserted – 14 drowned, 38 killed in battle, and 62 dead of starvation, dysentery and the hardships of the journey.

Stanley, known as *Bula Matari* – 'smasher of rocks' – was reduced to a bundle of bones. His incredible journey across Africa had turned his hair white and he was riddled with fever.

Devil's byway on God's highway

This great Victorian explorer was the first European to have succeeded in a journey down the great Congo River. Now, 122 years later, it is our turn to tackle the Congo's heart of darkness. A friend suggests that our east–west journey across Africa, up the Zambezi and down the Congo, should be called 'God's highway, Devil's byway'. God's highway because of Dr Livingstone's missionary work on the Zambezi; Devil's byway because of the terrible Congo atrocities that had begun

with the slave trade, then the shootings and killings that had accompanied Stanley's expedition, followed by King Leopold of Belgium's brutal rule of the Congo as his personal domain. During this timē, the Belgian traders in his employ would cut off the hands of African villagers if they failed to collect sufficient wild rubber for the trading stations. News of these and other horrific atrocities finally forced King Leopold to hand over authority to the Belgian government.

After 50 years of colonial rule, the transition to independence in the early 1960s was a disaster that led to riots and a bloody coup. The Belgians (those who weren't murdered) were shipped or airlifted back to Europe, others fled across the border to neighbouring countries. The UN, French and Belgian paratroopers, mercenaries and blood-thirsty Simba rebels all played a role. Popular leader Patrice Lumumba was murdered by his adversaries and, in 1965, a powerful army commander, Mobutu (born Joseph Désiré), seized power in a military coup. Calling himself Mobuto Sese Seko, he set himself up as a cult figure, built a personal palace in the jungle and declared himself president for life. Posters appeared everywhere, extolling his virtues as the perfect African leader, and anyone with any caution kept his mouth firmly shut. Nurtured by the CIA, Mobutu deftly courted France and the USA, who used Zaïre as a launching pad for covert operations against bordering countries, particularly Marxist Angola.

It couldn't last forever. With the help of foreign assistance, Mobutu had to fight off two major coups – and inflation that ran up to 1 000 per cent. In late September 1991, in protest against low pay, a few hundred paratroopers ransacked Kinshasa. The riot quickly spread to other cities, and France and Belgium had to fly in troops to evacuate their citizens.

In 1993, there were further riots that left buildings and businesses trashed and looted. Mobutu's disastrous policies drove his country to economic collapse – while he siphoned off millions of dollars for himself and his family.

A new democratic republic

Our latest news from 'Zaïre' is that the rebel leader, Laurent Kabila, has, with his revolutionary forces, ousted Mobutu Sese Seko's corrupt regime. Kabila's army, made up mostly of Tutsis from Rwanda, together with dangerous boy-soldiers, have an uneasy hold over the new Démocratique République de Congo.

We hastily remove the word 'Zaïre' from all our earlier expedition documentation, and from vehicles and boats, as our modern-day expedition heads northeast from the source of the Zambezi towards the Zambian copper belt.

Congo, our adopted dog, gets carsick and pukes all over Ross. Linda has tearfully flown back to Australia. Dave Gwenca and Adrian Verduyn are still with

'Dr Livingstone, I presume?' – the famous meeting between Livingstone and Stanley

us, as is Mike Yelseth, the cameraman taking pictures for *National Geographic*, and the very British Marcus Wilson-Smith.

There is a strong military presence at the Zambian border at Kasumbulesa. Groups of Congo refugees with sad-eyed children are camped out alongside the road under tattered UN blue-plastic tarpaulins. The Zambian exit stamp is banged down with a flourish, and with boozy breath and a broad smile, the customs man asks, 'You've got something small for me?' A few cigarettes and the last of the football magazines change hands. 'Have a good journey!' he shouts. We hide the dog, the boom is raised and the metal shark's-teeth road spikes are pulled aside. Our two expedition vehicles, now branded *Zambezi / Congo Expedition* and overloaded with inflatable boats and supplies, trundle down the stretch of no-man's-land towards the border. The new visas in our passports now read: Démocratique République de Congo. Mobutu Sese Seko's old Zaïre is no longer – and we don't know what the hell to expect.

With an explosion of shouts in French and Swahili, things go wrong from the very beginning. No sooner do we stop at the border, then Mike's video camera is grabbed by a tall Tutsi fighter in camouflage and cowboy hat. Heavily armed boy-soldiers with glazed looks, grenades and knives hanging from their belts, AKs at the ready, march Mike away to a bullet-holed office. It appears he had been observed sneaking off a few video shots. Bad, bad timing.

Five hours later, after a complete search of the vehicles, much explaining and even papers for Congo the dog (whose name we've suddenly changed to Puppy), we are free to go. It appears the authorities are paranoid about mercenaries.

With our green 4x4s and somewhat unkempt looks, did we look like fighters – family Holgate, complete with dog? I doubted it.

Driving on the opposite side of the road (bloody colonial Belgians!), we dodge the potholes down to Lubumbashi – the old Elizabethville – and second largest city in the DRC. Behind us, hooting loudly to pass, is a battered saloon car – no windscreen or back window. The cowboy from the border is in the driver's seat, one of the boy-soldiers is sitting warlord-style in the passenger window, legs inside the vehicle, body out. He waves his AK-47 as they rattle past. Squashed in the back seat are kids in camouflage with sunglassed faces, cigarette smoke and guns.

We've been told to report to military security in town. By tomorrow we hope to be free of Lubumbashi's officialdom and off down to the headwaters of the Congo River near Kolwezi, from where we hope to commence our long journey down the Lualaba and Congo rivers.

Strange, when you think of it, this narrow Central African divide that separates the sources of two great African rivers. A drop of rain that falls on the southern side of the divide will travel by way of the Zambezi over the Victoria Falls to the coral-clad shores of the Indian Ocean, whereas on the northern side, a raindrop

from the same thunderstorm will make its way down the Lualaba and Congo, through the equatorial jungles of the Congo basin, looping twice across the Equator to finally arrive on the cold Atlantic coast.

Feeling somewhat gung-ho from the success of our mouth-to-source Zambezi journey, we can't wait to be on the water again, and our excited conversation is filled with imaginings and planned logistics for the journey ahead.

Lubumbashi house arrest

But it's not to be as, once again, we're taught the lesson that it is Africa who owns the time. Military security in Lubumbashi refuses to give us permission to continue, and we are placed under house arrest at the old Hotel du Shaba, now known as the Katanga Hotel, until they can get the go-ahead from their bosses in Kinshasa.

Frank, the young Belgian owner-manager, makes us as comfortable as possible – Mashozi and I in one shabby room, the lads in the other. 'Be careful not to let your dog run out in the streets,' says Frank. 'It'll get eaten.'

The military, he tells us, have taken over his hotel to billet their young Tutsi soldiers. 'They've been here for two months and haven't paid me a cent. I'm sorry I can't offer you much. I've even closed the kitchen.'

Kabila's soldiers certainly have taken over the hotel. Most of them are young Tutsis from Rwanda. Armed to the teeth, they're called the 'magic boys'. Some of them are as young as 12 to 14 years, many of them street children who have been press-ganged into the army. Ross speaks to them in Swahili, we send out for Cokes and Simba beer, and soon they're no longer the enemy. They even escort us round to Nick the Greek's Taverna for great flat chicken and chips. They stand guard outside, then escort us back to our 'barracks'.

It's difficult to sleep. The music blares, the boys who won the war are celebrating; there is a constant stream of young girls to their rooms – and always, the rat-tat-tat of automatic fire. Such is the way of victorious troops – but what makes this particular situation so different is that these lads are only teenagers who have played already with life and death.

The magic boys

We hear all the stories: marches on foot of up to 100 km a day, indoctrination camps in the bush, good-luck charms and magic spells that are placed on them. Magic that helped them win the war, that had full-grown men in the former Mobutu forces throwing down their weapons and running for their lives.

In the Heart of Darkness

One pleasant young guy tells us of how he had been taken from a park in Kinshasa at seven years old. He had been press-ganged into fighting for UNITA in Angola, and finally ended up training in Burundi to become a commander in Laurent Kabila's army. Struggling with a stutter but with a serious look he says, 'I live by the gun and will die by the gun.'

We invite Father David Mahoney from the Catholic mission for a few drinks. 'I was here in Lubumbashi when it was liberated,' he tells us in his Irish accent. 'Mobutu's forces finally dug in at the airport, but as the fight got closer, the officers deserted and flew to Kinshasa, leaving their men to be massacred. I saw the bodies being carried in the backs of trucks. It was strange,' he continues, between sips of cheap red wine, 'there wasn't much shooting here in town. The young troops marched in single file, led by a witch doctor wearing traditional cloth. On her head she carried a covered pot of magic charms for the "magic boys" who defeated Mobutu. It was as if Mobutu's forces had lost their will to fight.'

Every day I go down to security, but still no news from Kinshasa. Still they won't let us move. Away from prying eyes, we go up the fire escape to the flat roof of the hotel and use our satellite phone to contact the South African Embassy in Kinshasa. They promise to try to sort things out from their end. One of the magic boys gets drunk and threatens us, waving a flare pistol under our noses. His two friends apologise and drag him outside. Next day we hear that they've shot him.

While in Lubumbashi, we hear rumours of the killing of Hutu refugees on a massive scale by Kabila's Tutsi forces. One man tells us how, when the Hutus tried to escape across the river, they were massacred in their hundreds. Dugout canoes were shot up and sank; many refugees, including women and children, could not swim. They drowned and were swept down the river. This does not augur well for our expedition, as these massacres are said to have taken place on the river south of Kindu and around Kisangani.

With the Rwandan genocide of the Hutus by the Tutsis still fresh in people's minds, the UN Human Rights Organization sends a delegation to the river. Laurent Kabila stymies their investigations, journalists and UN officials are kicked out and the area is closed down to foreigners. What bloody chance do we have now? Already we are being viewed with suspicion. Is our expedition just a cover-up to investigate the atrocities which seem to be a way of life in this part of Africa?

Stanley's Lualaba

During Henry Morton Stanley's 40-day march from Lake Tanganyika to the Lualaba, he, like Livingstone, was sickened by what he saw: a caravan of over a thousand slaves, mainly women and children, in an appalling state from lack of food.

Stanley recorded the following words:

> *The surviving children were in a condition ill-resembling humanity. The chests jutted out with the protuberance of a skeleton frame, while the poor bellies were in such a fearfully attenuated state, like an empty bladder; ribs and bones glared out; legs were mere sticks of bone, resembling weak supports to the large head and large chest …. The elders were in chains, but the number was so great that heavy bark cords had been made, to which the slaves were strung by the neck a few foot apart. Even children a few years old were subjected to the same treatment, probably because it was easier to count the list by gangs than one by one. Many of the older males were quite new to this servile treatment, as was evinced by downcast heads and abashed faces when strangers looked at them.*

Stanley reached the majestic Lualaba on the 17th October 1876. He was amazed by its size. Nearly a mile wide and pale grey, he wrote that it was 'like the Mississippi, before the full-volumed Missouri pours its rusty brown waters into it'. Ten days later he arrived at the Swahili trading post of Nyangwe, the furthest point down the Lualaba yet reached by any European. It was here, in July 1871, that Livingstone had witnessed the massacre of hundreds of defenceless Africans by Arab slave traders – women and children hunted down and shot through the heads as they tried to swim for cover.

Five years later, Stanley noted:

> *… the natives are regarded by the slavers and their African mercenaries as if they were cattle, to be left to graze until required for the slaughter house.*

Tippu Tip

Morton Stanley was outraged and blamed the despicable trade on the inability of the Sultan Barghash of Zanzibar to adhere to the recent anti-slavery pact between Zanzibar and Britain. Even with his hatred for slavery, however, Stanley realised that if he were to succeed in a journey down the river, he would have to have the slave traders on his side.

And so he struck a deal with Hamed bin Muhammed, the most adventurous and ruthless of all the Zanzibari merchant warlords. Known to all as Tippu Tip,

THE SLOW SWEAT
OF THE CONGO RIVER

~ ABOARD THE M.B. NANCY ~
THE SLOW SWEAT OF THE
CONGO BECOMES A NIGHTMARE
OF INTERROGATION, SUSPICION
AND AK 47'S

RIVER

Tippu Tip

he was considered the greatest slaver in East and Central Africa. For the sum
of US$5 000, Tippu Tip agreed to escort Stanley, together with 140 men armed
with guns and spears, on condition that he be permitted to return after 60 days of
marching beyond Nyangwe.

Their combined caravan of 700-strong wound out of Nyangwe on the
5th November 1876. All went well until they were swallowed by a black curving
wall of rainforest. They had been in forests before, but nothing as thick as this, and
the human caravan had to burrow through the jungle like wild animals. Stanley
recorded that they had 'a fearful time of it, crawling, scrambling, tearing through
the damp dark jungles'.

After 11 days, Tippu Tip threatened to abandon the expedition. 'I never was
in this forest before and had no idea there was such a place in the world,' he told
Stanley. 'The air is killing my people, it is insufferable. You will kill your own people
if you go on.'

Stanley begged and pleaded, and Tippu Tip agreed to accompany him for 20
more marches. Morale was dropping, so Stanley decided to call his men together.
He told them:

> 'This great river has flowed on thus since the beginning, through the dark
> wild lands before us, and no man, either white or black, knows whither it
> flows; but I tell you solemnly that I believe the one God has willed it that
> this year it shall be opened throughout its whole length and become known
> to all the world … I am not going to leave this river until I reach the sea.'

Stanley wrote later that his words had an electrifying effect on the younger of
his men, who called out, 'Inshallah, master, we will follow you and reach the sea.'

But the older men could not hide their misgivings and 'shook their heads gravely'.

The Lady Alice

The men carrying the dismantled boat, *Lady Alice*, were the worst off, for the sections
'had to be driven like blunted ploughs through the depths of foliage'. Stanley had
called his boat the *Lady Alice* after the enchanting 17-year-old American, Alice Pike,
with whom, shortly before leaving London, he had fallen head over heels in love. She
had given him her photograph, which he kept wrapped in silk in his breast pocket.
The wedding date had been fixed for 14 January 1877. Stanley realised that he wouldn't
make it in time, and the delays made him miserable and impatient with his followers.
But the thought of her drew him like a magic charm, onwards down the Congo
(assuming, of course, that the Lualaba was the Congo), to the Atlantic and Alice.

The horrors of the slave trade

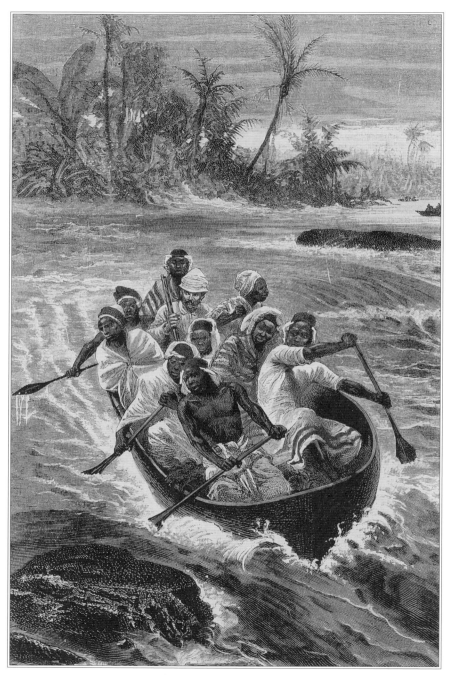

Conquering Stanley Falls

In his last letter to her from Ujiji, he'd written:

You are my dream, my stay and my hope, and believe that I shall still cherish you in this light until I meet you, or death meets me.

By mid-December, the expedition was in tatters, depleted by dysentery, smallpox and typhoid. Many of Tippu Tip's party had expired, including three of the favourite girls from his harem. On 19th December, at a village called Vinya-njara, their camp was attacked by over 1 000 tribesmen. Stanley put his Snider rifles to good use and they were beaten off. Four of Stanley's men were killed and 13 wounded. Tippu Tip had had enough and announced that he was leaving.

On Christmas day, Stanley held farewell games, which included canoe races and a 300 yd sprint between Tippu Tip and Frank Pocock, Stanley's only surviving white companion. Tippu Tip won the silver cup by 15 yd.

On December the 28th, the expedition waved goodbye to Tippu Tip and the Wanyamwezi (the people of the east coast) and rowed away downriver. Most of Stanley's party were weeping, convinced that they would never see Zanzibar again. Had they have known what lay ahead, few, if any of them, would have continued. For months, they battled cannibals, starvation, disease and the rigours of the river. Day after day, they fought for their lives, surviving only because of Stanley's Sniders. As fearful as the drums and war cries of the attacking cannibals, was the roar of the cataracts.

Stanley Falls and Kisangani

The preceding months have been a disaster. Stuck in Lubumbashi, I'd finally got permission to fly to Kinshasa where, after a lecture on the evils of colonisation and the west, the expedition had been turned down flat by the head of security.

'Mr Holgate,' he said, 'our country is still at war and it is simply too dangerous.'

I think his real concern was all those shallow Hutu graves on the banks of the river. And so, terribly disappointed, we'd taken the long road home – out through the Congo pedicle (a finger of land thrusting into the centre of Zambia) and on to the source of the Luapula River where it flows out of Lake Bangweulu in the Lake Districts of northern Zambia, not far from where Livingstone's heart lies buried. Later, the same river becomes the Lualaba, and then the Congo.

In Johannesburg, friends gladly adopted Congo the dog, who took an instant shine to their Rhodesian ridgeback bitch. I hear he's sired a litter of eight pups, which were immediately adopted into good homes as genuine Nguni expedition dogs.

Somehow, despite Mashozi suggesting that I laugh the whole Congo thing off, I'm restless and just can't let go. Acting on a tip-off from a friend at the embassy in Kinshasa, I find myself waiting in the reception area of the Intercontinental Hotel in Sandton, Johannesburg. A bodyguard frisks me and I am escorted up to the sixth floor to meet Mr Didier Kazadi Nyembe, right-hand man to President Laurent Kabila of the DRC. He's a tough ex-bush fighter who's spent 30 years in exile in Tanzania – and he heard about our attempt to follow Stanley's journey down the Congo River.

'Come back to Kinshasa, Mr Holgate,' he says as we sip a few Castles up in the Gazebo Bar. 'Things are quieter now and you will get your permission.'

So I'd flown to Kinshasa on my own, but, finally, all I got was a letter of introduction from the Minister of Tourism. It was a start, and three weeks later, here we are at Stanley Falls.

I sit on a rock, my feet dangling in the Congo River, looking out over the boiling rapids and cataracts of the falls. From rickety scaffolding lashed together with vines, near-naked Wagenia fishermen use monkey ropes to hang huge, woven, conical fishtraps into the raging rapids below. With me are Mashozi, Ross and Marcus. Time had run out for the others.

Now we have no boats or vehicles. Just whatever we can carry on our backs: a few small tents, sleeping bags, a couple of changes of clothing, a small medical kit, letters of introduction, camera equipment, some cash dollars, plus a sat-phone, a notebook and a blind sense of optimism. The local Wagenia are delighted. They haven't seen a foreign visitor at the Stanley Falls in months. They dance, and there's a wrestling match in the village square. Dugouts crisscross the river and we have to shout above the roar of the water.

Then there's the market at Tshopo: hundreds of dugout canoes, smoked fish, crocodiles, snails, monkeys, homemade peanut butter and secondhand clothes. The colour of it all! Women turn out traditional clothing on old sewing machines – it's all so fascinating. To ward off the equatorial sun, I purchase a traditionally woven wide-brimmed hat. I imagine the *Lady Alice* floating past, Stanley in his pith helmet, the silk-wrapped picture buttoned down in his top pocket, the Zanzibaris with their guns.

Conquering the falls

On 6th January, Stanley's expedition came across a chain of boiling cataracts and rapids that were to disrupt the river for the next 50 miles. Stanley named them after himself, and despite the Africanisation of place names, they remain the Stanley Falls. It took them nearly a month to traverse this treacherous piece of river. Boats

had to be hauled out of the water and paths cut through the forest. Apart from the *Lady Alice*, many of the dugout canoes they were using were over 50 ft long and enormously heavy. They hauled them with cables made from forest vines, very often fighting off attacking tribesmen at the same time.

The 11th January, in Stanley's words, was a 'terribly trying day'. One of Stanley's men drowned when a canoe capsized. Another was smashed by rocks in the same rapids, and a crewman by the name of Zaidi only saved himself by desperately clinging to a rock that jutted out of the water at the very lip of a ferocious waterfall. A rattan cable was attached to a canoe, floated out to the stranded man, but the cable snapped 'like pack thread' and the canoe disappeared downstream.

A second canoe, secured with three cables made of rattan and tent rope, was rowed out by three volunteers towards the stranded Zaidi. Seven attempts were made before they got close enough to throw him a line. But in grabbing it, he slipped from the rock and vanished over the lip of the falls. For half a minute there was no sign of him, then, slowly, his head appeared as he pulled himself back over the edge. 'Pull away!' screamed Stanley, but as the men hauled the canoe towards the shore, the cables snapped one by one. Fortunately the men, dragging Zaidi behind them, managed to reach a small island in the middle of the river, where they had to spend the night.

At first light a group of armed men were sent out into the forest to cut more creepers. Three cables were made, and using a whipcord and a stone, the new cables were floated out to the island and made fast. One at a time and with fervent prayers to Allah, the men pulled themselves through the wild whitewater back to the safety of the riverbank. But as Stanley's diaries disclose, their troubles were far from over:

> *January 2: The Wenya planned to attack us by two points … while our working parties were scattered over a length of two miles dragging heavy canoes over the rock terraces. Thirteen guns and a few successful well placed shots sent them flying.*

> *January 29: Today we have had three fights …. In the last … Muftah Rufigi of the Mgindo was killed by a desperate savage who attacked him with a knife 18 inches long which cut him on the head, almost severed the right arm from the shoulder, and then was buried up to the hilt in his chest.*

> *January 30: We were assaulted in the most determined manner by the natives of the populous Yangambi …. They were the bravest we met.*

After the expedition made it through the seventh and last cataract, the river swung to the west, beginning the enormous bend towards the Atlantic, so ruling out Livingstone's belief that the Lualaba River flowed north to become the Nile. Stanley noted that the local natives referred to the river as Ikuta Yacongo. The Lualaba had now become the great Congo River. His belief had proved correct.

Mr Impossible Botongolongo

After their terrible battle to get round Stanley Falls, they must have launched their boats near here, back into the wide, open river. The rainy season is upon us and the river races broad and full down towards Kisangani, where we're holed up under military guard in the old Stanleyville Hotel, waiting for a Congo River barge to carry us downstream in the footsteps of Stanley.

Not quite how we'd imagined it, but nevertheless a great adventure. Henry points at his watch and picks up his AK-47. 'Pappa King,' says François Chikala, 'it's time to go.' We've become friends with our military guard, Henry. He likes Primus beer. Our translator is a little man called François – an ex-welterweight boxing champion who speaks English with an American accent.

In Kisangani, the local military commander, a tall Tutsi from Rwanda complete with cowboy hat, sunglasses, camouflage and riding boots, is extremely suspicious of us, convinced that we have come to spy and take photographs of the nearby Hutu killing fields. If he had his way, I think he would lock us up and throw the keys into the Congo River. It's just the paperwork that saves us (letters from the South African embassy, Ministry of Tourism and our normal file of newspaper and magazine clippings, all endorsed with our own large red-and-black Zambezi Congo Official rubber stamp. A must when travelling in Africa.

Apart from Henry, the armed guard who never lets us out of his sight, we now have another man foisted on us, this time from the Department of Information. His name is Merland Botongolongo. We call him Mr Impossible. He watches our every move.

May we take dugouts down the river? No, impossible! Spend a few days in the equatorial jungle while we wait for the next riverboat? No, impossible! May we cross the river to the other side, taking the dugout ferry boats that everybody uses? You can guess the answer. It's bloody impossible!

We do not allow all this officialdom to dampen our spirits as, day after day, we hang on in Kisangani, waiting for some form of local riverboat transport to take us downstream to Mbandaka and Kinshasa, a distance of approximately 1 700 km down the Congo River.

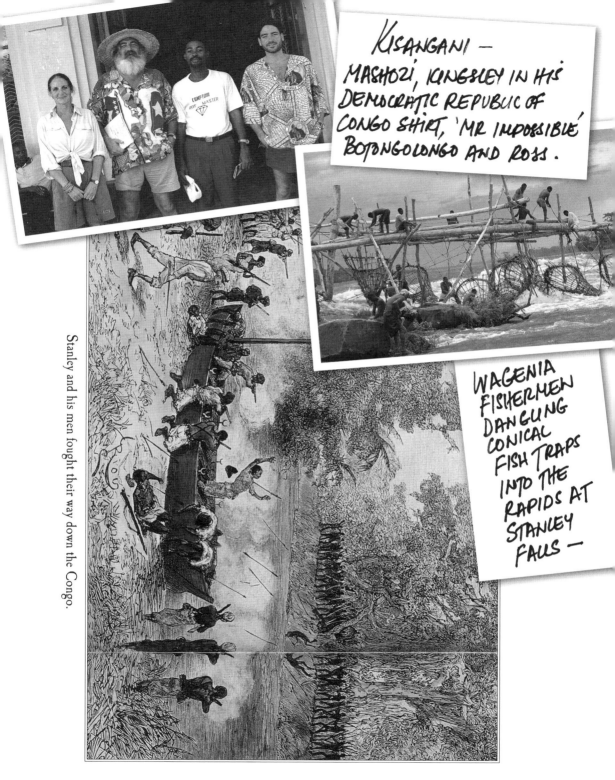

Stanley and his men fought their way down the Congo.

In every situation, however bad, one seems to meet good people. In Kisangani, we get adopted by a colourful Asian trader by the name of Fazal, who we nickname *Songolo*, the call sign he uses on his HF radio. Initially, we'd stayed in his flat above Beltexco Wholesalers, where they sold everything from fish hooks to plastic buckets, and where money was weighed in big bales, millions of Zaïrean notes worth only a few dollars. Then the military moved us and kept us under surveillance at the old Stanleyville Hotel (South African mercenaries hung out here in the 1960s). Here, antique ceiling fans still turn slowly over the old dance floor, but now there is no menu, no beer in the bar and the rooms are filthy. The veranda overlooks a palm-lined boulevard. Touts try to sell us diamonds, emeralds and antique masks. It's incredibly hot and humid, and at night the mosquitoes and bugs attack us with a vengeance!

Kisangani has over 3 000 bicycle-taxis. Decorated with colourful plastic flowers, bells and reflectors, they are called *tolekas* and we use them as daily transport wherever we go. Sometimes I feel guilty, but the *toleka* owners need the money and love the association as they pedal my large frame to the market, the docks, the Greek club (the only place with decent grub), and always back to the docks again for news of the next boat.

A cement monument at the town centre commemorates the Simba massacres of 1962, displaying the letters MPR (Mouvement Populaire de la Révolution). The once elegant Hôtel des Chutes now serves Primus beer only in bottles. No doubt the glasses have gone up into the rooms where the local 'ladies of the night' do a roaring trade with the visiting Tutsi military. An array of interesting underwear hangs from their balconies, and with shouts of laughter, we're invited to come and visit.

Big Mama and Shakespeare

Known during the Belgian era as Stanleyville, this town was a European show place with cinemas, theatres, restaurants and cafés. White-uniformed *gendarmes* directed the traffic along tarmac'ed boulevards lined with trees. The crumbling homes of the Belgian civil servants and the ruined mansions of the elite still stand along the Congo River, as do the old colonial buildings and goods sheds that once catered to this busy, well-run river port. It was from here that the Belgians had fled when the savagery of the Simba fighters was unleashed, taking with them only what they could carry. Those who remained are buried in the cemetery behind the yacht club. The tombstones carry messages in French, Belgian, Greek, Italian and Zaïrean. On the edge of the cemetery lies the collective grave of the slaughtered priests and nuns.

Sitting in the shade of a large flamboyant tree, overlooking Stanley's Congo River, I struggle to come to grips with all this bloodshed and savagery. The ordinary people we meet are wonderfully friendly: the women in the markets selling giant snails and coconut wine, the young men who pedal us around on their bicycle-taxis, Henry, our armed guard, Philippe, the helpful little manager at the hotel. So with all these good people around, where did this savagery begin?

I think of the horrors of the slave trade, which led to Stanley's expedition being constantly attacked as they fought for their lives, also shooting and killing, as they came down the river. Then came the atrocities of King Leopold's Congo 'free' state, the severing of hands, the senseless beatings and killings – perpetuated, it seems, by the savagery of Mobutu's coming to power, the riots and pillaging, and now the unease with which the locals accept Kabila's new government. The initial euphoria is over, and it all seems like another form of colonialism, this time enforced by Rwandan-trained troops from outside. To make matters worse, there's the greed – diamonds, copper, cobalt and gold – as corrupt politicians battle to secure it all for themselves.

It's no wonder that, in 1890, Joseph Conrad's visits to Kisangani and the Stanleyville Falls river station inspired his book *Heart of Darkness*.

The British consul, François Seneque, invites us for drinks. He's a colourful old character who believes that the only way to survive malaria is with regular doses of scotch. His English, spoken with a French accent, is peppered with colloquialisms like 'old chap', 'jolly good' and 'damned shame'. Very British. He'd been awarded the OBE for his services to the British expatriate population during Mobutu's pillaging.

'It was a damned shame,' he says. 'The army just walked in and took everything. Then came the masses, who even lifted the fitted carpets, light fittings and plugs off the bloody wall. Frightful! They even shot my dog. There was nothing we could do, old chap. One fellow, a Scotsman, got dressed up in his kilt and stood outside playing his bagpipes while they took everything. Another poor fellow went to the market to find his valuable works of Shakespeare all piled up next to a big mama, who was tearing out one page at a time to make a paper cone for selling ground nuts. Shocking! Scotch, anyone? Are you taking any bush babes on the boat with you? The girls are lovely here, you know. Very willing. They make excellent cooks.'

The floating market

Finally, we find a place on board the tugboat *Nancy*, which is pushing two massive barges, one carrying hardwood timber raped from the primeval equatorial forests of the Congo basin, the other for passengers. We are the first official group of

foreigners to make the journey since the liberation of the country by Kabila's forces. We've been waiting 12 days for the boat to leave, but the docks have been without electricity, which has meant that the antique crane was not able to load the timber. In the end, a generator was brought in on the back of a lorry and the timber was loaded. We're all aboard, after final goodbyes to the officials who are certainly glad to see the back of us, especially Merland, the Impossible Botongolongo. We pitch two tents behind the wheelhouse of the tugboat, and soon we're off, delighted at last to be on the river.

Hundreds of passengers quickly erect makeshift shelters from old UNHCR tarpaulin, propped up with bamboo poles. Most of them are regulars who spend their lives travelling up and down the great Congo River in whatever transport they can find. They're traders, selling and bartering as they go. Aunts, uncles and tiny babies; chickens, ducks and goats; cooking pots, charcoal and bedding; it's home away from home. With a wail of the klaxon, the MB *Nancy* belches a big black cloud of diesel smoke and we leave Kisangani for the 1 700 km journey downriver to Kinshasa.

Another adventure has begun as our 'floating market' makes its way somewhat erratically downriver. There's no fixed timetable; hours run into days on the timeless Congo. The equatorial heat beats down, Mashozi's medical kit treats malaria and tropical ulcers formed by bites gone septic. Heat, sweat and endless noise from the engine room make sleep almost impossible.

Catching a trading vessel down the Congo must still be one of the most fascinating river adventures in the world, energetically engaged in by the people of Africa with their ability to adapt, trade and survive. A large mama – her name is Josephine – spends her days making tasty doughnuts cooked in palm-nut oil. We visit her each morning for breakfast.

A noisy *padre* has mustered a colourful congregation of crew, traders, travellers, drunks and prostitutes – all of whom, each morning and evening, pray for Godspeed on the river. These church services turn into a carnival event, with much vibrant drumming, singing, hand-clapping, and dancing. This evening, the *padre* speaks in tongues; a woman becomes so affected by the spirits, she barks like a dog

Full moon, a broad river; tall dark equatorial forests and magnificent orange sunsets; villages with huts built on stilts over the water; old derelict trading posts with red, rusty corrugated-iron roofs dating back to King Leopold and the old Belgian Congo. We are in another world.

On the barge, people trade and barter. There is everything imaginable: dried fish; palm wine; smoked monkeys and chimpanzees, with clenched teeth and human-like hands frozen in death and blackened by smoke; live and smoked crocodiles, jaws bound with creepers, legs tied over their backs; pens of goats, pigs, chickens;

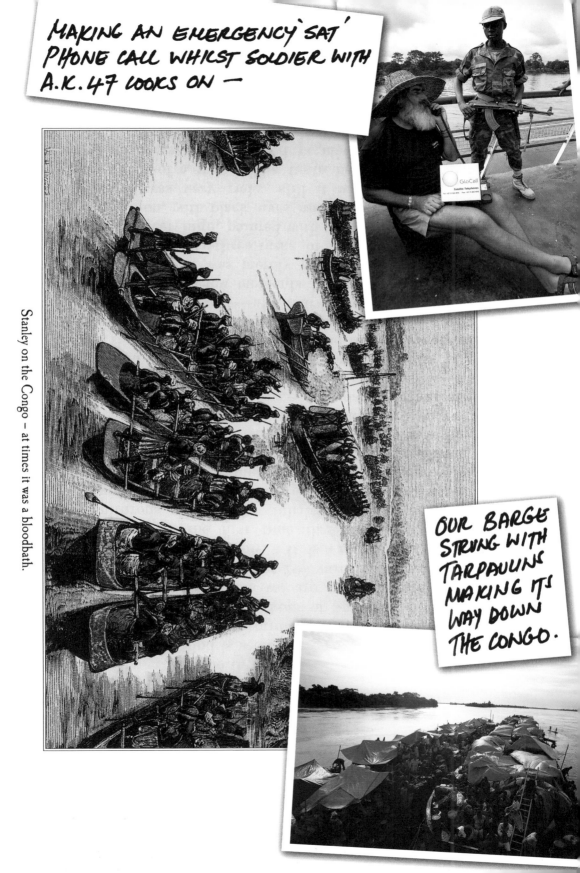

MAKING AN EMERGENCY 'SAT' PHONE CALL WHILST SOLDIER WITH A.K.47 LOOKS ON —

Stanley on the Congo – at times it was a bloodbath.

OUR BARGE STRUNG WITH TARPAULINS MAKING ITS WAY DOWN THE CONGO.

bundles of pineapples, green and yellow bananas, cassava raw and cooked. It's a noisy, floating, smoke-belching supermarket. Colourful cloth, woven baskets, hand-carved chairs. Flying ants, cutworms and snakes are exchanged for plastic buckets, fish hooks, expired medicines and secondhand clothes. At the sound of the old diesel engines, the local villagers come paddling out from the depths of the jungle in massive dugout canoes. Tough, agile rowers tie up alongside the moving barge with much shouting and laughter. The trading language of the river is Swahili and Lingala. In a never-ending scene of barter and trade, live crocodiles and massive vundu (catfish) – some the size of people – are hoisted aboard. At every stop, more passengers are loaded. There is only one toilet. More sacks of maize and cassava, and bales of black-smoked fish, are manhandled off dugouts and onto the barge. Soon we are filled to capacity, but still soldiers and government officials with stamped papers demand a place on board. The humidity is broken from time to time by thundering equatorial downpours. The 'slow sweat' of the Congo River continues.

Aruwimi cannibals

We are now crossing the mysterious Congo basin, the water-filled belly of the African continent that stretches from Kisangani to the Atlantic Ocean. The MB *Nancy* looks like a river ghost as it slowly chugs through the warm, milky, early morning mist. It creaks, rattles and groans as it pushes its overladen barges of timber, its crowds of Congolese passengers and the small family team attempting to follow HM Stanley down the Congo. We reach the confluence with the Aruwimi River.

It was here on 1st February 1877 that Stanley looked up to see *'a sight that sends the blood tingling through every nerve and fibre … a flotilla of giant canoes bearing down upon us which both in size and numbers eclipses anything encountered hitherto!'* Stanley counted the canoes in the enemy fleet.

> *There are fifty-four of them! A monster canoe leads the way, with …*
> *forty men on a side, their bodies bending and swaying in unison as with*
> *a swelling barbarous chorus they drive her down towards us …. The*
> *crashing sound of large drums, a hundred blasts from ivory horns, and a*
> *thrilling chant from two thousand human throats, do not tend to soothe*
> *our nerves …. We have no time to pray.*

Stanley shouted out to his men, 'Don't think of running away, for only your guns can save you!' By this time, Stanley had survived over 25 battles on the river. He anchored his boats in a line and protected his men from spears and poisoned arrows with a wall of shields stretching from bow to stern on each vessel. He and his men opened fire with Snider repeating rifles. Soon the enemy lay 'groaning and dying' in the bottom of their canoes. Stanley wrote:

> *Our blood is up now. It is a murderous world, and we feel for the first time that we hate the filthy, vulturous ghouls who inhabit it …. We continue the fight in the village streets with those who have landed, hunt them out into the woods, and there only sound the retreat.*

Stanley's men then looted the village for food. They noticed a shrine made of 33 tusks. They helped themselves to these, together with 100 pieces of carved ivory. Stanley admired the craftsmanship, but was revolted by the evidence of cannibalism:

> *… the human and 'soko'* [gorilla] *skulls that grinned on many poles, and the bones that were freely scattered in the neighbourhood, near the village garbage heaps and the river banks, where one might suppose hungry canoemen to have enjoyed a cold collation of an ancient matron's arm.*

Freedom to the pigs!

The few 100-odd passengers aboard the MB *Nancy* are really friendly. They offer to cook for us and invite us to taste snake, crocodile and monkey. One pretty young Lingala woman, with her hair braided into spikes, wants to marry Ross. No doubt she wants a life away from the crowded riverboat heat and humidity!

Last night a massive rain storm and high winds forced us to stop for the night. This morning everybody is drying out their kit, steam rising from wet bedding as the equatorial heat weighs heavy. We've had endless delays at the ports of Bumba and Lisala – but tonight we are filled with optimism. The weather is good and the skipper has promised to sail through the night.

Soon, however, we hear shouts of anger coming through the darkness. Not only have we collided with a dugout canoe, we've also gone, at full speed, headlong into a sandbank and a massive tree. Amazingly, no-one is killed or hurt – but we're in for a long night. To no end the tugboat's pushing and pulling to get the two barges

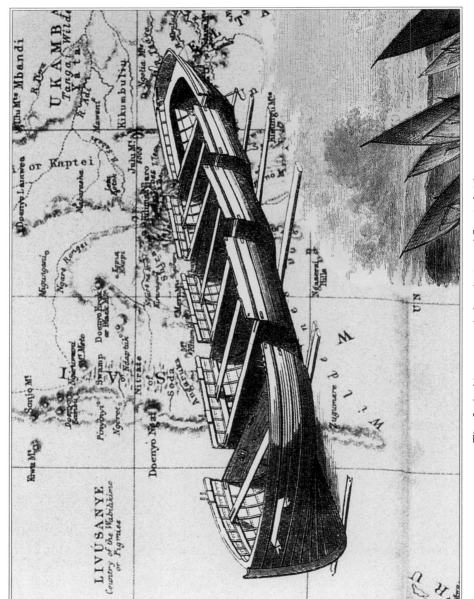

The *Lady Alice* – named after the love of Stanley's life

to move. Eventually the crew unties the barges: one is pulled to a nearby island, the other left on the mudbank like a boatload of stranded refugees.

During the night, a prisoner being escorted to Mbandaka jail uses the opportunity of being run aground to dive overboard and escape. The soldiers who are supposed to be guarding him, drunk with palm wine, spray the equatorial jungle with automatic fire. Next morning, two young fishermen accused of helping the prisoner escape are dragged up and forced to lie face down outside our tents, arms outstretched on the hot metal deck. Using the magazines from their AK-47s, the soldiers proceed to smash their knuckles. The kids scream in agony. Ross, I can see, is itching to throw a punch. Mashozi is irate. 'Can't you stop the bastards?' she hisses under her breath. François, our interpreter, urges us to stay calm. Ross and I pull Mashozi to one side and avoid eye contact with the drunken soldiers. They're showing off, trying to look powerful in front of all the passengers. The tortured, screaming kids then get dragged off through the crowds. They'll probably get shot and thrown in the river. It makes us feel sick, but I know if we'd made one wrong move, it could have been tickets for us.

Using massive old-fashioned hand winches and lengths of cable, it takes most of the day to get the barges off the sandbank. A group of sweating, ebony-bodied men pull up alongside in a massive pirogue loaded with squealing black pigs and eager hands stretch down to trade. The klaxon blares, the captain is furious. As a Muslim, he won't allow pigs on board. Confusion reigns as the pigs get tugged to and fro. The bow wave of the barge catches the pirogue and over it goes, pigs and all. Fortunately their legs aren't tied and, like Olympic swimmers, they strike out for the shore. Mashozi claps and whistles, calling out, 'Freedom to the pigs!'

Interrogations after interrogations

Further downstream, President Laurent Kabila has flown into the port of Mbandaka – and such is the concern for his security, that all riverboat transport is stopped. We end up at the village of Lulanga for five days. Over 1 000 people in various boats sit and wait. Drinking water from the village well has dried up; so have food supplies. Palm-wine sellers are doing a roaring trade and the priests and pastors on the boat are running out of sermons.

At every stop, Ross, Marcus, François and myself are marched off the boat to be interrogated by the military (we always insist that Mashozi be allowed to remain on board, in the care of the captain). Cameras are taken off us and we are dragged off to some dingy establishment for a going-over. Typically, I say to little François, who's nervous as all hell, 'Now listen, François, when I talk, you must translate slowly and to the point. Our lives will depend on it.'

His little feet battling to keep up with mine, he looks up at me and with his American accent says, 'Pappa King, you donno my black brothers, man. If they think we're up to no good, that'll be the end of us, and I'll never see my family again!'

This is the twelfth time we've been dragged off like this. First our passports are scrutinised, then the questions start. Who the hell are we? Who has sent us? Why the cameras? Why have they not been informed?

Always, I try to slow down the process with a little play acting, complaining fiercely about the heat, waving my big straw hat like a fan in front of my face, and dabbing my chest and neck with a small towel pulled from the pocket of my brightly coloured DRC shirt. Taking out a wad of notes, I strongly suggest that one of the boy-soldiers be sent off immediately for a crate of Primus beer. Slowly I introduce us all by name, clearly indicating that we are no threat, merely a family plus friends following Henry Morton Stanley's journey down the Congo.

With a seemingly confident flourish, I hand over our letter from the Minister of Tourism and from the Head of Security. I then glance at Ross. He knows it's his cue to open up the satellite phone. Showing them Mr Kazadi Nyembwe's card (Kabila's right-hand man, whom I'd met in Johannesburg), I explain that the arrangement is, we report back every day to Kinshasa on how we are being treated on the river. Of course, it is all a bluff and there are always those terrible, tense moments when you don't know which way it's all going to go. The situation, we know, is volatile. One wrong move, and that could be the end of us.

The beers arrive and it's all handshakes as we get marched back on board, always to cheers and clapping from the passengers of the MB *Nancy*, who by this time have adopted us.

'Not bad, *Nondwayiza*,' says Ross, calling me by my Zulu name.

'Eight out of ten,' says Marcus.

They've started to score me on each performance – if it gets to under five out of ten, we're in deep shit! I've learnt though – the important thing is to be patient, smile a lot and not lose our cool.

A long, long journey

Seventeen days after casting off from Kisangani, we tie up at Mbandaka, a bustling river port known during the Belgian colonial era as Coquilhatville. Once again, it's the interrogations that spoil it for us. This time the commanding officer is a woman of generous proportions, squeezed into a tight-fitting camouflage outfit. She immediately takes a shine to Ross and it's quite obvious she'd like to get him into the sack. Ross glares at me and whispers, 'If you think I'm gonna … to save the

family, you can go to hell!' I roar with laughter, luckily the situation is diffused and we're allowed to wander into this colourful river port for some cold Primus, who-knows-what-meat on a skewer, fresh bread and bananas. The music blares from streetside markets, there's an air of jollification. It's also a hotbed of military activity.

Yet more soldiers squeeze on board the MB *Nancy*. They've got orders to get to Kinshasa for the Liberation Celebrations. The Democratic Republic of Congo is about to have its first birthday. Marcus Wilson-Smith gets a lift to the airport on the back of a truck – he's out of here! Mashozi, Ross, little François, the translator, and I are left to the slow sweat of the river.

Again, the shrill cry of the klaxon and our floating village glides past riverside mud-walled shacks and abandoned, crumbling Belgian homes. Red-rusted carcasses of forsaken river steamers have become floating shacklands with people in every nook and cranny. Washing is draped over the side rails; shouting, laughing, waving children fish from the decks.

Downstream from Mbandaka, the 3 000 km-long river crosses the Equator for the second time. We celebrate with bully beef stew, steamed bananas and rice, washed down with the last bottle of rum. The sight of the galley cook using the heat from the tugboat's exhaust to singe the hair off a white-faced monkey (the captain's favourite) doesn't do much for our appetites, made even worse by the smell of the toilet.

The Congolese laypeople are lovely – but we're sick and tired of the constant feeling of unease, the suspicion, the arrogant attitudes of the military, the interrogations, all now made worse by the security surrounding the celebrations. We've all had enough: the heat, the overcrowding, the absolute lack of privacy, waking up in the night to feel a body next to you because someone short of space has moved hard up against the outer wall of your tent … I am FED UP.

Then Mama Josephine shouts out, 'Hey, Pappa King, your *mandazis!*' pointing to a big bowl of fresh, golden-brown doughnuts and bright yellow slices of sweet pineapple. We laugh and wander down for breakfast. She offers me an old oilcan to sit on, people smile and greet us, we are part of the boat. The boat is Africa. My mood improves.

I look out across the wide river, second only in size to the great Amazon; two million cubic feet per second rushing towards the Atlantic. Later, we enter a giant pool which appears to stretch to the horizon.

It was here that Henry Morton Stanley recorded in his journal the words of Frank Pocock, one of his faithful team members.

> *Why, I declare sir, this place is just like a pool, as broad as it is long.*
> *There are mountains all around it and it appears almost circular.*
> *Why not call it Stanley Pool?*

And much later, when they got to Kinshasa, it was in the devilish rapids below here that Frank Pocock drowned. Stanley recorded it thus:

> *… black woeful day! Alas, my brave, honest, kindly-natured, good*
> *Frank, thy many faithful services to me have only found thee a grave in*
> *the wild waters of the Congo.*

In the 32 huge, boiling cataracts that followed, many more of his men drowned. Stanley's boat, the *Lady Alice*, had to be abandoned – left to rot in the sun as the survivors struck out overland towards the sea. After they had rested for two days at Boma, Stanley and his men were taken by steamship to Cabinda on the coast just north of the Congo estuary, and then, via Cape Town and Durban, from Luanda to Zanzibar aboard the British warship HMS *Industry*.

In Zanzibar Stanley received the news that Alice Pike, the thought of whom had kept him alive on his 1 000-day journey across Africa – *the dream, the stay, and the hope* – had jilted him and married an Ohio railroad millionaire 10 months before he'd sailed down the Lualaba River in the *Lady Alice*.

Out by a whisker

Finally, after 21 days on the River Congo, our tugboat reaches Kinshasa. It has been an incredible journey, a rich kaleidoscope of riverboat life on Africa's greatest river. It's early morning and Kinshasa is sealed off. We are grabbed by the military, who are paranoid. I explain we have a plane ticket out this afternoon to Johannesburg. They try phoning the airport for verification but can't get through. The commanding officer puts an armed guard into an old Volkswagen Combi taxi and we race to the airport.

Through François we learn that the armed guard's instructions are: if we don't fly out, we're to be taken immediately to military headquarters. The reality is, while we have open tickets, we don't have a firm booking! The airport is chaotic. Loaded with kit, we race for the counter, François and the armed soldier running behind us. The boarding gate has closed. With a sick feeling in my stomach, I explain our situation and beg to get aboard. I flash some bucks, the man nods, we give little François most of our kit. 'Bon Voyage!' he shouts.

The plane circles and I look down at sprawling Kinshasa. On the other side of the river is Brazzaville – and a raging civil war. The flight attendant cannot believe our dishevelled looks. I explain we have just come off the Congo River – she brings us double servings of dinner and is generous with the drinks trolley. Everything seems so clean and orderly, no smoked chimpanzee, strapped-up crocodiles or guns. I feel the tension rolling off my body. Mashozi winks at Ross and me. We raise our glasses to the mighty Congo.

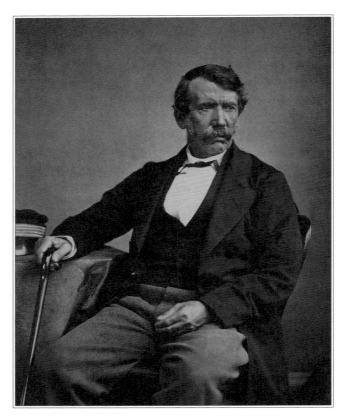

Dr David Livingstone, the great missionary explorer

Chapter IV

Río Rovuma

to the Lake of Stars

Being the Narrative of a Modern-day riverboat
Journey up the Rovuma – a Wild and somewhat Unexplored river – Memorable
night on the Rufiji – Lumbaye the Samburu – Curry in the Radiator – Plastic Cows
for lobola – Flooded rivers and Washed-away Bridges – an Overland
exploration of Livingstone's Lake of Stars

The whole Replete with
Maps, sketches and Extracts from David
Livingstone's field Notebook

An adventure is born

Paul Hallowes was nicknamed *Smungmung* ('the mumbler') by the Zulus because when he first came to Zululand, he only spoke Swahili and was prone to mumbling while learning his Zulu. Paul was born in Kenya, where he grew up on a farm at Ol'Kalou during the Mau Mau rebellion. In the late 1960s, he and I operated a trading store and safari company, and so became great friends.

Now, we two old greybeards in creased blazers and borrowed ties, wrinkled faces darkened by the African sun, sit reminiscing at the bar of Nairobi's old colonial Muthiaga Club, a rambling structure built on the site of an old Maasai *manyatta* that has probably seen more fornication than any other club of its kind in the world. It's a place of forgotten scandals, brawls, adulteries, arson, bankruptcies, insanity, suicides – and even duels. A crazy Happy Valley scene that played itself out 8 000 ft above Kenya's steamy coastline. Long-bladed fans creak slowly overhead, an old moth-eaten, stuffed lion's head glares from a glasscase. Kenya's *White Mischief* days are over, the big game hunters no longer rent rooms at the club, and I doubt if anyone has ridden into the bar on horseback lately. But the Muthiaga Club still has all the colonial charm of yesteryear.

Paul and I had flown up to Nairobi from South Africa to bring back my battered old 4x4s and boats, the survivors of our 1993 Cape to Cairo expedition. The Kenyan authorities had threatened to impound them as their carnets had expired; we had to have them out of the country within 24 hours or face hugely exorbitant penalties. I'm a useless mechanic but fortunately Paul, armed with a huge toolbox and an eternal sense of optimism, had agreed to come along for the ride. Our respective wives had called it the 'Grumpy Old Farts Safari'.

Next morning, at 4am, we push-start old faithfuls *Thirsty*, the petrol-guzzling Land Cruiser that's done close to a million kilometres, and *Vulandlela* out of a friend's driveway in the Nairobi suburb of Karen. We'd fixed the punctures and tied up all the loose bits with wire. Smungmung leads the way in old *Thirsty*, I follow in *Vulandlela*, loaded with old canvas tents, expedition equipment and Samburu companion, Lumbaye Lenguru, a faithful friend from past East African expeditions. Sensible people would have taken the main tarred road south through Tanzania, Zambia and Zimbabwe, so nursing the old vehicles home. But, no! The Grumpy Old Farts had to do it the hard way ….

We decide to follow the coast of Tanzania and Mozambique. It's a challenge, as we've never crossed the Rufiji and Rovuma rivers before. We've got a box of pots and pans, a few bottles of – guess what? – and an old wooden box of basic bachelors' provisions. Lumbaye is an excellent cook, and for currency, there are a few hard-earned dollars stuck amongst the broken seat-springs. I should also add: we've chosen the rainy season ….

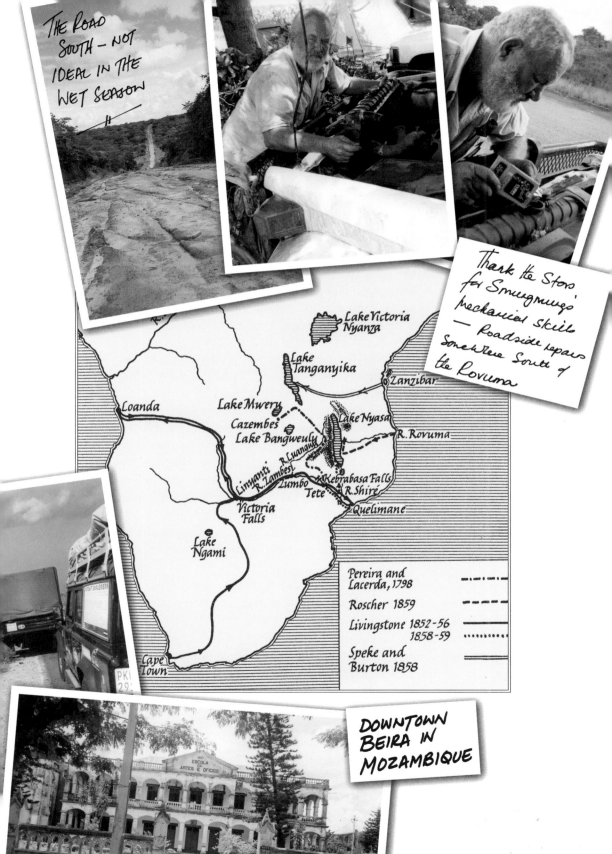

THE ROAD
SOUTH — NOT
IDEAL IN THE
WET SEASON

Thank the Stars
for Smugmug's
mechanical skills
— Roadside repairs
somewhere South of
the Rovuma

Lake Victoria
Nyanza

Lake
Tanganyika

Zanzibar

Loanda

Lake Mwery

Cazembes

Lake Bangweulu

Lake Nyasa

R. Rovuma

Linyanti

R. Luangwa

R. Lambezi

Zumbo

Kebrabasa Falls

Tete

R. Shiré

Victoria
Falls

Quelimane

Lake
Ngami

Pereira and
Lacerda, 1798

Roscher 1859

Livingstone 1852-56
1858-59

Speke and
Burton 1858

Cape
Town

DOWNTOWN
BEIRA IN
MOZAMBIQUE

Crossing the Rujiji

Smungmung is the most fearful snorer I've ever come across, despite the fact that he goes to great pains to lubricate his throat around the campfire! Lumbaye and I would often wake up in the middle of the night, believing that we were being attacked by lion.

Filling porous radiators and leaking 'diffs', we rumble south, pushing and winching until we finally reach the Rufiji where we sleep under the stars next to our vehicles on the ferry.

The mozzies launch a frenzied attack on us and throughout the night the ferryman repeatedly bangs on the deck with a stone. At first, this produces a light ring, but by early morning it becomes a deep booming *doing, doing*. The ferry hull is fast filling up with water. I suspect that my old wrecks will end up in the Rufiji – but a portable pump soon arrives, the ferry is pumped dry and the old dilapidated ferry chugs across the Rufiji to the opposite bank.

At Mikindani, in southern Tanzania, we stay at a lively pub called 10° South. In the town, I'm delighted to find the place where Dr Livingstone stayed during his journey from Zanzibar to the Rovuma River in 1866.

Little did he know at the time that it was to be his final journey. He would never see his beloved Scotland again. David Livingstone set off from here with his two loyal companions, Chuma and Susi, and a team of porters. His objective was to follow the Rovuma River once again into the untamed wilds of the Central African interior, this time in search of the source of the Nile. He believed that if the Nile were to prove navigable from the interior down to Egypt and the Mediterranean, this would become the great artery to open up Africa to Christianity and civilisation, thus putting an end to his greatest loathing, the slave trade.

Rovuma expedition

As a family, we've spent over a decade crisscrossing Africa in the footsteps of Livingstone. The thought of a journey up Río Rovuma, following Dr Livingstone's journey, now occupies my thoughts. Smungmung and I head south to the new ferry on the Rovuma, recently brought in pieces from Germany by the Catholic fathers at Mtwara. The days of having to put your vehicle onto eight dugouts lashed together with planks are over.

The Rovuma is full and wide. It is also running swiftly and the somewhat inexperienced skipper allows the ferry to be swept downstream by the current,

finally dropping our vehicles off in the reeds on the Mozambican bank. I gaze upstream towards the blue hills in the far distance. The dream of another river journey following Livingstone is being born. The Rovuma is little more than a name (if that) to most people. Almost 500 miles long, it forms the northern boundary between Mozambique and Tanzania.

David Livingstone's initial interest in the river was a practical one. He was concerned about the power of Portuguese Imperialism and the sovereignty it claimed over the Zambezi – waterway to the slave preserves of Central Africa. It was Livingstone's ambition to destroy all this. In September 1859, Livingstone had discovered a desirable place for a British colony in the highlands to the south of Lake Nyasa/Niassa (present-day Malawi), but it could only be reached by way of the Zambezi and Shire rivers which were under Portuguese control. Livingstone wrote: '*The Portuguese have refused to open the Zambezi to ships of other nations.*' He desperately needed to find an alternative route to Lake Nyasa, and the Rovuma seemed the practical answer.

Curry powder in the radiator

The humidity and rains persist as we make our way south down Mozambique. The rear diff goes in *Vulandlela*, so we take off the back propshaft and turn her into a shuddering front-wheel-drive. The trouble with using curry powder and cassava flour to fix small radiator leaks is that, when the vehicle gets hot, such is the overwhelming smell of Rajah curry that I begin to dream of curried prawns at my favourite KwaZulu-Natal North Coast Indian restaurant, 'Impulse by the Sea'.

The Zambezi ferry at Caia is broken and the roads washed away, so we're forced to make a detour up to the Malawian city, Blantyre, named after Livingstone's birthplace in Scotland. After a sponsored night of luxury at Ryall's Hotel, I go in search of local historian Frank Johnson, who owns an Africana bookshop in Blantyre's main street. The thought of a Rovuma expedition is still uppermost in my mind – but Frank has nothing on the river in his shop. He does, however, have a single book in his private collection at home. I can't believe my luck. Printed in a simple triangle, the title on the faded cover reads: *Livingstone and the Rovuma*. It's a copy of Dr Livingstone's personal field notebook, covering his 1862 journey up the Rovuma River! His private handwritten notations run down the left-hand pages and the text is transcribed in type onto each opposite page. There are sketches, latitude and longitude bearings, and in the back of the book, a neatly folded map. It is a sure sign. Using this book as a reference, I vow to tackle the Rovuma.

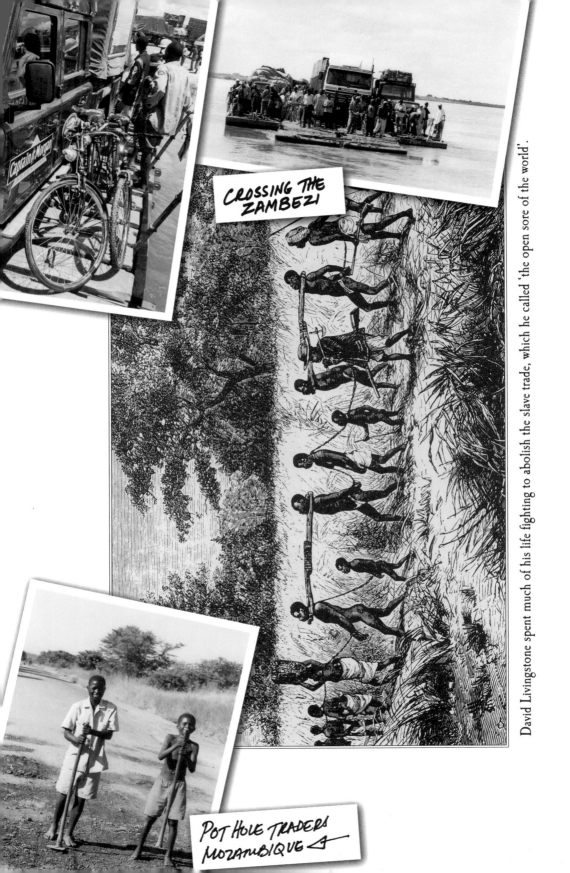

CROSSING THE ZAMBEZI

David Livingstone spent much of his life fighting to abolish the slave trade, which he called 'the open sore of the world'.

POT HOLE TRADERS MOZAMBIQUE

At the old slave-trading river port of Tete down on the Zambezi, both Smungmung and I go down with malaria. I think it's those bloody Rufiji mosquitoes that did it. We treat ourselves and keep going, sweating out the fever. We were meant to have been gone for 10 days – but it was almost a month before the two Grumpy Old Farts limped home, their vehicle rescue mission now complete. Smungmung's daughter, Phillipa, fondly known to all of us as Flops, was there to welcome us home. Dennis, her boyfriend, dressed in full traditional Zulu regalia, looked decidedly nervous. No sooner had a bottle of Captain Morgan rum been opened, then the young man went down on his knees to ask Smungmung for permission to marry Flops. From a small bag he produced 11 plastic cows – the Zulu *lobola* price for a bride.

Back with our respective families, we raise our glasses and the party begins. Later that night, I put the small Livingstone Rovuma book safely into the glass book cabinet in the downstairs Africa Room.

A new expedition begins

We must move, the rainy season is drawing to a close. From an old sea pilot's guide, I learn that high water on the Rovuma is possible at the end of March. In his Rovuma field notebook, David Livingstone writes about river pirates, crocodiles and the cruelty of the East Coast slave trade. Looking at our survey maps, I'm drawn to northern Mozambique again – names like Cabo Delgado, Niassa and Mocímboa da Praia. They have a wonderful ring to them, as do the words Río Rovuma, Lake of Stars. What a great name for an expedition!

Our family objective is clear. Using our copy of Dr Livingstone's private notebook, we plan to follow the journeys he made up the Rovuma River, still one of the wildest and most unexplored rivers of East Africa. If we survive the river, we'll then follow his later overland route from the Rovuma across the wilds of Mozambique's Niassa Province to Lake Niassa (Nyasa on the Tanzanian side) to explore the Mozambican and Tanzanian shorelines just as Livingstone had done. This was his 'lake of stars'. Ross tells me that, to his knowledge, no expedition has ever completed these particular sections of Livingstone's journeys as a single odyssey.

Livingstone's first attempt to tackle the Rovuma was made on the 12th March 1861, in a small steam vessel aptly named the *Pioneer*. His expedition forged only 30 miles upstream before shallow water and sandbanks turned them back. It was a disaster. The extra ballast that had been put into the *Pioneer* for the sea crossing from Britain had increased her draught from the designed three feet to five. The bitter

lesson now learnt was that the Rovuma would only be navigable in smaller boats. Then, to make matters worse, fever broke out on board the boat. While anchored in the mangroves at the mouth of the river, Livingstone's assistant, John Kirk, wrote these melodramatic words:

> *Dark, gloomy and damp mangrove forests, loaded with malaria and swarming with mosquitoes, where the sun seldom pierces through the leaves above and a death-like stillness prevails, broken only by the wild scream of some fish-eagle or the chatter of the monkeys*

It wasn't in Livingstone's nature to give up, however. Now, 142 years later, we're travelling north from South Africa to follow his second attempt at the Rovuma. We hear that the rains are late this year Will the Rovuma be full enough and will the backup team be able to get through to resupply us on the river? How bad will the malaria be?

Land Rovers remain our vehicles of choice; we load them with expedition supplies – tough Yamaha outboard engines, inflatable expedition boats, lots of malaria treatment, a surprise bottle or two of Captain Morgan Black Label rum, and my precious copy of Livingstone's 1862 personal field notebook.

Mashozi and I bounce along in the long-wheel-base 130 Land Rover Defender truck; with Ross in the Defender station wagon is our wonderfully adventurous backup team of Steve Ellis and Joceline Roe. They've both lived in Mozambique before and have a feel for what lies ahead. Better still, quietly spoken Steve has good mechanical skills and is an excellent fisherman. Joceline is a good-humoured, talkative bundle of energy – and nothing is too much trouble for her. We've got a great team that all get on famously together. This is the most important ingredient in the bag of surprises that make up a successful expedition.

African potholes

Ireland's got Guinness and the potato; Holland, tulips and cheese; France has its champagne; but few know that north of Mozambique's great Río Save is the home of the notorious African pothole. These giant craters are a source of employment for the locals. Children throw spadefuls of earth into cavernous holes in the hope that passing motorists will throw coins. In roadside villages, older men have their own pothole turf which they jealously guard. On hearing an approaching vehicle, they rush out with a flurry of spades and stamping poles, sometimes even blocking the road until a contribution is made. There are invisible potholes that lurk in

Livingstone's field notebook

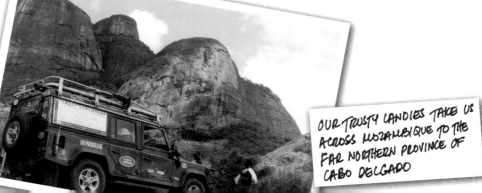

OUR TRUSTY LANDIES TAKE US ACROSS MOZAMBIQUE TO THE FAR NORTHERN PROVINCE OF CABO DELGADO

the shade of a tree; water-filled holes that spray 100 litres of viscous muddy slush across your windscreen – ensuring that the lack of visibility makes you *klap* another neighbouring six; then there's the sharp-edged broken-tar pothole which, on impact, blows out your tyre with a bang. You think you've hit a landmine, which leaves a wobble in your rim. On some sections, the bloody potholes are so bad, the laughing, waving locals overtake you by bicycle while your rocking, top-heavy Landie knocks seasick heads together and pulls springs from their mountings. And in uninhabited areas, as vehicles slow down to their first-gear crawl to avoid being swallowed by yet another mudhole, that's when the bandits pounce. It got so bad that the Mozambican army had to set up patrols and road-side checkpoints.

Caia ferry crossing

North of Gorongosa, the Zambezi River crossing at Caia is a nightmare. The river is flooding, humidity is thick as golden syrup and lorries are backed up; they've been waiting for over a week. Drivers are sleeping under their trucks waiting for their turn. Again, Africa measures the pace. Finally – after distributing a bottle or two of Captain Morgan – one Land Rover boards the ferry at last. Lorries slip and slide. A tractor pulls a lorry forward but the chain snaps, whips back and crashes through the windscreen, nearly killing the driver. Last week a man was crushed to death as the lorry slipped off the ferry into the Zambezi. Now, the ferry is crowded with overladen lorries, bicycles, mothers with tiny babies – and a green-painted expedition Land Rover. All are simply trying to cross Livingstone's mighty Zambezi.

Oil and diesel leak from the ferry's noisy, rattling engines as the strong current takes it downstream. Mashozi and I put our passports and money in our top pockets. There are only a few moth-eaten life jackets tied to the side of the ferry – certainly not enough for the mothers with their tiny babies. Slowly, and perhaps miraculously, the ferry makes its way up the opposite shoreline, where the current is weaker. There is a patent sigh of relief as the first expedition Land Rover rolls onto the northern bank of the river.

The heavens open, a relief from the mind-numbing humidity, and I stand outside laughing, rain dripping from my beard. A man wearing an Osama bin Laden T-shirt looks at me as if I'm crazy. In the thatched bar, on the banks of the river, a fight breaks out. A very drunk albino-looking deaf mute falls amongst the tables, knocking over several bottles of 2M beer. The pretty bar girl strides across the mud floor and slaps him across the face with a crack that a heavyweight boxer would've been proud of. Next minute, they're out in the mud fighting like cats and dogs. He gets her down and is kicking her to pieces, blood and teeth everywhere.

Moustache bristling, I race across, shouting at the top of my voice. The albino takes one look at this great, red-faced, grey-bearded apparition towering over him and drops to one knee, crossing himself repeatedly. The crowd roars with laughter.

He thought the end of the world had come; I'm just glad it stopped this way. I'm not really a fighter

Things can get tense at the ferry point; the endless waiting. It ends up taking another five hours before Ross, Steve and Joceline finally cross the river in the second Land Rover.

Hazardous bicycles of Quelimane

The rain stops and the humidity thickens as we head north to the ancient slave-trading port of Quelimane (some say the name comes from the phrase 'kill a man' because of malaria and blackwater fever). Driving into Quelimane at night is a bloody nightmare – trucks with no indicators, 'one-eyed' lights and pedestrians everywhere. Death-wish cyclists feel it their democratic right to play 'chicken' with the expedition Land Rovers.

In front of us, a man wobbles on a bicycle. Between his legs bounces a large spotted brown-and-white goat, forelegs tethered to the handlebars; on the back carrier is his lady, dressed in a bright pink and yellow wrap, with her baby tied to her back. Hanging down on either side of the Made in India back wheel are large, bright-green bunches of bananas. Not to be outdone another fellow, wearing a large palm-frond-woven hat, balances a baby underneath one arm while steering with the other. His wife sits side-saddle on the crossbar, tiny baby tied to her back, and on the carrier sits an older child. A family on the move, they ride right across our path without looking left or right.

There are bicycle-taxis with decorated pillions, firewood carriers, coconut carriers, charcoal merchants, water distributors, palm-nut oil transporters, and fishermen peddling large woven baskets of salt-dried fish. There are old battered bicycles with buckled wheels; newer models with white-walled tyres; noisy bells; decorated chain guards; and bicycles whose tubular framework still proudly wears its plastic wrapping.

The first time Livingstone had come down this part of his River of God – between Caia and Quelimane – was during his triumphant journey across Africa, from the Atlantic coastline to the Indian Ocean, a journey also made famous by his discovery of the Victoria Falls. Dr Livingstone ended his famous journey here at Quelimane on 20th May 1856.

We spend the night at Hotel 1 de Julho, an old colonial Portuguese *pousada* just off Samora Machel Avenue. At a pavement table, the waiter Señor Gilbert, who has learnt his English in Malawi, apologises that 'today the prawns are small, but plenty!' Plates of huge prawns arrive …. I'd love to see the big ones!

That night it's so hot that Ross wets his sheets in the shower and wraps them around him to keep cool. The fans, like the bedsprings, are *kaput*. Across the road, ironically, are the once-ornate municipal swimming baths, still with spectator seating, and an old restaurant. The water is now green. Ladies of the night ply their trade and friendly but desperate children beg with sad eyes.

Our bhangra dancer

After a considerable journey to Nampula and beyond, we reach Pemba on the Indian coastline. Colourful Pemba resident, Xali Gornall Jones, friend from old shared adventures is here to meet us. Under a coconut-palm thatched roof, a giant tree trunk supports a Makonde-carved wooden counter. It's Saturday night at Blackfoot Camp, and the eccentrics from the pub are busy 'tying the dogs loose'.

Microphone in hand and dressed in a bright red cloak and turban, a little fellow gyrates to Indian 'bhangra' music. Big black boots, black beard and shining eyes, his arms jerk from side to side as he bends and shakes. The late-night revellers roar with laughter. Blond-haired, tomboyish Veronica Bouwer switches off the little battery-powered 'bhangra dancer' and offers it to me with a shy smile.
'It's yours,' she says. 'It'll make a wonderful expedition mascot! I've heard you're asking for a Portuguese interpreter? I'm desperate to come along …. It's been a lifelong dream to explore the Rovuma.'

So, not only do we adopt a mascot, but also a new expedition member.

Pemba's not an easy place to escape from. The next day, famous local sports fisherman Martin Visagie and his colourful wife, Annetjie, armed with cool boxes of fillet steak and a motor launch to get us to Pemba Bay, throw a party on its shores. Everybody and his dog pitch to wish us well. Martin is a wonderful host, and as the sun sets over the largest bay on the East African coast, the South Africans sing a Zulu song. Everyone joins in, then the Dutch and Italians give it a try, followed by the Mozambicans. Kenyan-born Neville Slade, a likable agricultural advisor from Lichinga, the capital of Niassa Province, stands up and announces his engagement to Veronica – who leaves with us for the north tomorrow. I'm not sure how keen Neville is for her to disappear off into the blue with a bunch of crazies, but she's adamant she's coming. Next morning, the bhangra dancer jives on the Land Rover bonnet as we leave Pemba for Mocímboa da Praia.

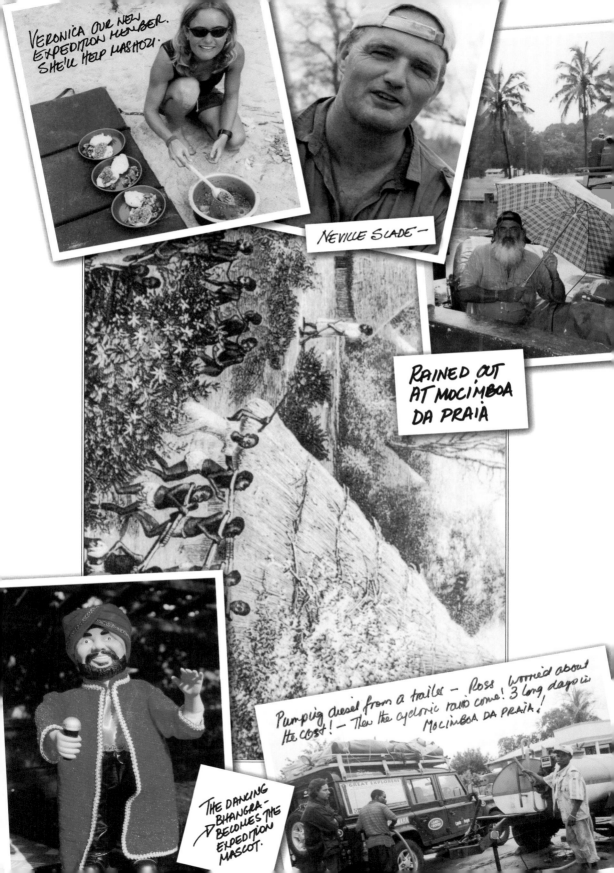

VERONICA OUR NEW EXPEDITION MEMBER. SHE'LL HELP MASHOZI.

NEVILLE SLADE—

RAINED OUT AT MOCÍMBOA DA PRAÌA

Pumping diesel from a trailer — Ross worried about the cost! — Then the cyclonic rains come! 3 long days in MOCIMBOA DA PRAIA!

THE DANCING BHANGRA — BECOMES THE EXPEDITION MASCOT.

Fuel thieves

Black skies and palm trees are thrashing in the howling wind. Suffocating humidity brings endless cyclonic rain, forcing us to take refuge in the old administrator's house, Villa de Mocímboa da Praia. Three days of sheltering from the rain, eating calamari and immense bright-red mud-crabs and drinking. It's too long in one place … the local thieves have time to check you out.

Last night they hit us. The guards woke up and managed to sound the alarm. I fell naked out of bed and went racing down the road after the petrol thieves. Fortunately they only got away with two jerry cans of boat fuel, having dropped the others at the sight of a roaring bearded monster in his birthday suit.

At last, the sun shines and our bhangra dancer bops again on the bonnet of the Land Rover. We churn along the sticky red mud-road to the village of Palma, bolt the Yamaha engines onto the boats, and on the full tide launch them into the Indian Ocean.

The entire village turns up to see us off. Pushing and shoving, they crowd around the boats in wild confusion. Thank goodness for Ross's Swahili and Veronica's Portuguese. We say our farewells to Steve and Joceline, the Land Rover backup crew, whom we hope to see in 10 days' time at a GPS point on the Mozambican bank of the Rovuma River. Theirs is a tough task and we're concerned for their safety. The escarpment above the river is one of Mozambique's most densely landmined areas. Fortunately, in Pemba we'd met Chris Boshoff, who had de-mining experience in Kosovo, Somalia and Afghanistan. A likable fellow! Chris and his Halo Trust de-mining team, based at the Makonde capital, Mueda, have agreed to guide Steve and Joceline into our supply points. Since they're working in the area, they're able to use our expedition as a recce.

In our inflatable expedition boats, we have sleeping gear, a change of clothing, a medical kit especially for malaria, food supplies, Howling Moon expedition tents, enough fuel to last 250 km, and a bottle or two of you-know-what rum. The locals warn us of river bandits, giant crocodiles and plenty of hippos. Our valuable copy of Dr Livingstone's 1862 journey up the Rovuma River is packed away safely in a waterproof bag.

In his field notebook he writes:

> We had stopped at a village to buy some fowls and then up a bank we shot a large Puff adder. At the sound of the gun the locals attacked us, firing poisoned arrows and three musket balls through the sail. We returned the fire and shouted, We are not slavers and have only come to explore the river!

Rounding Cabo Delgado

Heading out to sea, winds and rain lash us again. The sky goes ugly black and the ocean turns upside down. Ross motions towards land. We duck into the leeward side of a mangrove island and take cover. Later, the storm clears and the water turns an inky blue tinged with the gold of sunset.

In our two small open boats we round Cabo Delgado, the northernmost Cape in Mozambique. Just past the Cape, we pass a large dhow heading south, its enormous lateen-rigged sail pregnant with wind. The skipper waves from the tiller bar, a crewman stirs porridge over a charcoal stove at the stern. They're traders travelling from the southern Tanzanian port of Mtwara to Mocímboa da Praia.

Concerned about security, Ross and our local guide, Fai Chababe, sleep on the boats while Mashozi, Veronica and I roll out our bedrolls amongst the mozzies on a small, white, sandy, moonlit beach. In the dead of night, Ross shouts out a warning to me to expect visitors. Soon a gang of fishermen spring silently from their dugouts and surround us. I've got the long Maglight ready – it makes a great weapon! I smile, shake hands and offer cigarettes.

I wonder what would have happened had they caught us fast asleep? Nothing, probably ….

Sitting on a mangrove sandbank, I learn from Livingstone's field notebook that as he sailed toward the mouth of the Rovuma in August 1862, his spirits were at a very low ebb. A few months earlier he'd buried his wife, Mary Moffat Livingstone, under a baobab tree on the banks of the Zambezi, where she'd died of malaria. Besides grief, his conscience was troubling him. He had neglected his wife and family to go exploring and had only been with Mary for four of their 17 years of marriage. In his melancholy state he also relived the painful memories of the gossip relating to Mary, who, en route to Shupanga by boat on the Zambezi River, had been the not-unwilling recipient of the indiscreet attentions of fellow passenger James Stewart. It was also rumoured that Mary, in her loneliness, had developed a taste for alcohol. Now that she was dead, he blamed himself bitterly.

Livingstone was also concerned about his son Robert, who, instead of joining up with him in Africa as had been arranged, had skipped South Africa to enlist in the United States army. He'd later died of wounds, at the age of 18, in a confederate prisoner-of-war camp in North Carolina.

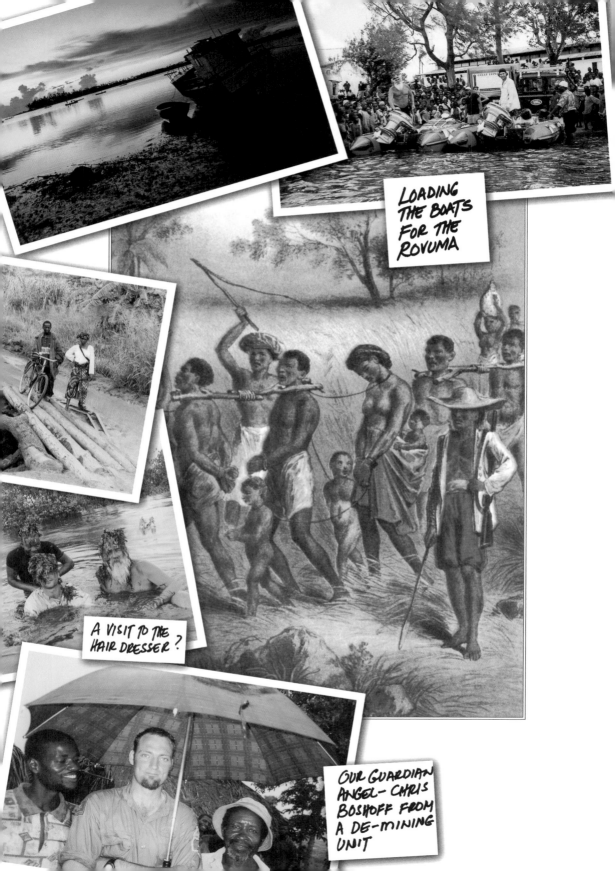

LOADING
THE BOATS
FOR THE
ROVUMA

A VISIT TO THE
HAIR DRESSER ?

OUR GUARDIAN
ANGEL — CHRIS
BOSHOFF FROM
A DE-MINING
UNIT

Into the Rio Rovuma

As Ross navigates us into the wide mouth of the Rovuma, I realise once again how fortunate we are to be able to do these crazy adventures as a tightknit family. There are sandbanks aplenty and we soon catch sight of our first massive crocodile.

Livingstone writes:

> '… *alligators and wild life abound – slave traders travel up and down the river on foot and in small boats, and that whilst some of the local people are friendly, others run in fear. They trade for fowls and manioc. The tribes people are tattooed in dots and many have their teeth sharpened to a point – some villages are built on sandbanks so as to better escape the Makua who come from the south by night and steal from them.*

And on the 18th September, he writes:

> *The river seems to be falling daily.*

For us it's the very opposite as, further up the river, I write these notes in our expedition journal:

> The river is chucking everything at us – cyclonic rain, intense, mind-numbing heat and a 7–10 knot river that's roaring past our little tented camp. Ross and Fai, a local man who has now joined the expedition, are loading the boats, Veronica is collecting firewood and Mashozi uses the rubberduck pump as a bellows for the early morning *renoster koffie* fire.
>
> Eight dugout canoes full of village people have pitched up to visit the strange *waZungu* ('white people'). None of them have ever seen an outboard engine before and are intrigued by our red 'balloon' boats and Yamaha motors. They say that yesterday, when they heard us coming, they thought it was an aeroplane and looked up into the sky.
>
> Swahili is the language of the river and they talk to us about the war years in Mozambique, the elephants that raid their crops and the huge crocodiles that inhabit the river. A man from the Mozambique bank tells us about the war against the Portuguese; how they were trained in Tanzania and would cross the Rovuma at night to attack the Portuguese as far south as Pemba. When wounded in battle, stretcher bearers would run them along the bush paths from village to village,

and back over the Rovuma to be treated in Tanzania. Three of the
fishermen show us enormous crocodile scars. They are lucky to survive.

Malaria and deep, septic, tropical ulcers trouble the river people and
Mashozi and her medical kit are constantly in need. I look across at
Mashozi, that girl from Yorkshire who came out to Africa 35 years ago,
now wearing rubber gloves and squeezing ointment into a suppurating
tropical ulcer.

There are many hippos and Rashid, a village headman, tells us that
sometimes men and canoes get chomped in half. Last night the drums
kept us awake. Rashid, with his round smiling face, tells us it is to keep
the elephants and wild pigs out of the millet fields. We share some
ubuda, small sardine-like fish, vundu and tilapia, which are caught in
woven fish traps.

Today we must reach a point on the river called Namatile. It is here
that the Land Rover support party will resupply us with much-needed
fuel, food and a bottle or two of Captain Morgan – urgently required
as a mosquito repellent!

We're working off GPS points on a survey map and regular contact by HF
radio. Unfortunately there are approximately 150,000 landmines laid along the
escarpment by the Portuguese against the Frelimo. South African-born Chris
Boshoff is busy leading our Land Rover support team down to the river. Over the
radio we hear that it's hard-going – elephant grass higher than the Landies, many
pole-bridges washed away.

From the locals we learn that the track is separated from the river by a
crocodile-infested swamp. Our next radio call to them is at 12 noon today. We
need to stop on a sandbank and stretch the aerial across two upright boat paddles
supported by tent ropes, giving our call sign: Great Explorers. We're hoping we will
be able to rendezvous safely.

On the 10th September 1862, Livingstone wrote of '*immense sandbanks with
winding shallow streams that go from side to side*', and of constantly having to 'drag'
their small sail boats.

Nothing much has changed. The constant problem for us remains having to
jump off the boats and drag them off sandbanks – always with the fear of crocodile
attacks. One minute you're in six inches of water, the next you're up to your bloody
neck in the Rovuma.

It is exquisitely beautiful, though, pristine and untouched, with tens of
thousands of borassus palms. It is only 8am and already heavy clouds are building
up, our shirts wet with sweat. The villagers roar with delight as we open up the
Yamahas to head upstream. They wave till we're out of sight. Secretly, I am as

anxious as all hell. If the Land Rover party doesn't reach us, we will have to abort the expedition – and once out of fuel, we'll have to row some 200 km back down to the mouth of the river.

A huge, angry crocodile, its massive head raised out of the water, prepares to attack Ross's leading boat. He doesn't see it and I shout to him to accelerate.

Slave merchants

We are now in the vicinity of the island Kichokomane. In the shade of a tall borassus palm, I read this extract from Livingstone's journal:

> On the 16th September, we arrived at the inhabited island of
> Kichokomane. The usual way of approaching an unknown people is to call
> out in a cheerful tone 'Malonda!' Things for sale, or do you want to sell
> anything? If we can obtain a man from the last village, he is employed,
> though only useful in explaining to the next that we come in a friendly
> way. The people here were shy of us at first, and could not be induced to
> sell any food; until a woman, more adventurous than the rest, sold us a
> fowl. This opened the market, and crowds came with fowls and meal,
> far beyond our wants. The women are as ugly as those on Lake Nyassa,
> for who can be handsome wearing the pelele or upper-lip ring of large
> dimensions? We were once surprised to see young men wearing the pelele,
> and were told that in the tribe of Mabiha, on the south bank, men as
> well as women wore them.

[What we now understand is that many tribes purposefully disfigured themselves so as not to appear attractive to the slave merchants.]

> Along the left bank, above Kichokomane, is an exceedingly fertile plain,
> nearly two miles broad, and studded with a number of deserted villages.
> The inhabitants were living in temporary huts on low naked sandbanks;
> and we found this to be the case as far as we went. They leave most
> of their property and food behind, because they are not afraid of these
> being stolen, but only fear being stolen themselves. The great slave-route
> from Nyasa to Kilwa passes to N.E. from S.W., just beyond them; and
> it is dangerous to remain in their villages at this time of year, when
> the kidnappers are abroad. In one of the temporary villages, we saw, in
> passing, two human heads, lying on the ground.

When Dr David Livingstone travelled this area 142 years ago, he came across the decapitated bodies of slaves. As a result, many of the villagers ran in fear of his expedition, thinking they were slavers. The Rovuma was one of the principal slave routes from the Lake Nyasa region of Central Africa, where thousands of Africans were forced to suffer death marches to the slave markets of Kilwa and Zanzibar. Livingstone abhorred this trafficking in human flesh, calling it the 'open sore of the world'.

Field notes – early vs. modern explorers

On day 39 of our expedition, Ross writes in the expedition journal:

> By the time the land party found us on the river, they were looking exhausted – elephant grass taller than the Landies, washed-away pole-bridges, slipping and sliding, and the ever-present fear of landmines. According to Chris, from the Halo de-mining unit, it's the first time that vehicles have got this close to the river in years. It's a huge credit to Steve, who heads up our support party and to his girlfriend Joceline, who so ably mans the radio. What made matters even more difficult was that the track didn't make it all the way to the Rovuma, and fuel and supplies had to be finally ferried across a crocodile-infested swamp in dugout canoes.
>
> Steve's a master of understatement, and is always calm and collected, with a wry grin on his face. Tonight he's wearing his favourite old faded blue overall, great for keeping out the mosquitoes. Its been a hell of a journey for them with all the unexploded antipersonnel mines around. Chris had warned them not to get out of the Land Rovers and not put a foot on the ground. Better to blow off a vehicle wheel than a leg, and now it was getting dark, and all these crocodiles …. You know it's dangerous, Steve had said, when a little village child tugs at your leg and warns you not to go into the water. The transfer took well into the night, and by the time I got back to our sandbank camp and the boat, the river had risen and was now lapping around the tents. And Kingsley's down with malaria. I never thought it would be easy – but can you imagine what it was like for Livingstone, with only wooden boats, sails and paddles? And here we are with our shiny new Yamaha outboards, inflatable boats and backup Land Rovers. Bloody luxury!

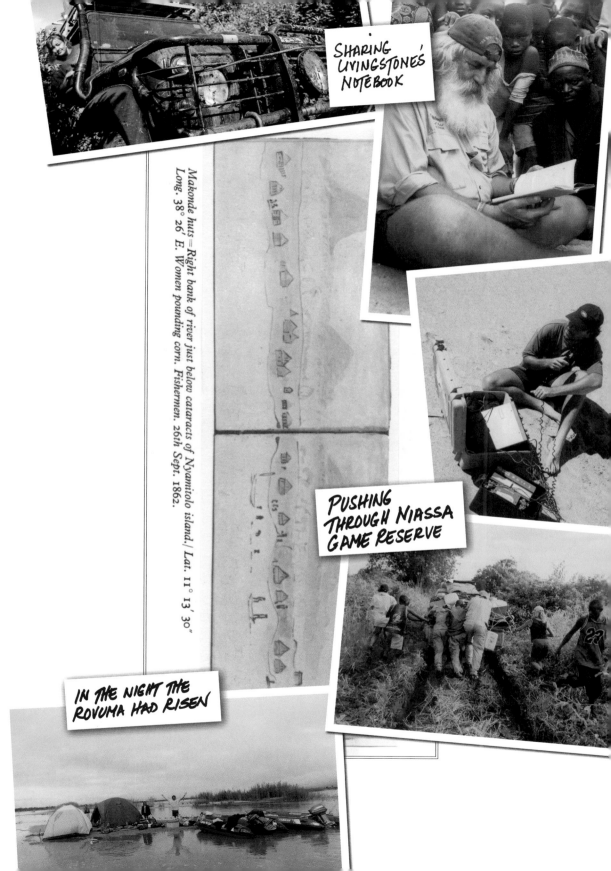

SHARING
LIVINGSTONE'S
NOTEBOOK

Makonde huts = Right bank of river just below cataracts of Nyamitolo island./ Lat. 11° 13′ 30″
Long. 38° 26′ E. Women pounding corn. Fishermen. 26th Sept. 1862.

PUSHING
THROUGH NIASSA
GAME RESERVE

IN THE NIGHT THE
ROVUMA HAD RISEN

The river is incredibly beautiful and wild – more beautiful than the lower Zambezi. Hippo and crocodiles are still plentiful and palmnut vultures circle overhead. Now that we are higher up the Rovuma, it's deeper, with fewer sandbanks.

Each day, despite the fact that I'm still feeling a bit malarial, I make handwritten notes in the Rovuma River expedition journal, cross-referencing them to Dr Livingstone's field notebook. Against our modern Magellan GPS, it's interesting to note how Livingstone's latitude and longitude readings are only slightly out. What's even more fascinating is when, in the late afternoon, we sit around a sandbank camp to compare Livingstone's sketches with recognisable rocky outcrops and other noticeable landmarks.

The soot-blackened camp-kettle of Rovuma water bubbles on the fire and local tribespeople gather around while Mashozi dispenses malaria pills and treatment for septic ulcers. One poor fellow's foot has been lacerated by an angry crocodile caught in his fishing net. The local fishermen tell us that Zambezi sharks come way up the river and are also sometimes caught in their nets. They point to the pontoons of our Gemini inflatables to indicate the size of the sharks. Hmmm ….

We are offered scrawny village fowls and fresh fish caught in woven fish traps. Everybody is fascinated by our boats and outboards. All they know are hand-crafted wooden dugouts.

Soon, the evening drums start beating again and there's the mournful drone of a kudu horn. We've been warned about dangerous river pirates, but so far, so good!

Friend of the African

Livingstone wrote in his field notebook:

> *Before sunrise next morning, a large party armed with bows and arrows and muskets came to the camp, two or three of them having a fowl each, which we refused to purchase, having bought enough the day before. They followed us all the morning, and after breakfast those on the left bank swam across and joined the main party on the other side. It was evidently their intention to attack us ….*

> *With great courage, our Mokadamo waded to within thirty yards of the bank, and spoke with much earnestness, assuring them that we were a peaceable party, and had not come for war, but to see the river …. All we wanted was to go up quietly to look at the river, and then return to the sea again. While he was talking with those on the shore, the old rogue,*

who appeared to be the ringleader, stole up the bank, and with a dozen others, waded across to the island, near which the boats lay, and came down behind us. Wild with excitement, they rushed into the water, and danced in our rear, with drawn bows, taking aim, and making various savage gesticulations. Their leader urged them to get behind some snags, and then shoot at us. The party on the bank in front had many muskets – and those of them who had bows, held them with arrows ready set in the bowstrings.

Notwithstanding these demonstrations, we were exceedingly loath to come to blows. We spent a full half-hour exposed at any moment to be struck by a bullet or poisoned arrow. We explained that we were better armed than they were, and had plenty of ammunition, the suspected want of which often inspires them with courage, but that we did not wish to shed the blood of the children of the same Great Father as ourselves; that if we must fight, the guilt would be all theirs.

This was typical of Dr Livingstone's nonconfrontational ways. So unlike the other great Victorian explorer, Henry Morton Stanley, who in such a situation would probably have opened fire and blazed his way up the river. Livingstone, on the other hand, through his conciliatory attitude became known as 'the friend of the African'. It wasn't always easy, though.

We so far succeeded, that with great persuasion the leader and others laid down their arms, and waded over from the bank to the boats to talk the matter over.

'This was their river; they did not allow white men to use it. We must pay toll for leave to pass.'

It was somewhat humiliating to do so, but it was pay or fight; and, rather than fight, we submitted to the humiliation of paying for their friendship, and gave them thirty yards of cloth. They pledged themselves to be our friends ever afterwards, and said they would have food cooked for us, that the affair had been amicably settled.

Those on shore walked up to the bend above to look at the boat, as we supposed; but, the moment she was abreast of them, they gave us a volley of musket–balls and poisoned arrows, without a word of warning.

Fortunately we were so near, that all the arrows passed clear over us,
but four musket-balls went through the sail just above our heads. All our
assailants bolted into the bushes and long grass, the instant after firing,
save two, one of whom was about to discharge a musket and the other
an arrow, when arrested by the fire of the second boat. Not one of them
showed their faces again, till we were a thousand yards away. A few
shots were then fired over their heads, to give then an idea of the range of
our rifles, and they all fled into the woods. Those on the sandbank rushed
off too, with the utmost speed; but, as they had not shot at us, we did not
molest them, and they went off safely with their cloth. They probably
expected to kill one of our number, and in the confusion rob the boats.

Dr Livingstone noted: *'It is only where the people are slavers that the*
natives of this part of Africa are bloodthirsty.'

Malaria and the madondola

It's day 42 and we're still on the Rovuma River. Bloody malaria, it'll probably kill
me one day! Mashozi tells me I've had it 36 times. I've lost count – but thanks to
quick treatment, I'm over the sweats now. We carry our own test kits and treat
ourselves with Artesunate (Arinate) and a course of Doxycycline. The trick is
instant treatment. You're never going to die from the treatment, but if you delay
in the meantime – even just for a day or two – it will get to your liver – or worse
still, your brain. Cerebral malaria can be the end of you. We do whatever we can,
personally, to treat people in the fight against this disease, and wherever possible, we
distribute mosquito nets from the Land Rovers.

Livingstone had his own cure for malaria made from the oil of jalap (a Mexican
climbing plant), calamine, resin, a little opium and quinine. He called his
homemade remedy Livingstone's Rousers. And the dosage? He took them until his
ears rang ….
 Surprisingly, it wasn't malaria that finally killed the missionary explorer. It was
dysentery and a blood clot as big as a fist, which Chuma and Susi, his faithful
companions, removed from his abdomen while cutting out his heart. He had died a
sad and lonely death at Chief Chitambo's village on the shore of Lake Bangweulu
in 1873 – but that's another story, and right now, we're having quite a time of it
following his 1862 journey up the Rovuma.

Some children on the Mozambican side are afraid of my bulk and bushy beard, and run away in fear, believing I'm a *madondola*, an evil white vampire that is said to prey on children. Witchcraft is rampant here among the Mkua, Matambwe and Makonde tribes. Back at Mocímboa da Praia, we'd been told that Makonde witchdoctors at Mueda had turned 42 people into lions. There was also a powerful witchdoctor in Tanzania that turned men into aeroplanes.

Isolated on the Makonde plateau, some Makonde tribe members still file their teeth and show a willingness to protect their cultural conservatism and defend their territory. Makonde carving is the Rovuma region's greatest art form. For centuries, figures carved of ebony have played a central role in their ceremonies and are also the focus of their beliefs concerning the origin of man on the river.

The rhythm of rowing a dugout canoe, laying fish traps, planting crops and brewing millet beer is interrupted by malaria, angry crocodiles, hippos and marauding elephants that raid village crops.

Fortunately, slavery is long gone, the war in Mozambique is over and the landmines are at last being lifted. Groups of tough young fishermen gaze longingly at our Yamaha outboards. Ross has taken to sleeping in the boats at night, the anchor rope tied to his leg.

26ᵗʰ September 1862

Lat. 11 ° 13' 30". Long. 38 ° 26'E. We struck sunken rocks several times yesterday. This morning found further progress impossible without dragging the boats over a cataract called after the island Nyamitolo. It is a mass of low rocks with no great fall, for the native canoes go up and down with ease. We might go up too but the boats would sustain damage in coming down and before we reach Ngomano three days distant there is much worse inasmuch as the rocks are larger and the passages narrower.

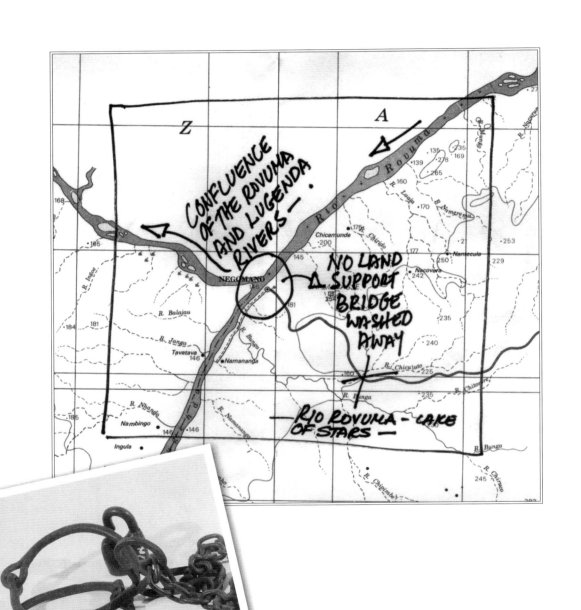

Handwritten annotations on map:

Z

A

CONFLUENCE OF THE ROVUMA AND LUGENDA RIVERS —

NO LAND SUPPORT

BRIDGE WASHED AWAY

RIO ROVUMA — LAKE OF STARS —

SLAVE CHAINS —

Nyamatolo island

In the distance, we can clearly see a massive, squared-off granite outcrop – the very same one drawn in Livingstone's field notebook. We've reached Nyamatolo Island and pitch camp on a beautiful sandy beach, covered in hippo tracks. In the footsteps of Livingstone's journey in 1862, this is as far as he got before being turned back by the rapids.

We raise our dented enamel mugs in a salute to the tough Scottish explorer. I play a tune on the harmonica, and in the distance, the village drums beat endlessly. Livingstone was not beaten, however. Four years later he returned to follow the Rovuma on foot, again searching for a route that would take him to Lake Nyasa and beyond.

Back again at the mouth of the Rovuma in March 1866, he set down these words in his journal:

> *Now that I am on the point of starting another trip into Africa, I feel quite exhilarated. The mere animal pleasure of travelling in a wild unexplored country is very great – the effect of travel on a man whose heart is in the right place is that the mind is made more self-reliant; it becomes more confident of its own resources – there is a greater presence of mind.*

As he made his way up the Rovuma, though, he was once again astonished and dismayed by the ravages of the slave trade.

> *19ᵗʰ June. We passed a woman tied by the neck to a tree, and dead. The people of the country explained that she had been unable to keep up with the other slaves in a gang, and her master had determined that she should not become the property of anyone else, if she recovered after resting for a time. I may say that we saw others tied in a similar manner. The explanation we invariably got was that the Arab, who owned these victims, was enraged at losing his money by the slaves being unable to walk, and gave vent to his spleen by murdering them …. All along the path there were innumerable signs of this infernal trade – human bones and slave sticks were everywhere.*

The lightning strikes on the horizon and soon dark clouds block out the stars. The faces around the fire turn serious. Blonde Kenyan-born Veronica is proving to be

a wonderful expedition team member. She enjoys a 'ciggie' and an enamel mug of plonk around the fire, pours a great river tot and, apart from Portuguese, speaks reasonable Swahili. She's strong, has a great sense of adventure, and just loves the bush. Mashozi throws another log on the fire and wiggles her toes in the sand. Ross switches on his head-torch and walks over to check on the boats. This year, the rains are indeed late. The HF radio crackles into life: 'Great Explorers, do you copy?' It's Veronica's Neville on the air. She looks embarrassed because she knows what's coming. 'Do you miss me, Veronica? Do you love me?'

'Sure, sweetie. Love you lots.'

Nothing private in *this* camp.

That's life ...

Late rains mean a full river. We're thus able to survive the rapids that turned Dr Livingstone back. Ross's boat *Stanley* runs upfront, navigating between the rocks; I follow in the boat *Livingstone*. The Yamaha engines roar at full throttle. There's that familiar nervous feeling, buttocks clenched, eyes squinting against the glare of the afternoon sun on the river, holding your breath while waiting to hear the sound of tearing propeller blades against rocks or, worse still, the smashing of an outboard gearbox. Thrilled to be on an engined boat and not the usual dugout, local fishermen guide us upstream. Between rapids we throttle back to save juice. It's slow-going, zigzagging around sandbanks, rapids, fallen trees and pods of hippo, but today, despite being sunburnt and worn-out, there is a new feeling of excitement. We can taste victory. River life on cramped expedition boats will soon be over. Just 48 kilometres to go to the rendezvous point where Steve and Joceline, in the two Land Rovers, will haul us off the river. Tonight we will celebrate! The expedition will be reunited, there will be ice in our Captain Morgan, fresh meat and vegetables, dry clothes. Tonight, the bhangra dancer will boogie again.

On the riverbank we stop to make an HF radio call to the land party. Ross stretches the aerial between two boat paddles dug upright into the sand. Local villagers gather around to stare at the dishevelled expeditioners, the village headman offers us ground nuts, and the heat burns down. Ignoring the danger of crocodiles, we sit in the cool water next to the boats, dipping our heads under the water from time to time. Dead on 12:00 noon, we hear our call sign over the static: 'Great Explorers, Great Explorers, do you copy?' Ross races excitedly for the radio. Steve in a tired voice delivers the bombshell. He explains that about 80 km from the rendezvous point a pole-bridge has washed away. It is a raging torrent deeper than a Land Rover – impossible to winch across – and the surrounding area is all swamp. The villagers can only rebuild the bridge in the dry season.

'I'm really sorry, it's pissing down with rain again. There is nothing we can do. We must go back to higher ground. Talk again in one hour's time. Over and out.'

Taking it on the chin

Ross gazes at the radio in stunned silence. I start to giggle. This, after all, is what expedition life is about – learning to cope with the unexpected.

Taking a stick, we map out our options in the sand. One possibility is to give away any excess kit to the local villagers, make the boats as light as possible and head downstream. Once fuel has run out, row all the way back down to the Indian Ocean, where Steve and Joceline would pick us up in the Land Rovers. None of us like this option, however. It would be going backwards; we would have to abort the rest of the expedition.

The next option is to head on to the village of Negomane in the hope of finding fuel, then push on even further in the hope of finding a way off the river.

The radio crackles into life again. This time it's Neville Slade, Veronica's fiancé, who's based at Lichinga, down towards Lake Niassa. He's a keen adventurer himself and has been party to all our HF radio calls. He explains that if we can reach a village called Gomba, situated on the south bank of the Rovuma, at the end of a track that crosses the vast unfenced Niassa Game Reserve, he will attempt to meet us there. With him he will bring an armed ranger, four local tribesmen and a chainsaw and axes to remove trees that have been knocked down by elephants and are certain to be blocking the track. He has a winch, mud ladders and radio 'comms'. Neville explains carefully that there is no guarantee whatsoever that he will make it, and it could take at least three days.

We all favour this option as it means we'll be able to remain true to our expedition objective, which is now to reach Lake Niassa, Livingstone's Lake of Stars, following much the same overland route that Livingstone had taken in 1866. But can we reach Gomba on the remaining outboard fuel? And what about the serious rapids that lie further up the Rovuma? Steve and Joceline, our wonderful land party, who have put up with so much, will have it tough. They will have to back-pedal 1 200 km all the way to the coast, and then down to Nampula to hopefully meet us at Lichinga, the exit point of what we are now calling Neville's Rovuma Relief Expedition. So much hangs in the balance ….

Endless rapids

It is day 46 above Negomane and the beautiful confluence with the Lugenda River. We take the best part of the day to get around a roaring waterfall. With aching arms and 100 m of rope, we push and pull over endless rapids. At times it is a recipe for bloody disaster – up to our necks in water, we often lose hold of the boats and are swept downstream as live bait for crocodiles.

Ross swears at Veronica, telling her to be more 'bloody careful' as she gets swept under the boat and nearly gets caught in the prop. We're all on edge. Just imagine being chopped up … the blood in the water … the crocs!

I ponder how we'd struggle to survive without Ross. His navigational ability and knack of being able to read the river finally gets us through to Gomba, where, above the village, the boat crew throw themselves down on a reeded sandbank island covered in elephant tracks. We've made it with just a few litres of outboard fuel to spare. I give my Yamaha Enduro a final rev and pat the warm engine cowling with respect. The engines have done an incredible job. We pitch our Howling Moon tents and Mashozi cooks up a bean stew. We've only enough food for one more day.

For Livingstone, locating food was a constant problem.

> *The chief trouble was that the slave traffic has so ruined the country that the tribes have no grain to spare, and would not sell for ordinary trade goods.*

From bad food and water, Livingstone had developed serious stomach trouble and was constantly plagued by dysentery. He'd learnt to combat malaria with his own quinine-based pills, but the recurring dysentery was wearing him down. Despite his inability to get on with fellow European travellers, Livingstone never lost his ability to be respectful to the Africans he met along the way, indicated by this story that emerged some years after his death.

> *In 1877 Bishop Chauncey Maples met at Newala, in the uplands of the Rovuma valley, an old man who with much ceremony presented him with a coat, mouldy and partially eaten by white ants, that had been given him, he said, ten years before by a white man 'who treated black men as brothers', and whose memory would be cherished; a short man with bushy moustache and keen piercing eye, whose ways were always gentle, and whose words were always kind, whom, as a leader, it was a privilege to follow, and who knew the way to the heart of all men.*

A drawing from Livingstone's field notebook

MASHOZI
AND
ROSS
LAKE
NIASSA

Livingstone's old coat, found here on the Rovuma, is now exhibited at the Livingstone Memorial Museum in Blantyre, Scotland.

Rovuma Relief Expedition

It has been a privilege following Livingstone's journey this far up the Rovuma. Our next challenge is to search for an overland route that will take us to Lake Niassa. We are all apprehensive. What if Neville's Relief Expedition does not arrive? We sit around the HF radio, waiting for the next contact. If he can't make it to the river, we'll have to leave the boats and kit and make our way on foot, through elephant and tsetse country, to rendezvous with him. So we wait.

In the distance, we hear a chain saw, then the revving of a vehicle. The villagers shout from the riverbank downstream. Ross sends off two pencil flares in quick succession. Veronica and I jump in the boat *Livingstone* and head across to the south bank. There we find Neville, looking worn-out in a torn shirt, shorts and boots. The radiator cover of his mud-splattered vehicle is choked with grass seeds. Veronica leaps into his arms.

That night, sitting around the fire, we feast on all the goodies Neville has bought from Lichinga: fresh bread, cheese, imported Portuguese sausages, rice, bully beef and beans. And tins of Coke for the Captain Morgan. Isn't it just wonderful when a crazy plan comes together?

We celebrate well into the starlit night, our roars of laughter interrupted by a grunting hippo, the far-off cackle of a hyena and the loud trumpeting of a nearby elephant.

Journey to Lichinga

You have to be crazy to attempt this track in the wet season. The journey across the Niassa Game Reserve is a nightmare, especially for the expedition team perched on top of the load of rolled boats and Yamaha engines. The eight of us hold on for dear life, fending off attacks of tsetse flies and being swatted by low-flying branches. As if the river wasn't enough, we have to dig and push, repair pole-bridges, and get speared by grass seeds that fly off the bush bar into our faces. The tsetse flies, which seem to favour Ross, grow fat on our blood. I tell him it's because his feet stink. The trees and scenery are truly magnificent – great *inselbergs*, huge rocky outcrops that stick out like tall islands in a sea of trees.

Ross is nearly decapitated by a strand of disused electric fence, stretched across the track from a time when fences were placed to protect village crops from

marauding elephants. Now most of the high-tensile wire has been stolen for snares, and the solar panels have disappeared into far-off villages. Poaching remains a problem – we'd been offered 'bush' meat on the river. Still, it is one of the most spectacular areas of wilderness we have ever seen.

It's a dark Easter Saturday night by the time we lurch into the village of Mecula – a muddy street of thatched huts, a landmine de-mining unit and a few dilapidated old Portuguese administrative buildings. At a noisy bar, sweaty drunk bodies squash together, gyrating to loud music played through half-blown, scratchy speakers. In search of drinks to ease our journey, I walk out of the dark and into this den of happiness. A drunk, seeing my bearded figure lit by my head-torch, whispers Osama … Osama bin Laden! The crowd parts. I make my purchase and disappear into the night. By now the CIA have probably received strange rumours from Mozambique's Niassa Province.

At Lichinga, a few days later, we're all united once again – not only with Steve and Joceline, but also with good friend Charl van Wyk, who has travelled all the way from South Africa to support us on the lake. Everybody is tired, but in one piece – each with his or her own story to tell.

We camp out on Neville and Veronica's veranda. Lawrence, their little blond-haired boy, loves the bhangra dancer. We empty a bottle or two, there's the luxury of fresh bread and meat on the coals, and the humour and anecdotes of a shared adventure. Loaded with boats and equipment, the two mud-stained Land Rovers stand side by side. With Steve and Joceline is Shadrack, their Mozambican translator, a funny little guy who can't say Joceline so calls her Geografin – which, considering our journey, is quite apt. Everyone has gone through hell to get us this far.

And tomorrow, we load up for the lake!

A lake shared by three nations

From Lichinga we drop down over the eastern wall of the great African Rift Valley. On reaching the lake, we bid a fond farewell to Neville and Veronica, friends with whom we've been privileged to share one helluva adventure.

Livingstone arrived on the lake on the 8th August 1866.

> *We came to the lake at the confluence of the Misinje, and felt grateful to the Hand that had protected us thus far on our journey. It was as if I had come back to an old home I had never expected to see again, and it was*

David Livingstone's Field Notebook

FOR 23 AUGUST, 1862 TO 19 MARCH, 1863,
COVERING THE PERIOD OF HIS EXPLORATION
OF THE ROVUMA IN BOATS
AND HIS RETURN TO THE ZAMBEZI REGIONS,
BY WAY OF THE COMORO ISLANDS,
IN THE 'PIONEER'

pleasant to bathe in the delicious waters once more, and hear the roar of
the sea, and dash in the rollers. Temperature 71° at 8am, while the air
was 65°. I felt quite exhilarated.

The bhangra dancer bops a farewell as the local crowd that always gathers roars
with delight. Ross, Mashozi and I launch into the 100 million-year-old Lake Niassa
(you never call it Lake Malawi while on the Tanzanian or Mozambican side; to
them, it is, and always will be, Lake Niassa – or Nyasa). In the local dialect, this
simply means 'broad waters'. Running with the wind in a massive swell, we follow
Livingstone's journey up the Mozambican and Tanzanian lake shores.

By midday, the wind is howling and we have to hold on for dear life,
accelerating up the mountainous swells, then tapping off to surf down the other
side. If we breach, the whole expedition ends up in the drink. As always, there's that
exhilarating feeling of living on the edge; being close to nature and its elements.
To ease aching muscles, we swap positions in the boat. No sooner do you apply
blockout to your tortured nose, it gets slapped off by the next wave.

It was on 2nd September 1861, two years after Dr Livingstone had first discovered
the lake, that he and a small party of men emerged from the Shire River to become
the first Europeans to sail on the broad waters of Lake Nyasa/Niassa. Making their
way up the east coast of the lake, along the present-day shores of Mozambique and
Tanzania, they had a tough time of it. Sailing in an open boat, they were scorched
by the sun and battered by huge waves and storms that threatened to destroy them.
Matters were not improved by a robbery, which reduced them to their underclothes
and a starvation diet. In Livingstone's journals, he wrote once again of the horrors of
the despicable slave trade – the skulls, bloated corpses, and how, on one occasion, the
explorers had to draw their guns to prevent a murderous attack. On 7th December
1861, he wrote this report to the Royal Geographical Society:

We have been up Lake Nyasa, and carried a boat past the cataracts to
explore by. Went along the western shore; it is very deep, from 20 to 50
or 60 miles broad, and over two hundred miles long. It was excessively
stormy and you must not despise us for failing to find out all about the
Rovuma. We were on the west side, and could not cross in our little
boat at the period of the equinoctial gales; then we could get no food
in a depopulated part of the country near the north end. Pirates live
on detached rocks, and human skeletons and putrid bodies were lying
everywhere. It was a fair deadlock for us and we came back.

The Livingstone mountains

To this day, few foreigners travel up the Mozambique and Tanzania shoreline, and as we follow Dr Livingstone's route, we find the same curiosity that often overwhelmed him. The villagers come out in force to watch us pitch camp. They are amazed by our engined boats, tents and strange equipment. It's difficult for Mashozi, as there's simply no privacy. They follow her every move – even when she takes off into the bush armed with loo paper and a spade! She's a remarkable woman, and over the years she's learnt to cope with most situations. The villagers roar with laughter as I comb my beard in the morning, and they stand whispering and pointing as Ross makes his early morning and late afternoon HF radio calls.

The radio keeps us in touch with the outside world. While we wait for our land party to come on the air, we listen to Swahili voices from East Africa. This morning there's a somewhat agitated English voice talking to a man in northern Uganda. A bus has been shot up by the rebels, the driver and a number of passengers have been robbed and killed, some have been abducted.

I look around me. The people of this lake are friendly and peaceful. Nearby fishermen come over to chat and light a cigarette from the coals of our fire.

Further north, the Livingstone mountains rise steeply out of the lake. Camping places are difficult to find, and high waterfalls tumble into the lake waters below them. In the pouring rain we take shelter on a tiny strip of beach. I feel as if my bones have been stretched on a medieval rack. The villagers rush forward to help us pull our boat up and away from the waves that crash into the shore. Despite the difficulties, there's always something exciting and different: the incredible mountains, the good humour of the fishermen in their dugouts, the cry of a fish eagle surveying the timeless lake from the heights of an ancient baobab. I wouldn't change this way of life for anything.

As it happened, David Livingstone never reached the end of his lake, nor even saw it. Sickened by the death and destruction of the slave trade, his expedition turned their boat back. Their last latitude taken was 11° 44'S in the vicinity of present-day Vsisya. They could see the mountain beyond a narrowing of the lake and convinced themselves they were now near its further extremity. To the day he died, Dr Livingstone believed Lake Nyasa to be 100 miles shorter than it really is. He never set foot on the far range of mountains that bear his name, nor did he climb to the heights of Livingstonia, where the mission station named after him now stands.

Lake of Stars

Further north we turn the boat away from the Livingstone mountains. The rain clouds are behind us now and the water an inky deep blue. In the distance, a giant cloud of *nkungu* lake flies sweeps across the water. Fishermen caught in the cloud have been known to suffocate. The locals catch the flies in nets and fry them. We're down to the last four jerry cans of fuel. That should be just enough to get us across the lake and down to meet the land party tonight. If all goes well the bhangra dancer will perform on the bar counter at Nkatha Bay in Malawi, on the opposite shoreline.

I look at Mashozi and Ross, burnt brown by the African sun. Their bodies, too, I'm sure, are stiff and sore from the hard ground at night and the constant pitching and rolling of the boat. But once again our little family unit has survived.

We commence the 80-km diagonal crossing. It's an eerie feeling – in a small boat in the middle of nowhere! I know Mashozi is nervous about running out of fuel, or a storm, or both. I give her the controls to take her mind off things. I wink at Ross. He opens the battered cool box and pours two stiff ones. Mashozi scolds us. 'Typical!' she shouts. 'What happens if something goes wrong out here?'

Ross grins. 'Don't worry, Mom,' he says. 'We'll make it.'

I gaze out across Livingstone's lake. It's no wonder that the Royal Navy Officer Lieutenant ED Young, who first circumnavigated the lake, claimed that this was the most beautiful sight he had ever seen in the world, and named its northern range the Livingstone mountains. Dr David Livingstone, who first discovered the lake for the Western world in 1859, called Nyasa the 'lake of stars' because of the way sunlight dances on the waves.

And for us, our humble family journey by Land Rover and open boats will always be simply remembered as Río Rovuma, Lake of Stars.

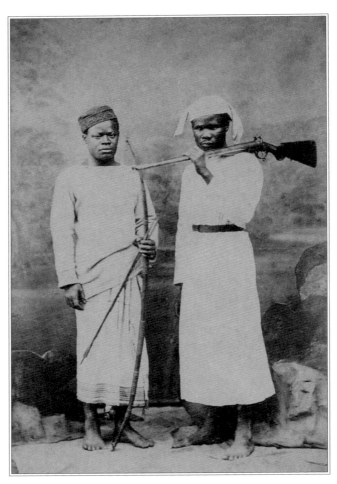

James Chuma and Abdullah Susi

Chapter V

Chuma and Susi

Two Unsung Heroes of African Exploration

Being a Narrative of Dr Livingstone's last
Journey – the Longest and most Historic Funeral March in
African history – A Tribute to the Loyalty and Bravery
of Chuma And Susi without Whom the
Story of the Final days of
Livingstone's Life would Never have been Told

The whole Enriched with old Woodcuts, Maps
and Excerpts from the Handwritten Journals
of Dr David Livingstone

Death at Chitambo's

It was at Chief Chitambo I's village, on the fringes of Lake Bangweulu in May 1873, that one of the porters, taking a sharp knife, cut Dr Livingstone's body open and, with blood-drenched fingers, searched for the missionary explorer's heart.

It's something of an untold Central African story that has always fascinated me. Over the years I've often imagined the events that unfolded on the 1st of May at Chief Chitambo's village in present-day Zambia.

It was at about 4am that the youth, Majwara, sounded the alarm from where he was stationed outside the *bwana's* hut (*bwana* is Swahili for 'mister' or 'sir'). Grabbing their spears and wiping the sleep from their eyes, Chuma and Susi rushed to the doorway of the rudimentary hut and peered inside. They were heartbroken to witness that their leader and companion had died during the night.

Chuma and Susi had been Dr Livingstone's loyal travelling companions for nearly 15 years. For them and a little band of faithfuls, it must have been a grievous blow. With their friend, they had faced unimaginable dangers and hardship, sharing hundreds of lonely campfires while searching for the world's greatest geographic prize, the source of the Nile. They had seen Dr Livingstone escape death many times. They also must have known that were he to die in the wilds of Africa, his wish was to be buried back in Scotland, his country of birth. Suspecting that Chief Chitambo would demand a huge *hongo* (ransom), Chuma and Susi secretly carried Livingstone's body out of the village.

I could imagine the scene: the corpse beginning to bloat and smell in the African heat, flies buzzing and vultures circling slowly overhead. The logical thing would have been for them to dig a hole, throw in the corpse and get the hell out of there! But such was their loyalty to Livingstone, they decided they would attempt to get his body home.

I imagined Chuma and Susi and the other porters gazing down at the lifeless form of their beloved friend, his sunburned face etched with lines of pain and weariness from his travels.

They stripped him of his tattered Victorian clothes and watched whilst Farijala, one of the porters who'd worked for a surgeon in Zanzibar, took a knife and cut open the emaciated body. Carefully he removed the heart, lungs and intestines and a massive blood clot the size of a fist – the probable cause of Livingstone's death. Lovingly they placed Livingstone's heart in an old watertight biscuit tin that he had

LIVINGSTONE EXPEDITION
A TRIBUTE TO
CHUMA AND SUSI

Captain Morgan
ADVENTURE

Blantyre, Scotland – birthplace of David Livingstone

CHIEF CHITAMBO
PALACE
welcome visitors

ROSS
LOOKING
FOR A WAY
FORWARD

TOUGH ON THE LANDIES – HEAVY
GOING THROUGH THICK REEDS

used to protect his expedition journals. Then, digging a deep hole, they buried the tin under a giant *mapundu* tree. I imagined the solemn occasion: one of the men reading the burial service as they lowered the tin into the hole. The man on whom they'd relied for leadership and protection was now dead and Livingstone's heart lay where it belonged – in African soil.

In order to preserve the body, Chuma and Susi rubbed salt into the gutted corpse, turning it every few hours in the sun – just as one would when drying a fish caught in the lakes of Central Africa. As an extra preservative, Livingstone's face was bathed in brandy. A stockade was built to keep out the lions, hyenas and other predators. Then his body was lovingly placed in a hollow bark cylinder. Susi added the finishing touch to the makeshift coffin by tarring it, ensuring that it was waterproof. The cylinder was then stitched up in an old piece of sailcloth and lashed to a pole; like a *kitanda* (a litter or stretcher borne on the shoulders of two men), it could then be carried by two men. So began one of the longest and most heroic funeral marches in African history, led by Chuma and Susi.

Blantyre, Scotland

It was a march I am determined to follow. Getting off the London train in November 1999, it's a dull wet day in Glasgow. I stop a red-faced Glaswegian, wrapped in an old duffel coat. He looks and smells like he's had a hard night at the whiskey. 'Can you direct me to the district line that connects to Blantyre?' I ask. Directions come in a broad, guttural Scottish accent. I thank him and take off down the road. Truth is, I haven't understood a bloody word, but I finally find my way to Blantyre, a small town 17 miles north of Glasgow. I have come here in search of Dr David Livingstone's birthplace.

Just off the Blantyre station platform, two welded-metal, life-size figures depict Chuma and Susi, carrying a bundle hanging from a pole. Their heads held high, they appear to be striding forward like men with a mission. Some passerby has stuck an empty wine bottle into the hand of the figure in front. I wonder if the joker knows the full story that's depicted here.

The cold wind bites through my jacket as I swing open the large wrought-iron gates that lead down to an old tenement workhouse known as Shuttle Row, built in 1755. Twenty-four families once squeezed in here, working their guts out in the nearby Blantyre Cotton Mill on the banks of the River Clyde. It was a tough life for the workers. Each family was crammed into a single room measuring 10 by 14 ft – just one room for eating, cooking, reading, mending, washing and sleeping. There was no piped water and garbage was sloshed down rough sluice holes cut into the sides of the circular communal staircase. It was here on the

19th March 1813 that David Livingstone was born, the second of seven children. Two of them died in infancy. Now this old building is a historic museum, a tribute to Dr David Livingstone.

George Paton, chairman of the Livingstone Trust, knows of my intention to follow in the footsteps of Chuma and Susi. He shows me to the small room that the young David had shared with five brothers and sisters, his father Neil and mother Agnes. I walk through the ruins of the old mill where the young Livingstone had worked for 2 pence a day. I imagine the sound of the slow-turning water wheel driving the belts and pulleys. The shouts of the workers and the cries of the child labourers who were kneed and cuffed into action. Unable to afford the horse carriage fare, it was from here that the young David, then 22 years old, had walked through the snow to Glasgow, found lodgings at Rotten Row and qualified to become a medical doctor. Now I understand where he got his Scottish grit and determination from. Whatever one might think of the man, he travelled an amazing 30 000 km across Africa, mostly on foot. He mapped a staggering one million square miles or thereabouts. Florence Nightingale called him a saint – his actions helped bring about the abolishment of the despicable slave trade.

His widely read books and deeds encouraged others to follow in his footsteps, but Livingstone's last journey would have remained unknown had it not been for Chuma and Susi. Not only did they take his body to the East African coast but also his journals, Bible and private belongings, all of which now grace this wonderful little museum. And the city of Blantyre in Malawi is named in honour of this village on the River Clyde.

A real prize

After Scotch broth and sandwiches, and smiles and handshakes from the friendly museum staff, George Paton hands me a handwritten tribute to Chuma and Susi, a message that I hope to carry across Africa to Chief Chitambo IV, in whose great-grandfather's village Livingstone died and where his heart lies buried. I place the treasured document in my green canvas safari bag.

Back in London, I explore narrow cobbled backstreets from one antique bookshop to another. The smell of old leather, doors that chime as you enter and librarian-types who peer at me over their reading glasses – they're all worth it. Finally, I hold in my hands a heavily bound but tattered copy of Livingstone's last journals, printed in 1875. In a rich red-brown-coloured envelope in the inside back cover I find a real prize: a detailed copy of Dr David Livingstone's hand-drawn map compiled from his own observations between the years 1866 and 1873. Mr Waller from the London Missionary Society had added a dotted line that

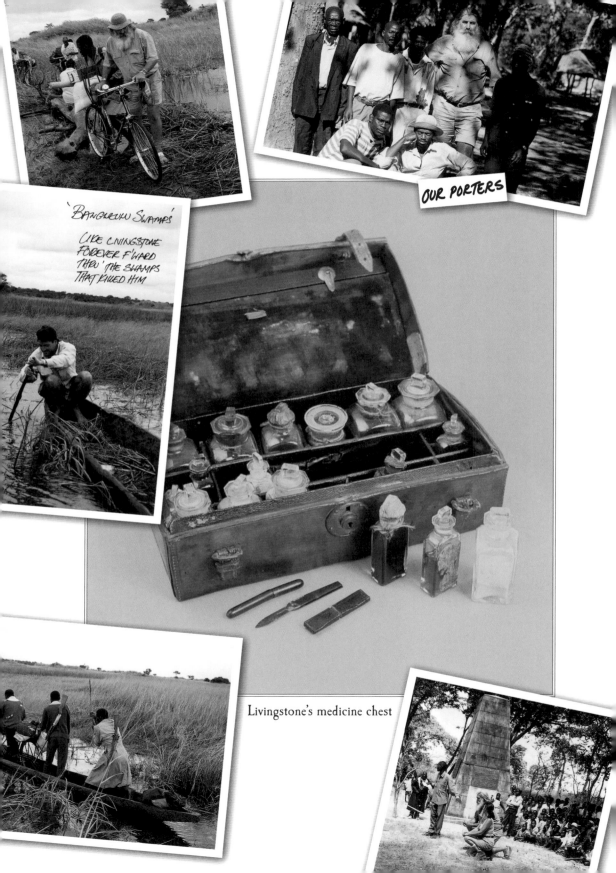

OUR PORTERS

'BANGWEULU SWAMPS'

LIKE LIVINGSTONE
FOREVER F'WARD
THRU' THE SWAMPS
THAT KILLED HIM

Livingstone's medicine chest

clearly shows the route taken by Chuma and Susi's brave party as they carried Livingstone's corpse from Chief Chitambo's village all the way to Bagamoyo, opposite Zanzibar on the east coast of Africa. Turning to the last few pages of the journal, I find an account of the heroic funeral march as told by the two loyal heroes, Chuma and Susi. It's exactly what I've been looking for.

Later that day at Westminster Abbey, with my bush hat in my hand, I gaze down at Dr Livingstone's gravestone set into the floor of the nave. It's here that his salt-dried corpse, minus his heart, was finally interred in a state funeral that took place on 18th April 1874. The amazing thing is, none of this would have come about had Livingstone's remains been left to rot in Africa. An incredible story of loyalty and bravery.

A familiar feeling of excitement grows in the pit of my stomach. I've made it to Dr Livingstone's birthplace in Blantyre; I have a letter of introduction to Chief Chitambo, signed by George Paton, chairman of the Livingstone Trust; and now, a copy of Livingstone's journal and a map of his final journey across Africa, albeit as a corpse. Another journey is about to begin, this time following in the footsteps of Chuma and Susi, the unsung true heroes of African exploration. What a challenge this will be! Outside the abbey, the autumn wind blows an oak leaf across my path. I pick it up and place it between the pages of my expedition journal.

On the road again

It's April 2000 in South Africa. We've waited for the summer rains to end so that, hopefully, there will be less malaria about. The names *Chuma* and *Susi* are sign-written onto our vehicle doors – one on each of our two turbo-diesel-injection Land Rover Defenders. The copy of Livingstone's journal rests alongside mine in the journal bag; copies of the old maps are placed in a waterproof plastic tube. We load the expedition supplies: medical kit and malaria treatment, tents, bedrolls, pots and pans, the condiments box with South African favourites like Aromat, Marmite, All Gold tomato sauce, rooibos tea, biltong, Mrs Ball's chutney and dry rations. There are also a satellite phone, GPS, large inflatable boat, spare fuel tanks, a 30HP Yamaha outboard engine, the Zulu calabash and a case or two of Captain Morgan rum for the hard times and lonely campfires ahead. Chuma and Susi and their tough band of porters never had it this good.

The saddest part is saying goodbye to the dogs. As always, my favourite and well-trusted expedition companions are Ross and Mashozi – that adventurous wife of mine. We will travel in the Land Rover *Chuma* and old friends Ian and Joy Douglas will follow in *Susi* as our backup team.

A modern-day David Livingstone

In Pietermaritzburg, I meet up with a modern David Livingstone – the great-great-grandson of the original missionary explorer! He gives me this note to take on my journey.

To whom it may concern

The day after Livingstone died, his followers elected Susi leader of the party, and thus began the journey of taking Livingstone's body back to Zanzibar.
He was joined by Chuma and other faithful followers. His body was dried in the sun for a fortnight, encased in a bark cylinder waterproofed with tar, and wrapped in cloth. The journey took almost a year and covered over a thousand miles, often through hostile and suspicious people – in fact a lot of the country was in the midst of a war. (Ten people in the party died on the way.)

The devotion and loyalty of these men was astounding and has never really been given the prominence and the credit it deserves. In a western society with its culture of heroes (and that was a very heroic age), these men would have been fêted, received medals and lauded by that society. In this case it did happen briefly but only in London, a sort of 'success' where they were paraded in society more as a curiosity. On arrival back in Africa they returned to relative obscurity.

It should be noted at this point that although Susi and Chuma were the chief protagonists, there were others in the party whose names we shall never know.

So, with this epic journey in mind, well-known explorer Kingsley Holgate hopes to capture people's imagination (what a terrific adventure story) and make aware that there were unsung heroes on this continent, and that devotion and loyalty and love existed on both sides in an era where greed was the order of the day and rapidly gaining ground.

In view of the African Renaissance, I feel that this would be a marvellous opportunity for a man such as Kingsley Holgate, who knows a great deal about Livingstone himself and who has travelled through much of the country, to be able to bring this epic journey to our notice. Africa doesn't have many heroes. Here we have some.

(Great-great-grandson to Dr Livingstone)

We've called the expedition 'Livingstone's Last Journey', and the farewell is held at Lesedi Cultural Village outside Johannesburg. Lumbaye Lenguru has flown in from Nairobi to join us. Most of the journey will be through wild areas of Tanzania and Lumbaye is a Samburu tribesman from East Africa, an old friend who is like a son to me. He is a great safari hand and we'll also need him as an extra Swahili speaker. Derek Watts, friend and colourful TV presenter from *Carte Blanche*, is there to interview us and we share a pot of Zulu beer. The Pedi people perform a rain dance and the Zulus, with their regimental shields and short, broad-bladed

stabbing spears, do a rhythmic foot-stamping chant that takes us back to the time of their great King Shaka. The Xhosa people dance their chest-beating, body-shaking *uqwensa* and the Basotho, in their colourful blankets and conical straw hats, perform the rhythmic boot-slapping gumboot dance of the South African gold mines. Lumbaye, who is used to the Nilotic high-jumping dances of the red-ochred Samburu and Maasai, is knocked out by the farewell performance – particularly the high-kicking, well-rounded, bare-breasted Zulu maidens …. Journalists scribble and cameras click and roll.

Then the dancers escort us out to the Land Rovers and Lumbaye catches the eye of one of the Zulu girls. Jumping into *Chuma* and *Susi*, we head towards Pretoria and the Great North Road. Ian and Joy Douglas follow behind. We've known them from our old trading days in Zululand and Ian's ambition has always been to undertake an overland safari.

So here we are again, setting off into the unknown. Lumbaye asks me about the Zulus. We talk about their military history and beautiful Nguni cattle. As a Samburu, he, like the Maasai, believe that all the cattle in the world belong to them. Lumbaye's father from Loyangalani in northern Kenya was killed by Somali cattle raiders, his mother was shot and badly wounded and, terrifyingly, his sister was thrown to the ground at the mouth of the cattle enclosure, where the bandits had the cattle stampede over her body, trampling her to death.

Colonial splendour

Chuma and *Susi* grind on relentlessly up the Great North Road, past the giant baobabs of South Africa's northern Limpopo Province. Before crossing into Zimbabwe, we fill our long-range diesel tanks. With the 'land grabs', economic chaos and acute shortage of fuel supplies, Mugabe's one-time paradise is in a mess and there's hardly a vehicle on the road as we head north to *Mosi-oa-tunya*, the 'smoke that thunders' – David Livingstone's Victoria Falls.

Because of the publicity surrounding our journey and out of interest for our expedition, that grand old lady, the Victoria Falls Hotel – built in 1904 – offers to host us for the evening in colonial splendour. Mashozi and I are given the Batoka suite. What a privilege! The window of our lounge looks out over the falls and the Batoka gorge. The level of the Zambezi is so high that every now and then, the wind-blown spray falls on the late-afternoon guests who have come to gaze at the breathtaking views.

We cross the old road-cum-rail bridge over the Zambezi. Cecil John Rhodes had ordered that the bridge be built close enough to the falls for spray from the thundering Zambezi River to fall on the carriage windows. Coming from the arid

vastness of northern Kenya, Lumbaye is amazed at the cascades of falling water. It's the highest it has been in years and, downstream, both the Kariba and Cahora Bassa dams have had to open their sluice gates.

As we head north through the town of Livingstone, I think what a tribute it is to the missionary explorer that, despite the Africanisation of place names, his name still endures, as does Victoria Falls, named after his regent queen.

We dodge the potholes to Lusaka and beyond as we head for Chief Chitambo's palace on the fringe of Lake Bangweulu in northern Zambia.

Chief Chitambo's palace

The whitewashed palace is swept and tidy. A sign orders subjects to get off bicycles and take off their hats before entering. A gate guard dressed in an old khaki bush jacket complete with colonial pith helmet gives us a wide smile and a snappy salute before raising the boom. A thatched rondavel has 'Silence Court House' scrawled in big letters on the wall. The guard ushers us to a small whitewashed office where we introduce ourselves and shake hands with Chief Chitambo IV. He is a slim, middle-aged, bespectacled and well-dressed man with a military bearing. He carries a fly whisk as a sign of rank. In perfect English he tells us that before taking over from his father he was a general in the Zambian army.

'I have approximately eighty thousand subjects and visit all their villages once a year by motorbike, Mr Holgate,' he says. 'All the homesteads must be neat and tidy, sufficient in crop production and have clean latrines. If not, they are evicted from my chiefdom. I do not tolerate witches and employ four witch hunters. The witches are tried in my courthouse and I can show you a pile of confiscated fetishes.'

I don't doubt for a moment that Chief Chitambo means what he says. I glance across at the expedition team, looking like naughty children sitting on a long bench in front of the chief. Mashozi and Joy have both had the good sense to dress conservatively, with knees and shoulders covered. Ian, with his shock of white hair and red sunburnt face, nods in agreement. Wide-eyed Lumbaye has borrowed a pair of Ross's khaki trousers. Too wide for his long-legged narrow Nilotic frame, they're bunched up at the waist and tied with an old beaded Samburu belt. Ross looks serious. I know he will be thinking of the logistics that lie ahead and the importance of getting permission from the chief to proceed.

The chief carefully reads our letter from David Livingstone's great-great-grandson and the letter of tribute to Chuma and Susi that we've brought from George Paton, chairman of the Livingstone Trust in Blantyre, Scotland. I explain the objectives and plans for our journey and politely request permission to travel through his territory. Chief Chitambo is courteous and agrees to consider our

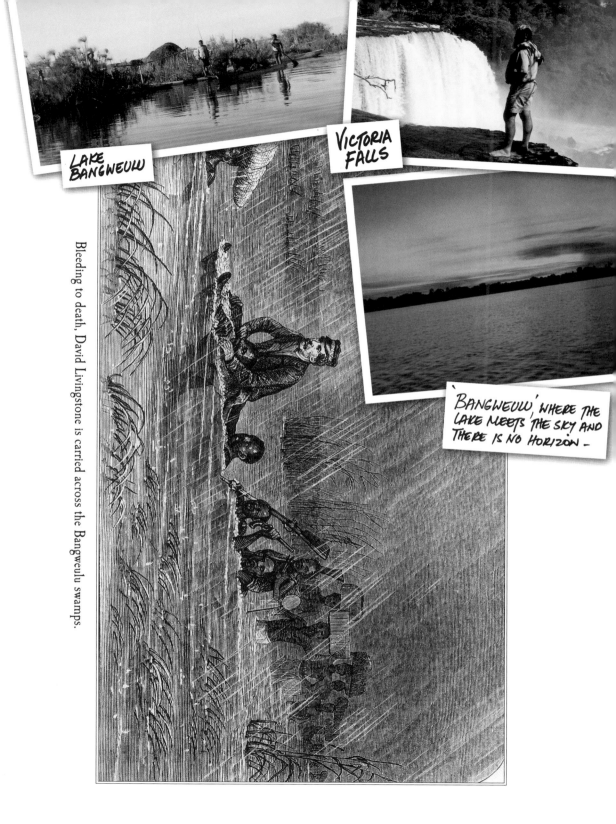

LAKE BANGWEULU

VICTORIA FALLS

Bleeding to death, David Livingstone is carried across the Bangweulu swamps.

'BANGWEULU,' WHERE THE LAKE MEETS THE SKY AND THERE IS NO HORIZON —

request. We should return tomorrow at 2pm. The meeting is closed. I catch Ross's eye. I know what he's thinking …. Is it going to be a money thing?!

That night we share our thoughts as we sit around the fire, eagerly watching the bubbling pots of stew and rice and rising from time to time to fill our enamel mugs. There's the drone of insects, the crackle of the fire and the smell of mosquito repellent. We crawl under our mosquito nets. Tomorrow will tell.

Back at the palace

It's 2pm and the pith-helmeted guard is expecting us – but the chief is still resting. We wait in the shade. I'm on edge, having worked so hard for this moment. I desperately want the expedition to commence well. Finally we're ushered into the office again, where in true African fashion the chief asks, are we all well? We wait patiently as he puts down his fly whisk, takes off his glasses and clears his throat. He has given our request a great deal of thought, but we should understand that not all the land we plan to walk through, as we relive the last days of Dr Livingstone's life, fall in his chiefdom. It is Chief Chiundaponde's territory that lies closer to the lake.

He slowly scribbles a letter to Chief Chiundaponde, requesting him to provide porters and assist in every way. The letter is folded and placed into a sealed Government of Zambia envelope. It is addressed to:

Chief Chiundaponde at own palace
From Chief Chitambo IV at own palace.

Then comes the good news. 'Yes, Mr Holgate, you have permission to cross my chiefdom to walk in the last few days of Dr Livingtone's life and, as per your request, to arrive on the 1st May at the place where his heart lies buried – the exact same day he died in my great-great-grandfather's village in 1873.'

And those magic words, 'You are *welcome*!'

I let out a sigh of relief. Lumbaye jumps up and shakes the chief's hand. 'But,' says Chief Chitambo, 'I want as many of my subjects as possible to be there to welcome you on the day. I will need motorbike fuel so as to spread the word. We'll also need maizemeal and fish.'

Mashozi, who's the expedition bursar, passes over the agreed amount. We all shake hands. I'm overjoyed and relieved, and we all pile into the Land Rovers to follow a remote sand track out into the depths of Bangweulu swamps.

I love Zambia, the politeness of the people, their old world charm and the beauty of the country. Overloaded *Chuma* and *Susi* creak and groan as we sway from side to side through the huge mud holes. In low ratio with the 'diff' lock engaged, we grind through fine, soft, white sand. At times the elephant grass is

higher than the vehicles. Ross guides us across the rickety pole bridges. There are only a few centimetres to spare on either side – one wrong move and we won't be able to stop the vehicles from being drowned.

Late that afternoon we pitch camp at beautiful Lake WagaWaga. Ross and I climb to the top of a nearby hill and, using Livingstone's old map, we are able to take bearings on some of his original landmarks. Beyond us in the sunset stretch the vast Bangweulu swamps – endless reedbeds and waterways fed by 17 principal rivers from a catchment area of 190 000 km². It was this giant swampland that finally killed Livingstone as he searched for the source of the Nile, which he believed flowed out of Lake Bangweulu. Looking out over the vast expanse, I can imagine how it must have been for Livingstone, Chuma, Susi and the other porters, battling through the rainy season, up to their necks in swamp.

Livingstone's personal account

That night with the help of a paraffin lamp I read these notes from Livingstone's journal:

March 24ᵗʰ 1873
We punted six hours to a little islet without a tree, and no sooner did we land than a pitiless pelting rain came on. We turned up a canoe to get shelter The wind tore the tent out of our hands and damaged it too. The loads are all soaked, and with the cold it is bitterly uncomfortable.

March 25ᵗʰ
The flood extends for twenty or thirty miles, far too broad to be seen across. Fish abound and hills alone lift up their heads The wind on the rushes makes a sound like the waves of the sea.

March 30ᵗʰ
A lion roars nightly.

April 3ʳᵈ
Very heavy rain last night.

THE CATHEDRAL IN ZANZIBAR

THE CHURCH AT BAGAMOYO

Livingstone, exhausted and close to death

EMPTYING THE CALABASH INTO THE INDIAN OCEAN

April 6th
The amount of water spread out over the country constantly excites
my wonder; it is prodigious …. It is the Nile apparently, enacting its
inundations, even at its sources.

I could imagine Livingstone's excitement as he believed he was getting closer to finding the source of the Nile – the geographic prize man had been searching for, for over 1 600 years. And imagine how it was for Chuma and Susi, who watched their friend killing himself in the process. In truth, Dr Livingstone had begun to bleed to death from dysentery, an old complaint that had troubled him for years.

On 18th April Livingstone wrote:

I am excessively weak and, but for the donkey, could not move a hundred
yards …. No observations now, owing to great weakness; I can scarcely
hold the pencil and my stick is a burden. Tent gone, the men built a good
hut for me and the luggage.

This is Livingstone's first admission of the full extent of his utter physical exhaustion. In true Livingstone fashion, however, he ends with the feebly scrawled wry comment:

It is not all pleasure, this exploration.

Chiundaponde's porters

Our meeting with Chief Chiundaponde is in an open-sided thatched rondavel. The old chief's hands shake a bit and I get the impression that he wouldn't be adverse to a shandy on a hot afternoon …. As is the custom, we offer gifts and our letter of introduction. The interpreter is called for. He is the teacher from the local school and transposes his l's and r's. The meeting goes well and the chief promises to send us guides and porters to where we will camp at Chikuni island.

Once again, it is tough going for the overloaded Land Rovers. The wheels spin as we push, slide and winch through the black mud – but it's worth it as finally we make it to the wide open plain of Bangweulu. I can't believe it! It's one of the most beautiful sights I have ever seen in Africa. We are surrounded by thousands upon thousands of black lechwe. The floodwaters have receded and, like the wildebeest of

the Serengeti, the lechwe have congregated in massive herds to nibble at the fresh green shoots. The birdlife, too, is prolific. Wattled cranes glide down to earth on massive wings; it's also the land of the elusive shoebill stork.

That night we sit around the fire with our porters, led by smiling pixie-faced Peter Fungameli who, at 72 years, claims he is still fit enough to lead us along the route taken by Livingstone and his party. Peter is Chief Chiundaponde's historian and he understands that our first objective is to follow the last 12 days of Dr David Livingstone's life.

Next morning we say goodbye to Ian and Joy. They will drive the Land Rovers all the way around by sand track to the place where Livingstone's heart is buried, as it's impossible to take the vehicles across the wet Bangweulu swamps. Ross, Mashozi and I will now proceed on foot.

Using the old Livingstone map and copy of his original journal, we set off. The porters use bicycles as wheelbarrows to carry the expedition supplies of tents, mosquito nets, dry rations, first-aid kit, camera equipment and a bottle or two of you-know-what.

We soon get a taste of what it was like for Livingstone, hour after hour. Chuma and Susi must have thought him crazy with his continuous search for some mysterious river source. By this stage of his journey, Livingstone was too weak to walk and was being carried in a *kitanda*. Off with our boots, on with our boots – I sympathise with what he went through as we wade constantly through deep, cold water, our eyes probing for crocodiles.

Livingstone's brief journal entries now read as follows:

22nd
Carried in Kitanda over sponge [swamps] S.W. 2¼ (miles).

23rd
1½ [miles].

24th, 25th
Just 1 mile per day.

26th
Do 2½. To [Chief] Kalungansofu.

From these journal entries, it's obvious that the Livingstone party were travelling painfully slowly. Things were getting desperate, with them having to force their way through the flooded swamps of Bangweulu in the rainy season.

Dr Livingstone being helped into Chief Chitambo's village

Chuma and Susi carrying Livingstone's salt-dried corpse

We find the hospitality in the villages quite overwhelming. They offer us food and shelter despite the fact that some of the kids have not seen white people before and run screaming behind their mothers' skirts at the sight of our motley bunch. The young village women sing beautifully as they pound cassava. Everybody turns out to see the strangers washing at the village well – the sight of me shampooing The Beard is the kids' favourite!

We share the porters' fire at night as, eating with our hands, we dig into a communal pot of maizemeal and chicken. We listen in amazement to the stories being recounted of the past.

Yes, Livingstone came this way! He camped under this giant wild fig tree and Chief Kalungansofu, the great elephant hunter, provided him with dugout canoes when he came to the Molilamo River. Livingstone's journey has become part of the people's history; stories are passed down from father to son, told around campfires like the one we're all sitting around.

Death at Chitambo's

Sitting on the dirt with my back propped up against a miombo tree, rucksack thrown on the ground, boots off, and Mashozi, Ross and the porters gathered around, I page through Livingstone's journal to the entry dated 27th April 1873. By this time Livingstone was too weak to put a foot on the ground without help from Chuma and Susi. I read out the last words Livingstone ever wrote:

> Knocked up quite, and remain – recover – sent to buy milch goats. We are on the banks of the R. Molilamo.

Dr Livingstone was bleeding internally and the reason he was desperately trying to find milk was that it was all he could digest. With each agonising movement he came closer to death, but still he refused to give up.

And here we are, camped at the same place where Livingstone had written those final desperate words. It's a friendly village, but we're tired out and footsore. The spirit of the porters soon improves, however, when I offer to buy three village fowls to add to the evening stew pot. Then I notice a bit of a commotion going on in the village. A large galvanised bath is brought forward and placed behind a grass screen. Soon the village headman arrives with a message for 'Mrs Livingstone'. Her hot bath water has been prepared ….

Somehow, word has got out that Mashozi and I are Livingstone's relatives. Mashozi wallows in the bath and I don't think it wise to correct them.

By 29th April 1873, Chuma and Susi had arranged for Dr Livingstone to sleep in a village hut, but now they feared he was too weak to be moved between the bed in the hut and the *kitanda* outside. The door was too narrow for the *kitanda* to be brought to his side, so he asked for the wall of the hut to be broken down. His pain was so bad he couldn't get into the dugout canoe, so they left him on the *kitanda* and lowered him gently onto the bottom of the vessel. Not only did Livingstone make his last journal entry here; this was also the last river crossing he would ever make in his life.

Next day we also cross the river by dugout canoe.

Step by step, Chuma and Susi carried Livingstone forward until they finally arrived at Chief Chitambo's village. It was drizzling softly so they laid the *kitanda* under the eaves of one of the huts while they quickly built Livingstone a rudimentary shelter out of reeds and grass. By nightfall the hut was ready, the expedition bales and boxes stowed in it, and Livingstone laid carefully on his bed.

And there he lay, suffering. During the night there was a noise as villagers scared a buffalo off their crops. Susi went to tell Livingstone what it was.

'Is this the Luapula?' asked Livingstone, speaking softly in Swahili.

'No,' replied Susi, 'this is Chitambo's.'

'How many days to the Luapula River?' asked Livingstone.

'I think it is three,' replied Susi.

Livingstone gave a painful sigh and seemed to fall asleep. At about 4am Chuma and Susi were summoned to the hut by the night guard, Majwara. By the dim light of a candle stuck with its own wax on a box, they could make out Livingstone kneeling in prayer by the side of his bed, his body stretched forward, his head buried in his hands upon the pillow. Beside him was his Bible, but there seemed to be no sign of breathing. One of them went forward and felt his cheek. It was cold. Livingstone, one of the greatest explorers of all time, had died a sad and lonely death on the desolate shores of Lake Bangweulu. He was 60 years old.

A pig for the slaughter

I have a lump in my throat. I feel emotional and footsore as Mashozi, Ross and I, together with our weary porters, walk slowly down the track that leads to Chipundu village. Chief Chitambo IV, Chief Chiundaponde and over a thousand of their colourfully dressed subjects wait to receive us. Here, on this precise day 127 years ago, Livingstone died. Here, under a giant *mapundu* tree, his two faithful and loyal African followers Chuma and Susi buried his heart.

At the ceremony, we hand over to Chief Chitambo IV a Chuma and Susi brass plaque of tribute, a remembrance to the fact that it was here, in his great-grandfather's village, that they had witnessed Livingstone's death. Through Chief Chitambo's interpreter, I am able to remind the audience of this incredible piece of history; how, after Livingstone died, Chuma and Susi had remained level-headed. How they'd salt-dried his corpse and packed his personal goods, his stubs of pencil, his journals, his Bible, sextant and compass and the red shirt that Henry Morton Stanley had given him. How Chuma and Susi had risked death to carry Livingstone's body across Africa to Bagamoyo on the coast of Tanzania. How ten of the porters had died doing so. I explain that we've come to this place in Livingstone's footsteps, but will now leave on a journey of tribute to two of Africa's great unsung heroes, Chuma and Susi.

The crowd cheers, the singing and drumming begins. The tempo increases and later on, after the chiefs have left, a woman dressed in beads and skins becomes possessed, her eyes rolling back in their sockets. In a trance she dances furiously to the drums before collapsing in a heap in the dust. The drums continue into the night. The porters slaughter a pig and bring the liver for me to eat.

What a wonderful party of men they've been. Livingstone would have been proud of them.

In the footsteps of Chuma and Susi

Next morning, from a little stream next to the memorial where Dr Livingstone's heart lies buried, we fill our expedition calabash with water to be carried across Africa to Bagamoyo.

Back with Ian and Joy in our Land Rovers, we bid farewell to Chief Chitambo and the porters as we head east for the Luapula River to trace the footsteps of Chuma and Susi's brave funeral party.

Travelling by 'banana' boat, we cross the Luapula River. What must Chuma and Susi have thought as they crossed here, Livingstone's body in the bottom of the dugout? He had fought so hard to reach this river, believing it to be the source of the Nile. Unbeknown to Chuma and Susi, the Luapula *is* part of the source of a great river – but not the Nile; rather, the mighty Congo.

In our case, the Land Rovers had carried us here rapidly. For Chuma and Susi, just to reach this spot on Lake Bangweulu they had lost several of their party to fever and paralysis from constant wading through the cold water. Their pack-donkey had been killed by a lion and they'd had to fight their way out of a hostile village. Such courage and loyalty!

Dr Livingstone's funeral, Westminster Abbey

Lake Bangweulu is a fascinating place. In the Bembe language it means 'place where the water meets the sky' – and, truly, no apparent horizon exists. In the fishing village, we're told about people that turn into crocodiles. In the backwaters of the lake, we find a giant shoebill stork. As the sun begins to set, so the lake meets the sky and the dugouts on the water seem to hang in mid-air.

Across the Kalungwishi River, then down into the Rift Valley and around Lake Rukwa we continue travelling in the tracks of Chuma and Susi and finally arrive at the southern shoreline of Lake Tanganyika. Here, our transport is local 'engine dhow' but we constantly need to use the bailing bucket as the skipper stops from time to time to stuff more cloth between the seams of our leaky tub. Still, we make it to the colourful market town of Mpulungu.

Lake Tanganyika is the world's longest freshwater lake and Africa's deepest (over 1 400 m in depth). It lies at an astonishing 650 m below sea level. The only lake on our planet that's deeper is Lake Baikal in Russia. Lake Tanganyika has a total volume of 19 000 km³, representing nearly one-sixth of the world's liquid fresh water.

Livingstone, together with Chuma and Susi, first saw this lake in 1868. He wrote in his journal: *'After a fortnight on this lake, it still appears one of unsurpassing loveliness.'* I try to imagine how Chuma and Susi must have felt, this time carrying his salted corpse as they made their way north to Tabora, shooting buffalo as they went to barter for permission from the chiefs, who were mostly unhappy about allowing the body of a dead white man to cross their area. Such a thing had never been encountered before; they were concerned about possible evil spirits and the 'devil' of the white man.

Heading north from Lake Tanganyika we make our way to the Kalambo Falls, which drop a staggering 220 m into a gorge above Lake Tanganyika – a height more than twice that of the Victoria Falls. And above the cascading waters of this, the second highest uninterrupted waterfall in Africa, giant marabou storks soar in the thermals. For some distance, the Kalambo River here marks the boundary between Zambia and Tanzania.

We camp at the border under the Zambian flag. The customs officer has gone on a raid to curtail the movement of cooking oil across the border. A difficult task, given the thick miombo woodlands, and so we wait, fully realising that whilst the Swiss might have developed the clock, it is good old Mama Africa that still owns the time.

Our destination is Tabora, in the centre of Tanzania. Here we are, attempting to follow a line on a map drawn over 100 years ago, bearing in mind that it had taken Chuma and Susi nearly four months to reach this point. Some days we drive all

day to achieve just 50 to 60 km. We're having to follow footpaths and tracks, and it's really tough going for the Land Rovers – and for us, too, as we get zapped by thousands of tsetse flies. Even worse are the stinging hairs of the buffalo beans as we push through the thick undergrowth. Still, the country is fascinatingly beautiful. We come across elephant and other game, and the rivers are teeming with hippo and crocodile. Outside Tabora, at a place called Unyanyembe, we find the old Arab house at which Stanley said farewell to Livingstone.

It was to this Arab *tembe* that Chuma and Susi headed. Five months after they'd left Chief Chitambo's village, they found Lieutenant Cameron and a party of Englishmen – the East Coast Expedition – looking for Livingstone. The Englishmen demanded that the body of Livingstone be buried there, but Chuma and Susi bravely stuck to their guns, insisting that it was Livingstone's wish to be buried at home in England. So their brave journey to the coast continued, as they smuggled Livingstone's body through hostile areas, made a detour round the fierce Wagogo tribe, and lost an expedition member to snakebite poison. Dr Dillon, one of the English party sent to accompany Chuma and Susi, suffered so badly from fever that he blew his brains out. And still, the funeral party followed its path east towards the coast.

The final chapter

From Tabora, Ross, Mashozi and I take the old German railway line from Lake Tanganyika. It follows the old slave traders' route across Africa – the same route used by Chuma and Susi. It's a fascinating ride – a crowded moving market traversing Africa, carrying salt-dried fish from the Tanganyika and Victoria lakes and bringing back trade goods from the coast. There is buying, selling and bartering at every stop. It's hopelessly overcrowded, the toilet smells, delays are frequent, derailments are not uncommon – but the people are wonderfully friendly.

Then, having survived the train ride, and together once more with the Land Rover party, words cannot explain our arrival in the old slave-trading port of Bagamoyo.

Chuma and Susi arrived, finally, in February 1874, nine months after they'd buried Livingstone's heart near Lake Bangweulu. Unimaginable, their relief, as they laid down the tattered bundle that was Livingstone, placing it reverently at the doorway of the Christian chapel in Bagamoyo.

There was an all-night vigil of singing and praying. Over 700 freed slaves filed past to pay their final respects to the 'friend of the African' who had fought so hard to abolish what he called 'the open sore of the world'.

Word soon reached the British in Zanzibar, and Livingstone's body and his personal possessions were handed over. Chuma and Susi were paid for the journey. Livingstone's salt-dried corpse was taken to Zanzibar, then across the seas to Southampton to be welcomed in a royal 21-gun salute. From there his body was carried by special train to the Royal Geographical Society headquarters in London, where it was positively identified by the fractured left arm, the result of that earlier terrifying lion attack.

It was a national day of mourning and thousands of people wept inside and outside Westminster Abbey. Queen Victoria sent a wreath; Henry Morton Stanley, who immortalised those words 'Dr Livingstone, I presume?', was a pallbearer, as were other famous men of the Royal Geographical Society.

To my mind, there were two brave men missing at the funeral: Chuma and Susi. Late that afternoon, and sailing with the wind by Arab dhow, we empty our Zulu calabash of water taken from Chief Chitambo's village where Livingstone's heart is into the Indian Ocean off Zanzibar. This is our final tribute to Chuma and Susi – two great unsung heroes of African exploration, without whom the final chapter of Livingstone's story would never have been told. Sailing with the trade wind in a lateen-rigged dhow, our odyssey ends in Zanzibar's old Stone Town. It feels good to have the wind and sun on our faces and feel the satisfaction of a completed journey.

The cathedral in Zanzibar is built above the old slave pits. The old whipping block is the pulpit and hanging on the wall of the cathedral is a small wooden crucifix, carved from the tree under which Livingstone's heart lies. The beautiful voices of the church choir sing in Swahili, beams of tropical sunshine stab through the stained-glass windows and in the distance we hear the Muslim call to prayer.

It has been an unforgettable journey.

Henry Morton Stanley

Chapter VI

Zanzibar to Victoria-Nyanza

A Journey

Being the Narrative of an Adventure
in the Footsteps of Henry Morton Stanley and
Comprehending what is Remarkable and Curious
in the world of African overland Travel

An authentic Account of Meeting the Wagogo, the seven-foot Warimi and
the Sukuma tribespeople – an Empty grave in the Wilds – a Baobab
forest in Full Moon – celebrating Spring with the waSukuma
usawo Dance – a Dusty dice with Death

Zanzibar to Bagamoyo

The hand-hewn mast on the lateen-rigged dhow creaks and groans as the Kusi trade wind pushes us westwards towards Bagamoyo, fast leaving the lights of Zanzibar behind us. There are 26 of us on board the *jahazi* dhow named *Baghdad*: four crew, the rest passengers. We sit on a pile of cargo tied down with an old green plastic tarpaulin. Every now and then some of the passengers roll out their little prayer mats and bow to Mecca. The 'nonbelievers' smoke, laugh and chat up the two brightly dressed Swahili girls while a crew member, high on *bungi*, tries in an irritatingly loud voice to auction off a basket of fresh *mandazi* (doughnuts).

An occasional wave breaks over the gunnels, setting the man with the blue bucket to work at baling out the smelly bilges – which have one of the passengers puking overboard. The skipper, dressed in an old T-shirt and *kikoi*, sits dozing in his corner at the stern while the younger crew members take turns on the well-worn wooden tiller arm. I am the only white man on board. These days, foreigners are not encouraged to ride on dhows; there have been a few drownings and to get on board, I had to write out my own indemnity and pay an extra 10,000 Tanzanian shillings to the dhow captain.

No compass or life jackets – only the moon and stars and the pitch and roll of this ancient craft built from mangrove ribs and pit-sawn planks, caulked with cotton waste and palm-nut oil, the whole held together by large, hand-beaten iron nails and a high degree of optimism. For centuries dhows like this carried the Arab trading caravans and early explorers from Zanzibar to the mainland. Sadly, they brought back ivory tusks to be turned into billiard balls and piano keys, as well as thousands of slaves – human cargo that was sold off in the auctions of Zanzibar.

The massive hand-stitched cotton sail glows white in the moonlight. A young man by the name of Dixon, who speaks a little 'eenglish', squeezes in next to me. He was born in Zambia and, a wood carver, had moved to Bagamoyo. Dixon asks me, why am I scribbling all the time in my little notebook? I explain that I'm simply recording the journey while making my way to Bagamoyo, and then overland to Lake Victoria by Land Rover, tracing the footsteps of the famous explorer Henry Morton Stanley. I let Dixon read from my copy of HM Stanley's journal. The entry for 12th November 1874 reads:

> *Left Zanzibar for Bagamoyo. End of Ramadan. Today my people embarked in six dhows and sailed for Bagamoyo.*

Dixon hurriedly explains the nature of my journey to the crew and passengers of the leaking *Baghdad*. Relieved, they laugh and shake hands. 'You see,' says Dixon, 'under the plastic tarpaulin – it's all contraband!'

Dhow anchored at Bagamoyo

FOLLOWING STANLEY TO BAGAMOYO —

Leaving.
the ruins
of Bagamoyo
we head for
VICTORIA NYANZA

The 17-year-old Alice Pike

In the dead of night, we anchor off Bagamoyo on the high tide. Everybody takes off their kit and, holding it in bundles up above their heads, jumps overboard into deep water. The two girls and I are treated differently. A dugout is called for, hands help us in the dark, then the dhow crew shout a farewell into the darkness: '*Kwaheri-safari njema!*' Moments later, a wave dumps us unceremoniously onto the beach at Bagamoyo.

By the time Stanley reached here in 1874, he had already found the missing Livingstone for the world and had immortalised his oft-quoted words. But Livingstone had refused to go back to England with Stanley, and in 1873 had died a sad and lonely death. At Livingstone's funeral in Westminster Abbey, Stanley was approached by Edwin Arnold of the *Daily Telegraph* which, with the *New York Herald*, agreed to send Stanley back into Africa. This time it was to circumnavigate Lake Victoria to verify or disprove once and for all John Hanning Speke's assertion that the river Nile flowed out of Africa's largest lake.

And that's the reason I find myself amongst the ruins in Bagamoyo, waiting for the Land Rover party to arrive from Dar es Salaam. Our objective is clear: to follow Stanley's overland journey all the way from Bagamoyo to the shores of Lake Victoria, a distance of approximately 1 500 km, and then to circumnavigate Africa's largest inland sea, just as Stanley had done in his search for the source of the world's longest and most historic river, the mighty Nile.

We spend the afternoon preparing for our Land Rover trip to Lake Victoria starting the next day, despite the long journey that got us here. Our tough Cooper Tires are still fine. We load food supplies, Howling Moon tents, our Magellan GPS and maps, first-aid kit, two tough Yamaha Enduro outboard engines – and a bottle or six of carefully wrapped Captain Morgan Black Label rum.

All we have to guide us is a copy of Stanley's expedition journal. I know it will be tough going making our way from village to village, asking as we go and sleeping wherever we end up. Tomorrow's the big day.

Leaving Bagamoyo

It's a sticky, humid mid-morning. Strange, I have the feeling we might've had a few drinks last night ….

The long-wheel-base Land Rover 130 Defender, christened *Stanley*, growls confidently in low gear. The Magellan GPS is on the dashboard, Mashozi has Stanley's journal open on her lap, Bruce, the keen young South African learning to be an adventurer, is in the back with the maps open, and Lumbaye from northern

Kenya and Mohammed the Brave are jabbering in Swahili, excited by the challenge of following Stanley's route all the way to Lake Victoria. Loaded on top of the Land Rover is a giant inflatable boat named the *Lady Alice*.

In London, just prior to the explorer Stanley's departure for Zanzibar and Bagamoyo, he'd met the lovely 17-year-old Alice Pike. Within days of their first meeting he was truly hooked.

> *I fear that if Miss Alice gives me … encouragement, I shall fall in love with her.*

Stanley wanted to get married immediately but Alice's mother pointed out that she was far too young, insisting that they at least wait until his return from Africa. The two lovers signed a marriage pact:

> *We solemnly pledge ourselves to be faithful to each other and to be married to one another on the return of Henry Morton Stanley from Africa. We call God to witness this, our pledge, in writing.*

Stanley wrote of how they'd spent their last evening together.

> *She raised her lips in tempting proximity to mine and I kissed her on her lips, on her eyes, on her cheeks and her neck, and she kissed me in return.*

As a parting gift, Stanley gave Alice a copy of *How I Found Livingstone*, which he inscribed with the words:

> *Ave Alice! Morituri te Salutant*
> [Hail, Alice! They who are about to die salute you]

And so Stanley's expedition boat was named *Lady Alice*. Built at Teddington on the Thames, it was constructed of Spanish cedar and consisted of eight five-foot sections, each small and light enough to be carried across Africa by a porter.

We are such a small, insignificant party compared with Stanley's Lake Victoria expedition. In the predawn light of 17th November 1874, the biggest and costliest expedition ever mounted from Bagamoyo left for the massive lake. Stanley's column of 347 men stretched for over half a mile and included some of the faithfuls that had travelled with him during his search for Livingstone – good men like Speke, Mabruki, Manwa Sera, Chowpereh and Uledi.

Apart from six donkeys and five dogs, their property consisted of 72 bales of cloth, 36 bags of beads, four man-loads of wire, 14 boxes of assorted stores, 23 boxes of ammunition, two loads of photographic materials, three loads of personal baggage belonging to the Europeans, 12 loads of boat sections (the *Lady Alice*), one box of medicines, one load of cooking utensils and 12 miscellaneous loads.

Stanley had also picked three European assistants: brothers Frank and Edward (Ted) Pocock – rugged young fishermen from the Kentish village of Upnor – and Frederick Barker, a zealous and energetic young clerk that Stanley had met at London's Langham Hotel.

But from the beginning things were tough for Stanley's caravan. By the time they reached Mpwapwa, some 160 miles from the coast, 50 men had deserted and the white men had all suffered debilitating bouts of fever.

Into Wagogo territory

Following Stanley's journal and compass bearings, we cross the Wami River and follow an old track. The local headman tells interpreter Lumbaye, 'This is the old travellers' route, once used by people tied in chains. It's the same route that was later used by white men who led large caravans of porters carrying loads on their heads. They camped on the side of the track and the villagers would trade with them.'

Like Stanley, we make our way to Mpwapwa. Fine red dust and bone-jarring corrugations force us to stop to let air out – it's hell for our sponsored Cooper Tires, but they're surviving well, as is the Land Rover suspension. Baobab forests stretch as far as the eye can see. Large groups of Wagogo tribespeople chant in unison as they work their way across a thorn-enclosed *boma*, beating the spread-out harvested millet using long thin sticks. Earthenware pots of millet beer are lined up in the shade for all those who have come to help winnow the crops.

Whilst this is how it must have been in Stanley's time, the village of Mpwapwa has certainly changed. Although old Land Rovers line the streets, there is still no running water; water sellers use two-wheeled carts and bright yellow secondhand cooking oil containers.

We fill up with diesel at the 'Peace and Love' filling station as the red dust hangs in the air. At Hafuns Bar and Restaurant, Blackburn Rovers are playing Arsenal on the TV. I gulp down a plate of *pilau ng'ombe* (stew and spiced rice), Mohammed the Brave goes for *ndizi ng'ombe* (boiled banana stew and rice), Lumbaye digs into *wali* and liver. A barefoot village idiot marches up and down the dusty street shouting military commands. I wonder, does he know the British have left? Cyclists pedal through the red dust, music blares from carpenters' shops, food stalls and general dealers.

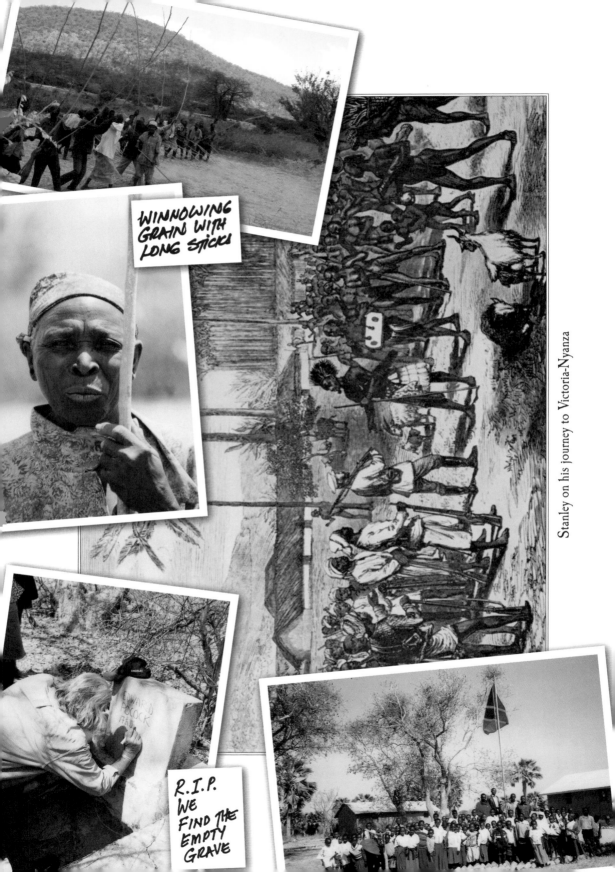

WINNOWING GRAIN WITH LONG STICKS

Stanley on his journey to Victoria-Nyanza

R.I.P. WE FIND THE EMPTY GRAVE

We fill up our water containers from the village well, where the women run in fright from my beard, shouting, 'Osama! Osama bin Laden!' Mashozi is going to have to give me a trim ….

We camp in a baobab forest and I toast the sunset with a mug of the Captain's brew. From my bedroll, I count 86 baobabs and hyena cackle hysterically into the night. Sitting around the fire reading Stanley's journal, we get into his head space, and the journey becomes much more than just us.

From Mpwapwa, Stanley's caravan abandoned the traditional route that travelled due west to Tabora and Ujiji on Lake Tanganyika. Stanley was prepared to risk all by taking the northwest route to Lake Victoria across the forbidding Merenga Mkali ('bitter water') desert.

> *The heat was intense, the earth fervid, the thorny jungle a constant impediment and a sore trouble, and its exhalations nauseating …*
> *the Expedition might have been ruined there and then, but a kind Providence watched over us and permitted us to straggle into camp, a wretched and most demoralised caravan.*

We have chosen the dry season to follow Stanley's journey. The heat burns down and the dust is suffocating. With the help of our Magellan GPS receivers, our old survey maps and the journal route descriptions, we navigate our way, stopping at every village to ask for directions, camping wherever we end up. I love the late afternoons and the evenings, the long lines of Zebu cattle tracking across the setting sun to be herded into *kraals* for the night. Local tribespeople come to sit around our fire, we ask questions about Stanley's route, about the names of tribes and chiefs, all the while Lumbaye translating. I still can't understand why Stanley tackled his journey in the wet season. It must have been absolute hell for him and his entourage.

Christmas found Stanley encamped in a downpour in famine-stricken Ugogo and, as a diary entry records, '*a more cheerless Christmas Day was seldom passed by me*'. Malaria and the difficulties of the journey had taken their toll. When he left Zanzibar, he weighed 180 lb; now he weighed a mere 134. It was miserably cold and all he had to eat was boiled rice.

In his words:

> *… unless we reach some more flourishing country … we must soon become mere skeletons.*

Once again he took up his pen to write to his darling Alice:

> *I sit on a bed raised about a foot above the sludge, mournfully reflecting*
> *on my misery …. Outside my tent, things are worse. The camp is in the*
> *extreme of misery and the people appear as if they were making up their*
> *minds to commit suicide or to sit still, inert until death relieves them.*

The sad part about these letters to Alice is that she was so wrapped up in the frivolities of city life, she wasn't able to comprehend what Stanley was going through. In one of her letters to him, she merrily wrote:

> *I do love dancing so much … although, honest, I would rather go to an*
> *opera than a party. Almost every evening some fellows come in – I get*
> *awfully tired of them.*

Fortunately Stanley never received this letter until his return to Zanzibar two years later. So he just kept on writing, holding on to their marriage pact, longing to be reunited.

It is tough, hard-going Land Rover country as we travel north by northwest in the footsteps of Stanley and reach the large granite rocks where Stanley's caravan had camped. We climb to the top of the outcrop and gaze out across Africa. Bruce takes a Tanzanian shilling and pushes it into the soft roots of a clump of elephant-foot grass – a tribute to Stanley's incredible journey. As if on cue, a tsetse fly crawls up his trousers and bites him on the butt. Mohammed the Brave roars with laughter. He's a tough, resourceful young fisherman and dhow sailor from the coast, built like a brick shithouse and typical of the type of man Stanley had hired as his *askari* – Mabruki. My good friend Lumbaye, not only the expedition translator but also the cook, is fascinated by Stanley's journey and reads aloud from the explorer's journal. Mashozi, as always, is in charge of supplies, all the paperwork, the medical kit, and the difficult task of making a little money go far. I've got a great team!

We camp at the base of the rock; firewood is plenty and there's a haze around the full moon. Mohammed the Brave says it's a bad omen and silently mouths a Swahili prayer – at which I shout to Mashozi to lock the passports and cash in the Land Rover. Lumbaye cooks up a beef stew and *ugali* (a stiff porridge made from maizemeal). Sitting on a warm rock, sipping my favourite plonk from my enamel mug, nightjars announce the evening and once again there is that unmistakable cackle of hyena in the distance. Africa is all around me; this is my peace. There are no mozzies tonight as the light of the fire dances off the rocks, lighting up our faces.

In the lands of the Warimi

Our ragtag modern-day Stanley expedition to Lake Victoria stops to buy wild honey on the side of the track. The Land Rover is covered in fine white dust. It's hard work, stopping at every village, enquiring painstakingly about place names, tribal boundaries and the names of past chiefs, comparing the information with Stanley's journal and constantly making sure we're on the right track. Lumbaye's probing for correct detail and his careful translations are invaluable, and we couldn't do it without him. At this point on the journey, there's an exciting feeling of rediscovery as we relive Stanley's travels.

We are about 800 km into the expedition and have reached the village of Suna on the lands of the Warimi people.

Stanley wrote that they were the finest people he'd so far encountered on his journey from Bagamoyo:

> *The men were robust, tall and manly. Their war costumes were of hawk and kite feathers and they wore the manes of zebra and giraffe around their heads. Their naked bodies were smeared with ochre, chalk and animal fat and they carried spears, long powerful bows, yard-long arrows, and war shields of rhinoceros hides.*

One of the men Stanley met was nearly seven foot tall – fortunately we found them to be friendly! Like their Wagogo neighbours, they'd also adopted the cow-dung and mud-hut architecture of the Maasai, and heavy thorn stockade fences to keep the cattle in at night and predators out. The huts look like loaves of bread – crops have been good this year and the maize and millet is piled high on top of the mud-roofed houses.

Stanley had left the coast with 347 men in November 1874, but by the time he reached this area in January 1875, the numbers had been reduced to 229. Twenty-one had died, 89 had deserted, and eight had been left behind sick. Within days another 24 would die in battle with a hostile tribe. If that wasn't enough, one of the Pocock brothers, Ted, had become seriously ill.

> *… whether it is smallpox, typhus, typhoid or African fever that he is suffering from, I know not. His tongue was thickly coated with a dark fur, his face fearfully pallid, and he complained of wandering pains in his back and knees, of giddiness and great thirst.*

On the evening of 17th January 1875, Stanley was called to his side 'only in time to see the young man breathe his last'.

> *Frank gave a shriek of sorrow when he realised that the spirit of his brother had fled forever. He bent over the corpse and wailed in a paroxysm of agony. We excavated a grave four feet deep at the foot of a hoary acacia with wide-spreading branches, and on its ancient trunk Frank engraved a deep cross …. When the last solemn prayer had been read, we retired to our tents to brood in sorrow and silence over our irreparable loss.*

Searching for the grave

We go in search of Ted Pocock's lonely grave. Amongst date palms we find a small village and a mud-bricked primary school. The Tanzanian flag flies in the courtyard and an old ploughshare serves as the school bell. The shy smiling children sing 'Three Blind Mice' for Mashozi. Charles Nkuwi, the head teacher, knows of only one white man's grave in the bush.

Pleased to be released from a normal schoolday, he points north by northwest as, together with one of the other teachers, Moses Bahali, they sit on the Land Rover bonnet directing us down a narrow track that runs through the thick, near-impenetrable *mhingi* thorn scrub that so plagued Stanley's expedition. It's hell on the tyres and we are forced to fold in the Land Rover side mirrors. On the path we meet an old man named Fanuel, who knows the history of the area. He guides us to an old miombo tree. Our Magellan GPS and Stanley's journal indicate that we are dead on track!

Instead of simply a cross on the tree, we find a seemingly empty grave with no name written on the headstone. It appears from old man Fanuel's story that when he was tiny – and with a stick he indicates his size at the time – white people, who were possibly relatives of Edward Pocock, came here with the British district commissioner.

They arrived in *garis* (motor cars); they camped there (he points to some massive miombo trees that would have provided shade to Stanley's party and the poor dying Edward). The white people and their party slaughtered a black bull and a black sheep. Then with the Waha tribespeople they had with them (originating in Kigoma on Lake Tanganyika), they built this proper grave with cement around it as we see it now. That was a long time ago, says Fanuel. 'In those days we used to walk around naked – very few of us had clothes.'

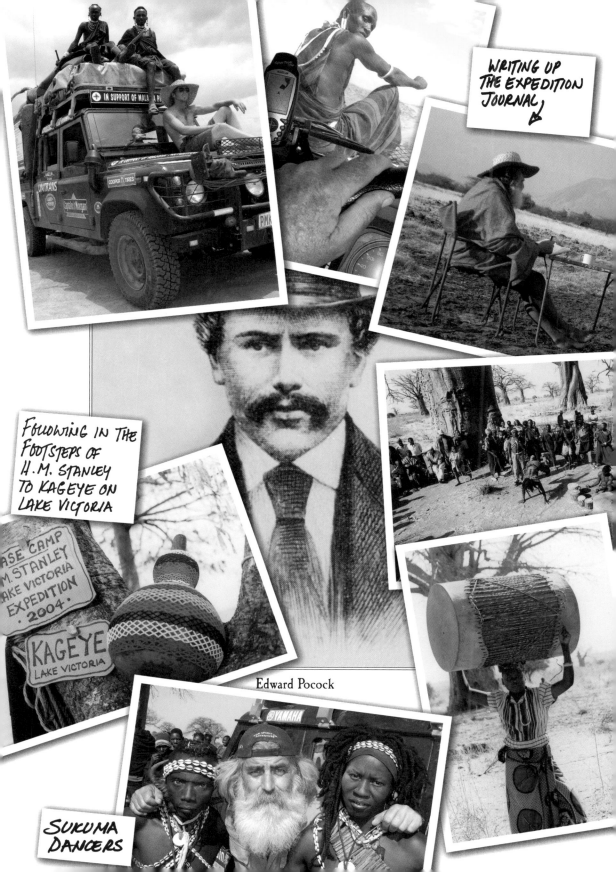

WRITING UP THE EXPEDITION JOURNAL

FOLLOWING IN THE FOOTSTEPS OF H.M. STANLEY TO KAGEYE ON LAKE VICTORIA

IN SUPPORT OF MALA...A P...

BASE CAMP
...M. STANLEY
...AKE VICTORIA
EXPEDITION
· 2004 ·
KAGEYE
LAKE VICTORIA

Edward Pocock

SUKUMA DANCERS

When they reburied the white man's bones they'd taken from beneath the tree, they added a metal box to the bones, then they covered this up and left, saying they would one day return to put writing on the headstone. But they never came back. Those same Waha tribesmen returned – this time as grave robbers – to dig up the grave and steal the box.

'Our people would never have done such a thing,' says the old man.

And so I take the liberty of standing waist-deep in that empty grave, and, using a black marking pen, I solemnly write:

EDWARD POCOCK
17TH JANUARY 1875
R.I.P.
H.M. STANLEY EXPEDITION

African-style, we spit on a stone to propitiate the spirits and this we place on top of the headstone. We then scatter dry leaves into the empty grave and call for a moment's silence.

In the informative Bradt's guide to Tanzania, the adventurous author Phillip Briggs writes that the 500-km drive from the town of Singida to Lake Victoria is 'something of a test of character'. With the weight of the *Lady Alice* on the roofrack, the bodywork of our poor overburdened Land Rover creaks and groans as it soaks up the potholes, corrugations and dust. It's a back-breaking nightmare that would tear a normal suspension apart as, like Stanley, we haul boats, people and supplies forever forward to Lake Victoria.

There's a serious drought and we come across Maasai-like people digging wells in the dry riverbeds for their cattle. These impressive-looking people are known as the Barabaig; they are the representatives of the earliest known Nilotic migration into East Africa from Ethiopia. They are fiercely proud and, like the Maasai, carry spears, wear traditional loin cloths and are prepared to die to protect their honour and cattle herds.

North of Singida we're warned not to travel after dark as bandits have been holding up trucks. The apology for a road is part of the 'hell run' from Dar es Salaam to Mwanza and a lorry has overturned on a boulder-strewn mountain pass. Using some hair-raising 4x4 tactics with our team all hanging onto the one side of the Land Rover to prevent it from tipping over, we work our way around the long line of lorries, which includes a convoy of UN trucks loaded with tanks. It is, no doubt, a peace-keeping force heading for Rwanda or the Democratic Republic of the Congo.

A forest of upside down trees

Now on a side track and still following Stanley's journal descriptions, we enter the vast plains of Sukumaland. *Usukuma* literally means 'the northern lands', referring to the area south and east of Lake Victoria, which is home to the Bantu-speaking Sukuma, the largest tribe in Tanzania. Travelling in low-ratio first gear, we leave the road and bounce and sway along a footpath that winds between ploughed fields. Zebu cattle kick up the red dust as, in long lines, they walk across the setting sun. We stop in a massive baobab forest – hundreds of upside down trees, their gnarled grey trunks glowing softly in the afternoon light. Mohammed the Brave approaches a group of curious women to ask them permission to camp; they take one look at him and race off screaming to their village. In a second attempt, we send off the more slender Lumbaye to request permission and for protection through the night.

He returns with two young tough-looking Sukuma men. The greeting is *ulimhala*, the answer is *mhala*. Their names are Ibazo Jiganza and Luhende Mwiguru. Sure, they will look after us! The elders are in their beer pots right now but will come and visit in the morning. We agree on 5 000 Tanzanian shillings for each man, and soon the tents are up and the kettle bubbling on the fire.

Luhende points to a nearby baobab and, with a big smile, warns us, 'A massive snake lives in that one'.

Unlike Stanley's unwieldy caravan, our logistics are so simple: our two Howling Moon tents – one for Mashozi and me, the other for Mohammed the Brave, Lumbaye and Bruce – some water containers, a couple of grub boxes, a basin to wash in, our canvas bedrolls, and a lamp powered by the Land Rover battery. There's the dented camp kettle, the braai grid that lives behind the bull bar, the black cast-iron three-legged pot, and an old metal East African folding table that generally straightens out with a good kick. Our equipment is incomplete without our well-used green canvas safari chairs and, of course, my favourite enamel mug – the one that gets used for the *renoster koffie*.

Stanley's 1875 journey was so different. He needed a large column of men to carry the trade goods required to buy safe passage, protection and food. There were no detailed maps and no Magellan GPS. I could just imagine their odyssey across Africa in the rainy season, dying like flies from disease, the threat of wild animals and hostile tribes, the men longing for home and Stanley longing for Miss Alice.

In the area where we're now camping, one of Stanley's men, Jumah Dipsingesi, died from an overdose of opium. He had been caught stealing and Stanley had him flogged and imprisoned in chains. Stanley was a hard bastard, possibly because of his early upbringing – born illegitimately to Betsy Parry, a strapping 19-year-old housemaid from rural north Wales. He was later dumped at the St Asaph

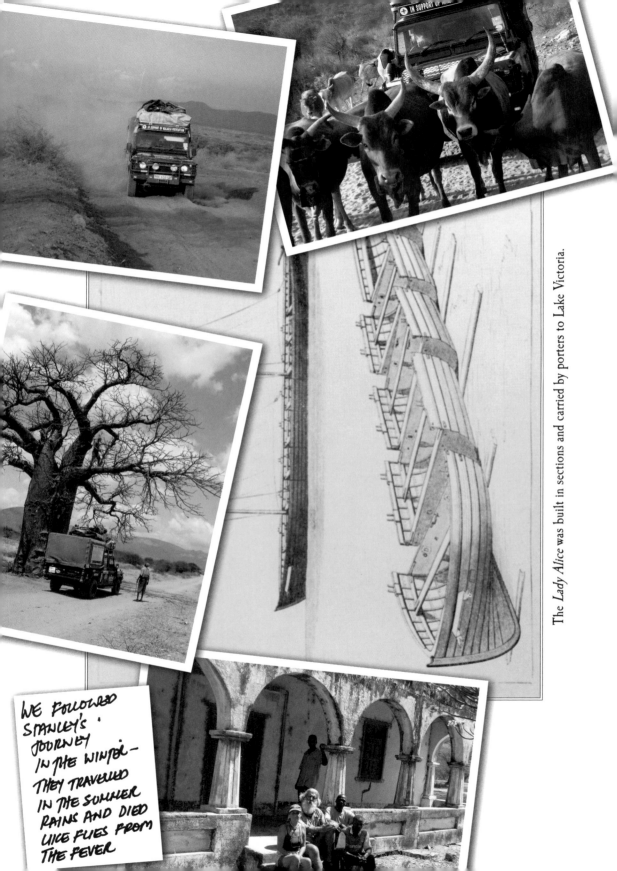

The *Lady Alice* was built in sections and carried by porters to Lake Victoria.

WE FOLLOWED STANLEY'S JOURNEY IN THE WINTER — THEY TRAVELLED IN THE SUMMER RAINS AND DIED LIKE FLIES FROM THE FEVER

Union Workhouse, which he called 'a house of torture'. Later, he ran away to sea on a Yankee merchant ship but in New Orleans ended up jumping ship, where he changed his name from John Rowlands to Henry Morton Stanley. He fought in the American Civil War and later became a successful freelance journalist, which led to his tremendous scoop for the *New York Herald*, when he found Livingstone at Ujiji on the shores of Lake Tanganyika.

By this stage of Stanley's journey, only 173 men answered to their names – 174 less than the number with which he'd left Bagamoyo. Stanley was getting desperate, and when five more of the men deserted, he sent ten trackers, or 'detectives', as he called them, to hunt down the men and bring them back dead or alive. Three runaways were dragged back, one of whom had stolen a box of ammunition. Stanley court-marshalled him, and left it to the men to decide his punishment, recording that 'fifty-one were for hanging him off hand' while 80 pleaded that the poor fellow be flogged, then chained until he reached Lake Victoria.

HM Stanley was now an accomplished explorer. But unlike Dr David Livingstone, dubbed 'the friend of the African', Stanley became known as *Bula Matari* – 'breaker of rocks'.

Sitting around the fire we share our spaghetti bolognaise – affectionately referred to as 'spag bol' – with our Sukuma friends. They're not sure about these white wormlike noodles, and one of them spits the food out into the fire. But they do enjoy slurping mugs of sweet tea. From our *askaris* we learn that their great herds of Zebu cattle can number as many as 2 000 head, and when the rains come, their crops are many – maize, millet, sweet potatoes and pumpkins – but their biggest threat remains the Maasai cattle thieves. The price for a bride is 45 head of cattle, but, says Luhende with a broad smile, it's not wise to have more than two wives as more than that are difficult to keep happy.

Around the fire I learn that other than cattle, their great love is for traditional dancing. Across Sukumaland there are many dance societies, originally founded some 150 years ago by two rural dancers and spiritual healers, Ngika and Gumha. Both of them used magic charms to attract spectators and to induce errors into their rivals' routines – the winner was the one who attracted the largest crowd.

The Sukuma also have a reputation as snake charmers, and one of their ritual dances is called the *bugobogobo*, in which the dancers coil a live python around their bodies and gyrate to a frenetic drumbeat, pretending alternatively to embrace the gigantic reptile and then fight it off.

Lumbaye, translating from the Swahili, tells us that before going into a competition, a Sukuma dance troupe will consult spiritual healers to obtain secret dance potions with which to cover their bodies, and will even build ancestral shrines around the dance ground.

The full moon lights up the baobab forest and their giant limbs creak and twist in the howling wind, sending showers of huge seed pods onto the fly sheet of our tent. From time to time I hear a murmur from our Sukuma *askaris* as they throw another twisted log on the fire. At least they're not sleeping!

Dancing the usawo

Next morning we wake to the sound of drums. About 50 waSukuma have turned up at the camp, faces and bodies rubbed with red ochre. Ibazo now wears a Rasta headdress of human hair, his torso is crisscrossed with cowrie shells and a bandolier of carved sticks crosses his chest. Around his waist is an old canvas army belt above red cutoff shorts and he wears goat-skin kneepads and ankle rattles. Jilungu wears a horn headdress, and around his neck, an engagement crystal and a rain charm. We seat the elders from the village in the front row, then the frenetic dancing and drumming begins. Called the *usawo*, it symbolises the arrival of spring and the planting of crops. There's great excitement. It's not every day they dance in the baobabs for *waZungu* – a young one, a strange bearded one, a petite courageous wife – a thin, spindly-legged African who wears a Muslim hat and looks like a Maasai, and a big strong black man from the islands, all of whom claim to be following some strange journey from a book.

After the dance we give out insecticide-impregnated mosquito nets and mosquito repellents to the women and children. This is part of our expedition initiative to promote malaria prevention. The frightening statistic is that in East Africa, a baby dies of malaria every minute of every day and every night.

Lucky to be alive

We leave the current main route to Lake Victoria, and according to Stanley's journal take a narrow sand track across a vast plain of dust-coloured whistling thorn, dotted with mud-built Sukuma villages. In the far distance I see a huge cloud of dust, probably cattle or another vehicle. The high *middelmannetjie* of the road, with deep sand tracks to either side, zigzags between the trees. So as not to get stuck in the soft sand, we're belting along in third gear – Land Rovers love it.

The next minute, without warning, there's a big truck, coming flat out towards us. Mashozi shouts, 'Watch out!' but it's too late. As if on a railway line, we're both locked into the same deep sand tracks. He's right on top of us, he's not slowing down and we're about to have a frightening head-on collision in the middle of nowhere. In the soft sand, there's no point in even trying to hit the brakes, so,

dropping a gear, I floor the accelerator and swing the steering wheel hard left. As if in slow motion, the Land Rover slides sideways off the track. I look up to see the lorry flash past with just a few centimetres to spare. The driver doesn't look left or right; there's a fixed, dazed expression on his face. He doesn't hoot, flash lights or even slow down.

Lumbaye tells me that local long-distance lorry drivers often chew *miraa* or *kat*, a mild hallucinogenic drug that's legal in Kenya but not in Tanzania. Some drivers take marijuana with it and there are often seriously bad accidents.

We pull back onto the track. We realise we're extremely lucky to be alive …. Had the Land Rover not pulled out of the deep sand track in time, our expedition would have turned into a mangled wreck of torn bodies in no-man's-land. A situation made worse by the fact that both HF radio and satellite phone are presently on the blink! We decide not to even discuss it.

Reaching the great Nyanza

When Stanley crossed the Luwamberi River and passed through this area, he recorded that they sighted gnu and rhinoceros for the first time, and that buffalo, zebra, giraffe, springbok (he was probably referring to Thomson's gazelle) and waterbuck were incredibly numerous and tame. They had three days of feasting before pushing on to Lake Victoria, where, on 27th February, they arrived at the village of Kagehyi, to be rewarded by their first glimpse of this great body of water.

> *We gazed upon a lake which was to the north west like a vast sea … the porters banded together and began an exhilarating song of triumph in honour of our successful march from the Salt Ocean to the great Nyanza.*

> *Then sing, O friends, sing, the journey is ended*
> *Sing aloud, O friends, sing to the great Nyanza*
> *Sing all, sing loud, O friends, sing to the great sea.*

Henry Morton Stanley had finally reached Africa's largest lake '*which a dazzling sun transformed into silver, some 600 feet below us, at the distance of three miles*'. Consulting his two pedometers, Stanley calculated that they had travelled 720 statute miles. He boasted that an Arab trading caravan would have taken at least nine months to a year to complete the journey that had only taken them 103 days, 70 of which had been marching days.

At Chief Kaduma's village of Kagehyi, on the shores of Lake Victoria, Stanley permitted himself only a week to rest and write dispatches to his sponsors, the *Daily Telegraph* and the *New York Herald*. He also addressed a love letter to his 'darling Alice':

> *The very hour I land in England I should like to marry you, but such*
> *a long time must elapse before I see you, that even to see your dear*
> *face again appears to me as a most improbable thing …. I have often*
> *wondered how you pass your time. I suppose it is in one constant round*
> *of gaieties? What a contrast to yours are my surroundings. My present*
> *abode is a dark hut; through the chinks of the mud I can but faintly see*
> *these lines as I write. Outside, naked men and women create a furious*
> *jangle and noise, bartering with my people for beads.*

Alice was indeed enjoying a 'constant round of gaieties' and had obviously chosen to ignore her marriage pact with Stanley. Within a few months she would become engaged to the wealthy Albert Barney of Dayton, Ohio. Although letters from Stanley continued to arrive, they were not read let alone answered. But Henry Morton Stanley, happy in the belief that Alice awaited him, began to make preparation for circumnavigating the lake in the *Lady Alice*, the 24 ft-long, 6 ft-wide cedarwood boat they'd carried in sections all the way from the coast.

Covered in dust, 1 356 km from Bagamoyo, our overloaded Landy sways down the potholed dirt track to the village of Kagehyi. Our arrival, while not as dramatic as Stanley's, is also accompanied by a great feeling of achievement. The original village no longer exists, but what is significant to us is the derelict 'monument' that now stands here on Lake Victoria's shores. Built by the early missionaries as a tribute to HM Stanley and his men, there's a replica of Stanley's tent modelled out of cement facing the ruins of Chief Kaduma's hut. There are also the graves of Chief Kaduma and his wives, and a small stone marking the grave of one of the chief's sons. He was poisoned by his mother, who preferred this to letting him go with Stanley, whom she believed was a slaver. A ring of grindstones marks the spot where the rainmaker ground his potions. We also identify the place where Chief Kaduma sold slaves to the Arabs.

We set up our modern-day Land Rover expedition camp on the beach where Stanley had assembled the *Lady Alice* 129 years earlier. A cool breeze blows from across the water, there's the sound of the waves crashing on the shore, and a lone marabou stork – looking like an undertaker – struts up and down the beach. Arab dhows, their sails filled with the equatorial wind, sail across Speke's Gulf to the island of Ukurewe.

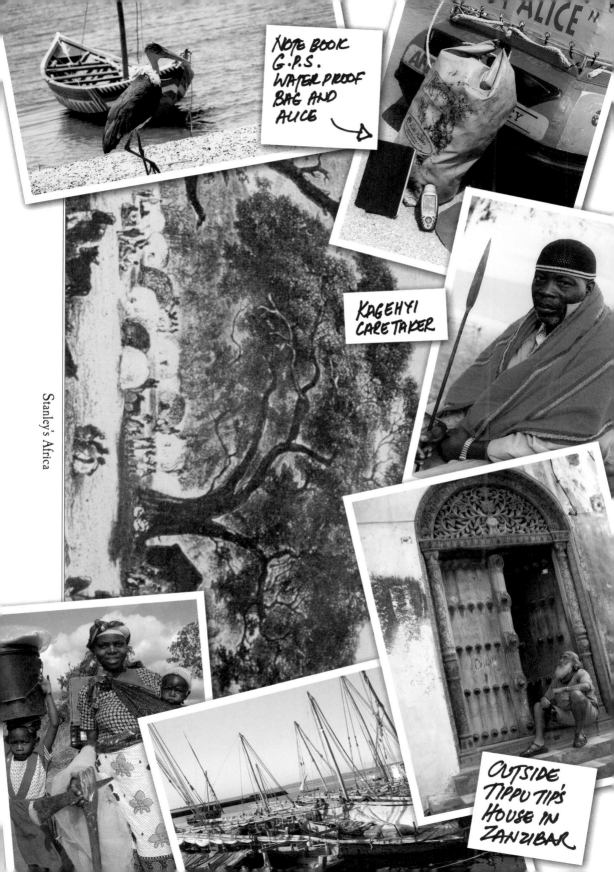

NOTE BOOK
G.P.S.
WATER PROOF
BAG AND
ALICE

KAGEHYI
CARE TAKER

Stanley's Africa

OUTSIDE
TIPPU TIP'S
HOUSE IN
ZANZIBAR

Yes, we have arrived, but now the challenge facing us is to assemble our own *Lady Alice* and follow HM Stanley's circumnavigation of the continent's largest freshwater inland sea.

We empty the Zulu calabash filled with seawater from distant Bagamoyo into the fresh waters of Lake Victoria. Then, like Stanley's men before us, we dash into the waves to wash the dust from our travel-weary bodies.

Henry Morton Stanley

Henry Morton Stanley

Chapter VII

Victoria-Nyanza

A Circumnavigation of Africa's Largest Lake

Being the Narrative of a Crazy journey in an Open boat
called the Lady Alice – Tracing the footsteps of HM Stanley's 1857 expedition to Prove
that the Great inland sea of Victoria-Nyanza was a Single lake
out of Which flowed Speke's Source of the Nile – a Story Dedicated to the Early explorers
Burton, Speke, Grant, Livingstone, and Sir Samuel & Lady Baker – All of whom
Risked their Lives in Search of Africa's greatest Geographic Prize

A True account of the Storms, Cruel waves,
Large fish and Swarms of lake Flies – including
Anecdotes of the People of the Lake

Kagehyi, 1875

HM Stanley's men were terrified by the village tales. People sporting tails dwelling on its shores; fierce dogs trained for war; a tribe of cannibals who preferred human flesh to any other meat ….The lake, they said, was so large it would take years to trace its sources so, who then, would remain alive after all this time? Stanley called for volunteers to sail with him on the *Lady Alice*. 'Where are the brave fellows who are to be my companions?' he asked. Not one man stepped forward. He recorded in his diary:

> *There was a dead silence. The men gazed at one another and stupidly scratched their hips.*

Finally, in the absence of volunteers, he press-ganged ten of his best men, all of whom had boating experience. Frank Pocock and Fred Barker would stay behind at Kagehyi with the bulk of the men to await his return. At 1pm on 8th March 1875 Stanley wrote:

> *I sailed from Kagehyi with ten stout sailors of the expedition in the Lady Alice, a cedar boat 24 feet long and six feet wide, which we have carried in sections from the coast. The men were all downhearted and rowed reluctantly.*

Little did they know it, but ahead of them lay a journey of over 1 000 miles across which they would be blown to hell by fierce storms, would face near-starvation and be attacked by bloodthirsty tribes.

I gaze out over the lake and I can imagine the scene, the *Lady Alice* loaded to the gunnels with supplies and trade goods, flying the Stars and Stripes and the Union Jack. Stanley, in his pith helmet, looking determined at the start of their 57-day anticlockwise circumnavigation to prove that Lake Victoria was the source of the River Nile. Fortunately I don't have to press-gang Mashozi and Mohammed the Brave to be part of our modern-day *Lady Alice* boat team! They are excited and more than ready to face the prospects of another adventure following Stanley's 1875 expedition on the lake.

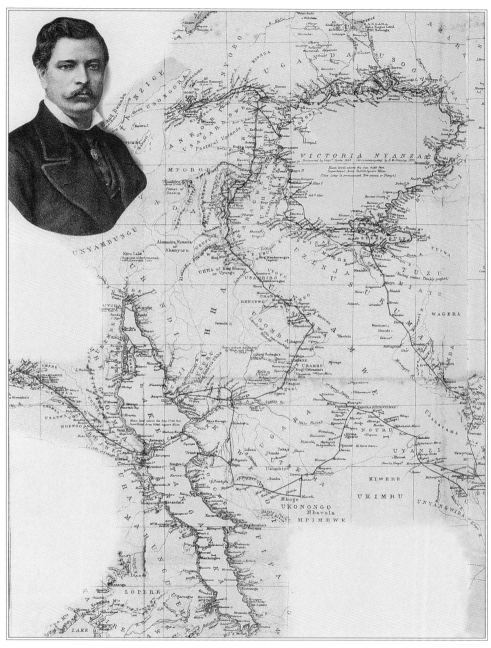

Destination – Victoria-Nyanza and the circumnavigation thereof

A wet start

Stanley's expedition was supported by the *New York Herald* and London's *Daily Telegraph*. With us on today's inflatable expedition boat – also sporting the name *Lady Alice* – is photojournalist and old friend Tony Weaver from the *Cape Times*, unshaven from a late night in Dar es Salaam. He has flown in to join us for the first leg and his bag is full of surprises: nuts and raisins, chocolates, film stock, Mashozi's brand of 'ciggies', some extra Captain Morgan rum – even biltong! And news from home.

Earlier this morning, Tony had to hold an umbrella over his camera to photograph us filling the Zulu calabash in the rain. Five hours later, we're still buttoned up in raingear, running northeast in a following swell and hoping to reach Bruce and Lumbaye, the Land Rover support team, who are waiting for us at a GPS point just south of where the vast plains of the Serengeti meet Africa's largest lake.

The wind changes with sheets of rain driving right into our faces, followed by huge swells, the odd one breaking into the boat. We throttle back on the Yamaha tiller arm and bounce like hell. Mashozi finds a seat down on the floorboards, Mohammed the Brave moves forward to keep the boat's nose down, Tony digs into his bag for a bottle with a sort of look that says, Shit! The start of another Holgate adventure …. I gasp as another bucketful of icy lake water slaps me in the kisser. I'm now feeling that old familiar rubberduck twinge of pain in my lower back. Another wave breaks into the boat, prompting Mohammed the Brave to ask in Swahili, 'Pappa King, are you sure this is a lake, is this not a *bahari* sea?' Tony, who has a good understanding of Swahili, gives a dry chuckle.

The storm worsens and fishermen reef their sails and paddle furiously for the shore. We come across a number of half-submerged fishing boats. In Stanley's words, it's not all easy, this exploration. On his second day out on the lake, the worst fears of his Wangwana boatmen seemed to be fulfilling themselves when they were overtaken by a storm that was 'wild beyond description'.

Bruce and Lumbaye refuel us with another three jerry cans from the Land Rover roof rack and we decide to push on to the village of Guta where we will all meet up again at sunset. Then the wind stops, soon the water is calm again and it's hard to believe this is the same lake. Off Guta, the shoreline is swampy with reedbeds. We push through the muddy shallows and it's dark by the time we meet the Land Rover team. No sooner have we set up camp, then everyone starts yelping and swearing, jumping around from one leg to the other – we're under attack from a thick, black ribbon of ants making its way up the lakeshore right into the camp. Bruce races for a jerry can of diesel and pours some across the path. Fortunately the smell of diesel turns back the termites, which retreat to the reeds on the lakeshore.

In this area on 10ᵗʰ March 1875, Stanley wrote:

> *We tried to land but were chased off by three hippopotami who rushed at us open-mouthed. The bay for a considerable distance from shore is very shallow, so these amphibious monsters had the advantage over us.*

Sadly, the hippos have now all gone. I'm feeling worn-out. Maybe it's the storm that did it. Tonight is chopped-up veggies with rice. Jeez …. No meat?! I complain. Mashozi mumbles something about budget, Tony laughs and spoons another mouthful. Fortunately there's no shortage of *renoster koffie* – Bruce sees to that. The odd ant still comes in for a nip.

Tomorrow we hope to reach Nansio, a small ferry port on Ukerewe, the largest island on Lake Victoria. 'Tomorrow, you must leave at first light, before the wind she comes,' is the advice the local fishermen give us – and we're going to take it. There's the normal Swahili pleasantry of *lala salaam* – 'sleep peacefully' – and we're off to bed. Tony has his own tent; he takes a nightcap and with his head-torch on scribbles in his dog-eared notebook. Mashozi and I have our own matrimonial tent; Lumbaye, Bruce and Mohammed the Brave share. Mohammed is the *askari*; he's got a torch, knife and stick and it's his job to sound the alarm should there ever be intruders in the night. We'd be lost without Lumbaye, who's great with people. He interprets and cooks, pulls in the local knowledge, acts as our public relations man, gets permission to camp, finds fuel, food supplies, firewood and anything else we need. Bruce, at only 22 years, has really taken to this life. He's got an amazing ability to get on with the indigenous people. He eats off the street while organising supplies and working out what fuel we need to carry, and he understands 'no' roads and 'bad' roads. He's young, he says, and happy to live this life of adventure for a few years so as to experience Africa.

During the night there's the sound of fishermen passing in their dugouts, the distant barking of village dogs, the odd murmur, snoring from the other tents, and the droning of mosquitoes. Lake Victoria, we're very much aware, is one of Africa's worst malaria areas.

Illegal fishing

Lumbaye is the first one up, using the rubberduck pump as bellows to spark up the coals in the *jiko* (a small tin charcoal stove) for coffee and rusks. Bruce and Mohammed the Brave fuel up the boats and already the wide-eyed village women and children are coming down to the lake to wash, fetch water and gaze curiously at this strange band of travellers who came to their waters in the night.

Hippo on the lake

A few pumps on the in-line fuel bulb, the choke out, throttle half-open, a pull on the starter rope and the Yamaha Enduro roars into life. There's a smell of outboard oil and that slightly queasy, early morning feel. I've got a headache and my joints are sore. It might be from all the bouncing in yesterday's rough storm, but if I'm still feeling a bit rough this afternoon, I'll do a malaria test. We punt and 'shallow-drive' out of the reedbeds, then drop the motor and open up the throttle. The water is like glass, and the Magellan GPS records our speed as 28–30 km per hour.

Hugging the shoreline into the next bay, startled fishermen drag their fishing nets into the reeds and run for their lives. Mohammed the Brave waves and laughs like a drain. 'They think we are the police or the army,' he says. 'They've got illegal, small-sized, out-of-season nets and think we're coming to arrest them.' To the locals, our big Gemini inflatable with its 40HP outboard probably does look like an anti-fish-poaching unit.

Throughout our odyssey on the lake, and especially in Tanzania, illegal fishermen continuously ran for their lives at the sight of our boat – sometimes dropping baskets of fish to scramble through the undergrowth, at other times their heads down, rowing feverishly for the shore and then abandoning their boat to leap into the lake and scramble up the rocks, shouting a warning to the others. Only when we pulled up onto the shore and they saw that we didn't have uniforms and guns did they come up to us and talk. Yes, they did understand the need for conservation, but in order to survive and feed their families, they have to fish as there's simply no other way.

When Stanley sailed his lake, the water was beautifully clear, the fish life plentiful, and hippo and crocodile were in abundance along the shoreline, as were other species of wildlife. Now, close to 130 years later, the lake, although still incredibly beautiful, is becoming an ecological disaster.

Change was brought about in the 1960s when the British colonial government introduced Nile perch, a voracious predator that can reach a size of 2 m and weigh well over 100 kg, and that feeds on the smaller fish. Nile perch put up a good fight – Bruce had caught a beauty from our base camp at Kagehyi, which Lumbaye had turned into an English fish-and-chips evening around the fire. The problem with Nile perch is that they are busy guzzling all the smaller cichlid species. Boston University's Les Kaufman describes it as 'the greatest vertebrate mass extinction in recorded history'.

Local fishermen prefer eating the smaller tilapia, but the Nile perch brings in money and the refrigerated trucks that work as agents for the fish export factories pay cash – which buys maizemeal, cooking oil, rice and salt. For the tough young men who pull the nets, it buys them flashy clothes from the secondhand market, batteries for their radios, booze and cigarettes, and, if they work really hard, a

bicycle. Thousands of locals make their way to the lakeshore in the hope of a fishing bonanza, and everywhere rustic thatched fishing camps and nets are spread out on the beaches. In the heat of the late afternoon, it's like one big nudist colony of wet ebony bodies as entire families come down to wash in the cool water of the lake, clothes spread out to dry on the rocks. Children jump and splash, the women and young girls bath and collect water, the men bathe separately. Young boys with long reed 'flick sticks' in each hand, lumps of green algae bait balancing on top of their heads, stand naked on exposed rocks. They're fishing for small fish to be used as live bait on the hundreds of long-line hooks that are suspended from colourful secondhand plastic cooking-oil containers and left to float out in the deep water where the big Nile perch hang out.

The southern shoreline of Ukerewe Island is a beautiful jumble of massive wind-sculptured white-grey boulders painted with bird droppings. There are small deep-water bays, fishing villages and sailing canoes pulled up onto sandy beaches. Pelicans fly gracefully in front of our boat, fish eagles inhabit every bay, and there are literally thousands of cormorants and egrets. Monitor lizards (we've never seen so many) sun themselves on the rocks.

A magnificent large sailing dhow with huge, billowing lateen sails moves across the gulf between Mwanza and Ukerewe. We pull alongside, the crew bum a few smokes and smile for Tony's camera. Mohammed the Brave points and says 'Pelican' with a big grin. We're teaching him English words and he's helping us with Swahili. Our journey seems to be following a similar pattern to that of Stanley's furious storms followed by idyllic calm days like today.

The test is positive

Lumbaye and Bruce wave and flash the Land Rover lights from the somewhat scruffy little port town of Nansio. We offload the boat. It's a hot Sunday afternoon and the beach is full of people cooling off in the lake. I'm feeling shocking and ask Mashozi to grab us some rooms in the little Gallu Beach Hotel set back from the shoreline amongst the palm trees. Despite the normal third-world pong of sewerage and bad plumbing, the rooms are clean and there are buckets of water for washing ourselves and flushing the toilets.

I do a quick malaria test. It's positive. I treat myself with Coartem and start a course of Doxycyline. Lying alone in the dark room, sweating out the fever, I'm on edge and wish the people outside my window would shut up! Kids screaming, dogs barking, and the shouts of what sounds like a lovers' quarrel … Mashozi brings me a mug of sweet tea and a bottle of drinking water. How Stanley and his men must have suffered. He didn't have the anti-malarial drugs we have today; all he could do

was dose himself with quinine. My body aches and I've got the 'squits'. I think of the journey ahead. My back won't last – the bouncing on the pontoon, sitting and steering in a twisted posture – I'm already hitting the Voltaren …. Hell, I'm a mess! I toss and turn, dreaming of logistics and boat fuel and massive storms. Later that night, the fever breaks. Everything goes quiet and serene, and there's that relieved feeling, knowing that once again I've survived the bite of the deadly *Anopheles*. Outside, the equatorial rain beats down on the corrugated-iron roof while Mashozi sleeps soundly in her bed. Tony has also taken a room and Lumbaye, Bruce and Mohammed the Brave have camped next to the boat as a security measure.

Breakfast is bread and mixed-fruit jam, eggs, liver and pineapple washed down with sweet tea. The team is looking a bit rough after a farewell night for Tony. It's become a custom that whenever Tony leaves, he distributes some of his kit as gifts to the team. Mohammed the Brave can't believe his luck; he gets a Captain Morgan rainjacket and a pair of Polaroid sunglasses – so he can see the rocks under the water when navigating, says Tony. Mashozi gets a large, soft, khaki cooler bag ideal for the boat; I get a floppy bushhat and T-shirt; Bruce gets the leftover rolls of professional slide film; and Lumbaye, a notebook and pens and some lock-seal plastic bags. Small things in a normal world, but great to have on an expedition.

The *Serengeti* blasts its horn; the ferry is leaving. Tony, armed with letters, rolls of film, a head of memories and a hangover, heads for Mwanza, Dar es Salaam and Cape Town. I feel a slight twinge of envy. Soon he'll be back home to hot showers, restaurants and his own bed. Ahead of us still lie over 1 500 km of lakeshore. Then I think of Stanley's expedition, rowing and sailing with no maps or GPS, Stanley sitting in his tent at night still writing to his darling Alice.

The sun comes out; it's hot and humid after the rain. Bruce goes into the village to buy boat fuel as tomorrow we hope to make an early start. Supper is masala beef, chapaties and rice. A bat flies in through the open door and gets caught up in the tablecloth.

Rounding Ukerewe Island

It's Tuesday 7th September. I wake early to grey, leaden skies, feeling weak in the legs but stronger. Marabous stalk the beach and the strong wind blows cold. Mohammed the Brave and Lumbaye fuel up and prepare the boat, Mashozi checks supplies and Bruce and I talk through emergency procedures. If we don't make Musoma in two days' time and if there's a breakdown in 'comms', he must backtrack to the village of Bukima, opposite the island of Burugwa in the south of Sugiti Bay. Like Stanley, we must now round Ukerewe Island. The wind picks up and it soon becomes bloody unpleasant – big swells and very wet; everything's soaking! We pull

into a small rocky bay to dry out. I sit scribbling my notes as the villagers all gather around. Mohammed the Brave boils up some tea and gathers firewood for tonight. The rain clouds come, so we bounce out into the choppy waters and speed for cover to Sizu Island. The headman of the village, Lubin (I presume he means Rubin), comes down to meet us. He speaks a little 'eenglish' and soon everybody is around the modern *Lady Alice*, prodding the pontoons in disbelief. A 'balloon' boat, such a thing they have never seen before.

Dagaa, small silver minnow-like fish, lie drying in their thousands on the beach. The fishermen use pressure lamps on floats to lure them into their nets at night. We give Rubin and his family some insecticide-impregnated mozzie nets, shake hands and move on up the side of the island. The boat crew swims and dives. Pelicans glide alongside the boat. Thousands of darters, cormorants and egrets have stripped the trees of their leaves.

The wind changes in our favour, so we make good time up the mainland shore with Ukerewe now behind us, the jumbled rocks of the island replaced by a dry, yellow-grass shoreline. Then comes the thunder, lightning and rain, giving us just enough time to get the tents up.

All night we're buffeted by the elements, and everything is wet again. Mohammed the Brave's gone very quiet. I think he's missing home – he just can't believe the size of the lake and what still lies ahead of us.

Stanley, in his journal of 19th March 1875, wrote:

> *We fastened bow and stern, but at midnight a storm rose and drove us against the rocks, and we should have been soon smashed irretrievably had not the oars lashed alongside of the boat fended us off somewhat. Amid a pelting rain, and angry loud sounding waves, we managed to get out of danger, and slept in wet clothes.*

White girls

Just south of Musoma we pull into a sheltered bay. Here, you can feel you're getting closer to the Equator – huge trees and thick undergrowth, with monkeys scampering down the rocks to drink. There are pied, malachite and pygmy kingfishers; glossy and sacred ibises; whitefaced ducks; and the ever-present fish eagles, egrets and cormorants. We dry out in the hot sun. It's all so peaceful. I wish we could stay here for days – but we can't! So we batten down the hatches, then once more bounce, bounce, bounce against the swell. We round Ingenge Point, the magnificent rocky outcrop that marks the entrance to Musoma Bay and the

The massacre at Bumbire Island

bustling town of Musoma, administrative centre for Tanzania's Mara district. Waiting for us on the lakeshore of the New Tembo Beach Hotel – it's really only a camping area, but the hotel is coming! – are Bruce, Lumbaye and the owner.

I can hardly stand, my back is so buggered. If only I could work out a way to face forward on the boat. I see a *fundi* cutting planks nearby and decide to discuss the problem with him. An hour and US$10 later, I've got a strong hardwood seat that fits over the transom and allows me to face straight ahead with my legs stretched out. I do a test run and it's an absolute dream!

Starving, we leave our two tents on the lakeshore and head into Musoma. It's a bustling, friendly place – free enterprise at its best. Little shops full of bicycles, radios, handmade furniture; there are tinsmiths beating out buckets and baths, bicycle repairmen and carpenters; bars, street sellers and rice mills; and a market full of fruit and vegetables, fish, goat meat and live chickens. Scores of pelicans nest in the palm trees in the main street.

We pull into an African self-service place called 'Mara Dishes and Fry's' alongside the bus rank in Kivuku Street. Outside is a massive wok filled with bubbling *slap* chips fed by a red-hot charcoal fire. As is the custom, we wash our hands in the little basin provided, grab a silver tin tray and join the queue. Here, eating is taken seriously; this is not a tourist joint. Local lorry drivers, fishermen, traders, farmers and civil servants line up for good, cheap food. We go for the full house: fish, chicken, goat meat, beef *ugali*, fried bananas, rice and chips. Mohammed the Brave uses his spoon like a shovel.

We return to our deserted beach to get the surprise of our lives. Our two tents are surrounded by a tent city, two overland trucks and more than 80 people! At the smell of mozzie spray, strange accents and lily-white faces with head-torches and confused looks, Bruce's jaw drops open. 'White girls,' he says. 'Just look at them, they're everywhere!' Lumbaye knows some of the truck crews from his safari days, so he takes Mohammed the Brave and Bruce off to meet them.

I'll never forget our night in tent city. Whispers and tent zips, cries in the night, alarm clocks bleeping in the early morning, queues of delicate stomachs outside the toilets. It reminds me of the words I once saw scribbled in the dust of an overland lorry's back window: Happiness in Africa is a dry fart. Next morning, I detect that Mohammed the Brave has an obvious hangover. Strange, I think, for a man who doesn't drink.

From Musoma, we follow the twists and turns of the lakeshore. At the village of Shirati, Bruce and Lumbaye fuel us up for our crossing into Kenya. I'm sad to be leaving Tanzania. I love the place and the friendliness of its people.

Death, sunburn and overfishing

High winds blow us into Karungo village in Luoland, Kenya – but no Land Rover to meet us. We drag the boat through the mud. It's so dry here, especially after the beauty of places like Ukerewe Island. A local teacher and farmer, Walter Andala, offers to assist us; his *shamba* (field) is a few metres from the boat. His assistant *askari* for the night is to be his neighbour, Kennedy Otieno.

'Don't worry about the rain clouds,' says Walter in perfect English. 'It hasn't rained here for five months, my crops are failing. Sometimes I can borrow a small manual water pump, and other times we carry the water from the lake in buckets. The soil is good, but without rains we suffer.'

In my notebook I scribble:

> The irony of it all is that here's a highly educated man who lives on the edge of the largest freshwater lake in Africa, but there's no water for his small subsistence garden.

Bruce and Lumbaye finally arrive, looking absolutely shattered. The road, they said, was a nightmare. Then, to make matters worse, they were waved down by a group of Luo tribespeople who, seeing our anti-malaria stickers on the Land Rover, begged for help for a father's dying son. Father and son loaded, the others jumped on the running board and pointed the way forward to the hospital. But too late; he was already convulsing and died a few minutes later in his father's arms. I could tell that Bruce and Lumbaye were quite cut up about it.

Sitting around the fire, Walter tells us that malaria, Aids and drought are their worst problems. And the fishing, I ask, what about the fishing?

'Ah! It's overfished, the lake. There's supposed to be no small-net fishing in the breeding season, but people still fish …. The system is corrupt. You just pay *kitu kidogo* – a bribe.'

Next morning, after having distributed mozzie nets to Walter's community, we head for the gap between Mfangano Island and the mainland, and then past Rusinga Island and round into Homa Bay. The water is deep here and provides some of the finest Nile perch fishing on the lake. It's late afternoon by the time we meet Bruce, who's waiting for us at the end of the jetty. He takes one look at me and can't stop laughing. 'What's happened to you?' he asks. 'You've gone as red as a beetroot!' What in fact has happened is that the Doxycycline antibiotic I've been taking as part of my malaria cure makes one sun-sensitive. The skin on my nose had peeled off and my face looked like I'd been burnt in a fire. Bloody painful. I stop the course immediately, but still suffer for three more days. Unfortunately the boat

doesn't have a canopy, and this close to the Equator it's really tough going. It gets so bad I have to use wet rags to bandage my exposed hands and feet – they swell up like bloody melons, and both big toes have turned into red-black blood blisters. That night Mashozi digs into the expedition fruit and vegetable basket and tries to cool my skin down with fresh avocado pear and cucumber.

We camp amongst the fishermen at Lela Beach. It's a hell of a job wading and pushing the boat through the water hyacinth, a big problem on Lake Victoria. Bernard Ogada, a young entrepreneur for the Luo fishermen, explains that it is only the rains and floods that improve the fish breeding, but if you work hard, you can make money. I help him pull in his nets. Jokingly I tell him that I'm a rainmaker. 'No rain tonight,' they tell me. But the clouds break and we all have to run for cover. Then it stops, and we're treated to a most magnificent Lake Victoria sunset.

All we've known on this lake is hospitality and friendship, despite the fact that at times we're taken for an anti-poaching patrol. Sometimes, too, we feel mobbed by the crowds who come to stare.

For Stanley, however, it was different. On several occasions, he had hostile encounters and on more than one occasion, a bloody battle. His entry for 28th March 1875 reads:

> *Passed a troublous night of toil and suffering from rain and a hail storm. The boat tossed and pitched and groaned as if each timber was being bent from the sides. In the morning while sailing close to the shore, we were stoned by the people. But a few revolver shots stopped that game.*

Later a fleet of 13 canoes containing over 100 men encircled them.

> *Again I beat them off with my revolver and having got them a little distance, opened fire with my elephant rifle with which I smashed three canoes, and killed four men.*

After criticism he received on his return to England, he changed the story, claiming that before shooting to kill, he fired warning shots over their heads.

Kisumu or bust

Stanley would have envied our dash from Homa Bay to Kenya's port of Kisumu in the Winam Gulf. Pushing out through the water hyacinth, we are on the water at

first light. By now we've learnt that the mornings are the best time for flat water. Today it's like glass and by midday, we've paid temporary membership at Kisumu's old Colonial Yacht Club and are quickly into beer shandies and chicken and chips.

We're refuelled by the Land Rover, then we're off again. What luck! The northern shoreline of the gulf protects us from the afternoon wind that normally blows up from Uganda. Filled with confidence, we've told Bruce to meet us at the village of Usengi, 120 km to the north. To keep the weight of the boat down, we haven't even loaded tents or supplies, and are carrying only just enough fuel to get us there. By mid-afternoon we're through the narrow gap that leads out of Winam Gulf. Heading up the channel between Rusinga Island and the mainland, we hug the shore just skimming on the plane of the water to save fuel.

Then it hits us, wind like we've never had before. Mashozi hastily buckles on her life jacket and takes shelter in the bottom of the boat and Mohammed the Brave holds on for dear life. The massive swell is hitting us from the side and getting worse. It takes all my concentration to keep the boat on course, but with the constant use of the throttle we're burning up the fuel. Kit is floating all over the boat so we turn into the wind to tie everything down again. It's freezing cold and wet, and the mad, wild wind is only getting worse. With just ten litres of fuel left, this is getting scary.

How bloody stupid! I'd become overconfident … I check the GPS. We're not going to make it by nightfall, so we make the decision to head for the shore. Now running with the massive swell, it's like being at sea. I know there's only one way – to run with the waves, praying for no rocks, and belt up the beach! If we get caught up sideways on a sandbank or rocks in this surf, we're in serious trouble. I choose a line and head for the shore, jumping a wave as we roar towards the beach. The locals come running down to the shoreline, their shouts lost in the wind – but not their gesticulations. They all point for me to go left. I push hard on the tiller bar and accelerate. Just off the side of the boat, white water foams as it breaks over jagged shallow rocks. Mohammed the Brave shouts and points ahead of us. There, only just visible in the last light, is a half-submerged sailing canoe. We swerve around it. A fisherman frantically waves me forward, I open the taps, and with the Yamaha screaming, race up the beach.

Drunk but willing hands help us from the boat; one inebriate keeps falling over. Mohammed the Brave can't wait; he races to the back of the boat for a pee – I think it's nerves.

The locals tell us this place is called Olago and that the road from the north is completely washed away, even for a Land Rover. This means Bruce can't get to us!

I buy some firewood, Mashozi finds some packet soup in the first-aid kit, we borrow a pot and some old, faded, furry plastic mugs. Mohammed the Brave, Mashozi and I huddle round the fire. The freezing cold wind blows throughout

the night and only at first light does it go dead calm. At sunrise, with John Otieno, whose pot we'd borrowed, we head the boat north to Usengi, arriving with just a tablespoon of fuel to spare. On a stretch of grass between the fishing boats stands our green Land Rover, and squeezed next to it, our blue-coloured Howling Moon dome tent. Bruce and Lumbaye are obviously still fast asleep. I cut the motor, Mohammed the Brave jumps off the boat and races silently up to the tent, picks up the corners and beats on the fly sheet. Lumbaye, with fists at the ready, comes shooting out the one side; Bruce, rubbing his eyes, stumbles out the other. The local fishermen howl with laughter.

We exchange stories, fuel up, grab supplies and are off. Our next meeting place is to be Speke's source of the Nile at Jinja, in Uganda. But this time, we've learnt our lesson …. We've loaded up with tents, bedrolls, extra fuel and extra food supplies. So our love-hate relationship with great Victoria-Nyanza continues.

Source of the River Nile

Herodotus wrote: 'Of the source of the Nile, no one can give any account … it enters Egypt from parts beyond.' Every expedition that ever explored the Nile upstream from Egypt was defeated. Early geographers knew that the Blue Nile came from the mountains of Ethiopia – but what about the parent river, the White Nile, which flowed from south of Khartoum? For nearly 2 000 years, the source of the Nile had remained one of the world's greatest geographical secrets.

On 20th December 1856, Richard Francis Burton and John Hanning Speke arrived in Zanzibar, their mission to launch an expedition in search of the source. Burton – charismatic, larger than life – was the mad, bad and dangerous type; Speke was the very opposite. Their westward march from Bagamoyo with 130 porters and 30 pack-animals was one of the toughest in the saga of African exploration. In February 1858, they limped into Ujiji on Lake Tanganyika with Burton suffering from a badly lacerated jaw, the result of a spear attack; Speke, by this time, was almost blind. Speke did recover his sight, and they explored the lake only to find that the Ruzizi River flowed into the lake from the north. This, then, was not the mythical source of the Nile, but they did hear about a large lake to the north called Nyanza.

Back at Tabora, Burton was happy to write up his notes, while the restless Speke went in search of this Nyanza. After six weeks he was back, grandly claiming that he'd solved a 'problem which it had been the ambition of the first monarchs to unravel'. He renamed Nyanza, Lake Victoria. From Zanzibar, Speke reached England before Burton did and presented his claim to the Royal Geographical Society. When Speke returned to Africa with his close companion, James

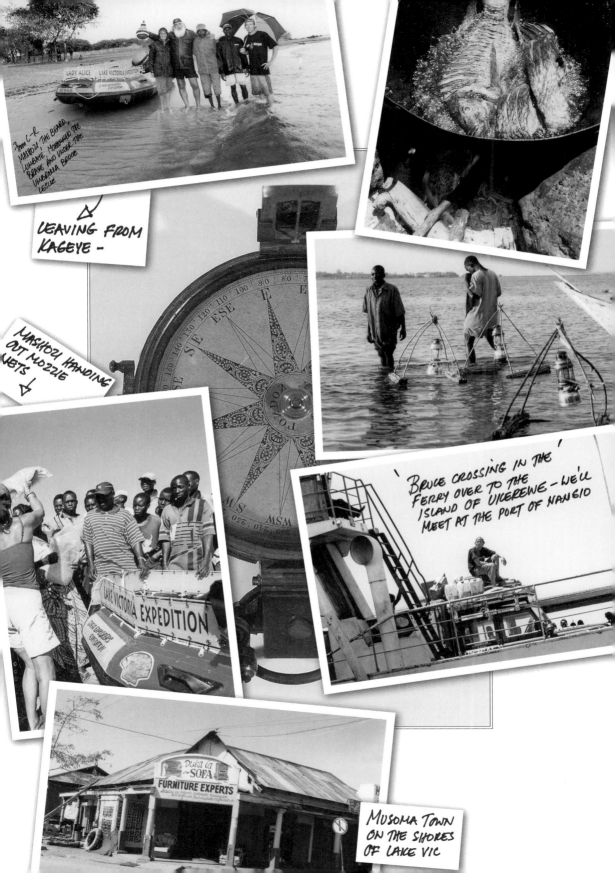

FROM L-R MASHOZI THE BEARD, LUNGILE, MONGWELE THE BRAVE AND UNDER THE UMBRELLA BRUCE LESLIE

LEAVING FROM KAGEYE –

MASHOZI HANDING OUT MOZZIE NETS

BRUCE CROSSING IN THE FERRY OVER TO THE ISLAND OF UKEREWE – WE'LL MEET AT THE PORT OF NANSIO

LAKE VICTORIA EXPEDITION

MUSOMA TOWN ON THE SHORES OF LAKE VIC

Augustus Grant, to explore the western and northern shores of Lake Victoria where he was 'well accommodated' by Mutesa, king of Buganda, Richard Burton discounted his expedition.

Alone, on 21 July 1862, John Hanning Speke discovered the White Nile, then marched about 60 km upstream to discover the Ripon Falls. He sent a telegram stating: 'The Nile is settled' ahead of him and arrived to a hero's welcome. But as things turned out, his glory was short-lived. His claims to have single-handedly discovered that Lake Victoria was the 'source' outraged geographers and journalists, and he was pressured into facing up to Burton in a public debate, which the press dubbed 'The Nile Duel'.

Speke could not back down, but on the day before the two were to meet at the British Association for the Advancement of Science, John Hanning Speke was found dead, shot through the chest with his own gun. The coroner's verdict was 'accidental death', but the surgeon who was first called to the body stated that the muzzle must have been held very close to the dead man's body. Many echoed Burton's words: 'By God, he's killed himself!'

On 29th March 1875, HM Stanley's circumnavigation of Victoria-Nyanza in the *Lady Alice* reached the Ripon Falls, first discovered by John Hanning Speke almost 13 years previously. Speke had named the falls in honour of the first Marquess of Ripon, who was president of the Royal Geographical Society, as he believed them to be the true source of the River Nile.

This supposition remained fiercely contested, and it was Stanley's task to complete the circumnavigation to confirm once and for all that Victoria-Nyanza was one large lake rather than several, and that Speke's Ripon Falls – as the lake's only major outlet – were the Nile's source.

It all started under that old mango tree

After an incredible journey past forested islands, gigantic rocks, beautiful narrow channels, great clouds of lake flies and colourful Ugandan fishing villages, we eventually arrive at Speke's source of the Nile. The Ripon Falls no longer exist, having been submerged in 1954 by the construction of the Owen Falls hydroelectric dam close to the town of Jinja. But there to meet us, near the old Ripon Falls Hotel, are Bruce, Lumbaye and a dear old friend, Jon Dahl. This is a special reunion for Mashozi, Jon and me.

We'd last stood here, 11 years ago, on a Cape to Cairo expedition in which we'd crossed the continent in open boats. Jon never forgot this beautiful place, and a few years after the expedition, he'd returned with some mates, two old Land Rovers and three inflatable boats to whitewater-raft the source of the Nile. Now, a few years

later, Jon and his South African business partner, Bingo, are the proud owners of Nile River Explorers, the finest whitewater-rafting company on the upper Nile.

Later, with *Lady Alice* out of the water for puncture repairs at Jon's workshop, while quaffing Nile Specials at their overlanders' bar which overlooks the Bujagali Falls – and headwaters of the Nile – Jon, in his normal laid-back way, tells me the story of the last few years.

'It all started under that old mango tree,' he says, pointing out of the bar. 'People soon heard we were rafting and kayaking some of the best all-year-round whitewater in the world – these were rapids that had never been run commercially before. We'd all meet at the mango tree, hump the gear down to the river, have a great day's rafting and end up back under the tree, drinking warm beer ... Now it's an overland camp with travellers coming from all over the world to raft the Nile. This pub is the most festive in Africa. Too festive, sometimes ... more injuries in the bar than ever on the river!'

He orders another round of Nile Specials – strong beer that comes in big brown bottles. The bar is full of foreign accents and eager sunburnt faces, checking each other out for a night of fun at Nile River Explorers.

Hot showers, thick fluffy towels and an incredible view over the upper Nile. Bloody luxury! Mashozi can't believe her luck; Jon's put us up at his luxury tented camp. Then there's the meal ... roast lamb and beef, crisp roast potatoes, proper gravy, rice and a full assortment of vegetables. Even ice cream and hot chocolate sauce! Jon begs us to stay longer but, like Stanley, we've got a job to do.

The king's executioners

By 3pm the next afternoon, nursing thick heads, we're gypsies again. The boat is loaded to the hilt with fuel and supplies. Mashozi, Mohammed the Brave and myself silently shake hands; it's a tradition that started from day one – we do it whenever we commence each new day's voyage in the *Lady Alice*. If all goes well, we'll see the Land Rover party again at Entebbe.

Leaving the source of the Nile and heading west, Stanley's *Lady Alice* was escorted by an envoy of six canoes, taking him to Mutesa I, the *kabaka* (king) of Buganda – a powerful Bantu kingdom of the 17th century. He was the most influential man in Central Africa.

Stanley was overwhelmed as he stepped ashore amid a concourse of 2 000 people who saluted him with a deafening volley of musketry and the waving of flags. After having been given a place to rest, Stanley was summoned to see the King.

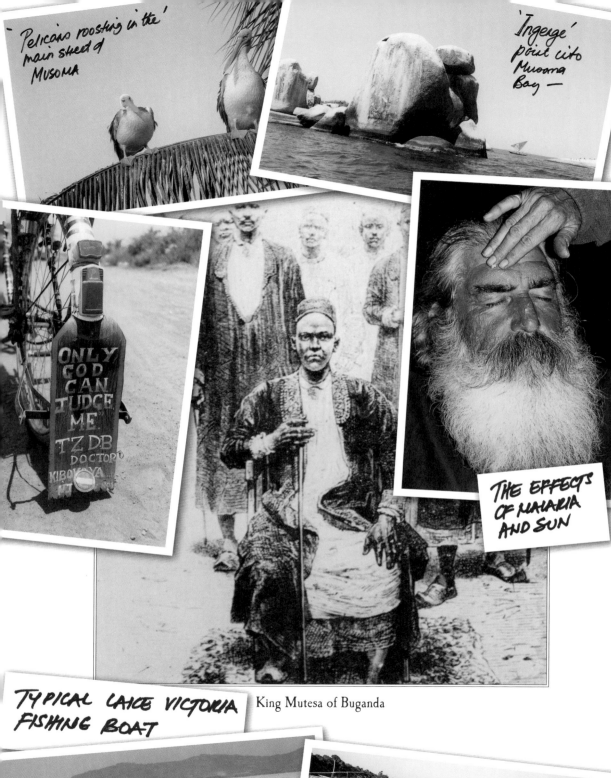

'Pelicans roosting in the main street of MUSOMA

'Ingenge' point cito Musoma Bay —

ONLY GOD CAN JUDGE ME" TZ DB DOCTOR KIBOYOYA NT

THE EFFECTS OF MALARIA AND SUN

TYPICAL LAKE VICTORIA FISHING BOAT

King Mutesa of Buganda

> *I found myself in a broad street eighty feet wide and half a mile long,*
> *which was lined by* [the kabaka's] *personal guards and attendants, his*
> *captains and their respective retinues, to the number of about 3 000.*

To the firing of guns and the beating of 16 drums, he was ushered in to see the *kabaka*. Stanley was captivated by the dignified, tall, broad-shouldered king, and in his notes of 5th April 1875, he wrote:

> *I see in him the light that shall light the darkness of this benighted region,*
> *a prince well worth the most hearty sympathies and evangelical teaching*
> *which Europe can give him.*

Only a few years previously, the explorer John Hanning Speke had offended his Victorian readers by writing of how the same Bugandan king, Mutesa, whom he'd called a 'wholesale murderer and tyrant', had delighted in taking his pleasure with grossly fat women. They were, according to Speke, so fat from being force-fed gourds of milk that they couldn't walk, and so rolled around on the floor or crawled on their hands and knees. The same king who, when Speke presented him with three rifles, passed one of them to a page, instructing him to go out and shoot someone at random. The page 'returned to announce his success with a look of glee'. Speke noted, however:

> *The affair created hardly any interest. I never heard, and there appeared*
> *no curiosity to know what individual human being the urchin had*
> *deprived of his life.*

No one, it appeared, was safe from the king's executioners or from being sold by him to the Arab slavers. Thirteen years after Speke's visit to Mutesa I, Stanley sent a joint dispatch to the *New York Herald* and *Daily Telegraph* claiming that he'd convinced Mutesa of the superiority of the Christian faith. All that now had to happen was for Christian missionaries to be sent to this part of Africa.

Stanley had been fooled, however. Mutesa had played a game with him to secure the European interest he needed to combat the Muslims from neighbouring Sudan and Egypt.

In later years, and thanks to Stanley's inflated reports, missionaries did arrive, but Mutesa remained a murderous pagan until his death in 1884. His successor, Mwanga I, then demonstrated his disrespect for the Christian faith by murdering the Right Reverend James Hannington on his arrival to take up a post as the first Anglican Bishop of East Africa. The European scramble for Africa had begun.

In later years, Africa and the world would be outraged by the cruel antics of Idi Amin, but today, as we continue to follow Stanley's 1875 circumnavigation of Lake Victoria, we find President Yoweri Museveni's Uganda to be one of the most friendly countries in Africa. Mohammed the Brave, our tough-as-nails, quietly-spoken *askari* and boatman from Mafia Island in Tanzania, on the other hand, doesn't like the rough fishermen we find along the Kenyan and Ugandan shores.

'Papa King,' he tells me, 'there's too much *pombe* [home-brewed sorghum beer] – people always drunk, loud music, marijuana and prostitutes. In Mafia we would not allow this.'

The truth is, at every village the girls gather around Mohammed the Brave, admiring his superb build and listening wide-eyed to his much-embroidered story of our Lake Victoria adventure! One silent admirer, looking from Mashozi and me to Mohammed the Brave, shouts to a friend, 'Look! They're travelling with their own bouncer ….'

A reminder of Entebbe

We hug Murchison Bay, speed past Port Bell with Kampala in the distance, and now, having refuelled at Entebbe, we come across a strange sight: the bullet-holed wreckage of the Air France passenger plane that was hijacked by Palestinian gunmen in June 1976! In the daring Entebbe Raid that followed, Israeli special forces wiped out the entire Ugandan air-force fleet of fighter planes, killed the Palestinian militants, every Ugandan soldier in sight and rescued 103 hostages. The raid was humiliating for Idi Amin and his hated army, especially because it appeared that he'd been in cahoots with the hijackers. Public opinion was shifting against the feared Amin who by this time, it was claimed, through his security agents had massacred up to 300 000 Ugandans. To divert attention and redeem the prestige of his army, Amin invaded Tanzania in November 1978, wreaking havoc in the Kagera delta along the shores of Lake Victoria. The Tanzanian army and Ugandan exiles enacted their revenge, marching on Kampala, and the ensuing massacre brought about the end of Amin's terrible dictatorship. Now the wrecked plane lies on the beach, goats grazing under its wings, and the *askari* tells me the owner wants to turn it into a restaurant.

We're now completely at home in our modern *Lady Alice*. Everything's got its place. Raingear, life jackets, maps, Magellan GPS, water bottles and the oars are all easily accessible. Strapped down under a grey plastic tarpaulin are our waterproof bags with sleeping kit and a change of clothes. There's one grub box, a pot, kettle and utensils, two lightweight Howling Moon tents, first-aid kit, a toolbox, spare propellors, patches, glue, a copy of Stanley's expedition journal, a notebook, and

waterproof pen. Hidden carefully are the money, passports and papers. In a line across the boat the lifeblood of the expedition is tied down: six 25-litre plastic containers filled with premixed outboard fuel.

The wooden seat from Musoma fixed over the transom to ease my back works like a charm, while the much-abused 40HP Yamaha Enduro, typically with a 'dinged' prop, rumbles on, hour after hour. We're all losing weight – I think it's the bouncing and hanging on for dear life! The equatorial rains have arrived in daily thunderstorms. Aah … the sense of pleasure when, in the late afternoon, we see the Land Rover lights winking at us from the shoreline at Bukatakata – *renoster koffie* boiling on the *jiko*, dry clothes, fresh supplies and outboard fuel.

Bruce and Lumbaye are tops … the next time we'll see them will be across the Ugandan border, at Bukoba in Tanzania. Skipper and passengers wave as we pass the ferry making its way across the Nabisukiro Channel to Bugala, the largest of the beautiful forested islands that form the Ssese group of 84. We pull up onto a sand spit. Once again, illegal fishermen run in terror, leaving their canoes behind. We shout that we come in peace, and soon they're sitting around our fire. Unfortunately the bugs chase us into our tents. In Stanley's words, '*The pests of the lake are the millions of white gnats.*' In this region, nothing has changed!

Bumbire Island

On Thursday 26th September, the day starts badly. We head into dark rain clouds with very little visibility; waves are huge, it's cold and uncomfortable. Then, ahead, massive clouds of lake flies! We know what to expect as we've had them before, so I try to steer through a gap – but then they're on us. In our faces, eyes and mouths … On the GPS, it's 117 km to Bukoba. The water is so rough!

I give up trying to stay on the plane; we'll break our boat and our bodies. We all squeeze down onto the floorboards, backs against the red pontoons, legs intermingled. I screw down the throttle knob to about 9 km an hour. My raincoat hood pulled over my head, I steer a GPS course. The water has turned an inky blue-black as the rain pelts down. We keep close enough to shore to be able to paddle for it should the motor konk out.

Then the sun blasts down, so we peel off our wet gear. And so it goes: rain, heat, humidity, then more rain. The angle of the swell changes so we race for Bukoba. The scenery is truly dramatic – cliffs dropping sheer into the inland sea; white, white beaches; thatched villages; cattle grazing on the grassy slopes. It so reminds me of the Pondoland coast of South Africa's Eastern Cape. The sun comes out, and what a paradise! Land Rover headlights wink at us from beside the old East African Railways & Harbours goods shed at Bukoba pier.

We camp at Buguruka, a beautiful village beach beyond the town. With Bruce is our old mate, Max Nightingale, who has flown in from Dar es Salaam via Mwanza to join us on the final leg. Tonight is a special occasion – not the normal boat-meets-Land Rover, smash-and-grab pitstop. Old camp chairs and tables are pulled from the vehicle. Long-horned cattle come down to the lake to drink, giving the herd boys a chance to gawk at these strangers who've arrived from land and water, and whose houses are tents! There's steak and boerewors, cold Captain Morgan, plenty of firewood, toes in the sand and a mass of stars.

Mashozi and I are absolutely and utterly exhausted. We've been beaten by the elements on capricious Victoria-Nyanza. The decision is easy. Tomorrow is a day off! We will stay another night here.

Max has never fished on Lake Victoria before but the dream of our new expedition member to land a Nile perch has just come true. Mohammed the Brave, Bruce and Max pose next to the *Lady Alice* with five good-sized fish, caught out in the deep waters near Bumbire Island. We keep one for the camp and the others go to Mr Kapoma, the friendly village chairman, and his assistant, the very serious Honoreth Baitani. I sit and chat to them about Stanley's disastrous visit to the same Bumbire Island 130 years previously.

Stanley, having spent ten days with Mutesa I, king of Buganda, and entrusted his newspaper dispatches and letters to the officer of a Sudanese force heading down the Nile to Khartoum, was now more than anxious to complete his circumnavigation and rejoin the rest of the expedition he'd left at Kagehyi. Sailing south along the west coast of the lake, the *Lady Alice* arrived at Bumbire Island. Stanley and his men were hungry and desperate to replenish their food stocks.

> *No sooner, however, had the keel of the boat grounded than the apparently friendly natives rushed in a body and seized the boat and dragged her, high and dry on land, with all on board. Twice I raised my revolvers to kill and be killed.*

The crew urged Stanley to hold back and they eventually negotiated peace in return for four *dotis* of cloth and ten necklaces of beads. But then, having received the *hongo*, Shekka, the Bumbire chief, reneged and his men seized the oars of the *Lady Alice*. Confident that Stanley and his crew could not escape the island, Shekka's warriors, brandishing spears, clubs and bows and arrows, retired to their village for a piss-up. The warriors later returned with the obvious intention, according to Stanley, 'to cut our throats'. With his elephant gun at the ready, Stanley gave his men an urgent instruction.

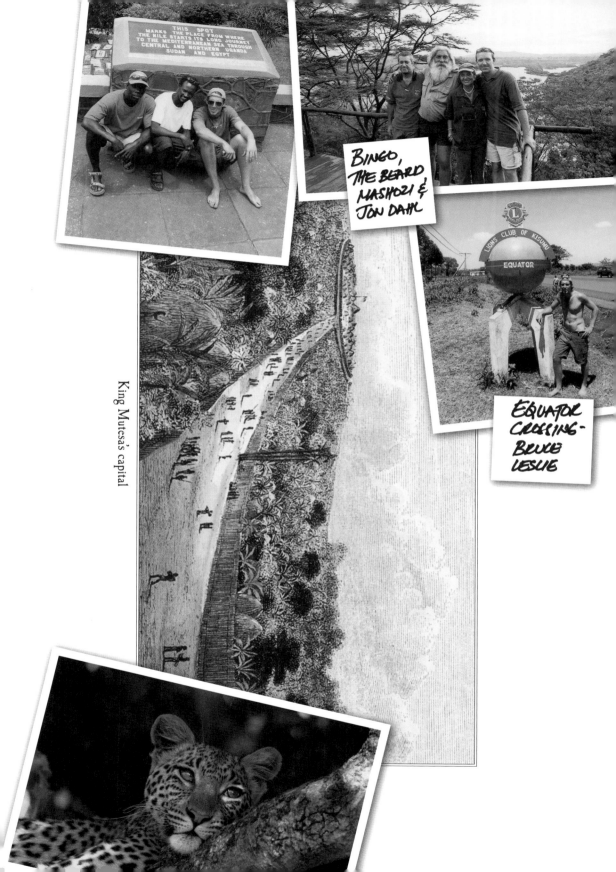

THIS SPOT MARKS THE PLACE FROM WHERE THE NILE STARTS ITS LONG JOURNEY TO THE MEDITERRANEAN SEA THROUGH CENTRAL AND NORTHERN UGANDA SUDAN AND EGYPT

BINGO, THE BEARD MASHOZI & JON DAHL

EQUATOR CROSSING - BRUCE LESLIE

King Mutesa's capital

... with desperate effort my crew seized the boat as if she had been a mere toy and shot her into the water.

Stanley let fly with his elephant gun and a double-barrelled shotgun while the crew ripped up the seats and floorboards of the *Lady Alice* and used them as oars to frantically paddle out of the cove, then set sail and make good their escape. In typical fashion, Stanley recorded:

This decisive affair disheartened the enemy, and we were left to pursue our way unmolested, not, however, without hearing a ringing voice shouting out to us, 'Go and die in the Nyanza!'

Which they almost did. That night a fierce storm blew up, and without their oars, they were unable to keep the *Lady Alice* facing into the wind. It was a miracle that they survived.

Fortunately we find the people of Bumbire Island to be friendly and full of questions about our journey. They offer us some massive Nile perch, but we're still recovering from Lumbaye's three-course extravaganza of fish soup, baked fish and English fish-and-chips, expertly prepared on last night's fire. By mid-morning the rain's pissing down, but it's good to have Max with us in the boat. Max's dad Jon and myself grew up in Zululand. What a character – and now I notice that the apple hasn't fallen far from the tree.

We slowly make our way south, down a long straight stretch of coastline, and by late afternoon we surprise a massive crocodile and a small pod of hippo sunning themselves off the northern tip of Rubondo Island. What a paradise! Rubondo, preserved as a national park, gives us an idea of just how beautiful the island and shoreline of the lake must have been in Stanley's time, before the trees got chopped for charcoal and the game was slaughtered. Rubondo still has magnificent birdlife, elephants and even the shy sitatunga. The giant trees and unspoilt bays minus countless fishing villages make this one of the most beautiful places on the lake.

Two days later, after yet another rainstorm, we reach Nyamirembe in the Emin-Pasha Gulf at the southwestern corner of the lake. Cold and wet, we boil up some tea, then fuel up. The next time we'll meet Bruce and Lumbaye will be back at Kagehyi, our starting point at Stanley's base camp, a short distance north of the Tanzanian port of Mwanza.

I notice that Mashozi is starting to feel the pace. We all have bad days and this is hers. She's feeling absolutely worn-out by the cruel elements of the lake. That morning she'd commented that I should simply roll her up in the tent and load her in the boat. Now I suggest she jumps in with Bruce and the Land Rover team,

but in true Mashozi fashion, she tells me where to get off. 'I haven't come three-quarters of the way around Africa's largest lake in a small open boat to give up now!' I love her dynamite-comes-in-small-packages personality.

We push on through the gap between the mainland and Maisome Island. It's slow-going as we nose into the swell. Max trolls a Rapalla fishing lure, hoping to add a big Nile perch to tonight's menu, but nothing!

We camp on a rocky point on a small beach between giant boulders. The setting sun, egrets and cormorants, a pair of fish eagles in a tall borassus palm, a dhow sailing past to Mwanza – all so beautiful ….

Victory circle

It's Monday 20th September and Mashozi, Mohammed the Brave, Max and I go through the handshake routine. I look up at a grey sky. Shit, the wind's wrong for us! I can see the prop turning in the clear water and there's a contagious sense of excitement. Soon there'll be no more 4am calls to beat the wind, no more bouncing around in a small boat – always either wet or burning up from the heat. No more constant consulting of the GPS and maps, worrying about fuel levels. Today is the last day! The big push for Mwanza, Kagehyi and the end of the expedition.

However, we simply don't manage to make it. In the last of the fading light, stiff and sore from bouncing into a punishing headwind, we camp on a rocky outcrop within sight of the lights of Mwanza.

There's not even enough room to pitch a tent! Max sleeps in the boat, Mohammed the Brave next to it, Mashozi and I roll out our bedroll on a flat rock. There's only one small village on the island, owned by Katarina, a lovely Sukuma woman who brings us firewood and tells us that occasionally one of her goats gets taken by a crocodile.

The early morning wind is blowing in the right direction. Now we can really taste victory as we enter Mwanza Gulf and the rocky entrance into the harbour. We tie up at the yacht club just in time for the breakfast buffet at the next-door Hotel Tilapia. We look like a bunch of scruffy refugees …. Only when I point to the boat and explain that we've just circumnavigated the entire lake do they allow us to sit down. Scrambled egg, hash browns, sausages, hot toast, marmalade, coffee. Like scavengers, we demolish everything. Mohammed the Brave fills two containers from the local petrol station. We sail past the dhow harbour and back out into the lake. Then, following the shoreline, I gun the motor. I know Lumbaye and Bruce will be worried about us. Just 30 km to go! We won't tell them we've had breakfast in Mwanza; that would be totally unfair ….

BASE CAMP KITCHEN

SWARMS OF LAKE FLIES

Stanley arriving to meet King Mutesa of Buganda

TYPICAL LAKE VICTORIA DHOW

WE EMPTY THE CALABASH

"LADY ALICE"

Stanley arrived back at Kagehyi on 5th May 1875. He wrote:

> *After nine hours' rowing, we arrived at Kagehyi to be welcomed by the*
> *men of the expedition.*

But he'd arrived to bad news. His friend Fred Barker, whom he'd left behind to look after the men, had died on 23rd April.

> *He was buried the same day between our hut and the lake, and a wall*
> *of stones surrounding his grave is all that marks his resting place …*
> *sorrowful tidings, Mabruki, Jabiri and Akida have all died of dysentery.*

There they are at Stanley's base camp – tents, camp tables and chairs, fires – and the village of Kagehyi has turned out to greet us. I do a victory circle in front of the camp – and with a loud, tearing screech, the propeller hits a submerged rock. Nevertheless, we roar up the beach, leap out, shake hands and embrace. Water from the Zulu calabash we'd filled here 22 days and 1 867 km ago glugs back slowly into the 70 000-km² Victoria-Nyanza.

Goodbye to timeless waters

At sunset, I walk stiffly up to the stones that still mark the graves of Stanley's brave men. I take off my cap and look down at Mabruki's grave – this unsung hero who guided and protected Burton, Speke, Grant, Livingstone, and then Stanley on their journeys of discovery into Africa. Now his remains lie at the edge of Africa's great lake. Alone, I walk up the sandy snail-filled beach. A sacred ibis jerks its black head and large curved beak from side to side as it walks in front of me. Egrets hop from rock to rock, cormorants with spread wings face the wind to drip-dry; a marabou stabs at the entrails of a gutted Nile perch. Fishing canoes with patchwork sails set off to string out their nets for tasty tilapia. An elegant high-prowed dhow, its massive lateen-rigged sail pregnant with the offshore wind, moves slowly across the sunset while the village girls come down to bathe and fetch water. Tomorrow will be the same on this timeless lake, but we'll be gone. All I'll have are memories of this journey in the footsteps of Henry Morton Stanley, when he proved that Lake Victoria was a single large lake out of which flowed only one great river. A time when the riddle of the source of the Nile was solved once and for all.

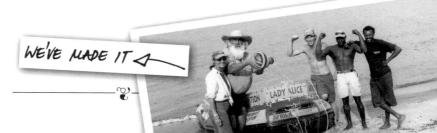

WE'VE MADE IT ⟵

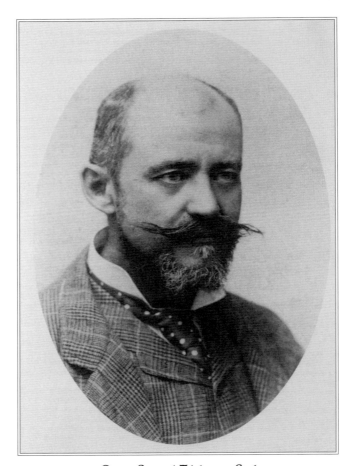

Count Samuel Teleki von Szek

Chapter VIII

Lake Turkana

A Journey to the Jade Sea

An Expedition to and Circumnavigation
of Lake Turkana – the Exploration of the Omo River
delta in the Footsteps of Count Samuel Teleki von Szek
and Lieutenant Ludwig von Höhnel

An Authentic account of Nomadic tribes and
cattle Wars – Flamingos and steaming Hot geysers – Joining
a Donkey caravan – Nabuyatom, stomach of Elephant – Demonic winds
and Thrashing jade-green Tempests

A new expedition, a fresh team

In 1886, at Taveta, just southeast of Kilimanjaro, to the horror of the etiquette-bound Englishmen camped nearby, Count Samuel Teleki von Szek smoked his long-stemmed German pipe continuously and never wore a coat to dinner. Teleki patted his bare, brick-red chest, then said, tongue in cheek, 'My dear Mr Jackson, all African travellers are liars, and I am going to be a liar. If I do not discover the lake, I shall say I did; if I do not discover a mountain, I shall say I did; and who will disprove it until long after I have received the credit?'

Count Teleki certainly had a great sense of humour. He had read Joseph Thomson's book *Through Masai Land*, published in 1885, and had become fascinated by the unknown lands and a large unexplored lake that Thomson said existed somewhere north of Lake Baringo, in present-day Kenya. Teleki was determined to find it for the world.

Born to the landed gentry in 1845, it appears this man was quite a character. After university he joined the army as a hussar officer for a few years, then went into politics. Also a keen hunter and sportsman, and a confirmed bachelor to the end of his days, he decided to go to Africa 'on a great adventure'. Money was certainly no problem.

In Africa, Count Teleki revelled in the relaxed atmosphere of the wilds. He wore his shirt wide open, shaved his head and wore a *kofia*, the cloth cap still used by the Swahili people of the East Coast.

Perhaps I identify with Teleki for both his humorous outlook on life and the fact that he was also a man of similar bulk to myself – his men fittingly named him 'Bwana Tumbo', which in Swahili means 'Mr Belly'.

At the outset of his travels Count Teleki was certainly a man of generous proportions, but what he didn't know was that ahead of him, in his search for the mysterious lake, lay one of the toughest expeditionary challenges of the time – a two-year journey that would strip him to the bone as he and his assistant, Lieutenant Ludwig von Höhnel, faced famine and death. Their only boat would be capsized and crunched by an enraged elephant, and they would be hard-pressed to survive the intense heat and debilitating dehydration of one of the most inhospitable areas in East Africa.

Now, 110 years later, we prepare to set off in the footsteps of Count Samuel Teleki von Szek – this crazy Hungarian count of the Holy Roman Empire who, in 1888, was the first European to discover the world's largest desert lake. He named it Rudolf, after his friend, son of Franz-Josef I, emperor of Austria and king of Hungary.

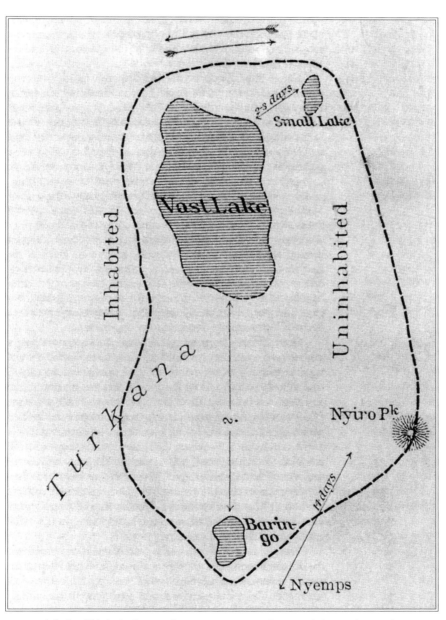

All that Teleki had to go by were rumours of a great lake to the north.

TELEKI NAMED THIS LARGE DESERT LAKE — RUDOLF.

Crown Prince Rudolf

For our expedition, we're using our two old Gemini semi-rigid inflatables nicknamed *QE2* and *Bathtub* – the same boats used in our 1993–94 crossing of Africa from Cape to Cairo. To get to the Jade Sea, the boats will be pulled by *Thirsty* and *Vulandlela*, tough 4x4 veterans of the Cape to Cairo epic.

Our adventurous Jade Sea expedition team is a group of crazy pilgrims of adventure. There's Mashozi, always in charge of supplies, money and the paperwork; second in command, 26-year-old Ross, who understands Swahili. He's recruited two experienced local men for this expedition – old friends from many a safari whom he can trust in difficult and dangerous situations. The older of the two is Lumbaye Lenguru. He speaks six local languages, which we'll need to accomplish our mission. Years before, he and Ross went through the ritual of spitting milk on each other and drinking hot blood as it pumped from the jugular vein of a slaughtered beast. In the eyes of the Samburu, Ross and Lumbaye are blood brothers. The other Kenyan is a tough, police-trained safari hand by the name of Harare – the sort of man you can trust with your life. Then there's the eccentric, freckled, British freelance stills cameraman, Marcus Wilson-Smith, a Fellow of the Royal Geographical Society. Marcus has a wry sense of humour, always wears longs and a collared shirt, whatever the conditions, and is known for having a shandy on a hot afternoon. Travelling with him is his wild, red-haired Scottish girlfriend, Janice Holland. To document our journey in circumnavigating our desert lake is Mike Yelseth, one of South Africa's finest documentary cameramen.

Profile of a lake

To see us off are our delightful Nairobi hosts, Rob and Dale Melville, and a smattering of friends, all drinking champagne and orange juice. The most distinguished of the well-wishers is undoubtedly East African character John Millard. A tough, 88-year-old veteran of the 1934 Lake Rudolf Rift Valley Expedition, he kindly writes this brief description of his expedition in the front of my journal.

To Kingsley

Sixty-five years have gone by since those faraway days and though, generally speaking, the African continent as we knew it then has changed, Rudolf or Lake Turkana, as it is called now, is still much the same as it was when we were there so many years ago – remote, little known, and in its own way romantic, and very beautiful.

The lake is some 300 kilometres from north to south and up to 60 kilometres from east to west. At its greatest, it was 450 kilometres long and was connected to Lake Baringo in the south and the Nile by way of a river that flowed from the northwest corner. This great lake also had connections to the Rift Valley lakes of southern Ethiopia, which explains their essentially Nilotic fish fauna. Massive subterranean upheavals and volcanic activity isolated it, cutting it off from the Nile, the Ethiopian lakes and Baringo in the south. Now Turkana has no surface outlet and only one perennial contributory, the River Omo, which flows into the north end from Ethiopia. The lake was discovered by Count Samuel Teleki and his companion Lieutenant (later Admiral) Ludwig von Höhnel in 1888.

The leader of our expedition was Vivien Fuchs, a born leader of men and an all-round scientist. Subsequent to our expedition and in more recent years, he explored the Antarctic continent and for many years represented British interests in the Antarctic. At this time, as I write, Bunny – Sir Vivien Fuchs (Fellow of the Royal Society) – is 90 years old and he and I are the only survivors of the 1934 expedition.

The northern frontier of Kenya, bordering as it does on the Sudan and Abyssinia, was, and still is, a rather dangerous terrain, and so we were accompanied by a dozen or so of King's African Rifles askaris. We had a 3-ton truck and two box-body vehicles, but because of the lack of roads (and, of course, no four-wheel-drive) we moved mostly with pack camels.

Sad to say, ultimately, after many months together on this adventure, disaster struck and we lost two of our happy band, namely Bill Dyson and Snaffles Martin. We will never know exactly what happened to them but at the time they were involved in mapping and making a survey of the large unexplored island at the south end of the lake. They could have been attacked by one of the enormous crocodiles of that area, or their little boat could have been swamped in one of the tremendous wind storms which are common in Rudolf. And so it was that our great adventure ended in sadness.

John Millard

John Millard's faded photograph album tells the sad story of their expedition. In the search for their missing friends, they had used an old biplane and a more seaworthy vessel from Lake Victoria. But strong winds and high waves also destroyed this vessel, and yet another man was lost to the violent waters of the Jade Sea. All this is a sobering thought for us as we take off on our expedition to circumnavigate the world's largest desert lake, in Count Teleki's footsteps.

Crossing Kikuyuland

Having sailed from Zanzibar to Pangani in an Arab dhow and then marched inland across Maasailand, it had taken Teleki von Szek over six months to reach Ngong, outside present-day Nairobi. To get this far, he and von Höhnel had paid a quick visit to Mount Meru, followed with an assault on Mount Kilimanjaro, where Teleki had climbed to an estimated altitude of 5 350 m before turning back to join his failing companion.

From reading Teleki's journals, meticulously written up by Lieutenant von Höhnel, I can imagine the scene, as on 7th September 1887, they loaded up from Ngong.

> *Directly a man had received his load, he carried it off to have a distinctive mark made on it, and also to get used to its burden. Many of the porters stuck a forked stick into the load so as to get it more easily onto their shoulders; whilst others, especially the Wanyamwesi, liked to divide each load into two parts, fasten each half at the end of a stout stick, and carry the stick on their shoulders.*

The caravan snaked out across Kikuyuland with over 400 porters, each carrying a 35-kilogram load – Count Teleki striding out in front looking for game to shoot, von Höhnel making notes and collecting botanical specimens. With Count Teleki was Jumbe Kimemeta, the experienced Arab trader and caravan leader who'd also travelled with Joseph Thomson on his famous 1883 expedition, and Dualla Idris, who'd travelled with HM Stanley on the Congo and now led Teleki's armed Somali escort. Teleki had expected to cross Kikuyuland in eight days – but it turned out to be a nightmarish trek of six weeks.

> *We had to abandon all hope that we should achieve our journey without difficulty for we were little more than prisoners, so surrounded were we with ever-increasing crowds of natives whose hostility to us was*

> *unmistakable. We were still, however, determined not to give in, and*
> *had we turned back there is no doubt that it would have been the signal*
> *for an attack We were constantly on foot, going about amongst our*
> *people to prevent any careless action of theirs fanning the smouldering*
> *fire; but at last, when arrows began to fall thickly, and the warriors*
> *on a hill on the north grew more and more insolent and aggressive, we*
> *thought it was time to damp their ardour by bringing our own weapons*
> *into evidence a little ...* [Buffalo-hide shields] *were set up at a distance,*
> *and, making the natives stand aside, we fired at our targets. The shields,*
> *riddled with holes, were then exhibited to the warriors, and they were*
> *warned that if we were attacked we should point our guns at them ...*
> *When night fell we sent up a rocket every now and then in one direction*
> *or another, the unusual apparition serving to keep the natives in awe.*

But Teleki would never have succeeded without the loyal support of his Kikuyu guides who organised 'blood brothership' ceremonies with the Kikuyu elders. Men like Dualla, Jumbe and Kijanga, the orator, who spoke fluent Kikuyu, were the unsung heroes.

Despite the expedition having to trade and fight its way across Kikuyuland, both von Höhnel and Teleki were still impressed by the industrious nature of the people.

> *The waKikuyu are not only zealous agriculturalists, they also keep bees*
> *and breed cattle, sheep, poultry and goats.*

They passed through districts 'so carefully and systematically cultivated that we might have been in Europe'. They decided that the Kikuyu were the most industrious of the tribes they'd come across. And they were right. In later years, the struggle for land and independence from the British was led by the Kikuyu leader, the late President Jomo Kenyatta.

Rift Valley Christmas

Christmas for us is a splendid affair amongst steaming geysers on the floor of the great African Rift Valley. We camp under the shade of giant sycamore figs, surrounded by the pink and white of over two million flamingos on Lake Bogoria. We even have paper hats and crackers with messages, a decorated thorn branch serves as a Christmas tree, and turkey, roast potatoes, rice and vegetables, served with jugs of thick brown gravy, have been cooked on the coals in an old army

Teleki's porters

tin chest. Greater kudu step daintily past our camp, while our carol singing has the baboons barking in the trees. There's even a tinned Christmas pudding, wine and beer chilled in a stream, and enamel mugs of Captain Morgan Black Label Jamaican rum! My Christmas present from Ross is Nigel Pavitt's magnificent book, *Turkana, Nomads of the Jade Sea.*

When Teleki reached this area, the local Njemps people were suffering a severe famine. If his vast caravan were to survive the arid crossing in search of the mysterious lake to the north, he would need to obtain food stocks. On 17th December 1887, he sent Dualla off with 170 porters, guides and *askaris*, and 22 pack-donkeys to go back into Kikuyuland in search of grain. In the meantime, the remaining men would have to live on meat, and Teleki was left to provide single-handedly for the entire caravan. He was charged 11 times by wounded buffalo, but succeeded in killing ten elephant, 69 buffalo, 21 rhino, nine zebra and a small number of hartebeest, eland and waterbuck. The men dried over three tons of biltong. Their journal read:

> *Our food had now for a long time consisted almost entirely of meat, and only on special occasions did we get some stiff porridge made of millet. The haunches and shoulders of the sheep and goats were reserved for us with the tongues, steaks, humps and breasts of the oxen, the last named being boiled, whilst the tongues were roasted on a spit for a very long time …*
> *We craved for fat or grease as do the Eskimos. We could have eaten pounds of it, and we gloated over the thought of the fat humps of the oxen days before we ate them. They were to us the daintiest titbits and we would not have exchanged them for all the triumphs of European culinary arts.*

It was soon to be that other travellers would follow Count Teleki von Szek's journey into northern Kenya and, sadly, it was the start of the wholesale slaughter of wildlife in East Africa.

After an absence of 36 days, Dualla returned with 128 loads of grain. It was time for Teleki to prepare for his journey to the unknown lake.

Gun-toting Maralal

Growling in first and second gear, the vehicles complain as we pull the expedition boats over the Rift Valley escarpment and through the lands of the fierce cattle-raiding Pokot tribe to the Samburu frontier town of Maralal. This is our last supply point in our journey north to the Jade Sea.

We spend the night with larger-than-life character Malcolm Gascoigne, an Englishman who owns a bush pub, lodge and campsite just out of town. Malcolm was one of the first ever overland truck operators to run regular safaris from London to Cape Town. He was also one of the first to do commercial gorilla trekking. Very sadly he lost his wife in a crash on the Mombasa road and he has subsequently 'gone bush'. As company, he brings in the odd girl from Nairobi's Florida Club and it's not unusual, after a hard night's drinking, for him to wave his revolver around in the air and shoot the windows out of his own pub while the guests take cover on the floor! Once a year, Malcolm organises a camel race around the village of Maralal, a three-day affair with participants coming from all over the world – but it's invariably won by the local Samburu tribesmen.

Idi, one of the local camel owners, tells me we must be crazy to be attempting to follow Teleki's journey into the depths of the Suguta valley. He once took an Italian safari down there; one of them died of dehydration. Idi warns me, 'Papa King, you've come at a bad time. Cattle wars between the Samburu and Turkana are getting worse; some places, they are not safe. Every day my people are getting killed. You should not go now.'

A setback

We remain firm in our intention to follow as closely as possible in Count Teleki's footsteps. This means travelling to the village of Tuum, in the shadow of Nyiru, the sacred mountain of the Nilotic Samburu people.

We pull the boats slowly northwards through a desolate area fringed by mountains. Although nervous, everybody is in high spirits. The canvas on *Thirsty* is rolled back and some Christmas tinsel is still entwined around the roll bars. Suddenly there's an awful screech of grating metal and the smell of hot oil as *Thirsty* lurches to the side. Out with the high-lift jack and Ross removes an oil-stained wheel. Not only has the bearing collapsed, it's also worn a deep groove into the side shaft. It couldn't have happened in a worse place. We'd hoped to get to Tuum before nightfall to meet a man named Julius. We'd hired him in Maralal to arrange pack-donkeys and armed guards. Right now we're in the middle of nowhere … no firearms, no protection. We pitch camp and light a fire. Mashozi cooks up a stew and it's a sombre team that rolls into bed. In the dark, we're at a low ebb, wondering whether we need to abort the expedition.

Ross, Lumbaye and I decide to backtrack in the Hilux to the village of Baragoi. The road is full of Samburu cattle. Lumbaye tells us they've been recaptured from the Turkana. Long-haired, red-ochred warriors – all of the same age – armed with guns and spears wave us forward. At a *nyama choma* (roast meat) place in Baragoi,

Hunting for ivory and the pot

we share sweet masala tea, Karanga goat meat and chapaties with the local street dudes. Three hours later, we find an old rusted side shaft under a bag of mielies in the back of a trader's store. We hire the services of Isak, the local mechanic, a large cheerful fellow who in the early hours of the morning is quite prepared to pull on his overall and accompany us back to the forlorn *Thirsty*. The side shaft fits perfectly and, even better, Isak the mechanic agrees to accompany the expedition! Where else but in Africa?

A very hung-over Julius, still smelling of grog, is waiting for us at Tuum. From the dudes in Baragoi, we'd already learned that the petty cash we'd given him to buy supplies had been spent on booze. He has, however, organised six pack-donkeys and tough Turkana handlers together with two armed Turkana warriors (one with an automatic rifle, the other with an old Lee Enfield 303).

But there's tension in the air in Tuum, and we have to wait as elders from the two warring Samburu and Turkana factions hold peace talks under the shady canopy of a giant umbrella acacia. Finally, we get the go-ahead to proceed. We load up the pack-donkeys with just the basics: sleeping gear, a medical kit, a satellite phone, food supplies, every available water container, and chewing tobacco to be used as currency. Ross is worried about our safety and we agree to have fixed satellite-phone call-times twice a day, and he will put emergency procedures into action if he doesn't hear from us.

Ross, with the bulk of the party, will continue in the two vehicles and launch the expedition boats into Lake Turkana to meet us at the base of an extinct volcano called Nabuyatom ('stomach of elephant'), leaving us to follow the route taken by Count Teleki. Mashozi, Mike, Marcus and I slowly follow the armed donkey team out of the village of Tuum, bound for the Suguta Valley and the Jade Sea.

Made to eat his own liver

Within an hour or two we are blasted by the scorching heat and realise we have to find shade. Temperatures are in excess of 54°C and it's impossible to walk in the heat of the day.

The tough, rocky conditions give us an idea of what it must have been like for Count Teleki's rambling entourage.

> *The scenery became more and more dreary as we advanced. The barren*
> *ground was strewn with gleaming, chiefly red and green volcanic debris,*
> *pumice stone, huge blocks of blistered lava and here and there pieces of*

petrified wood. There was no regular path, and we had to pick our way
carefully amongst the scoriae [masses of solidified lava], *some of which*
was as sharp as knives.

The suffocating heat is unbearable. Making matters worse, we get lost trying to take
a shortcut down a rocky slope covered with *kodja kidoko* ('wait a bit' thorn bushes)
that tear at our bodies. Finally we emerge in torn clothes, bleeding, but back on the
track leading to the waterhole of Parkati.

Walking in the moonlight, I make out a small wooden cross on the left-hand
side of the track. Our guides seem reluctant to tell me the story but, finally, Julius
the interpreter explains that it was here the missionary was killed. The local Turkana
had repeatedly warned him not to build a road … as cattle rustlers, they knew that
a road would bring the army and the police. But the missionary didn't listen, so one
day, as he was passing in his Land Rover, they shot him. The story goes, he didn't
die instantly; while still alive he was made to eat a piece of his own liver.

Now the road is just a jumble of boulders and a thin, red path enabling us and
our pack-donkeys to reach Parkati where the Turkana come to water their cattle. By
now, I've learnt the power of chewing tobacco, and using the word *ataba*. I know to
dip my hand twice into the tobacco bag and always to offer two pinches – as giving
only one is considered impolite.

The situation here is tense. A Turkana tribesman has recently shot down a
helicopter with his old 303 rifle, killing a high-ranking army officer in the process. I
am sure half of the cattle down here have been stolen from the Samburu.

A number of the Turkana are armed with spears and rifles, some also wear
traditional Turkana razor-sharp wrist knives worn like a bangle, the sharp outside
edge covered in a skin sheath. One wild-looking fellow is even wearing finger-
ring knives that curve like a lion's claws. It's not difficult to imagine what your face
would look like after being raked in a fight. Scarification on the Turkana chests
indicates the number of enemies killed.

At Parkati, Mashozi treats an old man for malaria, and once they realise we're
friendly, tension breaks and we're free to fill our water containers – our lifeblood!
Since Teleki passed through here just over 100 years ago, very little has changed
amongst the fiercely independent Turkana.

It's interesting to browse through these notes in his expedition journal:

Nearly all the Turkana ornaments are made of iron. The bracelets consist
of a number of loose rings of wire, and the neck ornaments of six strong
iron clasps resembling armour. In the pierced underlip of both sexes is

Charging Buffalo

worn a little brass rod, and from the nostrils is suspended an oval brass
plaque. In the lobes of the ears are inserted a number of little rings.
Turkana girls wear a leather apron which is prettily decorated with a
broad band of ostrich eggs pierced and strung together. The ornaments of
the women consist of several rows of beads worn round the neck, girdles
made of iron and brass rings or goat's teeth, and ear, nostril, lip, arm and
foot rings or plaques of various kinds.

A dehydrated New Year

No New Year's Eve bash for us this year as, slowly, we walk by the light of the full moon from the floor of the barren Suguta valley to the top of 'The Barrier' – a barricade of volcanic slopes that our guides tell us overlooks the Jade Sea. We're down to careful water rationing, having last filled our containers at the Parkati waterhole. We celebrate the Old Year with enamel mugs of sweet black tea, bully beef and two chocolate éclair toffees each. Bloody luxury!

A collapsible solar panel strapped to the back of a donkey has kept the small motorcycle battery charged, allowing us to make a satellite phone call through to Ross. They've arrived safely at Lake Turkana and are preparing to celebrate New Year's Eve at their base camp. I envy the high spirits of the boat team as, with the help of our Turkana guides, we wearily move rocks aside to allow small spaces for our sleeping bags. I am full of admiration for these tough nomads of the desert. They don't have to constantly drain their water bottles down their throats like we do. They survive on three or four mugs of sweet black tea a day and, provided they have enough chewing tobacco and sugar for their tea, they never complain.

The Turkana language is one of the most complex in Africa. For example, they have 23 different verbs to describe the way a person walks. It is no wonder they are full of jokes as they see us hobbling over this broken terrain, our skin turning bright red in the heat.

Wherever we stop or camp, the armed guards first climb up onto a high point to scan the area. I'm told by Julius that killing is not new to them.

The real heroes, however, are our tough little, thin-legged, heavily-laden pack-donkeys. Initially we thought to use camels, but they would never have been able to scramble over all the loose volcanic rock and lava. The real test is tomorrow. The donkeys last drank at Parkati and there's no more water for them until we reach the lake.

We're up before sunrise; sweet tea and porridge, then the slow task of tying our kit and the remaining jerry cans of water onto the donkey panniers. The guards check their guns and roar with laughter as I straighten up with a grimace. Julius,

our jovial round-faced interpreter, has taken to calling me Bwana Tumbo. I should never have told him Teleki's nickname!

'*Kazi mingi,*' he says – it's a 'big job' following this man Teleki, but we must move quickly before the sun kills us.

The fiercely hot gale-force wind dries us out like prunes. I look across at Mashozi. She has wet a cotton shirt and has it hanging over her head and the back of her neck. Every ounce of effort is needed to put one foot in front of the other, taking care not to sprain an ankle on the volcanic stones that are already bouncing back the heat. Today we add powdered glucose to our water bottles.

Our caravan is spread out like a long line of ants in a vast landscape. The donkeys and their handlers are out in front; Mike, with his camera over his shoulder, walks with the armed men; Mashozi, Marcus and I plod along in the rear. We struggle on for hours.

A sea of jade waters

With an excited shout the Turkana, in wild jubilation, wave their firearms and spears in the air. Julius beckons us forward with a grin. There, as if by a miracle, stretching away – from far below us to the Omo delta and Ethiopia in the north – is the famed Jade Sea. In awe, we gaze across this incredibly wild, remote, piece of Africa which holds in its hands a glittering green jewel of a lake.

To reach our rendezvous point, the extinct volcano of Nabuyatom at the southern tip of the lake, however, we must first cross a seemingly endless barrier of tortured, twisted, volcanic rock. We huddle in the shade of a scraggly flat-topped acacia. With the howling wind stealing my words, I read aloud from Count Samuel Teleki's expedition journal:

> *The void down in the depths beneath became filled as if by magic with picturesque mountains and rugged slopes, with a medley of ravines and valleys, which appeared to be closing up from every side to form a fitting frame for the dark green gleaming surface of the lake stretching away beyond as far as the eye could reach.*

Over a year since Teleki had left Zanzibar, now, finally, as if in a dream:

> *For a long time we gazed in speechless delight, spellbound by the beauty of the scene before us, at the sight of the glittering expanse of the great lake, which melted on the horizon into the blue of the sky. At that moment*

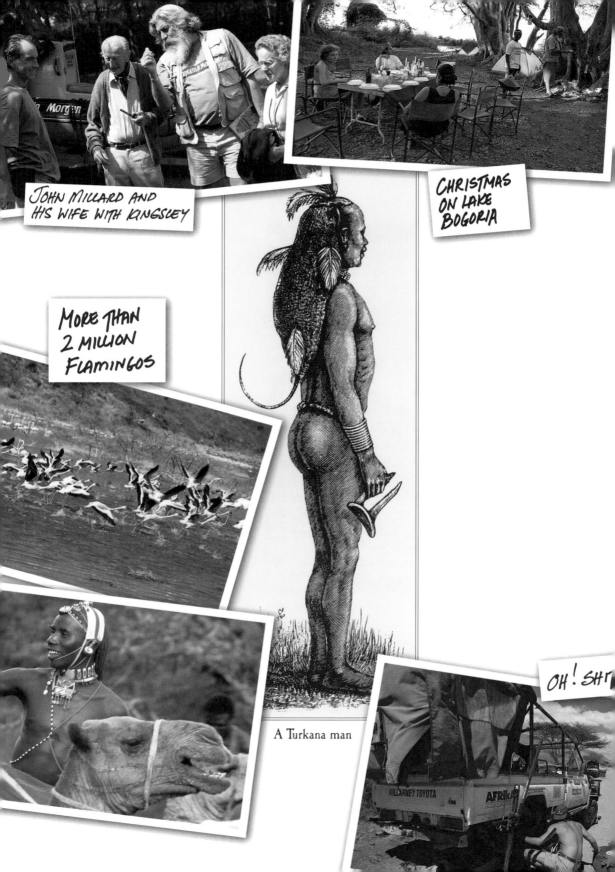

JOHN MILLARD AND
HIS WIFE WITH KINGSLEY

CHRISTMAS
ON LAKE
BOGORIA

MORE THAN
2 MILLION
FLAMINGOS

A Turkana man

OH! SH!

all our danger, all our fatigues, were forgotten in the joy of finding our
exploring expedition crowned with success at last.

— Lieutenant Ludwig von Höhnel,
scribe to Count Samuel Teleki von Szek, 1888

Furnace from hell

'The poor donkeys!' cries out Mashozi, as one of them loses its footing on an impossibly steep, loose-stoned path. The load breaks free – pots and pans litter the path and the last of our rations of salt, sugar, tea leaves, and rice lie scattered over the rocks.

The heat off the volcanic debris is like a furnace. The demonic wind howls. The Turkana patiently urge us forward, over huge, blistered blocks of lava. They know it's a race against time, intense heat and precious water. Nowhere else in Africa have we ever experienced such harsh conditions. It's no wonder that Teleki wrote:

> *When the sun rose higher, its rays were reflected from the smooth black*
> *surface of the rock, causing an almost intolerable glare, whilst a burning*
> *wind from the south whirled the sand in our faces, and almost blew the*
> *load off the heads of the men.*

Full of enthusiasm, and remembering the gracious interest taken in his plans from the first by his Royal and Imperial Highness, Prince Rudolf of Austria, Count Teleki named the sheet of water – 'set like a pearl of great price in the wonderful landscape beneath us' – Lake Rudolf. The Jade Sea had a new name – but before the century was out, the government of the independent Kenya changed the name to Lake Turkana.

Like Count Teleki, we are taking enormous strain. Mashozi is suffering from dehydration so we rest her under a lone acacia and feed her Re-hidrat and sweet black tea. Exhausted, she instantly passes out and we leave her to rest for an hour.

Samuel Teleki wrote:

> *The good spirits with which the thought that we were nearing the end*
> *of our long tramp had filled us in the morning had long since dissipated,*
> *and we were disposed to think the whole thing a mere phantasmagoria.*

Teleki and his men were badly dehydrated, and on the final march down to the lake, four of them died as a result. It is easy to understand the incredible disillusionment the magnificent lake had in store for them when they dived in to drink in the water with their entire bodies.

> *Although exhausted, we felt our spirits rise, rushed down shouting into the lake, clear as crystal, and, bitter disappointment: the water was brackish.*

It was 5th March 1888, and the Jade Sea had been seen by European eyes for the first time.

Our caravan has now been joined by a Turkana family, carrying their badly injured daughter on a donkey, her little body shaded with a canopy of palm fronds. Six days earlier her leg had been crushed to the bone by a falling stone. Rough, handmade splints have been tied to each side of the exposed bone and natural African medicines applied, but it has turned horribly septic. Gangrene is setting in and we can smell the rotting flesh. She's in great pain. Somehow, because of her dire condition, we stop thinking of our own misery as, with blistered feet and swollen lips, we stumble into camp in the late afternoon of 1st January 1999. And little has changed since Count Teleki's time 111 years before. Ignoring the crocodiles, we race into the cool, jade-green waters of Lake Turkana.

What a rare privilege to be able to adventure like this as a family, sharing the dangers and triumphs of the journey. Mashozi and I with our own story to tell as we all get together again with Ross and his team, waiting for us with the expedition boats and fresh supplies. At our camp at the base of Nabuyatom – 'stomach of elephant' – we slaughter a goat obtained from a nearby Turkana village to celebrate the end of New Year's Day and our arrival at the Jade Sea.

Mashozi cleans and treats the little Turkana girl's horrific wounds. Next morning, Ross races her across the heaving waters to the Catholic mission station at the oasis town of Loyangalani further up the lake. I will always remember the look of terror in her eyes as we tied on her life jacket and wrapped a waterproof bag over her bandaged leg. Days later we learn that she'd been flown out in the missionaries' plane and not only had she survived her first journey by inflatable boat and light aircraft, but also her injury.

A giant fish and an angry croc

The task ahead of us now is the circumnavigation of what must be one of the most dangerous lakes in Africa. High winds off the Kaisut and Chalbi deserts to the southeast create massive green waves that play havoc with small craft. Intense heat, crocodiles and snakes, banditry between the six nomadic tribes, and those from nearby Somalia, as well as violent cattle raids are all the makings of a great adventure. The logistics are difficult and there is no guarantee of fuel supplies.

Sunburnt and footsore from the march, I can tell already that the extreme conditions are going to highly test this expedition. Mike Yelseth's face is swollen with a severe heat rash while freckled, red-haired Marcus has been tortured by the sun and, as always, has taken to wearing long trousers and shirt sleeves. Very British is our Marcus, but he's a good man and you can't get him down ….

We load up *Bathtub* and *QE2* with expedition supplies, Ross inspects the motors, and there's the familiar smell of outboard fuel as we prepare for our circumnavigation of this weird and wonderful place called the Jade Sea. Let's simply hope we have better luck than Sir Vivien Fuchs' expedition; that Ngai, the god of the Samburu people, watches over us from the clearly visible peaks of Mount Nyiru.

It's day 12 and a hot, dry wind whistles from the southeast, enabling us to run with the swell as we round the steep-sided walls of the Nabuyatom crater. Our pack-donkey team waves goodbye from the shoreline, weapons raised above their heads. We've grown fond of this small fierce band of Turkana tribesmen, a bond of friendship forged by wild adventure. They will spend the rest of the day resting and eating the balance of the goat, then will walk at night, the full moon guiding them back on the long trek to Parkati, Tuum and finally to their families at the village of Baragoi. Simple, uncomplicated men but with a great warrior ethic. They've enriched my life.

We camp on the western shore of South Island. I think of the two men who went missing from Sir Vivien Fuchs' expedition. They'd sailed their small boat to this same island (in those days it was still called Von Höhnel Island) and had never been seen again. No bodies were ever found; only a hat and a half-empty water container that washed up on the western shoreline.

A monster crocodile cruises the bay in front of us, the wind continues to howl. Lumbaye prepares a Nile perch, one of several we caught in just a few minutes of fishing. While on the expedition recce to South Island, we'd landed a 200-pounder – so big that Ross could put his head into the fish's mouth! After taking some of the fish-meat for ourselves, we gave the bulk to a Turkana lady who had been cast out of her community and was living alone in a hut the size of a dog kennel. According to the locals, she hadn't spoken a word in years and had only survived on

scraps of food left by the odd passerby. The Turkana woman spent the entire night cutting the giant fish into strips, which she hung out to dry. Only when we offered her some salt to rub into the fish did she mumble a few words of gratitude. We were told they were the first words she'd spoken in years.

In the middle of the night, I get the fright of my life. *Bathtub* is being dragged into the lake and there's the hiss of escaping air. My immediate thought is that Lumbaye is being dragged into the water by a crocodile. My imagination runs wild – him hanging onto the boat with his hands, his legs in the croc's jaws. I stumble out of my sleeping bag and, by the dim light of a failing torch, painfully hobble barefoot over the rough volcanic pebbles down to the water's edge.

I shout for the others when I see the almighty commotion – a massive croc is chomping the boat! And the more it bites the pontoon, the more air escapes – making the bastard even angrier. It was obviously attracted by the smell of blood from the fish we'd caught in the boat that day. In my fury I start pelting the croc with handfuls of volcanic shale off the beach. It opens its terrifying jaws at me but gets another handful down its throat. I scream for Lumbaye. Nothing …. Earlier, he'd been sleeping next to the boat. In a panic I call for more torches. We keep on shouting. He finally appears, much to my relief, rubbing the sleep from his eyes from behind some rocks where he'd moved to take cover from the wind.

By the time we leave the island, *Bathtub* wears patches on her pontoon like medals earned in battle – boat damage that, later on in the expedition, would nearly cost us our lives.

Turkana and el-Molo

The light of the flames lights up the fierce faces of the Turkana gathered around our campfire. We are south of the oasis village of Loyangalani and a goat has been slaughtered. Dressed in animal skins and beadwork, and covered in red ochre, the Turkana dance around our fire. Tea leaves, sugar and chewing tobacco have served as our peace offerings. But the headman of the area has heard about us saving the little Turkana girl's life and we are being treated like kings.

Unlike all the other Nilotic peoples, the Turkana do not practise circumcision and, as such, consider themselves superior to the neighbouring desert tribes, who in turn despise them for this social transgression. The Turkana are extremely individualistic, they have few rules and regulations, and are often considered arrogant. Their lives are ruled by the acquisition of land and livestock; they are a law unto themselves. I admire their fierce sense of independence and also their ability to live in perfect harmony with their hostile surroundings. As a people, they are as tough as nails.

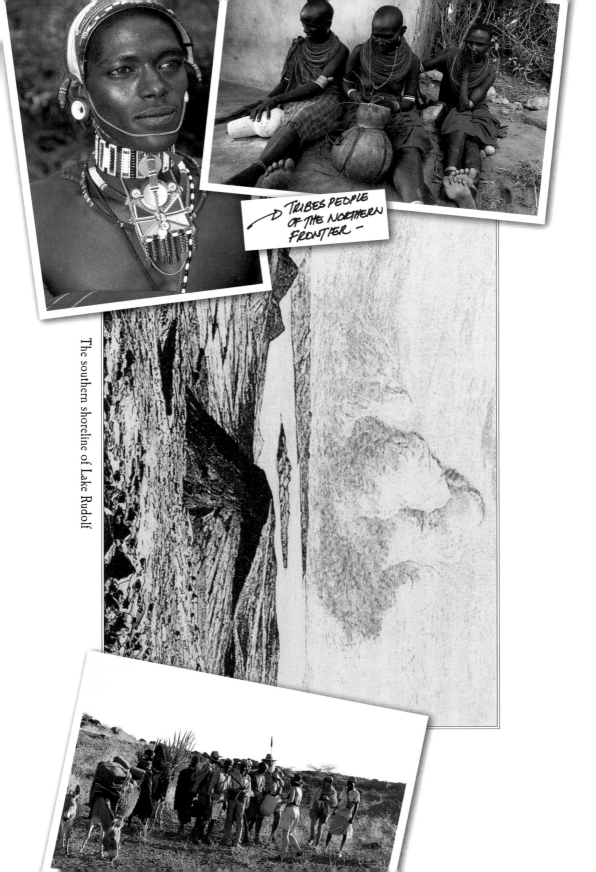

TRIBES PEOPLE
OF THE NORTHERN
FRONTIER —

The southern shoreline of Lake Rudolf

It was around Loyangalani that Count Teleki had made the mistake of wandering away from the lakeshore, believing they would find fresh water in the foothills of nearby Mt Kulal. The men were exhausted from weeks of incessant hard trekking. Von Höhnel describes the depressing scene:

> *Half the men were lying about staring vacantly before them; loads and animals were in the most hopeless confusion; donkeys and sheep wandering aimlessly about. All discipline was at an end, and the men were utterly demoralised.*

Further on he found the count in a narrow ravine walled in by towering columns of basalt. A scene of chaos prevailed, men and animals jostling and pushing around a tiny supply of water at the base of a cliff. The struggle to find sufficient water had reached frantic proportions, finally requiring the use of Somali whips and Teleki's personal efforts to control the shouting mob and ensure a fair share for everyone. The whole dreary night was spent this way, searching for and watering the stragglers. Early next morning, the caravan staggered the remaining few miles back to the lake. Tragically, the death toll continued. Four more men had died.

They should have stuck to the somewhat unpalatable green waters of the Jade Sea, whose remarkable colour is caused by green algae with high chlorophyll concentrations; nevertheless, it is drinkable.

From Loyangalani we journey up the east coast in our two small boats, loaded with basic camping equipment, a food box, drinking water, a change of clothes, medical kit, and jerry cans of boat fuel. Not to forget, of course, protected in the bedrolls, campfire solace in the form of a couple of bottles of my preferred expedition plonk.

We find the delightfully friendly el-Molo people are sheltering from the wind in their village of small domed huts on the shores of El Molo Bay. Numerically Africa's smallest tribe, they believe that all the fish, hippo and crocodile in the lake belong to them. The el-Molo have lived by the water since times unknown – certainly long before Count Teleki and von Höhnel reached this bay on their long march up the eastern shoreline.

We are welcomed by the el-Molo into their village where they teach me their dance and share crocodile and fishing stories with us. They've never seen inflatable boats before and the children shout with delight as I take them for a boat ride out into the lake. It's a shame that as a result of their poor diet (fish and alkaline water), rickets is widespread. In the adults it is particularly noticeable by their bowed legs, chests that stick out and the poor condition of their teeth. But their laughter and song is carried in the wind as we bid farewell to continue our voyage north up Count Teleki's Jade Sea.

The Hilux *Vulandlela*, loaded with two drums of boat fuel, Harare, the mechanic Isak, and joined also by Mike – who wants to document some of the land-support journey – will all make their way overland to our next supply point at Koobi Fora, on the northeastern shore of the lake.

On to Koobi Fora

The torch lights up crocodiles' eyes. I know it's dangerous to be travelling this late, especially if the wind comes up, but finally, on day 14, we reach the sanctuary of Moita Mountain and a deep-water landing. Soon the kettle is boiling and we wolf down some goat stew and rice, washed down with the Captain's *renoster koffie*.

We make ourselves as comfortable as possible amongst the rocks. This place is eerie and the cackle of bloody hyena keeps me awake for most of the night. The following day, at Allia Bay, we find a large herd of zebra and oryx drinking the alkaline water of the lake.

Reaching Allia Bay was an important milestone in Count Teleki's journey as it marked the beginning of better conditions. Here there was no lack of meat – rhinoceros, elephant, zebra, oryx, buffalo and gazelle abounded. The count, unfortunately, delighted in the pursuit of ivory. As if the porters didn't have enough to contend with by simply trying to stay alive; now they had to lug ivory tusks too!

Countless dry riverbeds make their way down to the lakeshore and the occasional Turkana herdsmen sit in the shade of scattered acacia trees, watching over their herds. Many are armed with antique Lee Enfield rifles; we're told that in this area they're under constant threat from their enemies, the Borana.

Boomerang Island is covered with crocodiles, so the chief warden lets us use one of the huts. We slaughter a fat-tailed desert sheep and have a feast as we wait for the backup truck. The team soon arrives; Mike's looking quite haggard, his face still bearing the signs of a severe heat rash, and he's got the 'squits' – but as always, he's doing a great job of filming our Jade Sea adventure. Consistently ready with a smile and a joke, he's a true modern-day adventurer.

We reach Koobi Fora at night, preceded by much shouting and questions from our guides about crocodiles. We camp on the shoreline, much to the annoyance of a disgruntled hippo.

In July 1967, Kenyan anthropologist-palaeontologist, Dr Richard Leakey, was flying over northern Kenya to join a research expedition on Ethiopia's Omo River. A thunderstorm forced the pilot to divert over the eastern shores of Lake

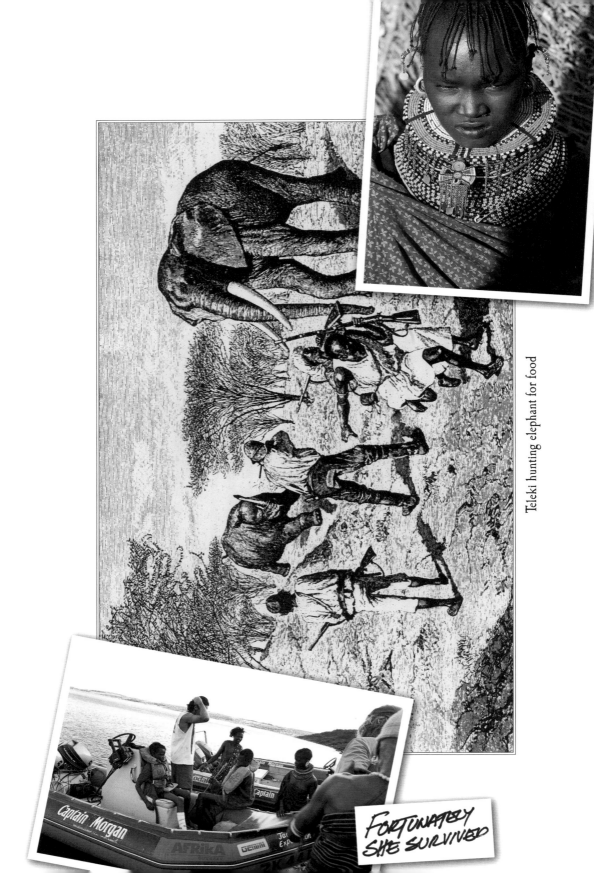

Teleki hunting elephant for food

FORTUNATELY SHE SURVIVED

Turkana. Below him, Leakey noticed a tangle of sedimentary deposits ideal for the preservation of fossils. The site was to become known as Koobi Fora (the Gabbra words for 'place of the *Commiphora* bush').

Bouncing through this area in our old vehicle is like taking a pilgrimage through the history of man. Dr Leakey's Cradle of Mankind is home to one of the world's richest hominid finds. Along the shores of Lake Turkana, bones have been found that suggest our ancestors walked here possibly up to four million years ago. It's a break from being pounded by the cruel waves of the Jade Sea as we squat in the dust around the 1.5 million-year-old fossil remains of a primeval elephant. Recent rains have half-exposed the fossilised skull of a prehistoric hippo protruding out of a bank. There are also the remains of long-snouted fish-eating crocodiles.

In Teleki's time, the whole of the Turkana hinterland supported large elephant herds. Teleki, on one day alone, had managed to shoot five elephant, with one tusk weighing 229 lb.

As we fuel up and bid farewell to the backup team, I wonder what other mysteries still lie underneath the windswept shores of the Jade Sea, a land that was once richly verdant and covered with animals. We won't see the land party again for some time as there is no way they can cross the Omo River at the top end of the lake. Their task is to get the truck back to base camp and await our circumnavigation and safe return (I do so hope!).

A river called Omo

So, north, towards the village of Ileret. The wind continues to howl and the sun burns down mercilessly. We spend the night on a sandbank island with local Merille tribesmen wandering in to squat on their hand-carved wooden headrests, their colourful clay headpieces (coiffures) reflecting in the firelight. To greet, we need to say *na*! The response is *faya*! All this creates much laughter and we feel quite safe with these tough-looking characters.

We now have with us Ari, a tribesman who says he can guide us into the Omo River delta and translate into the language spoken by the fierce Merille. This is a tribe whose warriors, until fairly recently, adorned themselves with the severed genitals of a victim – normally a Turkana or Gabbra tribesman whom they'd killed and castrated in a cattle raid or battle.

'Aah!' says Ari. 'Not much these days – and not to visitors like you!'
I involuntarily feel pain in my crotch.

We are totally lost. Even our 1960s British colonial survey maps and GPS points are unable to help us. The perennial Omo River has flooded out of Ethiopia and we're lost in a maze of channels, dead ends and flooded villages, burning up valuable fuel supplies while we search for one of the main streams into the Omo delta.

Then Ari excitedly points ahead, a wide grin on his impish face. We've just located the western mouth of the vast delta – but it has cost us dearly in fuel. With *Bathtub* and *QE2* just on the water plane to conserve the fuel, we push on regardless, up the brown snake of the river, twisting through green reed islands. This is what I truly love about an adventure: the looks on the faces of the expedition team members, the apprehension of what lies ahead.

We know we're hopelessly short on fuel but the temptation to explore this wild, untamed delta is too strong. Will we make contact, I wonder, with the fierce Ethiopian Merille people, known here also as the Dassanech or Galeb?

Ari, new-found guide and interpreter, assures us that if we make our way up the Omo into Ethiopia, we will find fuel at the settlement of Omorati. He gives us a colourful demonstration of what a petrol bowser looks like, explaining that there's a big black pipe that goes straight into the side of a motor car. Okay … so he's even seen it with his own eyes.

The first Merille tribesman we come across stands well over six feet tall and is armed with a spear. Totally naked, he's tending a large herd of beautiful white cattle that are swimming across a section of the delta. Taken by total surprise, he gazes in amazement at our red inflatable boats and strange cargo of pink, sunburnt adventurers. Further upstream we come across two more tribesmen, armed with a Chinese automatic weapon and long spears, on a crocodile hunt. Thank God we've got Ari with us to translate. The mozzies are bad so we decide to put up tents.

A true nomadic encounter

Next morning, young girls from a nearby village come over for a mutual stare. Beautiful and quite flirtatious, they take great delight in lining up to feel my beard. The little kids touch our legs and arms, amazed to find so much hair.

An unbelievable array of metal trinkets hang around the young Merille girls' waists, creating music for the colourful dances they perform for us on the banks of the Omo River. The warriors and old men are never without their stool-cum-headrests, called *karro*. Ash, often mixed with cow's urine, provides their evening dress, protecting them from mosquitoes and malaria. I enjoy this the most about our adventure – an opportunity to interact with true nomadic people whose lives are largely unaffected by Western ways. It's a feeling of stepping back into the past, and it's a special privilege.

Some of the well-armed young warriors are quite arrogant, intimidating-looking characters who, if we make a wrong move, could quite easily end our expedition. Once more, my imagination gives rise to an uncomfortable feeling in my groin!

By the time Samuel Teleki von Szek reached the northern regions of the lake, his expedition was desperate for food and fresh water. Teleki knew their only hope was to head up to the Omo delta where, they believed, they could trade for food with the Merille people (whom he referred to as the Reshiat). Their first encounter with these warlike people was as fascinating as ours. The following is recorded in Teleki's journal:

> *This was perhaps the most interesting day of our whole journey, for we were now for the first time face to face with a perfectly unknown people. And the way in which these natives, who had hitherto lived quietly far away from the rest of the world, received us on this first day of our arrival was so simple, so utterly unlike anything related in the accounts of their experiences by African travellers, that we could not get over our astonishment. First came a party of ten or twelve warriors, and behind them a group of some sixty or eighty men, who advanced fearlessly towards our camp. They paused every now and then, but evidently not from nervousness, for they allowed the women laden with food to approach a good bit nearer to us. We gazed at the dark, supple forms with eager curiosity, but drew back when the first group squatted down at a distance of some 200 paces from the camp, lest the sight of our white faces should upset the negotiations.*
>
> *We approached them in a friendly manner, to find that even the warriors shrank from us with the greatest dislike, not apparently from fear or shyness, but from disgust. Some prime tobacco, which I offered to one man, was indignantly refused, although the Reshiat (Dassanech) are very fond of chewing tobacco and taking it as snuff. The feeling of repulsion, however, soon wore off, and in the afternoon some two hundred men and women crowded into and about the camp, touching and staring at all the things new to them.*

Once again Ari assures us that the Ethiopian village of Omorati has petrol. At this stage we're down to just a few litres. When we get to the village, it's celebrating Christmas day according to the Coptic calendar. Beer and cool drinks are in good supply but the petrol station closed three years ago.

Mike and I walk to the nearby Lutheran mission station to beg for fuel. A tough and expensive negotiation with two even tougher missionary ladies results in the purchase of 100 litres that had been brought in by 4x4 all the way from Arba Minch, some 600 km away. A soft sandbank and a good campfire on the edge of the Omo is our home for the night.

As always, the local Merille come to visit. A near-naked young girl plays with her brother's AK-47 while the warriors look at each other through the viewfinder of Marcus's camera. I don't know who is the more curious – they about us or we about them. The men tell us that on a good raid they can bring back up to 8 000 head of cattle, stolen from the Turkana in the south. This southern piece of Ethiopia is bordered by Kenya and the Sudan, but these nomadic tribes appear not to give a damn about any borders.

Getting lost in Omo

The next morning we awake to a cacophony of sound: whistles, hoots and shouts. Are we about to be attacked or are the Merille warriors returning from a successful cattle raid? I walk to the top of a ridge to be met by a most interesting sight. Practically naked human scarecrows are perched on top of countless rickety platforms and trees, armed with balls of clay suspended from long whips (clay 'lats'), all the while shouting and whooping! Their task is to keep the thousands of birds away from their vast fields of tall, green, ripening millet.

Now I understand how Count Teleki's resupply of grain came from the Merille during his 1886–88 expedition to the north of the lake he called Rudolf.

Teleki stayed for weeks with the Merille, feeding up his half-starved men with grain, while the porters caught fish in the Omo delta and gathered freshwater mussels. Teleki went on to 'discover' a small nearby lake, which he named after Stefanie, the wife of Crown Prince Rudolf. Today it's called Lake Chew Bahir by the Ethiopians.

Teleki would have loved to have crossed the Omo delta but the river, which rises in the southern highlands of Ethiopia, was in full spate. Their only boat had been wrecked by a wounded elephant and their sole option was to retrace their steps.

For us, getting out of the delta is as difficult as it was getting in. We get hopelessly lost in a sea of reedbeds that defy any progress by boat. It's difficult and dangerous to pull and cut our way through them – there are huge crocs everywhere, and large pythons. Our guide tells us his father was killed by one – and there's no bloody way he's getting off the boat!

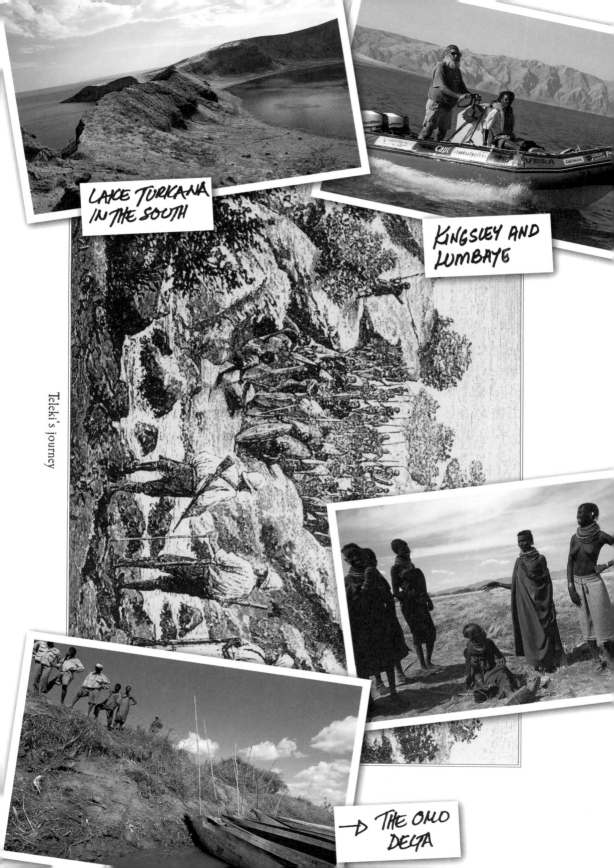

LAKE TURKANA IN THE SOUTH

KINGSLEY AND LUMBAYE

Teleki's journey

→ THE OMO DELTA

The river spirits are with us, though. We find a channel just wide enough for the boats which takes us clear of the delta and back into the stormy waters of the Jade Sea.

Boat fuel obtained from the friendly Catholic missionaries at Loarengak and carried to the lakeshore on the heads of tough Turkana women allows us to continue down the west coast of Lake Turkana. We now are south of the Omo delta – and the so-called Ilimi Triangle where the Sudan, Ethiopia and Kenya meet. I feel a lot safer back in Turkanaland.

At Katapoi, we take shelter from the wind and heat, and pitch our tents in a magnificent doum palm forest. Out of the dark next to our campfire, suddenly, without a sound, stands an unabashedly naked fisherman who offers us a crocodile skin and some freshly caught black tilapia. The fish augments our meagre rations. While it's illegal to hunt the crocodiles of Lake Turkana, many are caught in the fishermen's nets; the meat is considered a delicacy, but the skins have no value as they can't be processed because of the effect of the lake's alkaline waters.

A bathtub and a croc

At Kalakol we're resupplied by our old friend Rob Melville from Nairobi. Not only has he brought us fresh meat, eggs, beers and ice, he has also got a few crates of ice-cold Coke to go with the Captain Morgan. It's like manna from heaven.

By now, *Bathtub*, crewed by Mashozi and myself, has developed a number of serious punctures where the crocodile-bite repairs have come apart in the extreme heat and rough sea conditions. Pumping on the move has become a necessity. We cut the motors to land on Central Island, on a pebble beach, but the back of the boat with the punctured crocodile-bite pontoon immediately starts sinking. Our kit is floating all over the place. It's a mad dive as we scramble around in the green waters, trying to get everything safely to shore. Suddenly, I notice a movement. It's the biggest bloody croc I've ever seen heading straight at us. I scream at Mashozi to get out the water. Grabbing hold of a handful of pebbles, I lambast its massive prehistoric head which disappears under the surface. We lie panting on the beach. I need a drink! Ross arrives moments later in *QE2*. After catching a couple of Nile perch, added to our fresh supplies, there's reason to party well into the night.

A battle with the elements

The demonic wind howls on the lonely shores of Central Island, home to three volcanic craters, large Nile perch, and a breeding ground for massive Nile crocodiles. The following day Ross shortens the stricken pontoon, tying up the end

with old car tubing, making it look rather like a poorly made frankfurter. I move over to skipper *QE2*, while Ross and Lumbaye take over the responsibility of the 'badly injured' *Bathtub* – they're younger and fitter, and I'm starting to feel the pace …. By pumping the leaking pontoon on the move – and provided they keep on the water plane – they're able to keep moving. Enormous jade-green waves crash over the boats as we continue down the west coast, battling high seas and incredibly strong headwinds.

We make our way past the Turkwel and Kerio rivers, which, after good rains, flow into the Jade Sea from the west. Further south, the shoreline becomes drier, less inhabited and quite mountainous – a wild and windswept area across which just a few Turkana families and their livestock roam.

It's no joyride. Today I sense that, for some of the crew, the joy has gone out of the journey. The elements simply do not give up. We're a battered crew as, on day 22, tired and worn-out from the fierce heat and stormy conditions, we finally reach South Island and the end point of our circumnavigation. In a nomadic land of elaborate headdresses, ornamentation and body scarifications, we are not entirely out of place with our odd assortment of hats, sunglasses, scarves, sunblock and lip ice. A giant Nile crocodile cruises past as we empty the Zulu calabash of water we've carried with us, but there's little jubilation – just relief that we've survived Count Teleki's Lake Rudolf.

With a flick stick and spinner, Ross manages to land some black tilapia for the pot. There are crocodile tracks in every direction so we drag our bedrolls as far up the volcanic beach as possible. As always, the demonic wind howls continuously throughout the night – but we are covered by a blanket of stars.

Bathtub's final voyage

Count Teleki learned that if you spend time on the Jade Sea, the elements will do their best to destroy you, as they did Bill Dyson and Snaffles Martin here in 1934. Our crossing on day 23 from our lonely camp on the island to our base camp on the mainland, south of Loyangalani, is simply the toughest I have ever made.

I opt to 'skipper' the half-wrecked *Bathtub* on her final voyage. Her two pontoons are now tied together by strips of motorcar tube. Lumbaye, who has proved to be the star of the expedition, reluctantly agrees to be my crew. He ties on a bright orange life jacket and climbs aboard. The remainder of the expedition crew travel in *QE2*, skippered by extremely competent Ross. The large, six-metre Gemini Crusader is ideal for challenging the raging winds and huge waves that threaten to engulf us. I attempt to follow in the smoother water of *QE2*'s wake, but we're almost blown over backwards by a spurt of wind and spray. I motion for them to

carry on and turn our ailing craft into the wind. Waves crash over our boat, making visibility difficult. I shout to Lumbaye to sing loudly to his ancestral spirits and to bloody well keep pumping. The half-flat pontoons wobble crazily, but fortunately the outboards never miss a beat. After what seems like eternity, we get ourselves into a situation where we're able to run between the swells towards the oh-so-distant shoreline. Weak in the knees, eyes stinging from the alkaline water, and with a teaspoon of fuel to spare, we *finally* reach the shore. Had we run out of fuel out there, well ….

Lumbaye leaps off the boat to shake hands and hug the land party. He then turns towards Mount Nyiru and, with hands outstretched, gives a silent prayer to his Samburu ancestors. There are tears in his eyes.

We learn from the Land Rover crew that we weren't the only ones to have had a tough time. The Borana had stopped the vehicles at gunpoint and, on seeing a camera tripod – which they believed to be a gun mount – they'd stripped the vehicles in search of bullets.

Some five months after leaving the lakeshore, Samuel Teleki von Szek's expedition arrived in Mombasa on 24th October 1888. Neither Teleki nor Ludwig von Höhnel ever returned to the shores of their Lake Rudolf, but the names of these two stalwart heroes of an epic two-year odyssey on foot are assured of a permanent place in the annals of African exploration.

Unlike Richard Francis Burton and John Hanning Speke, who had fallen out bitterly during their journey in Africa years before, Teleki and von Höhnel managed to maintain a harmonious relationship throughout the two very stressful years of their march. The geographic and scientific results of Teleki's expedition rank with the highest in Africa.

We load the boats onto their trailers, fire up 4x4s *Thirsty* and *Vulandlela*, and climb slowly out of the heat and desolation of one of the wildest and toughest parts of Africa. Unrelenting, the fierce heat bounces off the black volcanic rocks and the wind howls to the last. We stop to photograph South Island and the endless stretch of emerald waters that are Count Teleki's fascinating inland sea and the world's largest desert lake.

Mashozi and Ross vow never to return. Marcus and Janice, I know, feel that it's the sort of journey you do only once. Mike, wearing an Ethiopian headscarf wound around his head, says with a lopsided grin that he'd love to do it all again. I love the wildness of it all, the fierce nomadic tribes.

Unlike Teleki's caravan, we do not have to go all the way back to Mombasa on foot, and soon we pitch camp on a dry riverbed under towering acacia trees. We are back in the shadow of Mount Nyiru, the sacred mountain of the Samburu, whose

god Ngai has safely guided us on our journey around the Jade Sea. That night, we slaughter a goat to celebrate our achievement. The Samburu *morane*, warriors all of the same age group, and pretty young girls from a nearby village dance into the night, their beads and gleaming red-ochred bodies lit by the firelight.

Three tough old characters holding 303 rifles sit on their wooden pillows, talking and chewing tobacco. I look at the animated faces of the expedition team. Somehow, we have survived this odyssey

Frederick Courtney Selous

Chapter IX

The Rufiji

Conquering the River from Source to Mouth

A tribute to Frederick Courtney Selous
in the Undertaking of a Tanzanian journey by Open boat from
the Headwaters of the Kilombero, down the Rufiji, across the Biggest game
Reserve in Africa, to a Mangrove delta

Being a True and Historic account of Pano and the lion
Maul – Cataracts and a Devil's cauldron – a Near Drowning – the Magical
snake Stone – Standing on a Ferocious crocodile

Rugby School, England, 1864

'Sir, I'm going to be a hunter in Africa and I am just hardening myself to sleeping on the ground,' explained the 13-year-old lad to the curious housemaster who'd just found him sleeping on the bare boarding-school floor. African diaries of the early hunters and adventurers filled the imagination of this tough little character. He loved nature and would bunk out from school at night to roam the nearby forests in search of birds' eggs. Such nocturnal adventures got him into trouble with Canon Wilson, the housemaster at Rugby School. 'So what do you wish to become?' asked an angry Wilson.

'I mean to be like Livingstone,' replied young Frederick Courtney Selous.

The Selous family was related to Scottish-born 18th-century Abyssinian explorer James Bruce. Courtney Selous' brother later noted that Frederick was born with a fierce passion to live the life of an adventurer in Africa. And in 1871, at the age of 18, Courtney Selous sailed for the Africa of his dreams. In search of ivory, he undertook a 400-mile wagon journey from the coast, had his double rifle stolen in the Kimberley diamond fields, replaced it with two rough elephant guns for £12 and, with no experience at all, headed north for the Limpopo and Matabeleland to explore and hunt.

Little did the young man realise that one day the largest game reserve in Africa would be named after him. President Franklin Roosevelt would later consider him the greatest naturalist of his time and he would become one of Africa's most remarkable outdoorsmen and hunter-adventurers. Twenty years later reports of his escapades would captivate Rider Haggard, the first important African novelist who, in 1885, created from Selous' exploits the fictional hero Allan Quartermain, the great white hunter of *King Solomon's Mines* and other novels. Haggard's romantic works, featuring other characters such as She and Nada the Lily, would become a magic inspiration for generations of young Englishmen, inspiring them to adventure in Africa.

I share Courtney Selous' passion for the great outdoors and this challenging continent, and have followed his footsteps across the Kalahari, Matabeleland and down into the Zambezi valley. I would love to have lived in Africa in the old hunting and exploring age but … it's never too late! Now, as a tribute to Frederick Courtney Selous, we're taking off to conquer the Rufiji, the river that flows through one of the last remaining pristine tracts of Africa, the Selous Game Reserve. After months of careful planning, it is a dream come true.

Dar es Salaam, 2004

Keven Stander, general manager of the Sea Cliff Hotel, the finest in Dar es Salaam, is a man the Zulus would say 'throws a shadow' – he's a bloke with a presence! Without knowing him from a bar of soap, I'd called him on the phone for help, and Keven had organised the meetings. I finally had a brown Republic of Tanzania envelope in my hand: permission, at last, to tackle the Kilombero and Rufiji rivers. It's people like Keven who make expeditions possible.

This morning, his driver, an entertaining man called Moody, drops me outside the old Boma in Sokoine Street, close to the Zanzibar ferry jetty.

'You want to do *what?*' asks the little bespectacled fellow at the government map office, housed in the grand old decaying building that dates back to the time of the Kaiser. I repeat slowly: 'Sir, we want to travel by boat from the headwaters of the Kilombero River, down the Rufiji, across the Selous Game Reserve and then through the Rufiji delta into the Indian Ocean. It's a journey of tribute to Frederick Courtney Selous, the man your Selous Game Reserve is named after.'

I show him my letter of authority from the Department of Wildlife, signed by Benson Kibonde, the official in charge of the Selous Game Reserve.

'Hmmm!' he murmurs, looking me up and down, no doubt taking in my 'portly' frame and grey beard ….

Three hours later the 1 : 250,000 survey maps, with stones to keep the corners down, are spread out along the dusty counter, across the floor and down the corridor; 22 maps in all, covering one of the most pristine wildlife areas in the world. Even the courtyard vendors, frying up a huge pile of potato chips, come over to look at The River – largest in East Africa, with its hand-shaped delta that's 65 km broad; a river artery that gives life to the largest game reserve in Africa.

The upper Kilombero

'*Basopo* (watch out)!' shouts our tall, cheerful backup man, Bruce Leslie, releasing the red ratchet straps and pushing the two large, rolled-up, expedition inflatable boats from the Land Rover roof rack. They land with a dust-filled thud onto the riverbank. We're at the ferry point, on the upper reaches of the Kilombero River, in Tanzania's Morogoro district. It's hot as hell. Roadside business at the small reeded market stalls, selling dried fish, fruit, vegetables and banana beer, comes to a standstill as everybody crowds the water's edge to nudge, point, pass comment, laugh and offer assistance.

Sweat pours as we push in the floorboards and take it in turns to pump up the boat pontoons. Of course, the local official needs to be part of it all, holding up the

launch of the expedition boats by demanding to see all paperwork. I do my na-na- normal stu- stu- stuttering bit, explaining that I'd pha- pha- phoned the ma-ma- magistrate for-per for-per for permission. The onlookers try not to laugh; the permissions man shakes his head and wanders off. It's a silly old trick I use from time to time … but it works.

It's late afternoon by the time we fill the Zulu calabash, according to tradition, and shout goodbye to 'learner explorer' Bruce Leslie and Selous game scout, Ramathan Nganguli, whose difficult task it will be to provide Land Rover backup support for our 600-km downstream journey to the Indian Ocean.

One boat behind the other, there's the familiar vibration of the tiller bar and throttle, shouting above the noise of the outboard motors, and the smell of outboard fuel – this time kindly sponsored by Unitrans Tanzania. With the two red Gemini inflatable boats just on the flat plane of the water, the Yamaha 40s at half-throttle, kit tied down in waterproof bags, we follow the Kilombero as it snakes through open grassland. To the west are the clearly outlined rainforest mountains of Udzungwa.

I love this apprehensive, nervous feeling in my gut, the start of another adventure, not knowing what the hell lies ahead. I've got a great team of adventure pilgrims. Ross, now 32, is the best expedition man I know – and he's a great mate. As usual, he will handle the technical side: HF radio and satellite comms, GPS navigation, boat repairs, and outboard maintenance. With Ross in the second boat is robust, good-natured, 24-year-old Geoffrey Chennells, who's starting a safari business in Tanzania and wants to cut his teeth on the river. I've known him since the day he was born. He understands there's no guarantee we'll make it, and with the vast number of crocodiles and hippo on the river, he knows he's risking his life. Also with them in the boat is armed Selous game scout Jabili Ngau, a capable middle-aged Tanzanian with a quiet, reassuring manner. In my boat is Mashozi, and dressed in khaki shorts and a red beret, game scout Edward Ngogolo. He's a man who has an opinion on everything, and because of his studious ways we soon nickname him 'the Professor'.

What a paradise! The Kilombero Game Controlled Area leads down to the Selous, a World Heritage Site and the single largest game reserve in Africa – three times larger than the Serengeti, larger than the whole of Switzerland, and more than twice the size of our Kruger National Park.

Elephants stained black with mud swim across the river in front of our boats, crocodiles are everywhere and the birdlife is magnificent, with more than 440 species having been recorded. At night we sleep on sandbanks. We don't see another human being. The game scouts make large fires around our camp, especially along the nearby hippo paths. I love the familiar night sounds: *simba* roaring in the darkness, the unnerving cackling laughter of hyena, grunting hippo, and in the

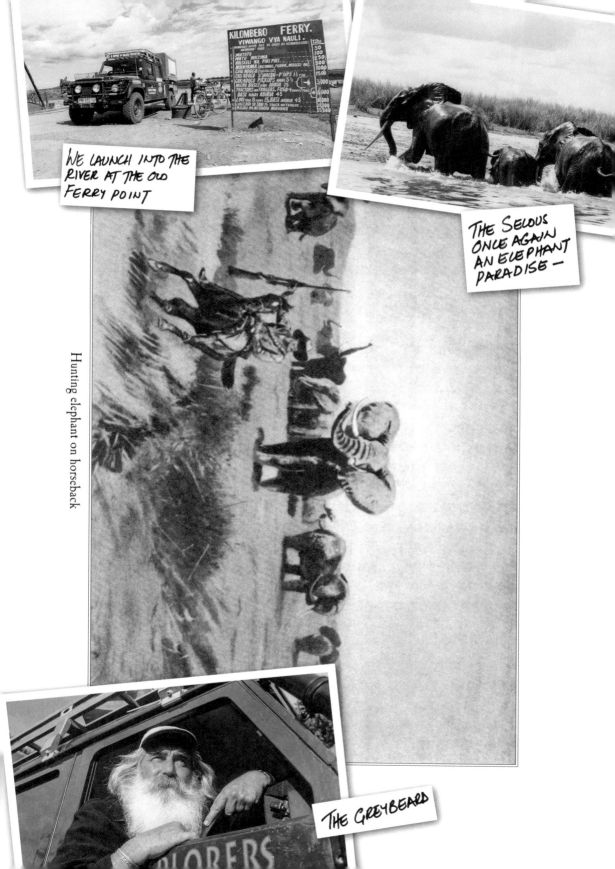

WE LAUNCH INTO THE RIVER AT THE OLD FERRY POINT

THE SELOUS ONCE AGAIN AN ELEPHANT PARADISE —

Hunting elephant on horseback

THE GREYBEARD

morning, the piercing call of the fish eagle as waterbuck step down to the river to drink while open-mouthed crocodiles lie like sunbathers on the beach. As I scribble these words in the expedition notebook, I realise that they read like a glossy tourist brochure – except, here, it's real and just us! Wild and untamed, not a human footprint. This is how Frederick Courtney Selous must have seen it.

A hunter's tale

Owing to a shortage of patrol boats, the Tanzanian Department of Wildlife is also using our journey down the river as an anti-poaching and reconnaissance patrol.

Around a corner on the Kilombero, we suddenly come across eight dugout canoes pulled up amongst the reeds. There are shouts of panic and the sound of running feet crashing through the bush. Out leap the game scouts, firearms at the ready. I hope silently that we don't end up in a running gun battle with poachers! We've stumbled across a well-organised fish-poaching camp, with fires still burning under smoking racks, tons of fish and turtles hanging from hooks, still alive.

The game scouts take a GPS reading for future reference; they'll be back with reinforcements. In a blazing fire, they burn the dugout, paddles and a massive pile of nets, lines and hooks. These Selous game scouts, with their limited resources, risk their lives to protect the wildlife.

Along the Kilombero River, vast hunting blocks line the river, catering to low-volume international trophy hunters. There's always great debate around the subject of hunting, but the truth is, the revenue from hunting supports the Selous Game Reserve. The controls are good and at least the professional hunting outfits assist with keeping out the poachers.

The hunters we meet along the way are tough likable characters, some built in the same mould as Frederick Courtney Selous. At Boma Ulanga, close to some old German graves, we meet Pano the Greek. Tough and grizzled, wearing an old camouflage outfit with cutoff sleeves, Pano is one such man. After eating hartebeest fillets around the fire, he relates one of his bush experiences – the story of an 'unlucky' hunter.

'This hunter,' says Pano, 'was from the southern states of America, a religious man who wanted no swearing and no-one to do his backup shots. If he missed, he would go after the wounded animal himself.' Pano signed the contract agreeing to the conditions, but it only took him a week to realise that 'the bastard couldn't shoot straight!

'He'd brought his son along with him, a bit of a "goofball" who walked around with a video camera. It happened on the other side of the river. The most beautiful black-maned lion I had ever seen … a grassland lion with no thorn scratches.

It was looking straight at us. I put up the hunting sticks and stood back as he fired. He *missed*! I couldn't bloody believe it. "Can't you fuckin' shoot straight?!" I screamed at him.

'So, breaking my contract, I shot the escaping lion from behind, causing it to somersault and fall behind a small ridge. I rushed forward with my gun-bearer, the client behind me. Then it happened … a second male lion that we had not seen leapt out of the high grass, straight on top of me.'

What saved him, Pano says, was that the lion didn't understand the human body. It bit into his calves and thighs, trying to suffocate his lower body, thinking his legs were the throat.

'There was blood everywhere. I was on my back and the lion had me by my thigh. I struggled into a sitting position and started to hammer at the lion's head with my fists – I was being eaten alive, fighting for my life! I saw its big yellow eye glaring at me in hatred. With all my force I stuck my left index finger into its eye and, twisting and turning, yanked the eye out of its socket.

Very fortunately for me, my gun-bearer's weapon had jammed – otherwise he might have shot both of us! The lion grabbed my left hand and tore it down the centre. Finally, the unlucky client let off a shot – missing, of course! – but the noise turned the lion off me.'

The enraged one-eyed lion leapt at the client who, with both hands, held his rifle across his chest in an attempt to ward it off. The lion grabbed the rifle and bit a hole right through the stock. Now on his back, the client screamed as the lion tore away at his arms.

'Of course, all this happened in seconds, playing out in slow motion in front of my eyes,' Pano continues. 'I saw my 460 Wetherby lying in the grass next to me. I tried standing, but my thighs were torn apart and I fell to the ground. My left hand was useless so, using my right elbow to pull me along, I leopard-crawled through the grass towards my gun – but in an instant, the lion saw me coming. It turned off the American and was about to pounce and finish me off. But then a miracle happened. The lion was thrown off-balance by one of its claws, which had got caught in the client's trousers. That gave me a second or two, which saved my life. As it shook the client's trousered leg free, from my waist I shot it full in the throat as it leapt at me. I rolled my bleeding body to the side. Next to me lay a dead one-eyed lion.'

He and the client were casevaced to Nairobi's Aga Khan Hospital where Pano received 256 stitches …. He fingers a gold necklace hanging round his neck to which a giant lion's claw is attached.

Lying in the tent that night, reading and listening to the sounds of the wild, I think of all the campfire stories Courtney Selous must have shared with his Bushman trackers and fellow hunters.

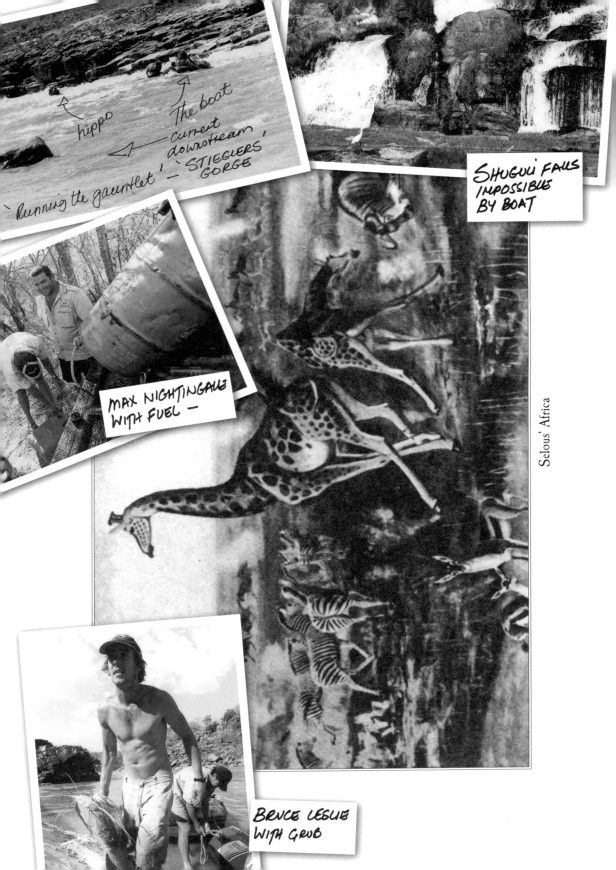

`hippo`

`The boat`

`current
downstream`

`'Running the gauntlet!' - STIEGLERS'
GORGE`

SHUGULI FALLS
IMPOSSIBLE
BY BOAT

MAX NIGHTINGALE
WITH FUEL —

Selous' Africa

BRUCE LESLIE
WITH GRUB

From Bartle Bull's magnificently written *Safari Chronicle* I read how Selous learned from the Boers to 'treat lion wounds with castor oil and milk, cauterizing the injuries with a strong solution of carbolic acid'.

He certainly had his share of adventures …. His horse was once knocked over by a charging elephant, and on another occasion, also on horseback, he was chased by a leopard for 70 yd before dispatching the cat with a fast shot.

Selous endured fevers, malaria, ripped tendons when his horse broke its back after it plunged into a hunting pit, brain concussion during an eland chase and a broken collarbone from a rhinoceros hunt. On safari, field medicine was part of Selous' life: treating his gun-bearers; pushing the intestines of Blucher, his dog, back in and stitching up its leopard-mauled flank; treating the lion-claw gashes on his horse's hindquarters; and setting his own broken bones in camp.

Selous wrote that a buffalo had 'pitched his horse into the air like a dog'. Once, while being chased through the bush by an elephant, his shirt and belt stripped from his body by thorns, he seized his elephant gun from the gun-bearer. His gun assistant unwittingly had loaded the powder twice and the shot lifted Selous off the ground, shattering the broken stock against his face.

Another shooting incident left a ¾-in-long chip of wood lodged at the back of his nose. A year later, while walking along Bond Street with the great naturalist Rowland Ward, Selous coughed up the chip of wood.

Early next morning, Pano shouts, 'Good luck, Kingsley, you'll bloody need it!' Last night he'd told us that to his knowledge, no safari had been crazy enough to tackle the Rufiji from this high up on the Kilombero River. Then he disappeared into the bush with a wealthy Spanish client, in search of leopard.

Shuguli and the Rufiji

It's a race against time. We should have started a month earlier and now the level of the Kilombero River is dropping by the day. We live in fear of destroying our outboard gearboxes and props negotiating countless rapids and rocks. 'Up engines, paddles in' is the constant refrain. It's hard work, especially as we reach the Shuguli Falls (sometimes called Siguri), where the Kilombero becomes the Rufiji. It's a devil's cauldron of rocks and cataracts, impossible to navigate by boat.

Winching, digging and pushing, we get the big Land Rover 130 double cab, nicknamed *Livingstone*, down to the river. We load up boats and equipment, then it's through the bush to below the falls. The tsetse flies are murderous, the old hunter's track a nightmare of dongas, long grass and sharp, hidden stumps. We grind all day in low gear – two boats, the outboards, 400 litres of fuel, camping

equipment, medical supplies, survey maps, food, and nine passengers. We're hopelessly overloaded, but you can't beat a Land Rover for this type of tough expedition work. Close to the riverbank, we slip sideways down a bank, the winch burns out and we're forced to dig our way out. Finally, bushed and bitten, we drag the boats and motors onto the top of a high sandbank.

Then we're back on the Rufiji. The river is wide and fast-flowing and, always, there is a pod of hippos to welcome us. I'm feeling jaded; I hardly have the energy to pitch camp. A fish eagle shrills. We all look up expectantly as a lion roars nearby. From the boat box we unwrap a padded bottle of Captain Morgan and raise our enamel mugs to yet another African sunset. Mashozi's hippo count, made up of hundreds of little ticks in the back of her notebook, now totals 2 297

At the Shuguli Falls, the Kilombero is joined by the Luwegu, a strong river flowing in from the southwest. Below the falls, this then becomes the mighty Rufiji River which, with its tributaries, the Great Ruaha, Kilombero and Luwegu, make up Africa's largest river basin, draining an area of 177 400 km². The Rufiji is wider than the Kilombero, with more sandbanks. Beautiful and unspoilt, it flows through the 45 000 km² Selous Game Reserve.

Unfortunately, due to poaching in the early 1990s, the elephant population was decimated from an estimated 110 000 animals in 1976 to less than 30 000 in 1989. Fortunately, successful conservation measures have now led to an increase, today approximating 60 000 elephant. The good news is that more than 50 per cent of Tanzania's remaining elephants occur in the Selous.

Recent surveys also indicate that every part of this wildlife paradise falls within the home range of at least one pack of wild dogs. The Selous reserve's total population of around 1 300 of these animals is believed to be twice that of any other African country, let alone any other single game reserve. If he were alive today, Frederick Courtney Selous would certainly have been proud to have had his name associated with this pristine piece of Africa's wilds.

Man overboard

We've never seen so many hippo in all our lives. There's not a day when we don't have a fright or three – it's no wonder the Rufiji has the highest population of any river in Africa. It's day six of the expedition. Steep, rocky gorges and dangerous fast water push us downstream to the confluence with the Great Ruaha, and on to the mouth of Stiegler's gorge, named after an old German elephant hunter. The gorge is quite frightening; the racing river with its wild rapids is compressed between high walls of jagged rock. A crocodile lies on a rocky ledge, while hippo grunt and snort from the deep pools. I get the sense it would be easy for a boat to

capsize and to be thrown into one of these rapids. With a shudder, I imagine being swept downstream as 'main course' on the *Crocodilus niloticus* menu.

Human figures wave from a distance. It's Max Nightingale and a party of game scouts. We've spoken on the radio and he's come down the Kilombero along a hunter's track to the river, escorting Bruce Leslie, our backup Land Rover man, to bring us fuel and supplies. With a wide grin, Bruce holds up a tiger fish still wriggling at the end of a line.

'So shall we portage round?' he asks. I see that look in Ross's eyes as he carefully scans the river, and his grin says it all. 'Let's be true to the river. We'll unload most of the kit and fuel. In case of an emergency, Bruce and Mashozi will meet us by vehicle at a point halfway down the gorge.' Max, a keen outdoorsman of the Courtney Selous persuasion, buckles on a life jacket. He's not missing this!

We lift the outboard engines and paddle hard. With a shout of terror, Jabili Ngau, the Selous game scout, is washed overboard into the wild white water. He gets trapped behind the transom, between the outboard and the pontoon. Fortunately he'd tied his rifle to the boat. Out of control, the boat full of water, we race backwards towards the next set of rapids. I pull the coughing and spluttering Jabili aboard, then pull-start the motor. Nothing! There are giant crocs everywhere. A hippo lurches out of the fast current and nearly knocks Geoffrey off the boat. Confusion reigns. Jabili, dripping and wide-eyed, points to the dangling red 'kill' switch. He'd pulled it off in error as he was washed off the boat. We hastily reconnect it, and with a pull that threatens to yank my arm from its socket, the outboard engine roars into life – with only a second or two to spare!

Wet through, sunburnt, tired out and with muscles aching, we anchor the boats onto a high white sandbank tucked away amongst the giant black-granite boulders of Stiegler's gorge.

There to meet us, and relieved that we're safe, are Mashozi, Bruce, the Land Rover crew and a man with a handwritten note from 'Babo Tembo', inviting us to spend a night with him. Babo Tembo turns out to be Eric Winson, a delightfully eccentric old African who owns Tembo Safari Camp, high above the gorge.

On Babo Tembo's satellite phone we get an urgent message across to Benson Kibonde at Wildlife Headquarters in Dar es Salaam: 'We're halfway down Stiegler's gorge, alive and surviving the Rufiji.'

Finding Courtney Selous' grave

That night we're disturbed by the loud trumpeting of elephant close to the camp. I shine my torch and watch the grey shapes dissolve between the trees. By the flickering light of a paraffin lantern, I return to Bartle Bull's *Safari Chronicle*.

When tracking elephant on foot, he often stripped down to what he called 'nice light running order': no trousers; only a long cotton shirt, hat and *veldskoene*. Selous admired the Bushmen, not only as hunters and trackers but also as the finest naturalists he had come across. He learned to speak Matabele fluently and Chief Lobengula called him 'the Young Lion'.

Heading north to the Limpopo, Selous suffered the first of many safari injuries. As he removed cartridges from a small box of loose gunpowder, his friend Dorehill turned to him with a pipe in his mouth, scattering smouldering tobacco into the powder. The explosion left them badly burnt. To prevent disfigurement, the two hunters rubbed a mixture of oil and salt into their skinless faces, and for a fortnight they could not bear any exposure to the sun.

On another occasion, galloping wildly after his first giraffe, Selous became separated from his companions when his horse smashed him against a tree. Stunned, lost and alone, without supplies, the setting of the sun brought on a freezing moonlit night. Desperate for food and water, and with a badly injured right leg, he wandered for four days before finding a Bushman with a calabash of goat's milk, which he exchanged for his clasp knife. The next day, he found his wagon and companions.

Years later, in 1879, just six years after Livingstone's heart had been placed in a biscuit tin and buried under a tree, Selous was to tell this story to the wildly excited boys at Rugby School. In 1985, nearly a century later, the Rugby Natural History Society was renamed the Selous Society.

In 1914, when war broke out between Britain and Germany, Selous, at the age of 62, unhesitatingly volunteered and was appointed captain of the 25th Royal Fusiliers, winning a DSO (Distinguished Service Order) in 1916. With his intimate knowledge of the bush, Selous was the automatic choice to head up the chase after the ragtag German guerilla army that General von Lettow-Vorbeck led through southern Tanzania for longer than a year, consistently evading or defeating the British troops.

On New Year's Day, 1917, German field companies found Selous trying to encircle General von Lettow-Vorbeck at Beho Beho camp not far from here, near the Rufiji River. As Selous raised his field glasses to his striking blue eyes, he was shot in the head by a German sniper. Selous' gun-bearer, Ramazan, charged the German lines, killing the sniper, and several officers and *askaris* around him. It was a tragedy for the battle-weary men of the Legion of Frontiersmen. Selous was wrapped in an army blanket and buried where he fell. His was the most famous casualty of East Africa's 'Battle of the Bundu'. It is known that, before the war, the Kaiser urged German youth to model themselves on Courtney Selous. After Selous' death, General von Lettow-Vorbeck, who claimed he'd once had Selous in his sights but had spared him, wrote that both sides had mourned this death.

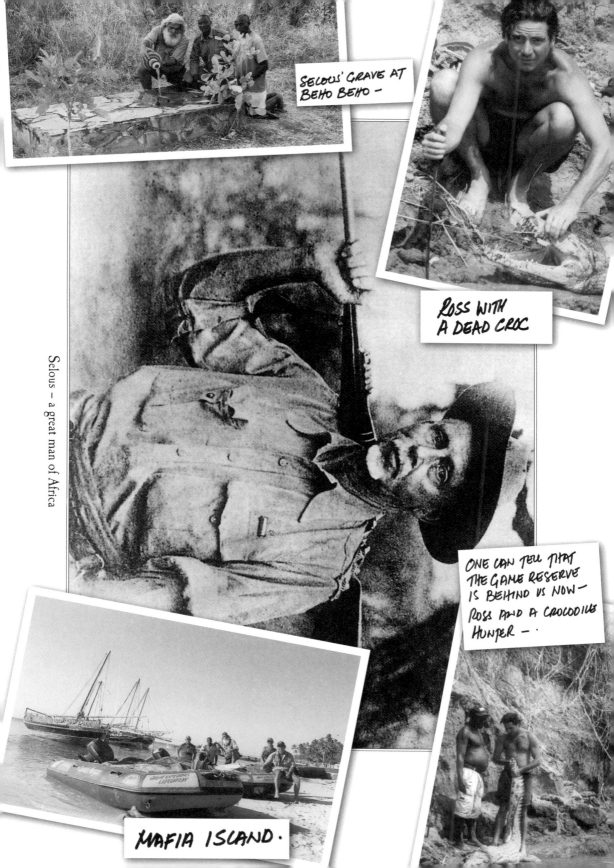

SELOUS' GRAVE AT
BEHO BEHO –

ROSS WITH
A DEAD CROC

ONE CAN TELL THAT
THE GAME RESERVE
IS BEHIND US NOW –
ROSS AND A CROCODILE
HUNTER – .

Selous – a great man of Africa

MAFIA ISLAND.

In the Land Rover, swatting tsetses while winding along a narrow sand track, we eventually locate Frederick Courtney Selous' grave. Our ragtag expedition team quietly gathers around.

Out of respect for the great man, we pour some of the Zulu calabash water taken from the upper reaches of the Kilombero onto the simple headstone. The game scouts take off their hats and solemnly lay down their rifles at the side of the grave. Edward Ngogolo kneels down and offers a Swahili prayer.

All around us is the African bush that Selous so loved. Ross asks me to say some words for the video camera. There's a lump in my throat! Then we call for a moment's silence.

The snake stone

The challenge of the bottom section of Stiegler's gorge still lies ahead of us. On the way back from Courtney Selous' grave, we peer over the edge of the gorge at the roaring rapids below. Once again, I catch Ross's eye. We are halfway down the gorge now; to turn back would be impossible.

Before getting into the boats, we clamber down the gorge for a few kilometres to familiarise ourselves with the river. Barefoot among this fallen debris of rock, we realise what a great hangout it is for snakes. How stupid! We really should be wearing the shoes we left behind in the boat ….

Frederick Courtney Selous had many a brush with poisonous snakes and I'm not surprised that he was curious to learn more about the rumour of a stone reported to cure snakebite. Travelling with the old well-known trader, John Cruikshank, he set off on horseback to visit the owner of this snake stone, an old surviving Voortrekker by the name of Friederick de Lange, who kept cattle near the Marico River. Old man de Lange was happy enough to show Courtney Selous the mysterious stone. He kept it carefully packed away in cotton wool in a small wooden box, locked away in a roll-top desk in a back room, which he also kept locked.

Despite an offer of £50, de Lange refused to sell the valuable stone. He said it was well known in the Marico as it had saved the lives of many local people – and even horses bitten by cobras, puff adders, mambas and the deadly boomslang. He went on to name a list of people whose lives the magical stone had saved. Among them was the young daughter of an elephant hunter named Fortman.

As it happened, two years after his visit to de Lange, Courtney Selous, by chance, met the Fortman family. He was shown the ugly scar. He was amazed; it was as if a large piece of flesh had been sloughed away on the young girl's left arm. Selous listened in astonishment as the Fortman's remarkable story recounted that,

after the little girl had been bitten, she became incoherent and the swollen arm turned nearly black. At first it seemed that all was lost, as a messenger had to first catch and saddle his horse before galloping off into the distance to return with de Lange's snake stone. Once fetched, it was applied twice to the wound to draw out all the deadly snake poison.

From Courtney Selous' journals we learn that the small stone was round and flattish, and of a very light blackish-grey, porous substance, with a smooth and polished upper surface. To use the stone, the rough unpolished underside was applied onto the wound. Only when a specific amount of poison had been absorbed, did the stone fall off. It was then immediately placed in ammonia or a similar liquid where the poison, looking like white threads, was seen to rise from the stone to the surface. Once clean of the poison, the stone could again be reapplied to a snake wound until the deadly poison had been extracted.

I wonder to myself, what became of the snake stone? It certainly would be a wonderful addition to our medical kit as, 111 years later, we continue to follow the Rufiji River in our tribute to Frederick Courtney Selous.

Clash with a crocodile

We tie our riverboats together, cut the motors, and with the odd thrust of the paddles, drift down the wide river, zigzagging between the large pods of grunting hippos. Here there is no fax, telephone or traffic. Simply the occupants of two small boats, highly relieved that we have survived Stiegler's.

Game scouts whistle and wave from the headquarters of the black rhino anti-poaching unit, a small building on the left bank of the river. They help pull our boats ashore. In 1980 the Selous reserve's estimated herd of 3 000 black rhino was the largest in East Africa. Then the poachers moved in and now there are less than 150. 'The Professor' tells us that there are 12 rangers in the anti-poaching unit and that black rhino numbers are now increasing. To think that the genetically distinct Selous population came so close to becoming extinct …. Now, with funding from the nearby Sand River Lodge, they even have the use of a patrol plane and are confident there's hope for the future of the Selous reserve's black rhinos.

Further downstream the Rufiji widens and the miombo woodland gives way to riverbanks of tall, stately borassus palms soaring to 25 m. We push and shove over the endless sandbanks. In shallow water, I almost stand on a gigantic Nile crocodile as long as the boat. It leaps out of the water, Mashozi screams, 'Watch Out!', I fall backwards into the boat – there's spray and confusion everywhere! I don't know who gets the biggest fright ….

Only moments later, once off the sandbank with the Yamahas purring along, do I fully realise just how bloody close it had been. I look across the boat at Mashozi, who wags her finger at me. Yet another sandbank ... and that prickly feeling at the back of my neck as I jump out to push, with my eyes out on stalks.

Mashozi's hippo count now totals 5 137 – that's not to mention the crocodiles and an impressive bird list, which now includes trumpeter hornbills, purple-crested turaco, whitethroated bee-eaters, palmnut vultures, yellowbilled stork, malachite kingfishers – the most we've ever seen – and our favourite, African skimmers swooping gracefully in front of the boat.

At the bottom end of the Selous Game Reserve, the Rufiji leads off into a labyrinth of five small lakes: Tagalala, Manze, Mzelekela, Siwandu and Mzizimia. They're quite beautiful. Giraffe stride between the doum palms, elephant come down to wallow, waterbuck with black wet noses glistening in the sun look up curiously at our red rubber boats. Crocodiles and hippo are everywhere.

The Land Rover team pulls the boat team up by rope to camp on a high bank above the river. Below us, 23 crocodiles cause a great commotion gorging themselves on a dead hippo. By morning, nothing remains of the bloated carcass.

Crossing the invisible line

It's time to move again. Bruce's expedition theme song plays through the Land Rover speakers. It's Ben Harper's number; the lyrics go something like:

'Slow down everyone, you're moving too fast,

Friends can't catch you when you're moving like that.'

Mashozi and Ross dance to the music. The words are quite apt for a team who, this morning, is battling to face reality and get moving. It's hot and overcast – we can feel we're getting closer to the coast.

We bid a fond farewell and *kwaheri* to our brave and loyal game scouts – we would not have made it without them. Leaving the unfenced Selous Game Reserve for the giant Rufiji delta, it's as if there's an invisible man-made line. Suddenly there are less trees, virtually no hippo and no waterbuck step down to the Rufiji to drink. Now there are huts, banana and cassava fields, and man-made bush fires. We find a hunter skinning a crocodile. I realise that one of the greatest pristine wildlife adventures of my life is coming to an end.

We camp in the muddy mangroves of the massive Rufiji delta. It was not far from our mosquito-ridden mudbank that, for ten months, the German Navy cruiser, the *Königsberg*, hid out during the First World War's East Africa Campaign in which Selous had died fighting. I ponder on this as we eat bully beef and rice, while boiling up a kettle of Rufiji water.

The sinking of the *Königsberg* in 1915, the first major British achievement of the campaign, was thanks largely to the bravery of South African Pieter 'Jungle Man' Pretorius. Disguising himself as an Arab trader, his skin already brown from the sun and malaria, he located the 3 400-ton ship as it lay hidden in the mangrove-jungle of a passage on the Rufiji.

Later, disguised as a native fisherman, the hunter made hundreds of soundings with a dugout-canoe pole, in order to determine how best British ships could reach her. The British then brought in flat-bottomed gunboats, assisted by aircraft spotters based on nearby Mafia Island.

The Germans, not to be outdone, dragged the ten naval guns off the sunken *Königsberg* through the bush, to the rail yards at Dar es Salaam. Here, each gun was mounted on wheels and the guns continued to blast the British. The ship's crew were added to the *Schutztruppe* and were taught Swahili and bush craft. When General von Lettow-Vorbeck finally surrendered to the British in Northern Rhodesia, shortly after the war ended in 1918, the *Königsberg* was still represented by a one-legged officer and 15 sailors out of an original crew of 323. Frederick Courtney Selous' regiment, the Legion of Frontiersmen, was the last white unit to survive in the East African bush.

> *In rags, shaking with fever, emaciated and white beneath their tans, they never lost their incredible determination.*

After the final battle, only 50 men were left standing out of a total campaign complement of 2 000. Selous had been the hero of the unit, tough and resourceful. One young official wrote:

> *Anything mean and sordid literally shrivelled up in his presence.*

A fish feast

The villages in the delta are built on stilts – with the occupants braving the mosquitoes and the mud tide. Our expedition is also in support of malaria prevention and we're able to distribute insecticide-impregnated mosquito nets, especially to pregnant mothers and those with tiny babies, who are most at risk.

Where the Rufiji meets the sea, we stand up and cheer, shake hands and hug each other. The incoming tide rocks the boat. Triumphantly, we empty our Zulu calabash of water taken from the Kilombero headwaters of the Rufiji into the Indian Ocean. The Kusi trade wind blows up white horses from the south as we follow a dhow loaded up with mangrove poles, heading for Mafia Island. That night, our expedition boats pulled up on a beach, we celebrate with a feast of giant kingfish, speared by Ross off the northern tip of the island and roasted on the coals. Sitting on the sand, we use our fingers to pull the succulent fish from the bone. We give the rest of the massive fish to a man from the village here. In return, he fills up our containers with fresh water.

We salute the moon with our dented enamel mugs and to mark the end of our journey of tribute to Frederick Courtney Selous.

German Navy cruiser, the *Königsberg*, hid out in the Rufiji Delta.

Our fight against malaria

Since the dawn of time, malaria has been a killer. The ancient Greeks were acquainted with the disease from around 500BC– it wasn't the sword that killed Alexander the Great, it was a bite from a tiny *Anopheles* mosquito, requiring a meal of blood to feed its developing eggs.

Many of Africa's earliest explorers, hunters and missionaries were wiped out by this disease. Dr David Livingstone, the great Victorian explorer, survived countless attacks of malaria only by treating himself with his 'Livingstone's rousers', pills he made from the oil of jalap, grains of quinine and a little opium and resin. However, it's hard to believe that in this modern world, every minute of each hour a person dies of malaria. The shame of it is that 90 per cent of these deaths occur in Africa south of the Sahara, and most of those who die are children. And this horrific situation is becoming worse. In many areas malaria – the silent exterminator – is now being regarded as a bigger killer than Aids.

Like the early adventurers, I have sweated it out with malaria on countless occasions. I've learned my lesson – sleep under a mosquito net and if I become infected, treat it immediately or risk death somewhere out in the African bush. Following the early explorers takes us to remote villages far removed from any regular health services – and here, most people are unable to even afford a mosquito net. In the mangrove swamps of the Rufiji delta, where malaria is their single biggest problem, fishermen paddle for days by dugout to get to the nearest clinic. While following Henry Morton Stanley's circumnavigation of Lake Victoria, Africa's largest lake, we were constantly shocked by the number of deaths caused by

the disease – babies crying out for help, mothers not knowing what to do.

With the help of the World Health Organisation, we use our expedition Land Rovers as mobile clinics to distribute educational material, anti-malarial products and insecticide-impregnated nets. Standing on the bonnets of our Land Rovers, our team gives malaria prevention talks, especially to pregnant mothers and those with young babies. (Pregnant women are especially vulnerable as they produce lots of blood to nourish their growing foetuses. When an infected mosquito bites a person, malaria parasites enter the bloodstream where they multiply in the host's liver and red blood cells.) In those villages where most of the pregnant women and children sleep under insecticide-impregnated mosquito nets, the rate of illness for all residents has dropped dramatically. Unfortunately, only one or two per cent of the population in malarial areas sleeps under these nets and in some villages we get to, the people simply can't afford them. In East Africa, a baby dies a minute of malaria.

Our support of the prevention of malaria fits clearly into the ethics of social responsibility linked to our modern Great Explorers expeditions. It's truly rewarding to meet the village chiefs, and experience their people singing and dancing in appreciation. While we're aware our efforts are but a drop in the ocean, our message is this: while malaria does kill, it is also an avoidable and curable disease that we simply must keep on fighting.

Part of the proceeds from the sale of this book will go to our
Malaria Prevention Campaign.

Poku and Lechwe, new African antelope, which were discoverd by Oswell, Murry and Livingstone

BIBLIOGRAPHY

In our humble journeys across Africa, we carry an old canvas duffel bag filled with treasured reference books that breathe life and history into our modern-day adventures. Upfront, I'd like to praise those who have gone before us and done a far better job in recording the adventures of the early explorers than I could ever have done.

For the Zambezi we used Michael Main's delightfully informative picture-book *Zambezi, Journey of a River*, together with that brilliant adventurous character Steve Edwards, whose book *Zambezi Odyssey* has always been a great inspiration to me. Tim Jeal's book *Livingstone* is arguably one of the best books ever written on the great Scottish missionary explorer and we used it extensively as research material, together with Livingstone's own *Missionary Travels and Researches in South Africa* and *David Livingstone and the Victorian Encounter with Africa* obtained from Livingstone's birthplace in Blantyre, Scotland.

The Other Livingstone by Judith Listowel is an informative gem and great reading, as is *Livingstone's Lake* by Oliver Ransford (for me the best book ever written on Lake Malawi).

When it came to travelling in the footsteps of HM Stanley, we had two everyday companions. One was John Bierman's *Dark Safari*, a wonderful insight into the life and travels of the man who will always be remembered by those words, 'Dr Livingstone, I presume?' The other, of course, is Stanley's own *Exploration Diaries of HM Stanley*, together with *Tippu Tip and the East African Slave Trade* by Leda Farrant.

For the early East African explorers, *Kenya, the First Explorers* by Nigel Pavitt is probably the most informative book available. Another treasure is Monty Brown's *Where Giants Trod*. Monty has done the most wonderful job of recording the old days in Kenya's wild northern frontier district.

The Jade Sea by Claudio Tomatis, *Cradle of Mankind* by Mohamed Amin and *Eyelids of Morning* by Peter Beard are great East African gems.

For early hunting stories and the life of Africa's greatest naturalist Frederick Courtney Selous, well, there's no better reading than *Safari: Chronicle of Adventures* by Bartle Bull and JG Millais' book *The Life of Frederick Courtney Selous* by Gallery Publications.

A bit big for the old duffel bag but one of the best for the world's largest river is Gianni Guadalupi's coffee table masterpiece, *The Discovery of the Nile*.

In our travels we've found Bradt's guidebooks by Philip Briggs to be impeccably researched and they make good reading.

Siyabonga and thanks

Kingsley Holgate

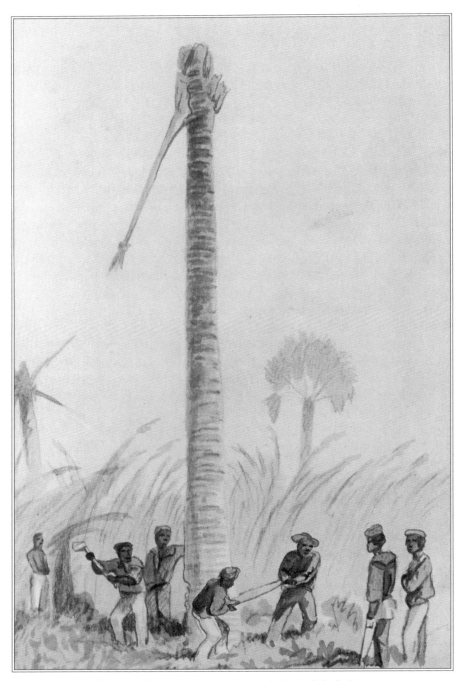

Cutting down a palm in order to fuel the *Ma Robert*

Picture Credits

All photographs copyright Kingsley Holgate, with the exception
of the following:

Front cover and **page 65** (bottom) – **Tony Weaver**
Pages 29, 35, 65 (top), **68, 73, 76, 80, 83, 86, 103, 109,
113, 166** (bottom right), **171** (top right), **258, 263,
266, 271** – **Marcus Wilson-Smith**